JUSTICE

JUSTICE

FACES OF THE HUMAN RIGHTS REVOLUTION

PHOTOGRAPHS BY
MARIANA COOK

DAMIANI

Mariana Cook
Justice: Faces of the Human Rights Revolution

DAMIANI

Damiani
via Zanardi, 376
40131 Bologna, Italy
t. +39 051 63 56 811
f. +39 051 63 47 188
info@damianieditore.com
www.damianieditore.com

Design by Debbie Berne Design

Printed in October 2012 by Grafiche Damiani, Bologna, Italy.

ISBN 978-88-6208-261-7

For Anthony Lewis

CONTENTS

PREFACE

—

HOW DO PEOPLE COME TO FEEL SO PASSIONATELY ABOUT FAIRNESS AND FREEDOM that they will risk their livelihoods, even their lives, to pursue justice? A few years ago, I became fascinated by such people—people for whom the "rule of law" is no mere abstraction, for whom human rights is a fiercely urgent concern. I wanted to give a face to social justice by making portraits of human rights pioneers. I am a photographer. I understand by seeing. Peering through the camera lens, I hoped to gain an understanding of how they had become so devoted to the rights and dignity of others.

The subjects I chose live in a multitude of countries, in both open and closed societies; they range widely in their ancestry and social origins. Some have been advocates from an early age. Others came to their crusades unexpectedly, even unwillingly. Several were simply doing their jobs, and then realized that doing so can, under certain circumstances, be a radical act.

To photograph and conduct interviews with these people, I traveled to countries around the world, often accompanied by my teenage daughter, Emily. We had dinner in Johannesburg with Edwin Cameron, a gay, HIV-positive judge on the Constitutional Court who helped draft the South African Constitution. We visited Thomas Buergenthal at The Hague, one of the youngest survivors of Auschwitz, who was at the end of his 10 years on the International Court of Justice. We were given a tour of the European Court of Human Rights in Strasbourg by its soon-to-be-president, Sir Nicolas Bratza, after my portrait session with him there. We were followed by the Myanmar secret police after photographing and interviewing Aung San Suu Kyi at the National Democratic League's headquarters in Yangon; my daughter learned more about the meaning of democracy in those few hours, I suspect, than she had in her entire year of United States history at school.

I met a number of my subjects in New York City when they visited for conferences or United Nations meetings. They would often come to my studio, where I could photograph them in natural light. With previous projects, subjects might ask where in my neighborhood they could buy a gift for a child or partner. None of the *Justice* subjects asked that. The only request I got was where they could find the entrance to Central Park. Many of them simply wished to walk freely in public, without a bodyguard, as they are unable to do in their own countries. Sometimes I would accompany them. Others preferred to walk alone.

Nader Nadery, a 38-year-old Afghan, preferred to walk alone. He told me that he had been accompanied by bodyguards for 15 years. "Now and then, I can't stand it anymore and I escape them in a crowd," he said. "They get very upset with me when I do that." What I want to know is why he is the only one of his nine siblings who has not left Afghanistan. Why does he choose to remain at risk with his wife and young child? His brothers and sisters grew up with the same parents in the same period of history in the same country—what is it that makes him stay and fight? I listen; I look; I learn.

While many of these advocates are devoted to a cause with which they have a personal connection—a cause that is, in some sense, a birthright—equally impressive are those who fight to protect people with whom they have nothing in common, save a shared humanity. John Kamm told me that few of the thousand Chinese dissidents whom he has helped have ever thanked him. His efforts are often unknown to their beneficiaries. But he does not care about acknowledgment, let alone gratitude. What moves him is the core conviction that there are basic human values, such as freedom, to which everyone is entitled.

I sequenced the portraits to emphasize each subject's individuality, rather than by place, time, or cause. The strength of character and conscience possessed by each person may have been determined, in part, by his or her upbringing, experience, and intellect, but there is something else that compels every one of them to persevere—a tenacity beyond comprehension.

The intent of this book is to pay tribute, not only to the courage of independent thought and action, but also to the dogged insistence that reason and fairness prevail. I hope I have been successful, through picture and word, in giving you a glimpse into the minds, hearts, and lives of some of the remarkable men and women whose efforts have launched and sustained a movement. Margaret Mead may have said it best: "Never doubt that a small group of thoughtful, committed citizens can change the world. Indeed it is the only thing that ever has."

M.C.
September 4, 2012
New York City

INTRODUCTION

ANTHONY LEWIS

LORD BYRON, THE GREAT ROMANTIC POET OF THE EARLY 19TH CENTURY, could be called the first campaigner for international human rights. He fought for Greek independence from the Ottoman Empire—fought in words, denouncing Ottoman massacres, and in the end fought with his body. He died of a fever in 1824 at the battle of Mesologgi. Many of the great examples of resistance to tyranny have been born of individual courage: in our age, the struggles against Soviet brutality and Chinese repression, against South African and American racism. Some heroes of the struggle for human rights have paid dearly, with their freedom and their lives.

The idea that people have rights beyond their rulers' control has grown steadily over the centuries. At Runnymede in 1215 the English barons forced King John to agree to The Magna Carta, guaranteeing that every man be judged not by a ruler's fiat but by the law of the land. The American Bill of Rights in 1791 expressed that assurance in the phrase "due process of law." Gradually, too, societies relinquished the notion that some human beings—blacks, women, homosexuals, the disabled—were lesser creatures not entitled to rights. In our own country, *Brown v. Board of Education*, the American Disabilities Act, and the recognition of marriage for same-gender couples have radically expanded the rights of millions of Americans.

Human rights include many particulars: freedom from torture and physical abuse, freedom of belief and speech, the right to a fair trial, equal treatment under law. But when we respond to the suffering of a particular victim, whatever the cause, what is offended in us is our sense of justice. Justice is an instinctive ideal around the world, treasured by those who have suffered under dictatorships and repressive governments everywhere. The cause of human rights is the cause of justice.

Much of the work for human rights has been done by lawyers and judges: work that can be and frequently has been dangerous for them. Lawyers from China and Singapore to Argentina and Chile who have agreed to represent unpopular clients or ideas have found themselves in prison. British and American lawyers, who act against injustice from positions of considerable safety, still run a certain risk. Judge advocates who were appointed by the military to represent prisoners at the Guantánamo Bay detention center—and who performed with admirable skill and commitment—sometimes lost their positions simply for doing their jobs. A considerable number of private American lawyers who volunteered to act for Guantánamo inmates were viciously attacked by right-wing zealots as "pro-terrorist." They were not pro-terrorist but pro the duty—and the honor—to represent unpopular clients.

Lawyers and judges have been joined around the world by scientists, journalists, human rights activists and other private individuals in the struggle for justice in their countries. Sometimes that has meant bringing to life rights supposedly guaranteed in a society but in reality ignored. When the National Association for the Advancement of Colored People was founded in 1909, its stated objective was to obtain for all Americans the rights guaranteed by the Thirteenth, Fourteenth, and Fifteenth Amendments to the United States Constitution—an end to slavery, equal protection under the law, and universal adult male suffrage—guarantees that had not lived up to their promise. As Aung San Suu Kyi drily observed of the Burmese governments that silenced her for years: "Those now in power have very little knowledge of what laws actually do exist in this country." At other times, as in South Africa and Chile, human rights groups took part in overthrowing tyrannical political systems. Michelle Bachelet was imprisoned in Chile under Pinochet for her human rights work; decades later, as President of Chile, she held its military to human rights standards.

Human rights as a set of principles that can be enforced beyond borders is a more recent concept. Over many years governments carried out mass atrocities without arousing effective international protests. That was the case in the Armenian genocide of 1915, when the Turks who ruled the Ottoman Empire murdered or exiled to desert areas without food hundreds of thousands of Armenians. The American Ambassador to the Empire, Henry Morgenthau Sr., sent passionate dispatches to Washington about the horrors taking place, warning about "crimes of Turkey against humanity and civilization." But President Woodrow Wilson was determined to do as little as possible.

Over the years since then American and other governments have often talked the language of human rights but done nothing to stop appalling violations—even genocide. In the face of growing Nazi atrocities against Jews, the United States maintained barriers to Jewish immigration. The countries that could have acted to stop the slaughter in Rwanda did nothing. Only after years of delay did the United States and its allies act against Serbian atrocities in Bosnia.

Savagery thrives on concealment. Disclosure of its horrors may arouse opposition. An early example was the slaughter of Bulgarians in the Ottoman Empire in 1876. A daring journalist, Januarius Aloysius MacGahan, made his way to Bulgaria, found thousands of rotting bodies and filed a story for a London newspaper. It aroused widespread protests in Britain—from among others Queen Victoria and William Ewart Gladstone, a former prime minister who returned to office on a tide of outrage.

Official recognition of the interest in human rights began in 1948, when the United Nations adopted the Universal Declaration of Human Rights. In 1953 a global region for the first time adopted its own measures against state violations of human rights: European countries agreed to a legal convention on human rights and created a court to enforce its terms, the European Court of Human Rights. In

2000, Britain made the convention applicable as law in its domestic courts, empowering judges to declare Acts of Parliament incompatible with the convention.

In 1975, in Helsinki, the Soviet Union and Western countries signed accords that included provisions on human rights. The U.S.S.R. did not expect those provisions to have any effect. But the Russian physicist Yuri Orlov and several compatriots formed the Moscow Helsinki Group to monitor Soviet compliance with the accord, and soon Western governments—and private groups like Helsinki Watch (later Human Rights Watch) joined them. "Helsinki" became a watchword for humanitarian concerns. A few years later, President Jimmy Carter made respect for human rights a formal objective of an American administration for the first time.

Along with the developments in official support for human rights has come a crucial growth in private support. The signal moment came in 1961, in London. Peter Benenson, an English labor lawyer, reacted with outrage when he heard about people unjustly imprisoned by tyrannical governments. He published an article in the British Sunday newspaper *The Observer* and began to mobilize world opinion on behalf of what he called "prisoners of conscience"—the signature phrase of the organization he started, Amnesty International. Amnesty worked by focusing attention on the plight of individuals who were victims of injustice—arbitrary arrest, incarceration, torture—because of their words or beliefs. Twenty years after its founding, Amnesty had two million members. It was awarded the Nobel Prize for Peace in 1977.

The flowering of interest in human rights in the latter part of the 20th century led to the idea of humanitarian intervention. The belief was that outside governments had a right—indeed, an obligation—to intervene when a country's regime grossly mistreated its own people. The doctrine was invoked in the case of Bosnia when other powers finally intervened militarily to stop the Serbian killings there. One argument for the American invasion of Iraq was the cruelty of the country's murderous Iraqi dictator, Saddam Hussein. But the high level of Iraqi casualties and revelations about American treatment of Iraqi prisoners made it hard for many to view the enterprise as humanitarian.

In recent years America's "war on terror" has produced a profoundly troubling phenomenon: the use of torture by the United States. President George W. Bush and Vice-President Dick Cheney authorized the brutalization of prisoners suspected of terrorist connections. When photographs were published of prisoners being humiliated by United States soldiers, Americans were shocked and ashamed. But without that visual evidence, extensive use of torture elsewhere caused less public outrage, and was explained away as legitimate in fighting terrorism. The use of torture was a violation of international understandings and treaties, and a violation of United States criminal law. But when the facts of American torture practices became known, the Bush administration's response was not to cease using torture but instead to

scramble for a legal justification for continuing to do so. Today, almost a decade later, no senior official has been prosecuted by either the Bush or the Obama administrations.

There are grounds for hope. As governments have failed tests of law and justice, others have stepped in. Judges and lawyers, for one. The Supreme Court of the United States, rejecting executive claims of absolute power, held that prisoners at Guantánamo were entitled to judicial hearings on whether in fact they had terrorist connections that justified their detention. And journalists, politicians, activists and ordinary citizens in many countries are working against the denial of human rights, not only in their own countries but all over the world: a lawyer from New England defends an Uighur prisoner at Guantánamo; a journalist from *The New York Times* raises awareness of sexual slavery in Nepal; a black American lawyer spends years fighting apartheid in South Africa. Byron's example is growing.

In an age so dominated by fear, the struggle for human rights will not become any easier. We have to believe that the humane spirit will prove to be the more important part of man's nature. John Adams, the second President of the United States, well expressed the urgency of this ideal more than two hundred years ago. Adams was a young lawyer in Boston, six years before the American Revolution, when British soldiers ("red coats") fired into a rioting crowd and killed five Bostonians. The soldiers were charged with murder, and Adams was asked to represent them—in the face of extreme public anger. Adams succeeded in getting most of the soldiers acquitted of what had come to be called the "Boston Massacre." He said later that it was "one of the most gallant, generous, manly and disinterested actions of my whole life, and one of the best pieces of service I ever rendered my country."

What drives women and men to overcome the natural human desire for a quiet life and struggle for the rights of all? The portraits in this book introduce us to some of the men and women who have stood up and spoken out. Mariana Cook traveled the world to photograph and interview them. The texts, some written by the individuals and others edited from interviews with them, provide their views of the nature and importance of human rights—and their personal reasons for devoting themselves to that cause. Through them we are reminded of the power of a single individual—one face, one voice— to transform the world. The subjects include the famous and the unknown. These fighters for human rights seek no personal gain. Any rewards are the benefits that we all enjoy when the rule of democratic law protects us. The pictures and the words in this book show, as I think nothing has shown before, the strength of human character that has made human rights such a powerful movement across the world in our lifetime.

PORTRAITS

LUDMILLA ALEXEEVA

RUSSIA — ACTIVIST

MY PARENTS were third-generation intellectuals. My mother was a mathematician and my father was a Communist. They came from very poor families who welcomed the Russian Revolution. They believed in the Communist ideals. The ideals weren't bad; unfortunately, the result of imposing them in real life is a totalitarian state. Without cruel pressure, it is impossible to make people equal.

I was born in 1927 and remember the beginning of World War II very well. My father was in the Soviet army and did not return. At the end of the war, I was a first-year history student at Moscow University and had begun to doubt the efficacy of Communist principles because of my experience of the poverty and totalitarianism in Soviet life. I could not discuss my doubts with anyone because, in Stalin's time, to do so would have been very dangerous. I had known this as a small child. Everyone knew that even if we expressed our doubts cautiously, we would be arrested.

The Communist Party was organized in such a way that it was possible to become a member, but there was no explanation as to how to leave the party. The only way out was to be excluded from it. Such exclusion meant you couldn't have a job and there was no possibility of education for your children. You would not eat because there were no jobs outside state positions. You would simply be excluded from the national system. For that reason, I continued to be a party member, but I was not active.

Only after Stalin's death, when Nikita Khrushchev spoke openly about Stalin's crimes against the Soviet people, could we discuss our doubts openly, although not officially. Censorship was not lessened, but there was more freedom to speak. I became very active in discussions with friends and acquaintances—not only about the problems of our country, but also about the relationship between power and society. Ten years after Stalin's death, one could do this in private without being persecuted. This was particularly important for me personally because I needed to understand what kind of society my father had fought and died for. I wanted to know what future we could have. I did not see happy people around me and I was not happy either.

I also understood that this was not a personal problem; in my private life, everything was all right. I was discontented because I saw the terrible problems suffered by many of my compatriots.

The human rights movement in Russia was born in the mid-1960s. Working for the movement was what I needed to do to be happy and fulfilled as a person. In the 50 years since then—in spite of being among unhappy people in a very unhappy country—I have been content because I do what I wish to do.

Under Khrushchev it was easier to fight for human rights than it is now. Then there was a predictable price to be paid: you knew you would go to jail. Human rights activity under such conditions is difficult, but it is possible. Now the movement covers the entire country; it is no longer a small group of people. Many have joined us, and I believe they will continue what I began. In this administration, however, you do not know what to expect. There are cruel and unpredictable repressions. One can just be killed. Today, we do not live in a democratic state or in a totalitarian state. Ours is an authoritarian state.

I doubt I will see democracy in Russia in my lifetime. But I know we will be a democratic country one day. I will never stop working to that end. I have two sons, one granddaughter, two grandsons, and two great-granddaughters. All of them live in America. During Brezhnev's time, I emigrated, but as soon as it was possible to speak openly again, in the 1990s, I returned to Russia to live and work. I hope I am not a bad mother and granny to have left my family, but the sense of my life is to see the rule of law and democracy in my country. I believe it is important not only for me but for the younger generations too.

LUDMILLA ALEXEEVA (b. 1927) is an historian and activist; now in her eighties, she is considered the doyenne of Russia's human rights community. A veteran of the 1960s dissident movement, she was a founding member of the Moscow Helsinki Group until forced into exile in 1977. In the United States, she was the group's official spokesperson and a tireless advocate for its imprisoned members, writing extensively on the dissident movement and speaking regularly on Radio Liberty and Voice of America. When the Former Soviet Union (FSU) fell, she returned to Moscow and in 1996 became head of the revived Moscow Helsinki Group. It has flourished under her continued chairmanship and is now the oldest active Russian human rights organization.

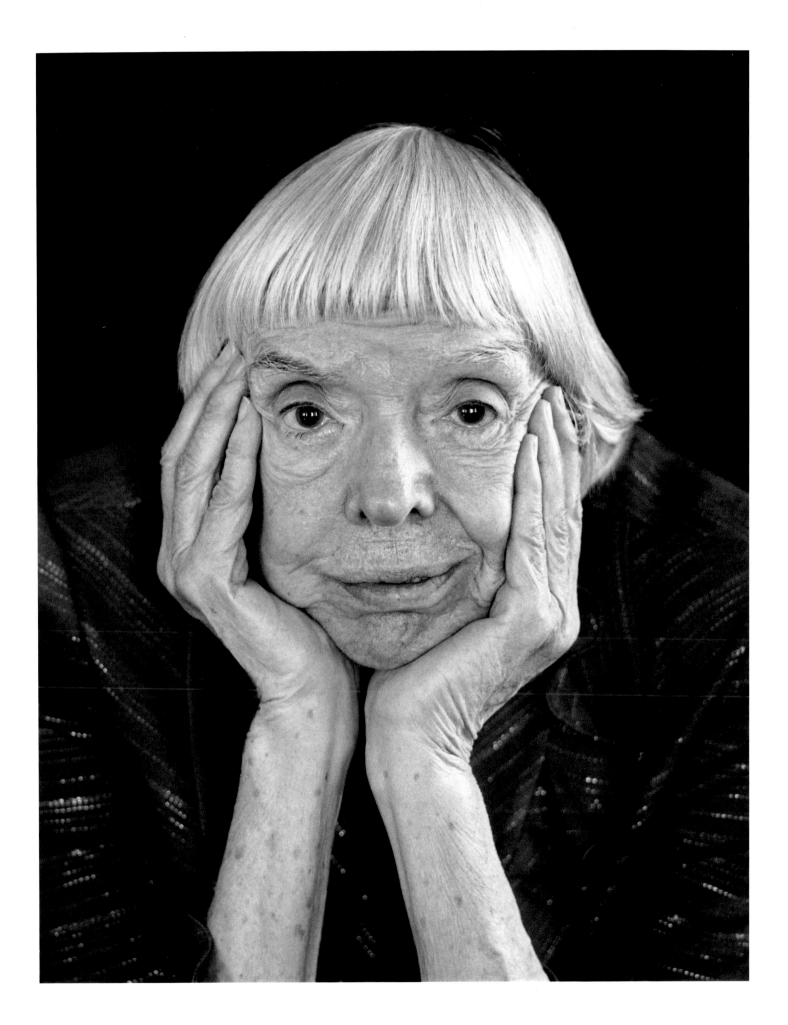

ROBERT BADINTER

FRANCE — LAWYER

THIS BEAUTIFUL PHOTOGRAPH, which represents a man marked by a long life, is in fact me today. What can this old man say in his defense before the young lawyer he was 60 years ago who wanted to change justice?

"I fought hard for justice in France so that it would no longer be a justice that kills. The death penalty is abolished. The guillotine is now a museum object. Are you satisfied?"

The young man shakes his head: "It is true you did what you could, but it was François Mitterrand who made the political decision. You put the abolition into words. That's all."

The old man: "And those heads I saved, the six men whose heads the mob outside the law courts were shouting for? Well, it was I and my strength of conviction that snatched them from death."

The young man: "The best of you in those moments was I, the young man still present within the lawyer in his prime who dictated fiery words that came from deep within, from the adolescent he was on the night of the occupation. It was I, the best of you. So, what else?"

The old man: "I always fought to improve prisons so that detainees would be treated as human beings, deprived only of their freedom, whose rights and dignity were to be respected."

The young man: "I hear you. Can you say today, after so many years, that you feel the conditions of prisons have truly changed? Your eyes answer, 'Alas.'"

The old man: "Do not forget my struggles to combat crimes against humanity everywhere. You know how close this cause is to my heart."

The young man: "I find you are lenient with yourself. When I was 20 years old, there were other brilliant victories I needed to win in the name of justice. From the perspective of my dreams, your accomplishments are few."

The old man: "I think about you sometimes when crossing the Luxembourg Gardens; you were ruthless with yourself then. You have not changed. And that is very good. I am going to tell you a secret: I did what I could, that is all. I would like to start over to try to do better. But there are no second chances, alas. Farewell."

ROBERT BADINTER (b. 1928) is best known for successfully abolishing the death penalty in France. He devoted himself to the cause after the execution of Roger Bontems in 1972, for whom he had served as legal counsel. During the 1971 revolt in Clairvaux Prison, Bontems and a fellow prisoner named Claude Buffet had taken a nurse and prison guard hostage and their throats were slit. Although the defense maintained that Buffet was the one who had orchestrated the murders, Bontems was also sentenced to death by guillotine—a fact that struck Badinter as profoundly unjust. Badinter was Minister of Justice and then President of the Constitutional Council under François Mitterrand.

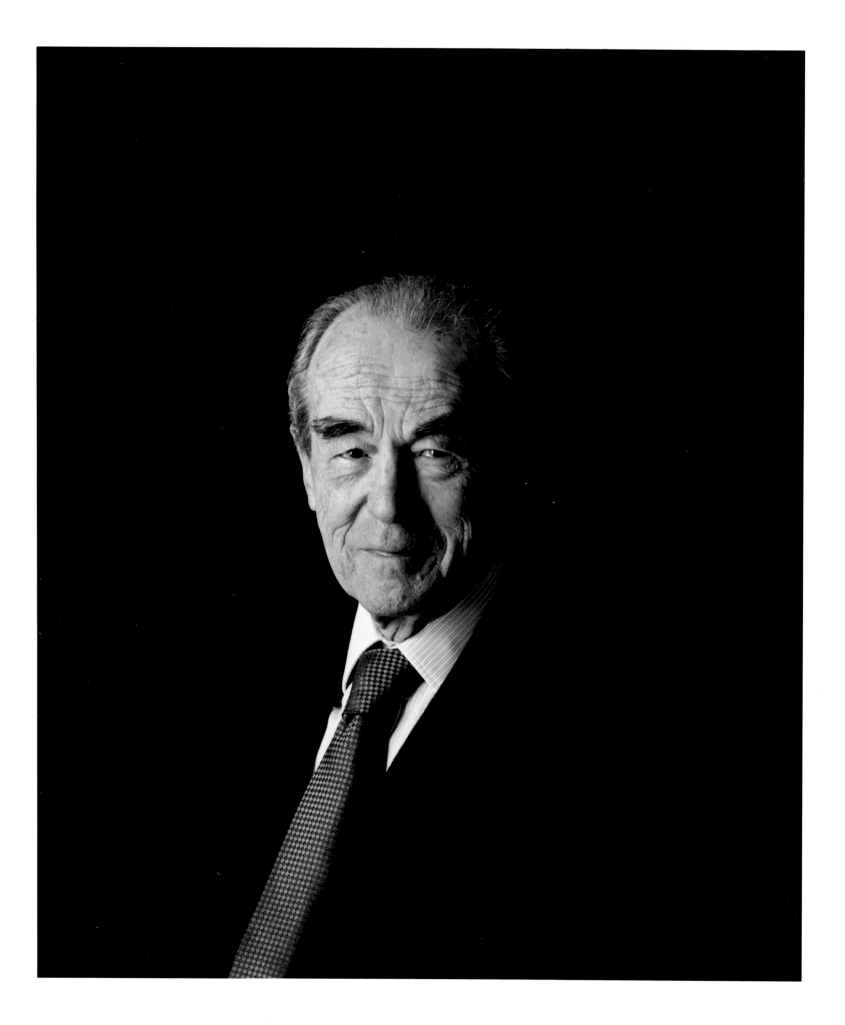

AUNG SAN SUU KYI

BURMA — ACTIVIST

I DON'T THINK YOU CAN SAY that a certain kind of person is particularly attracted to human rights. It attracts all kinds of people for very many different reasons. Some become involved in the struggle because of a personal experience; others are drawn to it because of the way they have been brought up, the values that they were taught as children. I belong more to the second category than to the first category, although what I saw in Burma during the 1988 uprising convinced me that we all had to work for human rights.

In 1990, we had the first democratic elections in Burma in about 26 years. I did not run, because I was under house arrest by then. Many of the leaders of the National League for Democracy were placed under house arrest before the elections—probably because it was felt that without our leadership the party could not fare well. But, in fact, we won a landslide victory. This was a bit of a shock to the military junta, who decided that they would ignore the results of the elections.

I was in a much easier position than many of my colleagues because, from the very beginning, I had the protection of my father's name. My father was the founder of the Burmese army, so they were quite restrained in how they treated me. The same restraint was not practiced with regard to many of my colleagues, who were arrested, brutally interrogated, and imprisoned for years under terribly bleak circumstances.

I have often wondered why people treat others in such an autocratic way. Now we know, of course, what it is like to be deprived of one's basic rights, and we would not subject anybody to that kind of experience. Putting it in a very general way, it's a mixture of greed and fear that pushes people to ill-treat others. They want to preserve their own security and enjoy the privileges to which their position entitles them. And also ignorance, because there are some people who really believe that it's all right to treat those who are "different" from them in any way they like. There must be some who are by nature sadistic, but I do not think that they are in the majority.

We have very good laws in Burma, some of which were carried over from the colonial period, and if we were treated in accordance with those laws, we would be perfectly all right. Those now in power have very little knowledge of what laws actually do exist in this country. We have noticed again and again that if we point out that there is a law saying that you cannot do this, they will open their eyes very wide and run back to their books and look it up. But often people do not question them because the ruling powers can do whatever they want to. We teach people that they must ask questions and not take it for granted that whoever is treating them poorly has a right to do so. We have published a pamphlet for the families of political prisoners to instruct them on what rights they have and what rights the prisoners have, and to encourage them to demand these rights.

You cannot say that these rights are never respected. If we stand firm and united, and present the letter of the law, sometimes we are successful in arguing the case of the rights of political prisoners. Perhaps we have won two or three cases in court out of the thousands of cases pleaded by our Legal Aid Committee. Nonetheless, I think our people appreciate the fact that they have somebody to stand up for them in court, to make it known that they are being treated unjustly and against all legal norms.

Our education system is in shambles. Young people in Burma may not know what a democracy is, but they certainly know that they do not want what they are getting now: they *want* to be well educated. That is a beginning. The next step is to make them understand that if they want things to be better, *they* have to do something about making things better. It is difficult to make them understand that they *can* do something. It is not just that they *have* to do something; they *can* do something. They are capable of doing something. They must try to bring about the changes that they want, instead of leaving it to the National League for Democracy, or to me, or to other political parties.

AUNG SAN SUU KYI (b. 1945) is a Burmese opposition politician, the former General Secretary of the National League for Democracy (NLD), and the daughter of Aung San—the father of modern-day Burma. The military junta first placed her under house arrest following popular democratic protests in 1989. Subsequently, she has been detained or under house arrest on at least six separate occasions, totaling 15 years. In 1991 she received the Nobel Peace Prize honoring her as "one of the most extraordinary examples of civil courage in Asia in recent decades." She was released once again from house arrest in November 2010 and elected to a seat in Parliament in spring 2012. Burma's leaders continue to ignore the fact that she and her political party, the NLD, won the majority of votes in a 1990 national election.

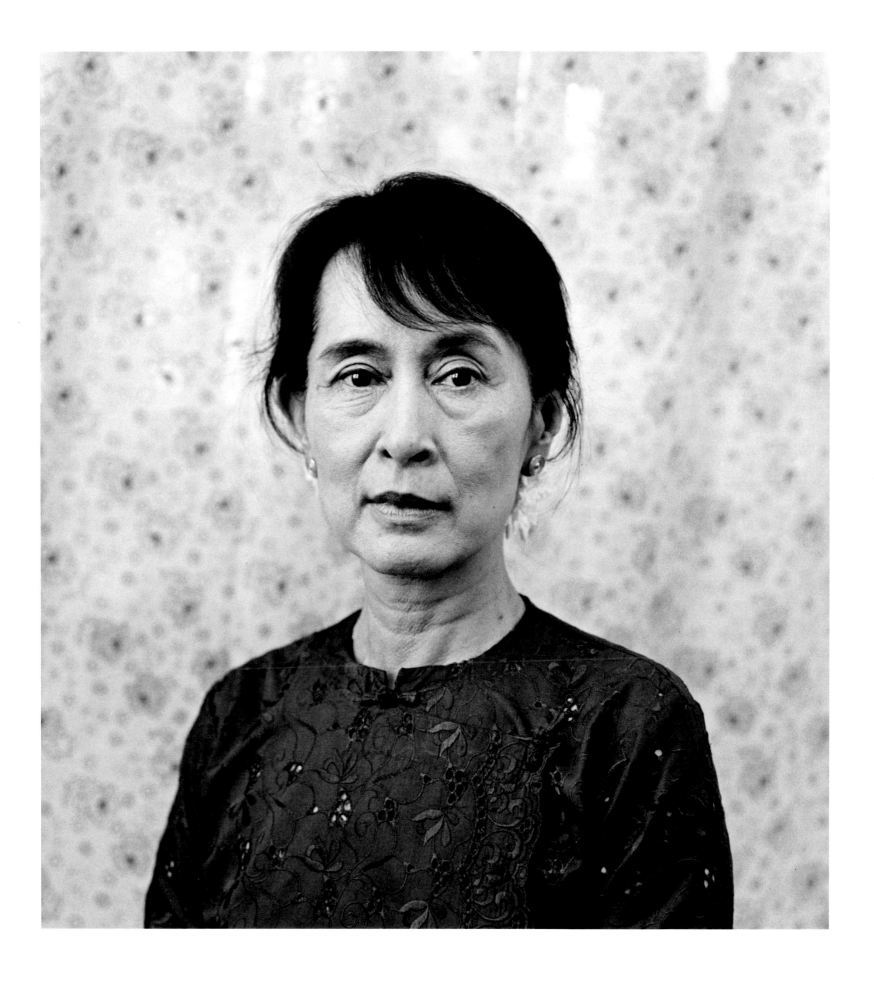

ARYEH NEIER

UNITED STATES — ACTIVIST

I WAS BORN IN NAZI GERMANY and was an infant refugee in England with my parents and my older sister at the start of World War II. For 11 months after arriving in England, I was separated from my family and lived in a hostel for refugee children. I attribute my professional preoccupation with limiting confinement in prisons, mental hospitals, and other asylums to that experience. After I got out of the hostel, I had a pleasant childhood in England thanks largely to the generous way the British dealt with each other and with refugees during the war years. It made me a lifelong anglophile.

A few years after the war, we immigrated to the United States. I attended high school and college in the 1950s, and though part of what was called the "silent generation," I was an early student activist. I did what a New York City high school student could to oppose McCarthyism, and I brought Raphael Lemkin to my school to speak about the genocide convention treaty that he drafted. In college, I published a piece in the school newspaper about the Montgomery bus boycott of 1955. The following year, when the Hungarian uprising took place, I organized events on campus to denounce Soviet oppression. After college, I helped launch a campaign by students at northern universities to support those conducting sit-ins and Freedom Rides against racial segregation in the South, and organized a 12-mile march from downtown Chicago to the suburb of Deerfield to oppose housing segregation.

My career has enabled me to collaborate with a large number of those who have led struggles for rights in different parts of the world and to take part, in ways both small and great, in many of the most important battles for rights of the past half century. Unlike many of those with whom I collaborated, I suffered no hardships for those efforts.

My professional career in rights began in 1963 when I became ACLU field director; in 1970, I was chosen as the ACLU's national executive director. The high points of my tenure included launching programs to defend peaceful opponents of the draft and the war in Vietnam; establishing programs to deal with police abuses, prisons, women's rights, reproductive freedom and gay rights, juvenile institutions, institutions for the mentally disabled; helping to organize the campaign to impeach Richard Nixon for his violations of rights; and taking advantage of the public's outrage against Nixon to dismantle political surveillance systems and enact laws protecting privacy. Some may associate my role in the ACLU with an episode in 1977 and 1978, near the end of my tenure—our defense of free speech for a small group of American neo-Nazis who wanted to demonstrate in Skokie, Illinois, a town whose residents included many Holocaust survivors.

In 1978, two colleagues and I founded Helsinki Watch. Our main purpose at the outset was to support a small group of brave Russians who had established the Moscow Helsinki Group to monitor their government's compliance with the human rights provisions of the 1975 Helsinki Accords, which had been signed by the Soviet Union and 34 other governments of Europe and North America. After leaving my post at the ACLU, I became director of the new organization, eventually transforming it into Human Rights Watch to defend rights everywhere. The organization emerged as the preeminent defender of rights by reporting on violations of the laws of war in armed conflicts and launching campaigns to establish international courts to prosecute and punish war crimes, crimes against humanity, and genocide.

In 1993, I took on my present post as president of the Open Society Institute. George Soros has been described as the only private citizen with his own foreign policy, and my role at OSI has been likened to being his secretary of state. While he puts his stamp on much of what we do, he has deferred to me in dealing with rights. I have taken full advantage. This is less demanding than directing the ACLU or Human Rights Watch, where the burden of raising funds always weighed heavily on me. Yet, as it permits me to help those doing the most innovative and important work on rights, it is immensely satisfying. To an even greater extent than previously, my work at the Open Society Institute makes me feel extraordinarily privileged.

ARYEH NEIER (b. 1937) was President of the Open Society Foundations from 1993 to 2012, and now serves as President Emeritus. An internationally recognized expert on human rights, he has conducted investigations of human rights abuses in more than 40 countries around the world. Over the past two decades, he has been directly engaged in the global debate on accountability and bringing to justice those who have committed crimes against humanity. He played a leading role in the establishment of the international tribunal to prosecute those responsible for war crimes and crimes against humanity in the former Yugoslavia. For a dozen years he wrote a column on human rights for *The Nation* and regularly contributes to newspapers and magazines, among them *The New York Times*, *The New York Review of Books*, *The Washington Post* and *Foreign Policy*. He has authored seven books, the most recent of which is *The International Human Rights Movement: A History* (2012).

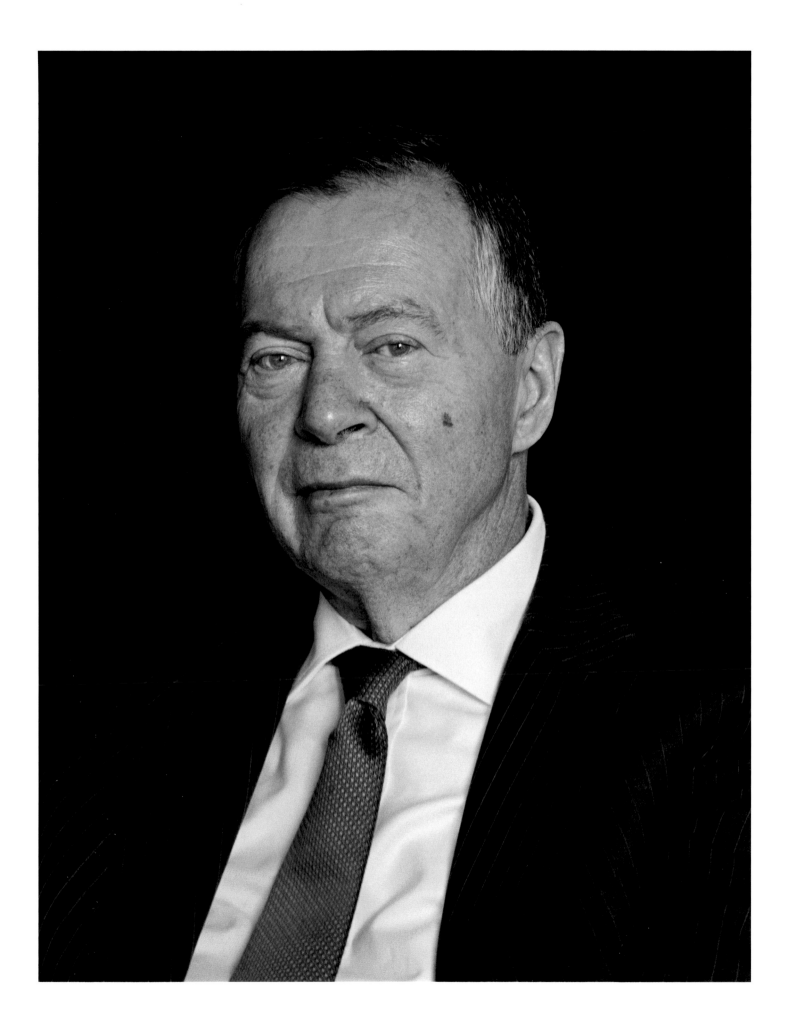

JOHN LEWIS

UNITED STATES — POLITICIAN/ACTIVIST

AS A YOUNG CHILD growing up in rural Alabama, I would visit the little town of Troy, about 10 miles from my home. I'd visit Montgomery, about 50 miles up, and Tuskegee, about 30 miles away. I saw those signs that said "White Waiting," "Colored Waiting." I saw how we couldn't use the restroom marked "White," couldn't get a drink of water from a fountain marked "White," had to sit at the back of the bus, go to the broken-down schools. When I asked my mother, my father, my grandparents, my great-grandparents, "Why?" they said, "That's the way it is, don't get in trouble." I didn't like it, and I wanted to do something about it. But I didn't know what to do.

At the age of 15, in 1955, I heard about Rosa Parks, and I heard the words of Dr. Martin Luther King Jr. on the radio. Rosa Parks and Dr. King inspired me to find a way to do something about it. I wanted to stand up, to speak up and speak out. When I had an opportunity to participate in the sit-ins in 1960, to go on the Freedom Rides in 1961, or to march for the right to vote, I did it. For more than 50 years, I have tried to do my part to bring about justice for all people. For me, it doesn't matter whether you're black or white, Latino, Asian American, or Native American. It doesn't matter. I care about justice.

I almost died for justice. I got arrested and went to jail 40 times in the South during the 1960s. I was beaten and left bloody and unconscious on the Freedom Rides. I got a concussion on the bridge in Selma. But I have committed my life to stand up, to speak up and speak out for what is right, for what is fair, and for what is just.

I've been in Congress for 24 years. For so many years, I worked on the outside looking in, trying to make things better on the outside. Now I'm trying to make things better on the inside, to have an impact on the outside. Sometimes I become impatient. In the '60s, we created the climate to get the Congress to act, to get the President to act. It seems as if it takes much longer on the inside. But you have a platform that says something, and I think sometimes more people listen when you're speaking from the floor of the Congress. I would like to think so. I hope so.

In *Brown v. Board of Education*, we had the Supreme Court decision of 1954, but we still have a great distance to go before there's justice in education for all our children. There must be a revolution of values and a revolution of ideas, not just a revolution under the rule of law. The law can say, "You can do this; you must not do that." But it's up to the people to breathe life into the law to give it meaning.

To take into consideration the needs of people, to humanize our schools, our institutions, and our local, state, and national government, it would take a movement—a movement of people similar to the civil rights movement, to the nonviolent movement of the 1960s. We should always put people first: All of the people, not just some people, but all of the people. When we seek justice, we must realize in the final analysis that we are one people. We are one family, one house—the American house—and we all live in that house.

JOHN LEWIS (b. 1940), born to a family of sharecroppers in Alabama, is among the most highly respected members of the United States Congress, where he has served since 1987. His personal history links key moments of the civil rights movement. He attended American Baptist Theological Seminary in Nashville in the late 1950s, and was among a core group of students that taught and practiced the philosophy of nonviolence. After they desegregated public facilities in that city in 1960, Lewis went on to join the band of black and white students who mounted the Freedom Rides in the spring of 1961. Lewis was a founding member of the Student Nonviolent Coordinating Committee (SNCC) and became Chair of SNCC in 1963. His militant speech at the March on Washington was a counterpoint to Martin Luther King Jr.'s "I Have a Dream" and distinguished him among the national leadership of the civil rights movement. While Chair of SNCC, Lewis helped organize the "Freedom Summer" campaign in Mississippi in 1964 and, in 1965, led protesters across the Edmond Pettis Bridge in Selma in a march for voting rights. The brutal assault by Alabama State Troopers on the marchers left Lewis with a fractured skull and drew national attention. This episode sparked a march of thousands from Selma to Montgomery and led to the passage of the Voting Rights Act. Lewis went on to direct the Voter Education Project, dedicated to expanding voter participation and helping to elect blacks to public office throughout the South. He served on the Atlanta City Council before being elected to the U.S. House of Representatives in 1986. His experiences are recounted in his award-winning book, *Walking with the Wind: A Memoir of the Movement.*

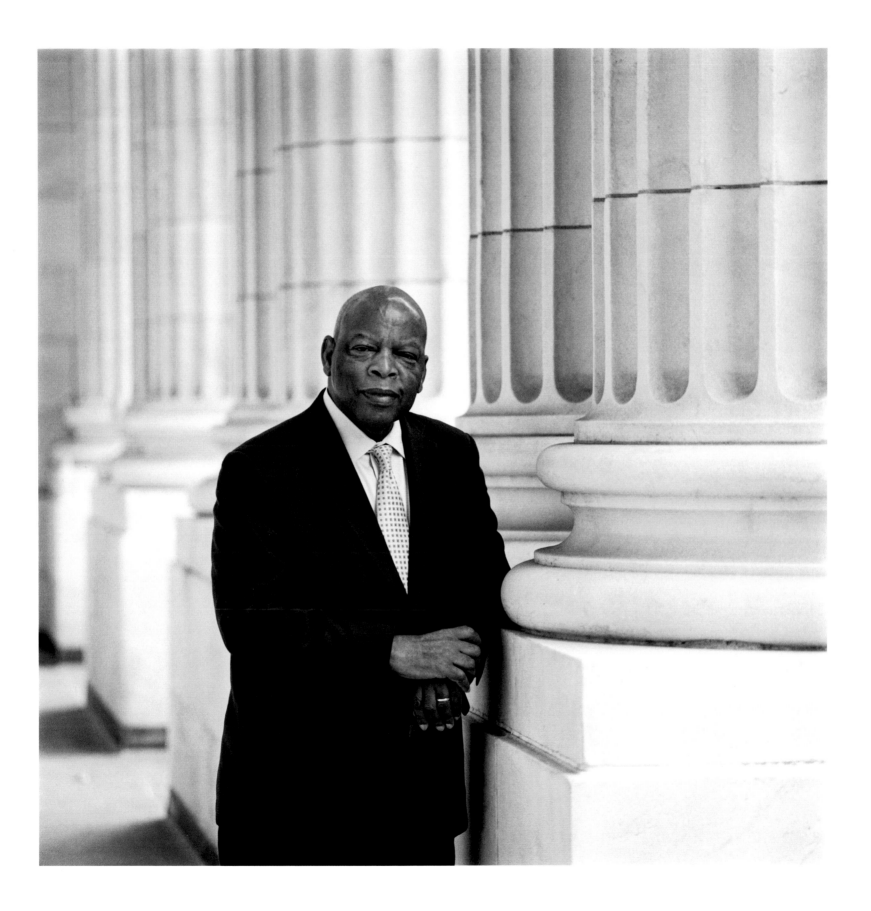

ANTHONY LESTER

BRITAIN — BARRISTER

WHY HAVE I SPENT A HALF-CENTURY working as what is now called a "human rights" lawyer? Why did I become a barrister against my barrister-father's perceptive advice that I would be "hopeless before juries?" Why did I abandon a lucrative commercial practice to work in government, found a maverick practice using American ideas in European clothing, and choose to join the House of Lords rather than the Bench?

I grew up in London during the Blitz. At age 10, I was horrified to see films of the Nazi atrocities during the Holocaust. I went to a liberal school whose staff was strongly anti-imperial and critical of the gross inequalities of British society. My father was a self-made Jewish barrister who always supported the underdog. My mother imbued me with a sense of patriotic duty to the country that had given her parents safe haven from the pogroms of Central and Eastern Europe.

I was and am, in Joseph Schumpeter's phrase, "psychically unemployable." The varied and risky life of a self-employed English barrister attracted me. After becoming involved with anti-apartheid activity at Cambridge University, I went to Harvard Law School, where I learnt from a fellow student— a Bengali professor—that law could be used as an instrument of political change. I also learnt from great teachers, like Paul Freund, about the benefits of the U.S. Bill of Rights and the courageous leadership of Earl Warren's Supreme Court.

I went to the Deep South during the "long, hot summer" of 1964, reporting for Amnesty International—then only a tiny NGO. I returned to London inspired and became part of a campaign against racial discrimination, leaving the Bar in 1974 to work in government on civil rights legislation. I could not have done so without the unconditional support of my lawyer wife, Katya, in rearing our children. She shared the risks and kept the home together while I gallivanted along the corridors of power in Whitehall.

I returned to the Bar in 1976, when senior British judges were fashioning new common-law remedies by way of judicial review to protect against the abuse of public powers. I used the constitutional ideas I had studied at Harvard Law School to argue free-speech cases before the European Court of Human Rights and discrimination cases before the European Court of Justice. It was litigation in Strasbourg that made free speech a positive right to be enjoyed and which strengthened the right to liberty beyond the formalities of the ancient writ of habeas corpus. It was Strasbourg that decided that the U.K. had acted in bad faith in enacting the Commonwealth Immigrants Act

1968, which appeared neutral but was in fact designed to revoke, on racial grounds, the right of 200,000 British citizens of East African-Asian origin to live in Britain.

The U.K. is alone in Europe and most of the common-law world in lacking both a written constitution and a modern bill of rights. That is why we had to rely on the European Human Rights Convention and the supra-national European Courts to reach places that were not covered by domestic law. I campaigned for 30 years to make European Convention rights and freedoms directly binding on U.K. public bodies and to empower British courts to give effective remedies. I was appointed a Liberal Democrat life peer in 1993 (Lord Lester of Herne Hill) and introduced two bills with that aim. At last, in 1998, Parliament enacted the Human Rights Act. And I have used my position in the House of Lords to introduce bills which have influenced legislation on equality, constitutional reform, civil partnership, forced marriage, and defamation reform.

I am currently on a commission set up by the coalition government to examine the case for a British Bill of Rights, building on the Convention and our Human Rights Act. I remain aware, however, of the wise words of Judge Learned Hand, who reminded us that "the spirit of liberty is the spirit that is not sure that it is right." It is that recognition of human fallibility which defines my kind of liberalism.

In February 1886, during a lecture at Harvard, Justice Holmes declared "that a man may live greatly in the law as well as elsewhere; that there as elsewhere he may wreak himself upon life, may drink the bitter cup of heroism, may wear out his heart after the unattainable." Holmes's magisterial language may today seem impossibly romantic, but it remains true that the scope of intellectual adventure in the law is at least as great as it was a century ago. It has been my privilege as a lawyer to have wreaked myself upon life and to have worn out my heart striving after the unattainable. If I had the chance, I would do exactly the same again.

LORD ANTHONY LESTER (b. 1936) is a practicing barrister renowned for his expertise in human rights and constitutional law. A Liberal Democrat peer, he has argued leading cases in European, British, and Commonwealth courts and written on freedom of speech, race and sex discrimination, access to justice, the right to liberty, and constitutional reforms. He has introduced landmark bills in the House of Lords on human rights, equality, civil partnership, forced marriage, and defamation reform. He serves on the Parliamentary Joint Committee on Human Rights and the Commission on a Bill of Rights for the U.K.

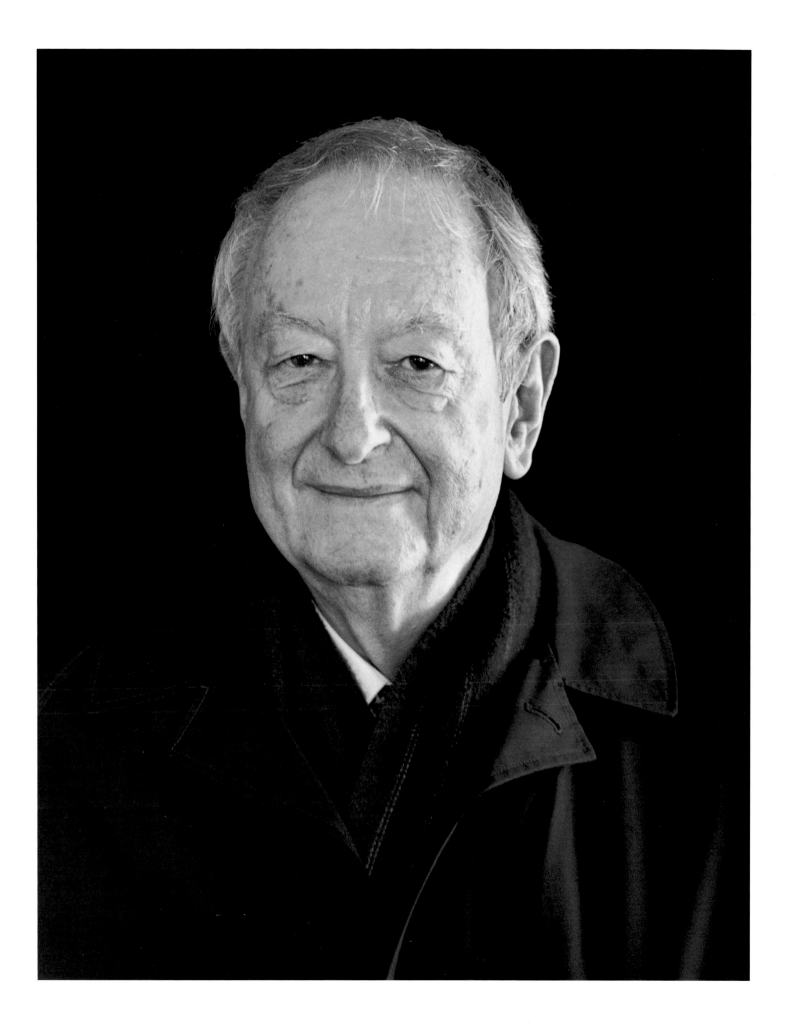

HELEN MACK

GUATEMALA — ACTIVIST

I WAS BORN IN GUATEMALA OF CHINESE ANCESTRY. My family moved to Guatemala during the Japanese occupation. My sister Myrna and I were sent to a Catholic school for Maryknoll Sisters. The Sisters teach social justice, and the graduates are very socially conscious. Myrna went on to become a teacher and then an anthropologist. I went into business and administration. When Myrna was killed, I was working with a very conservative association, running a program to improve literacy in the country.

Myrna was assassinated on September 11, 1990, by a presidential security guard. She was stabbed 27 times. She had published her study of the government's internal policies concerning the displaced population of Guatemala. More than 1,500,000 people (20 percent of our population) had been displaced by the conflict over the course of a decade. These people were not receiving any attention from our government or from the international community. They were persecuted because the military considered them to be guerillas. But they were human beings.

The army perceived my sister as an enemy of the state because her report recommended that the International Red Cross give humanitarian aid to our displaced people. In the '90s, the government held the position that they had won the war and there was no conflict in the country that warranted any kind of attention.

The government falsely stated that the murder of my sister had been a crime of passion and that she had been dealing in the currency black market. Neighbors and friends became distant from us. We were seen as troublemakers, and that was part of the injustice we suffered. Perhaps because of my Chinese roots, honor for the family is very important. I wanted justice not only for her but to protect my family's honor.

Myrna was proud of what she was doing. She was a professional academic linked to at least two American universities, Georgetown and Berkeley. The academic community felt it had been touched when she was killed; they understood that it could happen to any one of them. The solidarity of the academic community—especially in the United States—got the attention of the Guatemalan government, and with that support, I became a human rights activist. My sister's murder was the first human rights case to go before the new civilian government's justice system and was unprecedented in the history of Guatemala.

The case began with many threats. The police investigator was murdered because he identified the suspect as a member of the presidential guard. A delegation was sent from the U.S. Congress and Senate to Guatemala to investigate. The United States agreed to continue providing economic assistance to the Guatemalan government, but only under the condition that four human rights cases go to trial.

My sister's case opened the path for prosecuting human rights violations. Her murderer was tried and convicted. The order to kill her had been a government order issued by the military—a state order of execution. After the conviction of the presidential guard, I pursued the intellectual authors, because I had their names. I needed to prove that there was a chain of command. I did that. I got the conviction for one of them, but he fled with the support of the military.

We have 98 percent impunity in Guatemala. Only two cases of every hundred actually go to court and of those, less than 2 percent end in a conviction. With such impunity, what can our understanding be of the rule of law? What is our understanding of justice, and social justice? I stay and fight because it is the only country I have. We have so much corruption, kidnapping, and extortion. All Guatemalans are asking for justice and security. In an effort to raise issues about rule of law, human rights, and security in Guatemala, I established the Myrna Mack Foundation in 1993.

When I began my sister's case, I made some personal decisions. I decided not to get married, so I could dedicate my life to this work without the fear that someone close to me might be killed. I prepared myself mentally. There are many Guatemalans who have suffered even more than I have, and they don't have the opportunity to speak. It is my privilege and my responsibility to speak for them. It means I must have courage. It means I cannot have anybody close to me, anyone who could suffer because of me. It is a kind of mission. Justice is justice. It does not have anything to do with whether you are right-wing or left-wing. The need to seek justice is something natural that comes from inside.

HELEN MACK (b. 1952) was a successful and politically conservative businesswoman in Guatemala until her sister, a well-known anthropologist who had documented the abuse of Mayan peasants by the Guatemalan army, was murdered in 1990. In response, she founded the Myrna Mack Foundation, which is dedicated to fighting against impunity and promoting the rule of law in her country. In pursuit of justice for her sister's murder, she secured the first successful prosecution in Guatemala of military officers, which convicted the primary high-ranking official who organized the assassination. She has served as an expert witness in cases of human rights violations before the Inter-American Court of Human Rights and the Organization of American States (OAS). She is Commissioner of Police Reform, and continues to ensure that the military is held accountable for its crimes.

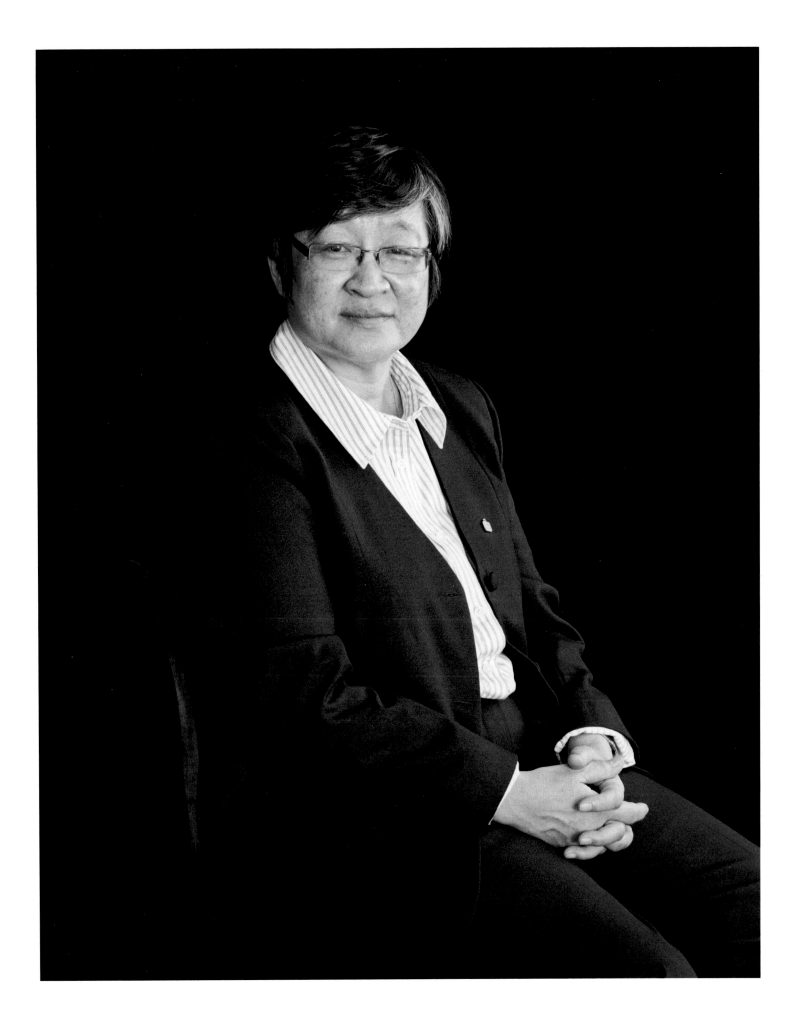

SYDNEY KENTRIDGE

SOUTH AFRICA/BRITAIN — LAWYER

I MORE OR LESS DRIFTED INTO THE LAW, although now I cannot conceive of any other profession that I could have practiced with any success or satisfaction. My father was an attorney, but he was also a member of the South African Parliament for nearly 40 years—so politics were always part of my life. I had no particular interest in law, however, and I had never seen the inside of a courtroom.

My decision was postponed by war service in the South African forces. After the end of the war, while still in Italy awaiting demobilization, I was told that the legal officers at South African headquarters had already been demobbed, and that I was to be the prosecuting counsel at two court-martials the following week. I protested that I knew no law. I was told that at least I had a university degree, and was given a small handbook of criminal law. I have little recollection of the cases themselves, but I found the trial process so absorbing that I knew that this was the profession for me.

With the help of a grant from the South African government, I was able to take a law degree at Oxford University. In 1949, I began to practice at the South African Bar. I did not escape the usual travails of a young advocate, but I had one piece of good fortune. The apartheid government had come into power in 1948, and by 1949 its aggressive measures were being directed at trade union officials. Some of them began to brief me in cases against the government. From then onwards, although my main practice areas became commercial law and tort law, I appeared in many political trials in both civil and criminal courts, for members of various anti-apartheid organizations.

Some critics questioned the effectiveness of fighting such cases, arguing that taking them to court gave a veneer of respectability to an oppressive system. However, the clients themselves almost invariably wanted legal representation, and, notwithstanding draconian legislation and a pattern of political appointments to the judiciary, it was sometimes possible to win. From 1958 to 1961, 90 leading members of the African National Congress and its allies were on trial in Pretoria on a charge of high treason. Naturally, it was a trial of great political significance. The historian Lord Macaulay said that in a trial for treason, an acquittal must always be considered a defeat for the government. In Pretoria, the court was a "Special Court" consisting of three judges specifically nominated for the case by the minister of justice—yet all the accused were acquitted.

Even when one had little hope of a favorable verdict, a hearing could be productive. At the inquest into the death in police custody of the black leader Steve Biko, the official verdict was "nobody to blame." Nevertheless, as counsel for his widow we were, I think, able to expose the savagery and callousness that had led to his death. The black population of South Africa generally saw the law as an instrument of domination. I believed that it was important to show that the law could be a protector of liberty. I represented many remarkable men and women of all races, including Mr. Nelson Mandela; Bishop (not yet Archbishop) Desmond Tutu; and Chief Albert Luthuli, president of the African National Congress in the 1950s and 1960s, all three winners of the Nobel Peace Prize.

After 30 years, I decided to practice the same occupation in a new country, and I was called to the English Bar. In England my practice has been a mixture of commercial and constitutional cases; I may, immodestly, mention one of the latter. The secretary of state for home affairs had deported an asylum seeker, despite the fact that a judge had issued an injunction prohibiting him from doing so before a further hearing. Proceedings for contempt of court were then instituted against the secretary of state. On appeal to the highest court (the House of Lords), the secretary of state contended that no court could issue an injunction against a minister of the Crown. I argued the contrary for the asylum seeker. We won. One of the judges said in his judgment that the case put up by the secretary of state, if successful, would have reversed the result of the 17th-century Civil War. The great English constitutional lawyer Sir William Wade said that this had been the most important constitutional case in England for 300 years.

Can there be a more interesting profession?

SIR SYDNEY KENTRIDGE (b. 1922) practiced law in South Africa for 30 years, becoming one of the most important advocates of the 20th century. He was the lead lawyer in the 1962 trial of Nelson Mandela and the 1977 inquest into the death of Stephen Biko, among other important political trials in apartheid South Africa. He served as an Acting Justice of the Constitutional Court of South Africa from 1995 to 1996. He was called to the English Bar in 1977 and appointed Queen's Counsel in 1984. He was knighted (KCMG) in 1999. Sir Sydney has been married for more than 60 years to Felicia Kentridge, a founder of the Legal Resources Center, the leading human rights organization in South Africa. They are the parents of four children, including the artist William Kentridge.

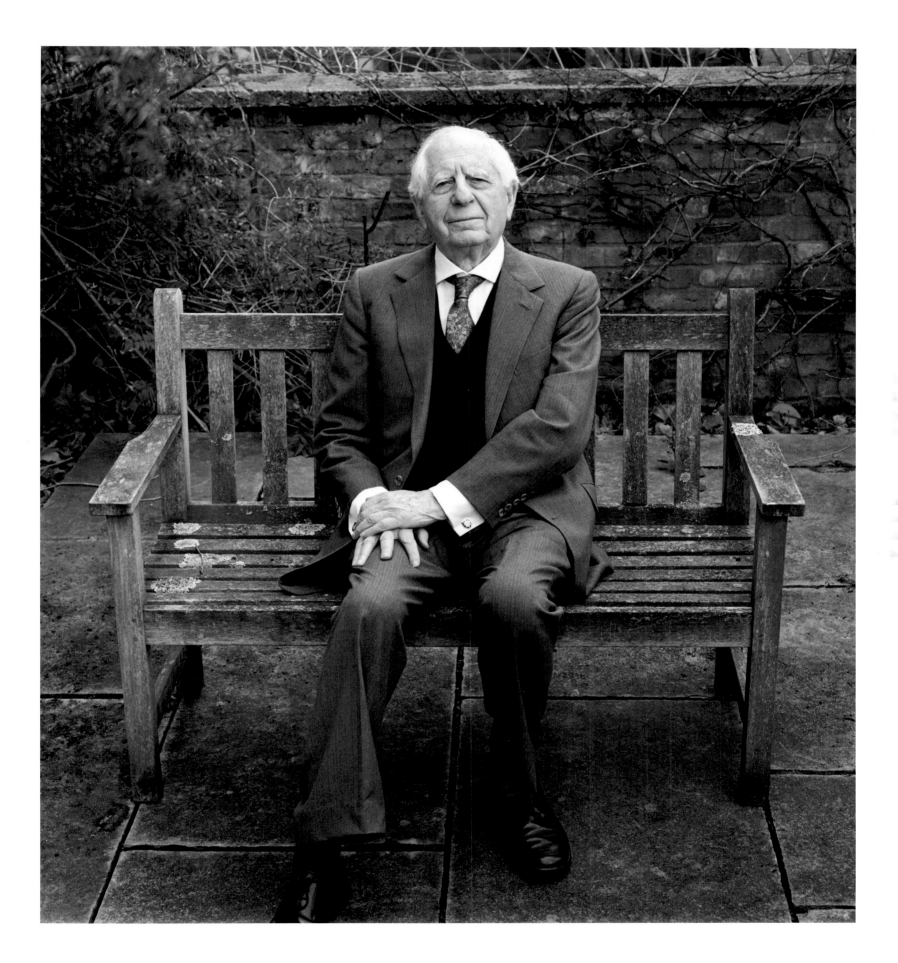

NATAŠA KANDIĆ

SERBIA — SOCIOLOGIST

BEFORE THE WAR IN THE FORMER YUGOSLAVIA, ordinary people like me didn't care who was Muslim, Croatian, or Serbian. Suddenly in 1990, everything changed. My friends left the country and the newspapers were propagating a language of hate, with politicians claiming that people from Croatia and Bosnia were enemies who wanted to kill Serbs. In Serbia, this led to the harassment of anyone who was not Serbian.

During Tito's rule, my father was a Communist accused of being a traitor. He spent four years in prison—it was a humiliating experience, and he never spoke about it. Perhaps it was a combination of my father's imprisonment and my chosen profession of sociology, but I felt it necessary to document the human rights' violations occurring around me. I traveled throughout Serbia and Kosovo and saw fear everywhere. This fear of never knowing what would happen at any time of day was overpowering and especially difficult for women with children. I listened to their accounts and established the Humanitarian Law Center in 1992 to document human rights violations and war crimes and to encourage people to help each other.

On June 14, 1999, international armed forces had entered Kosovo, and, in keeping with the peace agreement, the Serbian police started to withdraw. I wanted to see what had happened in a town called Jakovitza, because I had heard rumors of many people being killed, but the road was always blocked by Serbian police. On June 14, it was finally possible for me to enter. I went straight to the hospital—now flanked by houses the Serbian police had burned upon withdrawal. Women and children had taken shelter there out of fear. The doctors were in a panic because paramilitary forces had come that morning telling them to collect money to pay for their lives or face death. The doctors begged me to find international soldiers to protect the hospital, because in two hours the paramilitaries would return and they would all be killed.

I could not explain to them that I did not have the power to order international soldiers to come to Jakovitza. I did not even know how to find international soldiers. But they were terrified, so my friend and I left and drove for 45 minutes without any plan until we happened upon some Italian soldiers. With the help of two Italian journalists, we found the general and explained the situation. I asked if he could offer a division of his unit to help: four vehicles and twelve soldiers that would drive behind the Serbian police and ensure that they left the city. He agreed.

When we arrived, the doctors, patients, women, and children were ecstatic. The general instructed them to walk home and fill the streets to show the Serbian police that they were no longer afraid. After 20 minutes, the streets teemed with thousands and thousands of people. Many of them came to the hospital with flowers. It felt like a different city, like a dream. Two hours later, they were free. I cannot explain how I succeeded in meeting the soldiers or convincing the general. People thought it was my power. It was not. It was opportunity, chance.

Some justice has come, but only in small measure. In 2002, I met a policeman who revealed that his unit had filmed a genocide in Srebrenica. I found the video in 2003; the victims were six Muslims, three of whom were minors. Nobody begged for his life. Nobody cried. Their faces showed that they had accepted their fate, while the policemen appear as if they are on important state duty. The policemen were tried in Serbia; some were sentenced to 13 or 20 years, but only for criminal offences. The court claimed there was no evidence that the victims were Muslims from Srebrenica, even though their mothers had given testimony.

My greatest success is *The Kosovo Memory Book*. It is the first time that murdered and "disappeared" people have their names in a register accompanied by small narratives describing their fates. I was present in Kosovo during the war. I saw what happened there. Mass graves. Everything. With the help of 45 researchers and various organizations, I have succeeded in building a legacy based on the facts. It is important to advocate that the same register be established for other people in the region. In Bosnia, 100,000 people were killed. In Croatia, about 30,000 were killed.

We must use the same approach to break politicians; we prevent them from manipulating history by publishing the truth. War trials are not enough to end the cycle of crimes against humanity. It is very important that each individual be remembered forever. It is necessary to build a record of what has happened and include the entire society. Collecting facts, establishing commissions to investigate war atrocities, and recording the names of victims with their personal accounts is vital. The time will come when people will want to remember what really happened, and this information will bear witness to that truth.

NATAŠA KANDIĆ (b. 1946) is the foremost human rights defender in the Balkans. Following the war in Yugoslavia, she fought to bring the Serbian perpetrators of war atrocities to justice and continues to work in very hostile political circumstances. She meticulously documented abuses by all parties in the ongoing postwar conflict during the 1990s and is the Founder and Director of the Belgrade-based Humanitarian Law Center, where she continues to keep a record of human rights violations and to fight for accountability.

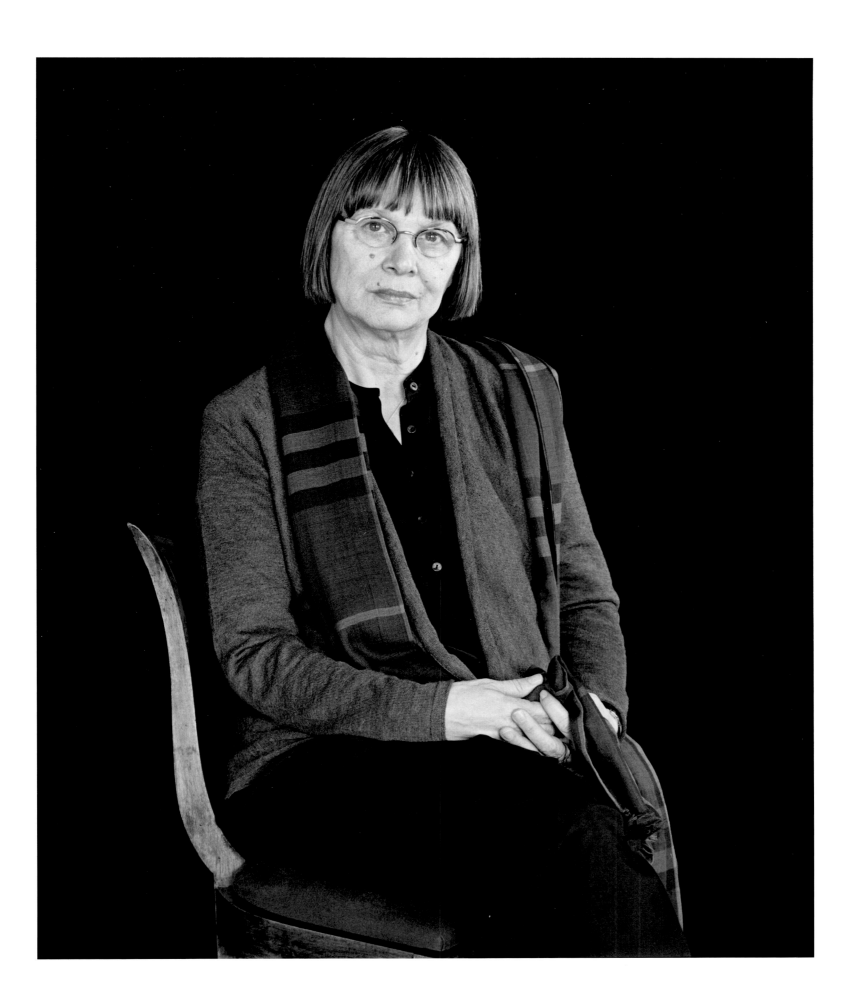

BEATRICE MTETWA

ZIMBABWE — LAWYER

I WAS THE FIRST GIRL BORN in a polygamous family in Manzini, Swaziland. When my father died, he had six wives and more than forty children. Growing up, I could see the injustices that exist in a polygamist situation. My fighting spirit began, I believe, because my father and I had a very antagonistic relationship. It was the beginning of my dislike for authority—particularly for this paternalistic kind of society.

My father's mother made it clear that no man should push me around; she sowed that seed in me. I had to finish high school, go to university, and I had to "kick butt" to ensure that my sisters would do the same thing. I had to make sure they would have the rights to which we were entitled. Interestingly, my father did pay the school fees for my siblings. It was a struggle to get school shoes or a decent dress for Sunday, but he understood that providing an education was not negotiable; I made it clear that I would sell his chickens, goats, and cows—legally or otherwise—to secure my siblings a good education.

My father did not think I would make a great lawyer. When I decided to go to law school, he said, "What female lawyer do you know? Have you ever seen one being effective?" When I started practicing law in Swaziland, he never showed me he was pleased, but I know from his friends that he was. He was too proud to eat his words.

I married a man from Zimbabwe, and when I moved here, I worked for the government. I could see injustices in how the system worked in Mugabe's government. After a few years, I went into private practice. That is when I decided to do human rights work. My initial inspiration was to help women, because the men usually had the resources to get themselves fancy lawyers, but the women almost never had that capacity. When things started to fall apart in Zimbabwe, I got sucked into mainstream human rights work—especially violations of the rule of law.

People must have confidence in the judiciary. They must have confidence that if their rights are violated, they have somewhere to go. If investors want to invest in Zimbabwe, the first thing they will want to know is whether the investment will be protected if they go to court.

If you go back to the beginning of the country's independence, you will see that there were pieces of legislation that were designed to deny basic rights, especially to members of the opposition. They were denied the right to speak freely, associate freely, or to articulate their beliefs without hindrance. There were also laws that said you could be locked up without bail. But we were lucky to have a strong judiciary that made it absolutely clear that those kinds of laws were out of place in an independent Zimbabwe. The judiciary almost always ensured that people were given basic rights until 1999, when we began to see open defiance of court orders by the government. If the government did not agree with the court's decision, they simply did not comply with it.

One of the first major cases exhibiting the government's defiance occurred when journalists reported on a story and were locked up and tortured. The courts came out very hard on the side of the journalists, but the government simply did not comply with their orders. That was the beginning of the crumbling of the rule of law. The government then proceeded to reconstitute the judiciary by packing it with those who thought like them. There have been more and more human rights violations ever since.

When I was president of the Law Society, we were leading a procession demonstrating against the harassment of lawyers. A couple of us were picked up and taken to the bush, beaten, and left there. I have never been arrested for committing a crime: they just grab me, and then after beating me up, release me.

Thankfully, I have received many prizes for the work I do with human rights. It has helped protect me because it gives me some visibility. I am very grateful to my colleagues within and outside Zimbabwe who recognize we are doing necessary work under very difficult circumstances. I will always work for human rights: my services will always be required no matter who is in power, because we know the nature of African governments. The opposition might speak about their belief in the rule of law, but as soon as they are in power, they will almost always dismantle what you thought to be a common understanding. I will continue to fight as long as I am able.

BEATRICE MTETWA (b. 1958) was born and educated in Swaziland. She is the first member of her family to graduate from college. After earning her law degree, she became a prosecutor and moved to Zimbabwe, where she focused on family law and human rights. Since the early 1990s, she has actively defended victims of human rights abuses and spearheaded constitutional challenges, including a case that challenged election results in 37 constituencies in Zimbabwe. Despite being physically attacked and receiving death threats, she has represented journalists charged under Zimbabwe's draconian media laws, defended political leaders from both the Tsvangirai and the Mutambara branches of the Movement for Democratic Change, and championed social causes, including eradicating AIDS, protecting the rights of women and children, and helping poor farmers reclaim land wrongfully seized by the government.

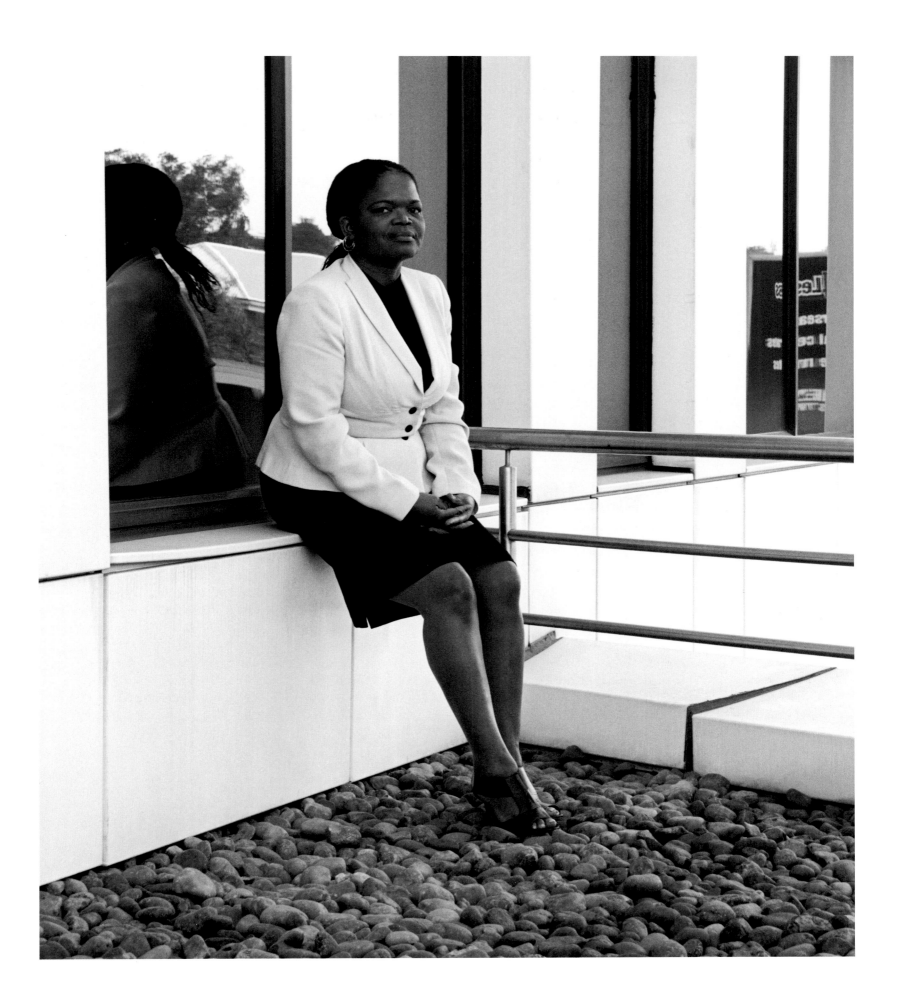

SULIMAN BALDO

SUDAN — ACTIVIST

I HAD AN EVENTLESS CHILDHOOD, growing up in the 1950s in a Sudan that was kind to members of its middle and higher classes, but heartless—just as it is today—when it came to the rights of the teeming millions of its rural citizens, particularly those living in the marginalized southern, western, and eastern regions of the country. I also enjoyed free education through college and decent health care, privileges that Sudan's current regime has long since abandoned.

My career as a defender of justice and promoter of human rights stems from early days of activism. Sudan's political turmoil created a lasting impression on me as a child. I remember in November 1958 when units from the local army garrison paraded the streets of my hometown, El-Obeid, the capital of the Kordofan region: the parade marked the military's overthrow of Sudan's first post-independence government, elected in 1956. I was no longer a bystander in October 1964. As a high school student, I joined street protests that students at the University of Khartoum triggered and that trade unions, opposition parties, and the public later joined throughout the country, leading to the peaceful toppling of the 1958 junta.

When famine hit Sudan and Ethiopia in the mid-1980s, I was a lecturer at the Department of French in Sudan's prestigious University of Khartoum. The university staff club was a cultural hub and a social oasis. During my spare hours, I taught classes at the Theater and Music Institute and directed interpretations of Molière's satires in colloquial Arabic to reach a broader audience. With like-minded colleagues, I organized film festivals and exhibits of modern Sudanese art for the university community.

The arrival in 1983 of hundreds of thousands of famine refugees from the western regions of Kordofan and Darfur to the outskirts of the tripartite Sudanese capital thrust me more forcefully into militant rights and justice activism. With colleagues, I formed the Famine Resource Group to counter propaganda by the regime of General Nimeiry, which claimed famine was but a malicious rumor and that Sudan was in fact the food basket of the Arab world. We worked with international reporters who used our field information in their articles to demonstrate the severity of the food deficits.

As the information officer of an undercover alliance of trade unions, I organized a yearlong series of public rallies in the staff club, denouncing the economic and development policies of the regime that were responsible for the famine. This alliance, which coordinated similar events led by workers, professional associations, and opposition groups, engineered a popular uprising that led to the toppling in April 1985 of Nimeiry's junta.

In 1985, I helped found and direct the Sudanese Popular Committee for Relief and Rehabilitation (SPCR). The committee pioneered projects for the rehabilitation and family reunification of famine and war orphans and distributed relief to victims of local wars in Darfur. It was in Darfur that I met the survivors of the terrible 1987 massacre of at least a thousand southern civilians in the town on the border between South Darfur and South Sudan. I co-authored a report, "Al Daien Massacre and Slavery in Sudan," that stimulated a heated debate on the role of intellectuals in exposing the hidden atrocities that were being committed in the south. By 1988, it became evident that it was no longer possible to continue with my activism while maintaining a full teaching load. I quit the university and joined Oxfam America as director of their grant program for famine relief and rehabilitation operations in the zones of Sudan and Ethiopia affected by the war. Following the 1989 coup d'état by Sudan's radical Islamist movement against an elected government, I played a key role in documenting the new regime's massive human rights violations against its real and perceived political opponents in the north as well as innocent civilians during Sudan's multiple civil wars. I had to flee Sudan in 1995 when it became evident that I was under increasing security surveillance.

Today, as Sudan's third military regime readies to celebrate its 22nd anniversary, I often wonder when the killings and rapes will stop, when perpetrators of atrocities will be brought to justice, when thieves of public goods will be forced to return them, and when my country will be returned to its rightful owners—the marginalized majority. Giving up is clearly not an option. What happened in Egypt and Tunisia in early 2011 was pioneered by the Sudanese in 1964 and 1985. My countrymen and -women need to tap into that vitality and optimism to dispel today's oppression.

SULIMAN BALDO (b. 1950) received his PhD in French literature. He is a longtime human rights activist and a former political prisoner in Sudan. He has worked for Human Rights Watch and the International Crisis Group and directs the Africa program at the International Center for Transitional Justice. He is an expert on conflict resolution, emergency relief, development, and human rights in Africa. When the African Union asked for a deferral of the International Criminal Court's prosecution of Sudan's President Omer Hassan Ahmed el Beshir along with six other Kenyan officials, Baldo insisted that doing so "would be a serious blow to accountability and send the wrong message to regimes that abuse human rights, such as Côte d'Ivoire's Laurent Gbagbo and Zimbabwe's Robert Mugabe."

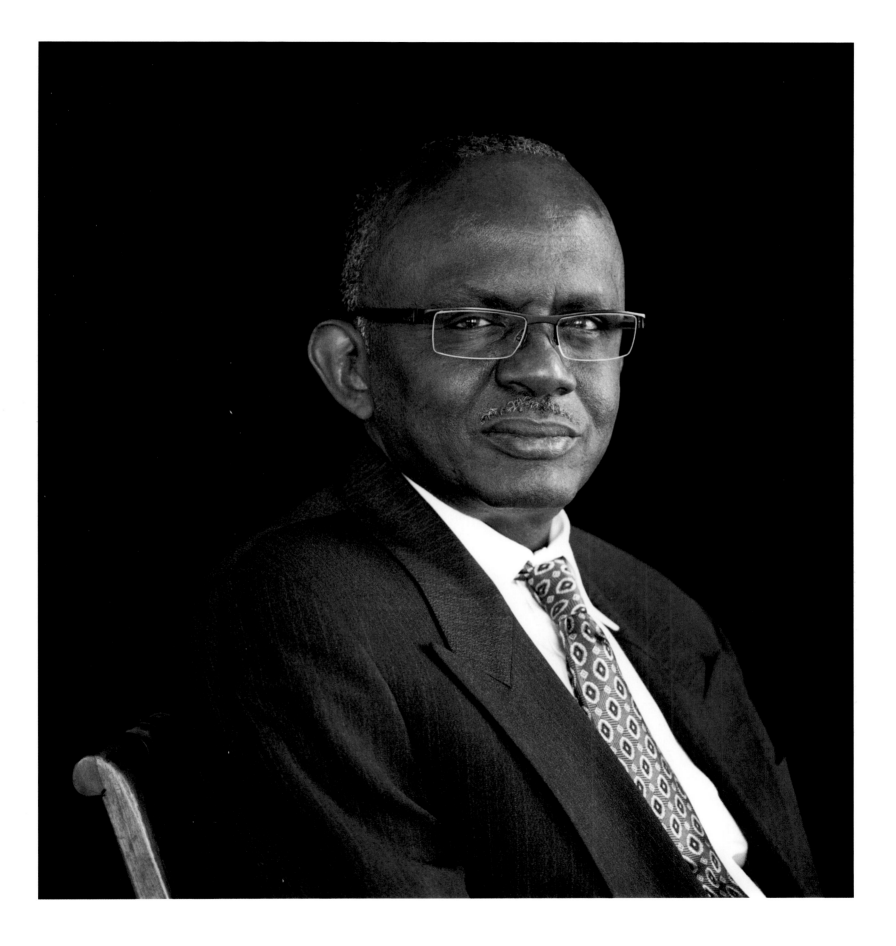

RAJA SHEHADEH

PALESTINIAN TERRITORIES — LAWYER

MY GRANDFATHER WAS A JUDGE during the British Mandate over Palestine. Both my father and uncle were lawyers, my father having begun his practice in Jaffa before he was forced out and came to Ramallah, where I grew up. I did my first degree in literature and my second degree in law. When I returned from my studies in London, I was appalled; Israel was violating one of the cardinal principles of international law by transferring its own population into the occupied territory, and no one was paying attention.

My father was one of the first to call for the establishment of a Palestinian state alongside Israel; I felt it important for me to contribute by promoting the principles of the rule of law. The challenge was immense, because Israel controlled every aspect of our society, and the West felt that Israel could do no wrong. I felt I was screaming out before a glass wall and not being heard. In 1979, I and a group of friends established Al Haq, the Palestinian affiliate of the International Commission of Jurists (ICJ). Al Haq means "justice and law," and it is also one of the names of God; it is a very good name.

Al Haq conducted investigations, collecting data. Our first joint publication with the ICJ was called *The West Bank and the Rule of Law*. The Israeli government was very upset because we reported how things were, but at that time its response was civilized. They published a rebuttal called *The Rule of Law in the Areas Administered by Israel*. Al Haq expanded and I continued to act as its volunteer co-director while practicing law and writing. Al Haq had trained fieldworkers all over the West Bank and Gaza, collecting affidavits and informing the world of our findings. Over the years the organization won many prizes. In 1985 I published a book called *Occupiers' Law*.

The ideology of every Israeli government has been that Israel and the West Bank territories belong to the Jewish people for eternity. Palestinians who live there can have autonomy, but no control over vital resources such as land and water. The Oslo Accords signed between Israel and the PLO in 1993 reflected these principles and so could not possibly bring peace. Instead, the accords both consolidated the illegal changes Israel had been carrying out unilaterally and facilitated the establishment of more Jewish settlements, contrary to the principles of international law. In 1997, I published a book analyzing the legal and human rights aspects of the accords.

Human rights documentation cannot singlehandedly save Palestinian land; the heroic steadfastness of the farmers who held on to their land despite many dangers is more impressive than anything I or my colleagues at Al Haq have done. One of these farmers was Sabri Gharib, who gave the first statement under oath to Al Haq in 1979. When I last visited him, in 2007, most of his farmland had been seized by the nearby settlement. To get to his house, I had to go through a narrow passage surrounded on both sides by wire fences.

For years, Sabri and his 10 children were shot at by the settlers and the army. He was often dragged from his house by the Israeli military and imprisoned to allow the settlers to construct more homes, erect a water tank, or build another fence on his land. Any other man would have run. Not Sabri. "This is my land," he would say. "I inherited it from my father and I will leave it to my children. Nothing matters but God and the land." Over the years, Al Haq provided Sabri with all possible support, including legal advice and assistance with court expenses. He left no possibility for legal challenge untested. As I stood on the few meters of land left around his house, an Israeli man walked by with his dog. I tried to catch his eye, but the Israeli looked the other way.

When you are younger, you want things to happen quickly. Then, as you grow older, you come to realize that advancing the cause of justice is a slow affair. You may not live to see the change to which you dedicated your life. There were periods when I felt utter despair and that the challenge was just too immense. Israel has powerful friends and the support of the strongest powers. But it is not so desperate. There is greater understanding of the situation now, both in European and American civil society. People there may not be familiar with the details, but at least they have come to realize Israel is doing something wrong. This is a big step from seeing Israel as the victim.

The most difficult struggle ahead for both Israelis and Palestinians is to find a way of living together with justice, on the tiny area of land we will always be sharing.

RAJA SHEHADEH (b. 1951) is a Palestinian lawyer, author, and one of the founders of the pioneering human rights organization Al Haq, a nonpartisan, West Bank affiliate of the International Commission of Jurists. He has written several books about international law, human rights, and the Middle East, as well as the highly praised *Strangers in the House* (2002), *When the Bulbul Stopped Singing: Life in Ramallah Under Siege* (2003) (which has been adapted for the theater), and *Palestinian Walks: Notes on a Vanishing Landscape* (2007), for which he was awarded the prestigious Orwell Prize for Political Writing in 2008. He continues to be an eloquent voice for the plight of the Palestinians in his two more recently published books, *A Rift In Time: Travels with My Ottoman Uncle* and *Occupation Diaries*.

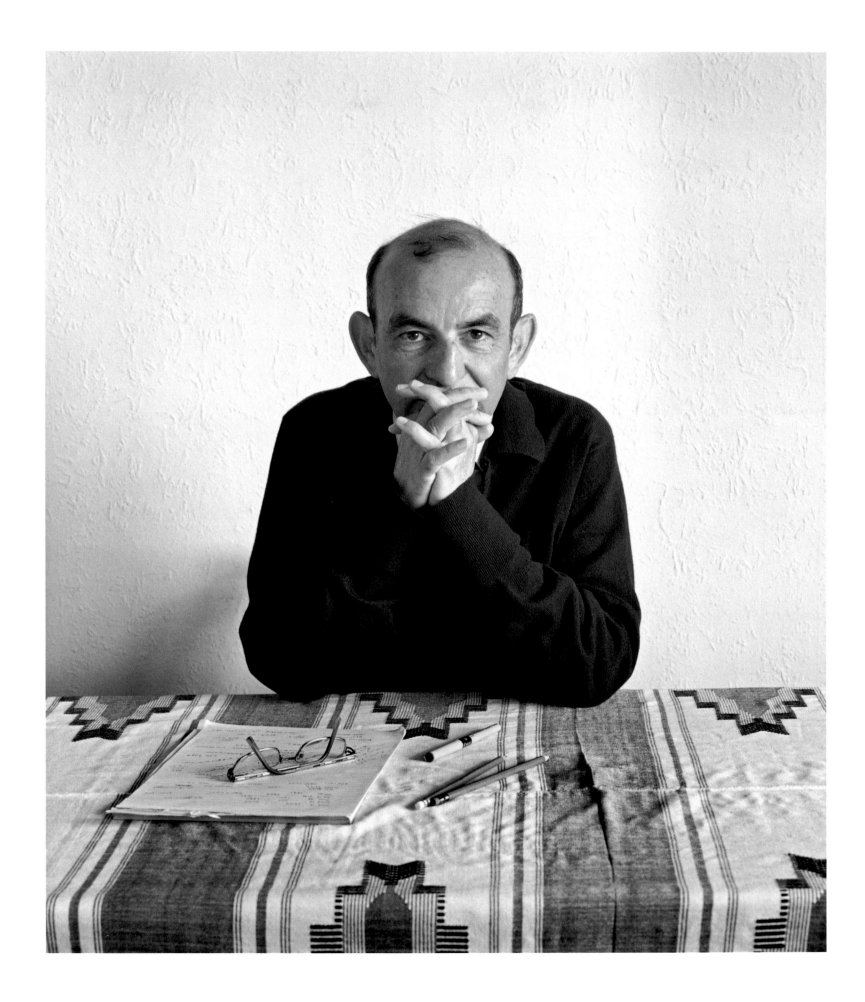

JUAN MÉNDEZ

ARGENTINA — LAWYER

I AM FROM MAR DEL PLATA, a seaside city south of Buenos Aires, where I went to high school and university and later practiced law. In 1969, we held the first student demonstrations in Mar del Plata, until then a sleepy resort town. Students and workers were among the first to rebel against the military government in a major uprising in Córdoba, in the interior of the country. The military shot at demonstrators, and many died. That was the awakening of many young people to revolutionary politics.

I graduated in 1970 and joined the left wing of Peronism, the movement created in 1946 by President Juan Peron. As a young lawyer, I defended political prisoners and denounced torture and political imprisonment. In 1973 the military government gave way to elections, and the Peronist movement won. Soon, a serious rift developed between its right and left wings. In 1974, I was arrested by the federal police and held for several days. My family and I moved to Buenos Aires, where I was less known. There I continued to defend political prisoners and worked in shantytowns and at universities.

In 1975, I was arrested a second time. I was brutally tortured and eventually thrown in prison under the "state of siege," which meant indefinite administrative detention without charges. Several colleagues who were doing the same work were arrested months later, when the military was already in power, and they are now counted among the disappeared. I spent a year and a half in prison, under progressively worsening conditions. Toward the end of my imprisonment, the military seized control of all the prisons, took inmates away, and killed them. Four friends were taken from my cellblock and killed days before I left. At final count, there are more than one hundred lawyers among the disappeared of Argentina, and another hundred or more who spent years in custody for political reasons.

Under the Argentinian Constitution, I had the right to choose to leave the country rather than remain in prison. But the military regime did not honor the Constitution. Luckily, I had been a foreign exchange student in the United States and, when my American family learned of my predicament, they campaigned to get me out. Amnesty International adopted me as a prisoner of conscience. Eventually, the junta relented and expelled me from my own country. I reunited with my wife and two children in France, then came to the United States.

I worked on immigration and refugee matters and, beginning in 1982, I became a full-time human rights lawyer with Human Rights Watch. I opened its Washington office and then worked for 15 years in its Americas division and then as general counsel. I later lived in Costa Rica, working in human rights education throughout the continent. I litigated many cases before the Inter-American Commission and the Inter-American Court of Human Rights; between 2000 and 2003 I was a member of the commission and became its president in 2002. I have taught human rights at Notre Dame Law School and am now a visiting professor at American University in Washington. Between 2004 and 2009, I was the president of a new international organization called the International Center for Transitional Justice (ICTJ), headquartered in New York. Kofi Annan appointed me his special advisor on the prevention of genocide, a position I held concurrently with my ICTJ post until 2007. In November 2010, the UN Human Rights Council named me special rapporteur on torture, the first Latin American and the first torture survivor to occupy that post.

The human rights movement has grown and diversified and is now sophisticated and professional. On the other hand, we have actually gone backwards in some areas. The "war on terror" has meant that the United States government is no longer an important actor in human rights protection abroad. Since 2001, Guantánamo, extraordinary renditions, the torture memos, the ill-fated invasion of Iraq under false pretenses, have all deprived the United States of any claim to a moral high ground. Whatever influence the U.S. government still has, it cannot be used for human rights protection.

But progress in human rights is never linear. Humankind abolished slavery more than a century ago and yet forms of slavery survive, such as the trafficking of women and girls for sexual exploitation. A final abolition of torture is within reach in our lifetime, but we have recently lost ground even there. The largest challenge that we face is that our societies come to tolerate torture as long as it happens to people we don't know, with names we cannot pronounce; we are told that it is ugly but makes us safe. We need to show that torture is counterproductive and illegal. We need to insist that it is immoral. If we tolerate such acts, we compromise our most sacred values.

JUAN E. MÉNDEZ (b. 1944) is Latin America's foremost human rights defender. As a young lawyer, he was arrested in 1975 for representing Argentinean political prisoners, becoming one of the notorious "disappeared." He was tortured while in captivity for 18 months, and his life was only saved by intervention from the U.S. After his expulsion from Argentina, he continued his work on human rights as a special advisor on torture and genocide with various international bodies. He is the UN Special Rapporteur on Torture and was Co-Chair of the Human Rights Institute of the International Bar Association in 2010 and 2011.

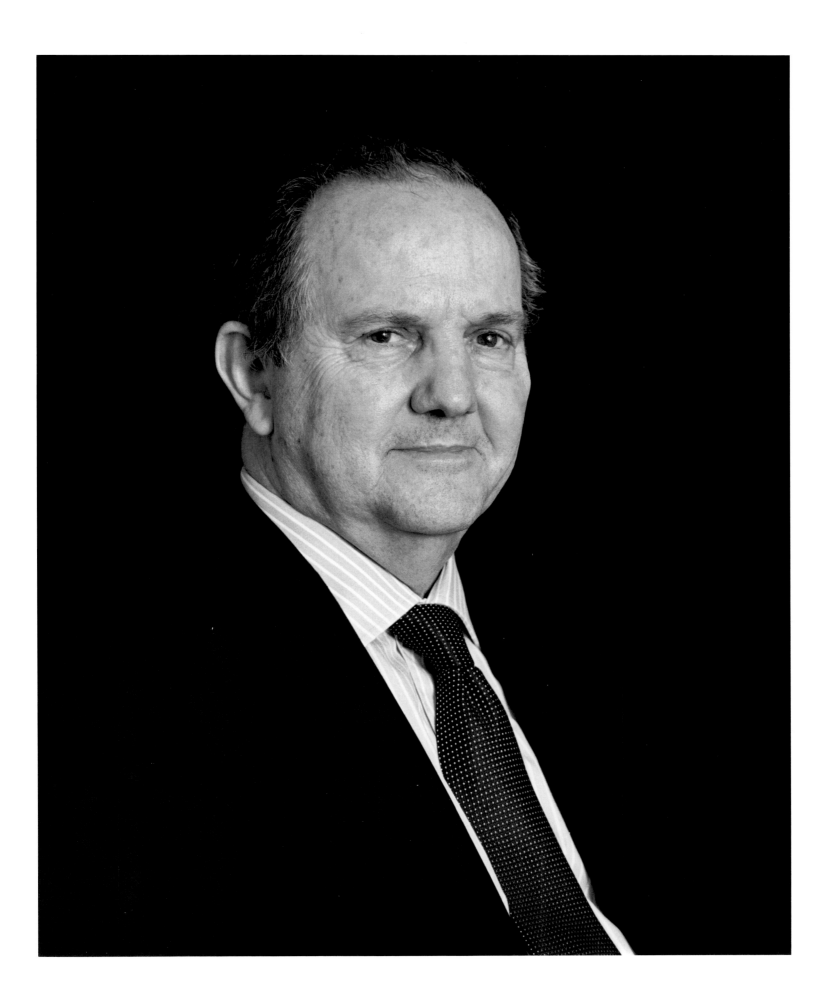

ANTHONY ROMERO

UNITED STATES — ACTIVIST

MY PARENTS PUT ME ON THIS PATH. I grew up in a very religious Catholic family. My parents are both from Puerto Rico. My mother finished the eighth grade, my father the fourth grade. They came here looking for a better life, and, since the church was such an important part of our upbringing, I learned about treating people with dignity. Do unto others as you would have them do unto you. Every person is entitled to live with dignity. For many years, I thought I would be a priest. In fact, as a little boy I would often preach on the subways, collect money, and put it in the basket on Sunday.

An experience that affected me a great deal took place when I was in grammar school. We were living in a pretty tough neighborhood in the Bronx. My father worked at the Warwick Hotel in Manhattan as a janitor. He wanted to be a waiter but was told his English wasn't good enough. But it was a banquet-waiter job—everyone gets chicken, everyone gets steak, you don't need a lot of English. My father filed a grievance with his union—Local 6—and he got the job. Our lives changed. We moved out of the Bronx and into a working-class community in Passaic County, New Jersey. We got our first car; my mother got a new living room set; I got my first 8-track player. My parents were not fighting over money so much. I could see what a difference one person's intervention—one young lawyer's intervention on my father's behalf—did for our family.

My father worked at the hotel for 39 years. I worked there during college and could see there were lots of other waiters there who were also immigrants: German, Italian, and Greek. Their English was no better than my father's, but my father looked typically Puerto Rican—dark hair, swarthy skin. When you see that prejudice up front, your family lives it, and then you have the ability to do something about it so that other families can also be given opportunities, that's a privilege.

My life is a miracle. I am the first in my family to finish high school, the first to go to college. I went to Princeton as an undergraduate—a big culture shock. I beat so many of the odds that are insurmountable for others. The mix of having seen my parents experience some injustices and knowing that I am blessed contributed to my sense of responsibility to give back. I went on to law school at Stanford afterward. If I had not been so circumscribed in my own thinking, I probably would have studied literature or art.

I am licensed to practice law in New York, but I haven't practiced since I passed the Bar. I worked for the Rockefeller Foundation, and then I worked at the Ford Foundation, where I was a program officer in charge of domestic civil rights work. I later became the global director of the human rights and international cooperation program. I was responsible for their grant-making, not just in the U.S., but at the global level.

I've met a lot of the other global leaders in human rights, who serve as inspirations. It's a blessing to be able to do this work. To wake up in the morning, read something in the newspaper, get angry about it, march into the office, and do something—that's a thrill.

We've made enormous progress in the 60 years since the birth of the modern human rights movement. The fact that we have a universal code of conduct—established norms that are internationally recognized—is remarkable, even though they are often broken by many countries, including our own. The norm against torture is one that we've now broken in the U.S. But the fact is that those rules exist. To have that so firmly established, both at the international level and at different state, local, and national levels, is real progress. In secular societies, the basis for human rights protection can be found in a human rights law or a bill of rights. In sectarian contexts, it can come from an understanding of human dignity, whether it's through the Koran, the Old Testament, or the New Testament.

One thing that is so spectacular about the human rights movement is that it appeals to the best of the human spirit. It's about the ability to live with dignity. To love the way you wish. To think what you wish. To speak what you wish. To associate with whom you wish. It's the idea that we are sovereign over our bodies, our minds, and our spirits. To articulate that in a way that gives freedom to people across the globe is one of the greatest of aspirations.

The most important thing to know is that we're going to need a human rights movement for as long as we have governments and government officials. Regardless of all the progress we make, there are always going to be setbacks. There will be new challenges to human rights, new leaders who play on fear and cynically manipulate the rights of the vulnerable to get themselves elected or to stay in office. This work is never done, because no human rights battle ever stays won.

ANTHONY ROMERO (b. 1965) is the Executive Director of the American Civil Liberties Union, the nation's premier defender of liberty and individual freedom. An attorney with a history of public-interest activism, he took the helm of the organization just seven days before the September 11, 2001, attacks. Since then, he has presided over the most successful membership growth in the ACLU's history. Romero is the ACLU's sixth Executive Director, and the first Latino and openly gay man to serve in that capacity.

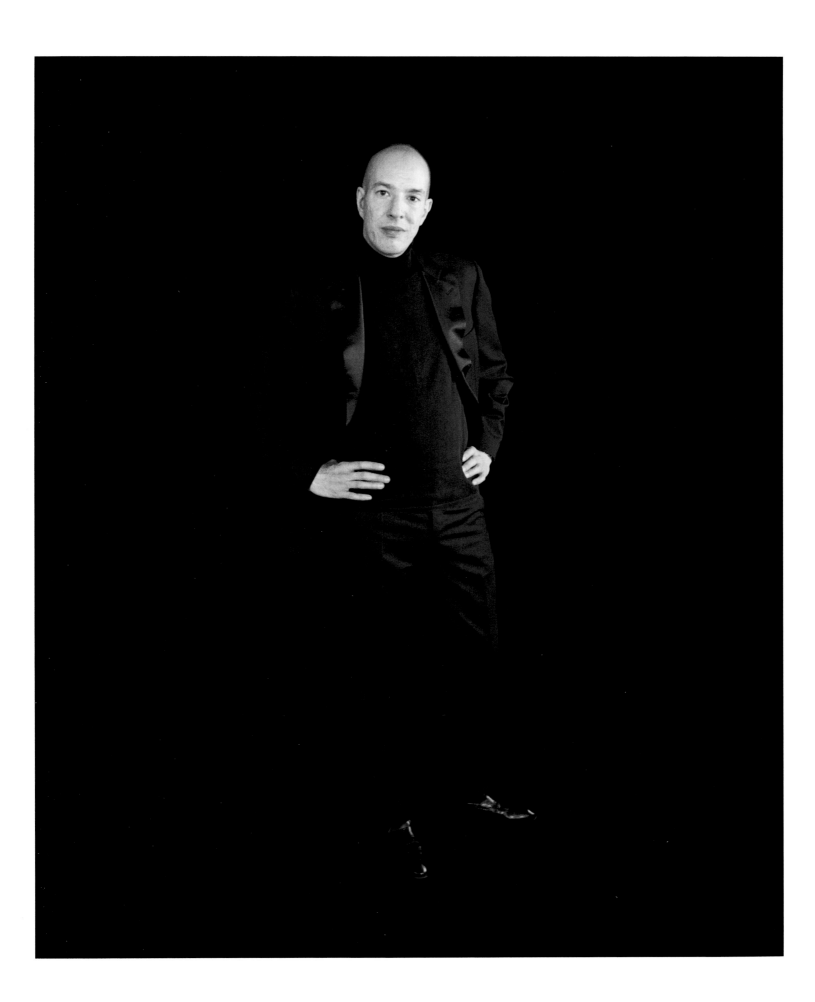

MARY ROBINSON

IRELAND — LAWYER/POLITICIAN/ACTIVIST

FROM QUITE A YOUNG AGE I would venture into my grandfather's book-lined study, and he would talk to me—not as a child but as an adult—about the cases on which he was working as a solicitor, imbuing in me a sense of how law could affect people's lives. As a teenager, I had a lengthy correspondence with my Aunt Ivy, a Sacred Heart nun on a mission in India. She captured my imagination with her tales of the children she worked with there and the terrible poverty in which some of them lived.

I left school wanting to become a nun myself, but that changed when I spent a year studying in Paris. There I was exposed to ideas about equality, feminism, secularism, and to current political writing. I was encouraged to read about revolutionaries such as Che Guevara, but I was more taken with leaders who espoused nonviolence—Ghandi, Martin Luther King, and Ireland's 19th-century political activist Daniel O'Connell. I began to question the role of the state and the church in controlling people's lives.

I read legal science at Trinity College Dublin, and in my final year I put myself forward as auditor of the student law society, choosing the topic "Law and Morality in Ireland" for my inaugural address. I spoke about the need for Ireland to open up, the need to change the laws to give space for private morality. I spoke about the "special position" of the Roman Catholic Church in the Irish Constitution and how the laws were mistakenly equating "sin" with crime. These were radical ideas at the time, and—together with gender-equality issues—they formed the basis of my burgeoning career as a human rights advocate and barrister.

In the '70s, I had the opportunity to represent a deeply courageous woman, Mrs. Airey, in what would become a breakthrough case. Mrs. Airey's situation was similar to those of thousands of women who had found themselves trapped in an irretrievably broken-down marriage, with no money to obtain the legal representation needed to improve their situation. What was different about Mrs. Airey, an intelligent but uneducated working-class woman, was her determination to seek redress. In June 1973 she hand-wrote a lengthy, detailed letter to the European Commission for Human Rights, a body she had read about in a local newspaper, complaining that her human rights had been violated. The commission granted her legal aid to test whether her right of access to the courts was being impeded by the Irish state, where no civil legal aid scheme was in place. Mrs. Airey's case set a precedent in the European legal systems that access to domestic courts could not be frustrated by a claimant's lack of means.

This was the type of case I favored, where an individual client has the courage to seek redress for injustices visited on them by acts or omissions of the state, and where the result of such a case ultimately impacts the entire system—and/or many people in similar situations.

It is difficult to describe the honor involved in representing your country as head of state. When I was elected President of Ireland, I was determined to be a working President for all of the people. I would seek out the excluded minorities and the Irish diaspora worldwide and I would represent them with as much dignity and vigor as I would the establishment. I learned about the power of symbols. On the night of my election I said I would put a light in the window of my official residence for all of those who had been forced to emigrate from Ireland. That light took on a life of its own and helped to shape an Irish diaspora worldwide.

In 1992, on a visit to Somalia as President, I witnessed the unspeakable suffering of thousands of ordinary people. I determined that I would somehow work to prevent such atrocities from recurring. When Kofi Annan asked me to allow my name to go forward as UN High Commissioner for Human Rights in 1997, I knew that this would be an extremely challenging office to hold. In the years since, I have tried to take a leadership role on issues of globalization, linking human rights and development, focusing on economic, social, and cultural rights, and on women's leadership issues. Through this work, I am becoming more and more focused on climate change in the context of human rights and development. This is a critical time. The decisions we make now, as a global community, will determine the quality of life of our grandchildren and their children.

PRESIDENT MARY ROBINSON (b. 1944) is a passionate advocate for gender equality, peace-building, and human rights. She was the first female President of Ireland (1990-1997), the former United Nations High Commissioner for Human Rights (1997-2002), and a human rights advocate most of her life. Robinson was the first head of state to visit Rwanda in the aftermath of the 1994 genocide, as well as Somalia following its 1992 crisis. As High Commissioner, Robinson gave priority to implementing the Secretary-General's reform proposal to integrate human rights into all the activities of the United Nations. She has strengthened human rights monitoring in such areas of conflict as Kosovo and Sierra Leone, as well as in China. After leaving the UN, she formed Realizing Rights: The Ethical Globalization Initiative and the Mary Robinson Foundation-Climate Justice.

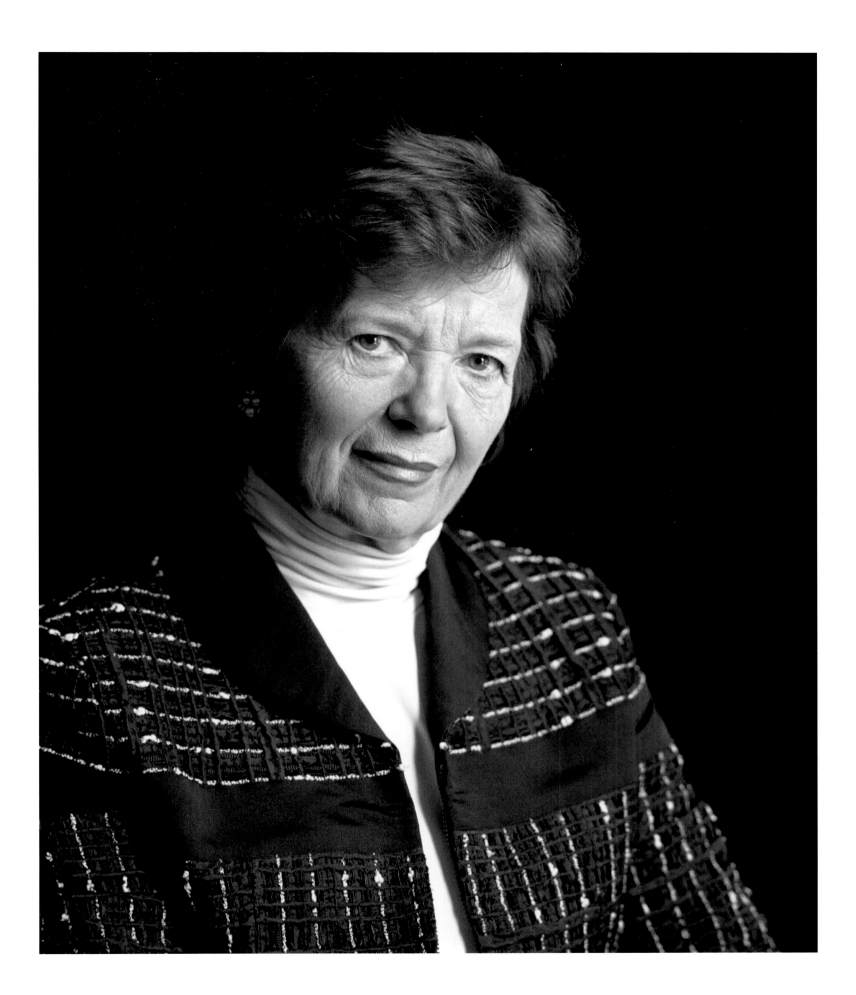

LOUIS H. POLLAK

UNITED STATES — JUDGE

IT STILL SURPRISES ME that for so many decades I believed in the existence of free will with respect to career decisions. It is only in the past few years that I have come to realize that my own life in law was marked out in advance by the life of my father.

Walter H. Pollak was born in 1887, the centennial of the Constitution; by the 1930s, he was one of the foremost civil liberties lawyers of his time. In a landmark case, *Gitlow v. New York* in 1925, he persuaded the Supreme Court to radically broaden the frontiers of free speech and the press by making those rights assertable against the states as well as the United States. In the 1930s, his arguments in the Scottsboro cases led the Supreme Court to twice overturn the death sentences of seven illiterate black youths convicted of a rape that never happened.

In the fall of 1940, just as I was beginning my freshman year at Harvard, my father died of a heart attack at age 53. After college and the army, I decided to become a lawyer. On graduating from Yale Law School in 1948, I served for a year as a law clerk to Supreme Court Justice Wiley Rutledge, a judge as profoundly committed to the Bill of Rights as any judge in our history. After the clerkship, I had the incomparable professional opportunity that has defined the balance of my career: to serve as one of the volunteer lawyers who assisted Thurgood Marshall and his associates of the NAACP Legal Defense Fund (LDF) in developing the legal strategies leading to the decisions in the school segregation cases—*Brown v. Board of Education* and *Bolling v. Sharpe*—in 1954 and 1955. The Supreme Court had at last brought the nation into compliance with its founding principle, promulgated in the Declaration of Independence and reaffirmed by Abraham Lincoln at Gettysburg, that "all men are created equal."

In 1955, I returned to Yale as a law professor; from 1965 to 1970, I served as dean. These were years of conflict, largely fueled by the student protests against America's war in Vietnam. Apart from riding out student demands and trying to address the anxieties of some of my colleagues, my principal decanal goal was to increase the number of Yale's black law students—part of an effort to alleviate the nationwide dearth of black lawyers. I also served on the New Haven School Board, steering the school system away from the constitutional shoals of school prayer and playing a role in shrinking the de facto (not de jure) segregation of our elementary and middle schools by reconfiguring school catchment areas. In 1974 I left Yale, moving to the University of Pennsylvania Law School. There I spent four peaceful years, three as dean.

Throughout these years, my teaching and writing were complemented by work on LDF cases. William T. Coleman Jr. and I assisted our friend Jack Greenberg (Marshall's LDF successor) on some of LDF's Supreme Court cases. In 1964 Coleman and I persuaded the court to overturn the convictions of "Dewey McLaughlin . . . a negro man . . . and Connie Hoffman . . . a white woman who were not married to each other" and who, in violation of a Florida statute, did "habitually live in and occupy in the nighttime the same room." In 1965, in *Abernathy v. Alabama*, I got the court to reverse the misdemeanor convictions of Reverend Ralph Abernathy, Yale Chaplain William Sloane Coffin, and several others involved in a "freedom ride" to penetrate the segregated South. And in 1977, in *Williamsburgh v. Carey*, I participated in persuading the court to sustain a redistricting of Brooklyn's seats in the New York State Legislature designed to equalize black voting strength.

In 1978, I was appointed a judge of the United States District Court for the Eastern District of Pennsylvania. I try to conduct my courtroom with respect for the rights and dignity of all trial participants—plaintiffs, defendants, lawyers, jurors, and witnesses alike. I also serve as an acting appellate judge. One of my principal job satisfactions is working with my law clerks, brilliant young lawyers dedicated to the law's highest values, who serve in my chambers for a year before going on to fine careers. For myself, I carry in my heart these lines of Robert Frost:

> *But yield who will to their separation,*
> *My object in living is to unite*
> *My avocation and my vocation*
> *As my two eyes make one in sight.*
> *Only when love and need are one,*
> *And the work is play for mortal stakes,*
> *Is the deed ever really done*
> *For Heaven and the future's sakes.*

LOUIS H. POLLAK (1922–2012) was universally beloved. As a lawyer, law teacher, and judge, he was involved in some of the most controversial areas of the law, and yet his relations with colleagues were characteristically warm, and he was known for his kindness. He served as Dean of Yale and the University of Pennsylvania Law Schools, and was a Senior District Judge for the Eastern District of Pennsylvania. His 77 law clerks have gone on to clerk for Supreme Court justices of sharply differing views, among them Burger, Rehnquist, Scalia, Brennan, Powell, Stevens, and Breyer. He received degrees from Harvard College and the Yale Law School, where he was Editor-in-Chief of the Law Journal.

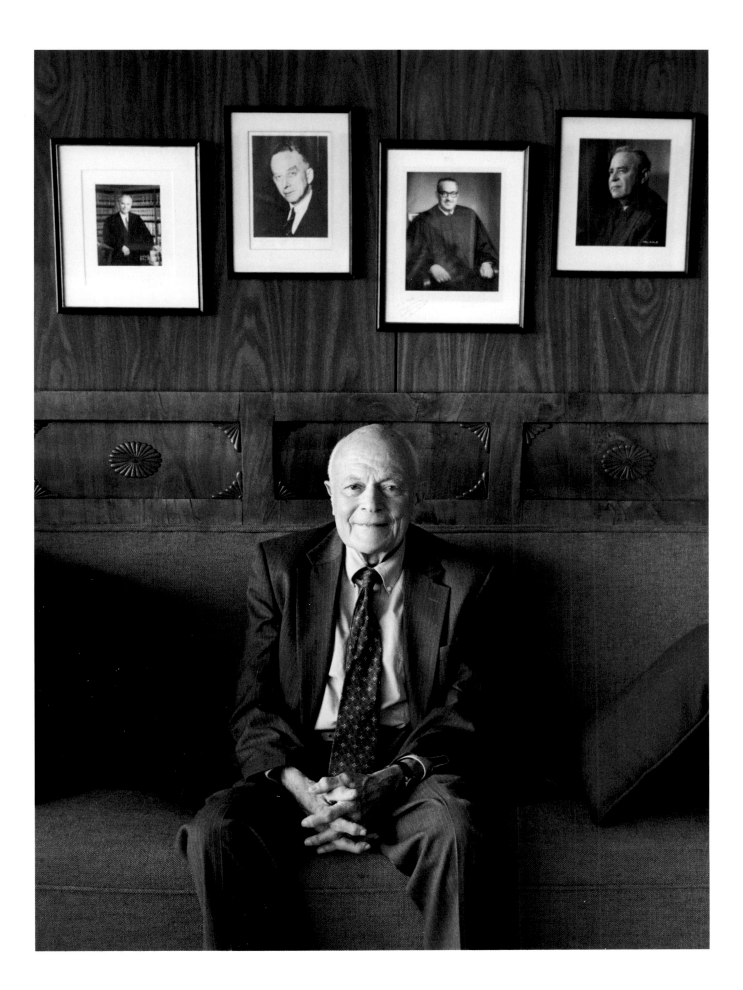

RICHARD GOLDSTONE

SOUTH AFRICA — JUDGE

I HAVE BEEN CONCERNED WITH the protection of human rights since my student days in Johannesburg, when I became involved in the anti-apartheid movement. In 2009, I was asked to lead the Fact Finding Mission mandated by the United Nations to report on human rights and humanitarian violations in Israel and the Occupied Territories relevant to Operation Cast Lead.

The Fact Finding Mission found evidence that war crimes, including crimes against humanity, had possibly been committed by both Israel and Hamas and other militant groups that fired indiscriminate rockets and mortars from Gaza into southern Israel. But the Gaza Report proved to be less a subject of controversy than "the messenger." Subsequent personal attacks were made against me by various figures in the Israeli government and media and by Zionist and Orthodox Jewish religious groups in several countries, including the United States and South Africa. Unfortunately, neither Israel nor Hamas was prepared to carry out the main recommendation of the mission—namely, that each should set up open and credible investigations into the report's allegations.

Some months after the report's publication, however, the Israel Defense Force announced that it had imposed a ban on the use of white phosphorous in civilian areas and had amended its rules of engagement. It also appeared that the bombing of the al-Simouni home near Gaza City during Operation Cast Lead was the result of a misinterpretation of a grainy drone photograph. While that explanation did not excuse the death of some 29 children, women, and men, it did not justify a conclusion that there had been an intentional attack on civilians. On the other side, Hamas failed to conduct any inquiries at all and continued to send rockets into civilian areas. These developments led me, in April 2011, to publish an op-ed in *The Washington Post* in which I suggested that, while the absence of full and open investigations by Israel was still regrettable, the finding we made of intentional attacks on civilians had not been justified. The other findings in the report were in no way retracted or placed in question.

I have no doubt that I was approached to lead this mission not because I am Jewish but because of my extended experience investigating both human rights violations at home and war crimes committed in the former Yugoslavia and Rwanda. I consider myself a lifelong supporter of Israel; I also considered it hypocritical to refuse this request. The hostility elicited by my participation only underscores the need for these fact-finding missions, which must transcend national and ethnic loyalties.

There are also lessons to be learned from the manner in which the mission was carried out, and they are the subject of an ongoing international discussion.

The recent development of international criminal law has been exciting and impressive. The seed was planted at the 1945 Nuremberg Trial of the Nazi leaders. The idea of a permanent international criminal court fell dormant during the Cold War, but then it was revived in 1993 when the United Nations Security Council established the International Criminal Tribunal for the former Yugoslavia and, in 1994, the sister tribunal for Rwanda. I was appointed as the first chief prosecutor for both of these tribunals. It was their success that led directly to the Rome Treaty in 1998 that resulted in the setting up of the International Criminal Court. To date, some 119 states have ratified the Rome Treaty and are thus members of the Assembly of States Parties that elects the judges and prosecutor of the court.

Prior to 1993, when the Yugoslavia Tribunal was established, there was universal impunity for war criminals; international criminal justice did not exist. It was not a topic of media interest and was not taught in law schools. Today, hardly a day passes without media attention—sometimes at an intense level—being devoted to international criminal justice. It is beginning to affect the way in which some political leaders and military commanders conduct military operations. Today, there are few leading law schools that do not have courses in international criminal law. I feel proud to have played a role in bringing about this important change.

I would conclude by paying tribute to the positive role that the United States has played in all the developments of international criminal justice. It is my sincere hope that it will continue to play that role, and in the not-too-distant future be in a position to join the Assembly of States Parties of the International Criminal Court.

RICHARD GOLDSTONE (b. 1938) was a judge in South Africa for 23 years and a Justice of the Constitutional Court from 1994 to 2003. He was one of a few liberal judges who issued key rulings that undermined apartheid, including restricting evictions, thereby completely undermining the Group Areas Act that banned non-whites from living in "whites only" areas; his actions ended almost all prosecutions under the act. Instrumental in South Africa's transition to a multiracial democracy, he headed the Goldstone Commission that investigated political violence. He was Chief Prosecutor of the United Nations International Criminal Tribunals for the former Yugoslavia and Rwanda, and was appointed by the Secretary-General of the United Nations to investigate allegations regarding the Iraqi Oil for Food Program. In 2009, he received the MacArthur Award for International Justice.

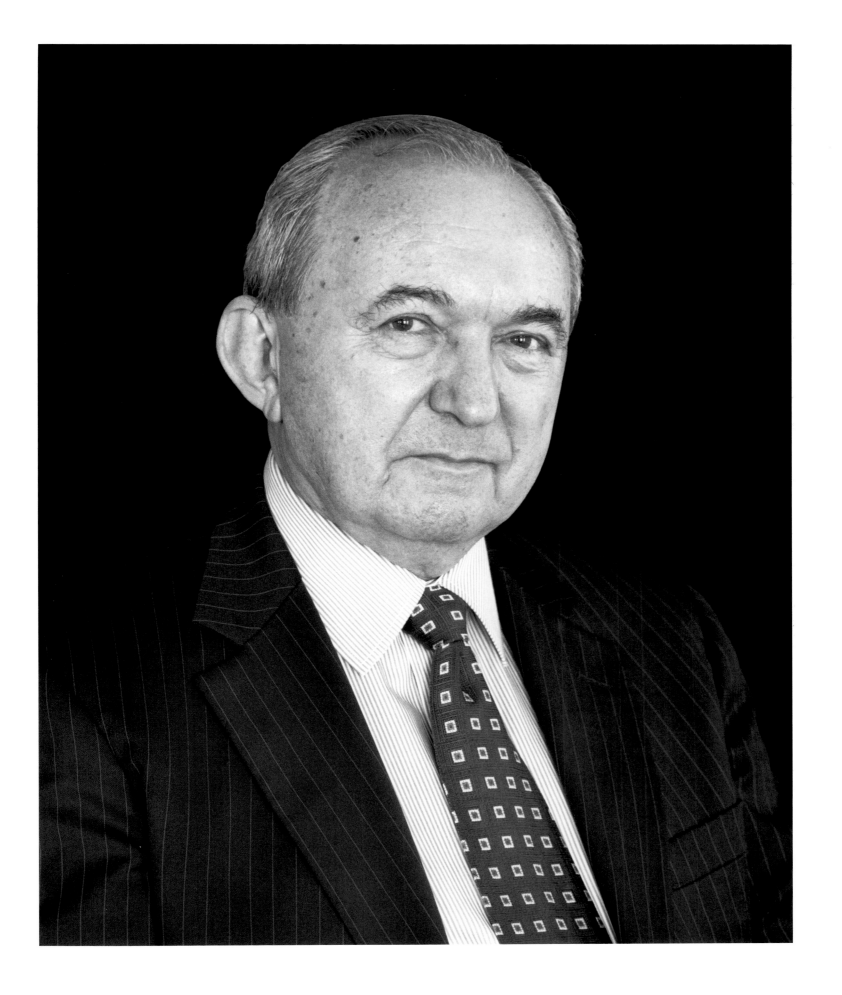

DESMOND TUTU

SOUTH AFRICA — ARCHBISHOP EMERITUS

THE SOUTH AFRICA OF MY YOUTH was deeply segregated. I was treated worse than the white children in our neighborhood of Klerksdorp, but I tried to make the best of it. I made toy cars out of wires and was read lots of books. My mother had only passed a few grades at school. She cooked and cleaned at a school for the blind. I have always known that I look like her physically—she was stumpy with a large nose—but I have also hoped to inherit her compassion, caring, and generosity. We were not well-to-do, but we were all right—my father was an elementary-school principal. When my mother cooked, she cooked for more than just our family. She said, "You never know if somebody will come in who is hungry and we must be able to feed them." My wife called her "the comfort of the afflicted" because she always stepped into a quarrel on the side of the one who was having the worst of it!

When my family moved to Johannesburg, I was 12 years old and I almost died after contracting tuberculosis. It made me interested in the field of medicine; I was intent on becoming a doctor and finding a cure. Although my all-black high school was financially strapped, I received an excellent education and was given the impression that I could be anything I set my mind to be. I was accepted into medical school, but we could not afford the tuition, so I became a teacher instead and tried to inspire the same dreams in my students that my high school teachers had sparked in me. Then, in 1953, the Bantu Education Act was passed, effectively ensuring that no blacks would receive an education beyond the minimum needed for a life of servitude. I could no longer in good conscience be a part of an education system that deliberately advanced inequality, so I left teaching to become a priest.

I have got to believe that we exist in a moral universe, that right will always prevail in the end, that we're all—all of us, without exception—made for goodness. Going off the rails and doing wrong are the aberrations. It is a testimony to the extraordinariness of God, possessing all of that power, that God could say, "I'm going to create you. And I'm going to make you a person who has free choice." We Christians believe that in the end God came into our world through Jesus Christ, who became a full human being in order to show us how to be human. We are enlisted by God in this extraordinary process, this great work of redeeming the world—a world where a Holocaust can happen, but also a world with people like Dietrich Bonhoeffer, a German Lutheran pastor, theologian, and martyr who opposed Hitler. It is a world where you can have a Mother Theresa, a Martin Luther King Jr., a Mahatma Gandhi.

And isn't it extraordinary, in a world where might *does* sometimes seem to be right, that in the end it is goodness that prevails? We were involved in a struggle against the injustice of apartheid. Many times we seemed to be overpowered. The apartheid government had all the paraphernalia imaginable. Even so, goodness ultimately prevailed, and there were individuals whose actions have transformed the world for the better. Someone like the English Anglican bishop Trevor Huddleston, who was the second Archbishop of the Church of the Province of the Indian Ocean. I remember the first time I met him; I was walking with my mother, and the white priest tipped his hat as he passed us. I had never seen a white man pay his respects to a black woman. It made me realize the injustice of inequality, and the ability of religion to bridge the overwhelming gap between the treatment of blacks and whites. Huddleston became both a friend and a partner as we strove together to bring an end to apartheid. We worked with the hope of creating a just and democratic society without racial divisions, where blacks and whites could receive the same quality of education, possess equal civil rights, and live together.

It is not the military junta in Burma that is admired by the world; it is a woman—petite, beautiful, with no military power but an extraordinary force for good. When I had the honor to announce the newly elected President Nelson Mandela, it was a glorious moment. I whispered to God that if I were to die, it would have been a suitable time. In the end, the truth will prevail over lies, light over darkness, life over death, human dignity over oppression.

ARCHBISHOP DESMOND TUTU (b. 1931) is Archbishop Emeritus of Cape Town, a veteran anti-apartheid activist and peace campaigner often described as "South Africa's moral conscience." He began his career as a high school teacher but turned to theology after the 1953 Bantu Education Act enforced racial segregation in educational institutions. He soon became well known internationally for his commitment to nonviolence and for his support for economic sanctions against apartheid South Africa. He organized many peaceful demonstrations and was awarded the Nobel Peace Prize in 1984 and appointed Chair of South Africa's Truth and Reconciliation Commission in 1994. "Without forgiveness," he says, "there can be no future for a relationship between individuals or within and between nations." Since 2007, he has been the founding Chair of the Elders, an independent group of global leaders who promote peace and human rights worldwide. He is one of the most loved and respected activists of our time, a man whom Nelson Mandela once described as "sometimes strident, often tender, never afraid, and seldom without humor."

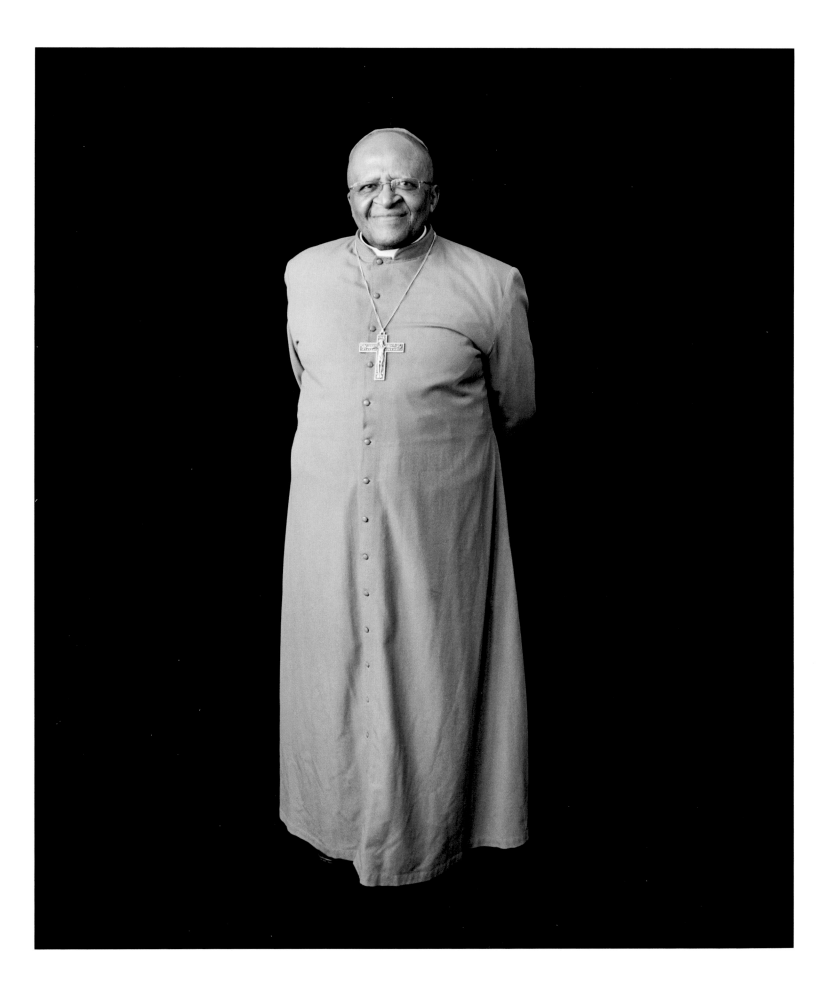

SOLI SORABJEE

INDIA — LAWYER

INDIA GAINED ITS INDEPENDENCE IN 1947, and with it came the first Indian Constitution and Bill of Rights that was expressly made to be judicially enforceable. This was very important because it finally gave us independence from British rule. We didn't have to imply or infer our rights—they were all clearly laid out.

I had been interested in human rights and philosophy since my youth, having studied at St. Xavier's College, a Jesuit school. I was very excited by the fact that rights are not merely ideals on paper but are also enforceable. Although I could make more money working as a lawyer in the commercial and corporate worlds—and did so in the past—my heart was never in it.

In June 1975, Mrs. Gandhi imposed a state of emergency, but it was a spurious one. When a state of emergency is imposed, certain fundamental rights are suspended. She also introduced a very drastic and harsh censorship order, and the censor acted arbitrarily. It was absurd. We couldn't receive news and it was risky to express ourselves. Many people were imprisoned, and people's courage was tested. Overenthusiastic officials, in order to enforce a family planning program, required compulsory sterilization.

Many people asked me, "Soli, why are you doing all this? Do the other work. Why do you want to annoy the authorities?" In my mind that was very easy sweet talk. Many people's rights were being violated. If the lawyers didn't defend them, who would? I appeared for them free of charge. That was the blackest period in India's history and democracy suffered a temporary demise. The government attempted to curtail the courts' powers. Fortunately, because of censorship, Mrs. Ghandi didn't get the news from the papers about what was really going on in the country. She heard what she wanted to hear, and her cronies advised her that if there were elections, she would have an overwhelming majority—so she declared elections. She had no inkling of the anger growing among the Indian people, especially in the north.

Mrs. Ghandi was ousted, and when the Janata government came into power, I was appointed additional solicitor general. I went to Delhi, where the Supreme Court was, and worked on many cases of human rights violations. Even though I was the additional solicitor general and afterwards solicitor general and attorney general for India, I had experience being on the other side. I would tell the administrators, "This can't be done. That's not right." Of course disorder must be controlled, but not by employing means which are disproportionate. In my mind, the essence of democracy is the right to dissent without fear.

The Janata government failed, and the next government appointed its own law officers, so I returned to private practice. At that point, my private practice was mainly in the field of human rights. Apart from combating censorship, my other focus was detention without trial. Unfortunately, even after the state of emergency, there were preventive detentions of those suspected to be dangerous to the state or the community merely on suspicion. Luckily, the situation has much improved since then.

We are very fortunate that we have an independent judiciary in India, which keeps the government on its toes. We also have a free press—so free it goes overboard at times. But that's the price you have to pay for democracy. When I travel abroad and people assert that their country is a democracy, I tell them to give me a law report and a few of their newspapers, because if all the papers sing the same tune in praise of government, it's a controlled press. Authoritarian regimes can't tolerate any kind of dissent or criticism.

Guantánamo Bay is a telling example of how even a "democratic" country like the United States has its black spots. The U.S. faced a very serious threat, but detaining people for months on suspicion without trial or legal assistance and then conducting secret military tribunals is simply unacceptable. Terrorism is a real danger that should be fought rigorously, but not by violating human rights or treating people like animals. A delicate balance must be struck between freedom and security, and the challenge lies in determining to what extent and how much one should be sacrificed for the other.

SOLI SORABJEE (b. 1930) was Attorney General of India from 1989 to 1990 and again from 1998 to 2004. His private practice is primarily in the field of constitutional law, particularly issues regarding freedom of expression and freedom of the press. During the sham emergency foisted on the nation by Mrs. Gandhi's government in June 1975, Sorabjee appeared free of charge for victims of censorship and persons detained without trial, whose only crime was that they were strong dissenters. In 1997 he was appointed by the United Nations Human Rights Commission as Special Rapporteur to report on the human rights situation in Nigeria. Sorabjee also served as a member of the UN Sub-Commission on Human Rights in Geneva from 1998 to 2004. In 2002, he was awarded the Padma Vibhushan Prize, the second-highest civilian award in India.

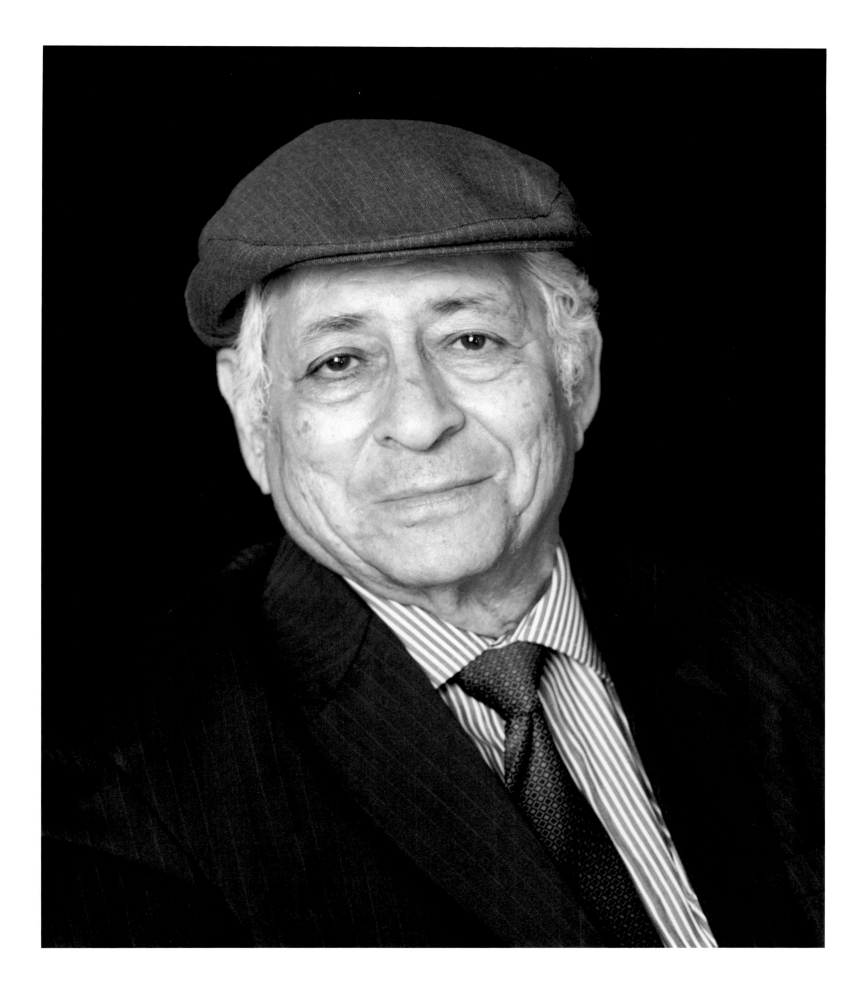

JOSÉ ZALAQUETT

CHILE — LAWYER

I AM THE SON OF LEBANESE IMMIGRANTS, one of seven children, raised in a Christian family, although I'm a nonbeliever myself. My country, Chile, secured independence from Spain in 1818. Except for two brief interruptions, it had a republican form of government up through the 1960s, when I graduated from law school, began an academic career, and started working as a lawyer.

When Fidel Castro came to power in 1959, politics throughout Latin America became polarized. This radicalization was particularly sharp in the so-called Southern Cone—Chile, Argentina, and Uruguay. In these countries, young people pressed for immediate changes. I was moderate in my politics but caught up in the whirlwind. In the 1960s, Chile moved from a right-wing government to a centrist government, and then to the socialist Allende government. Allende incensed the fears of some and the hopes of others until his administration ended with a military coup on September 11, 1973. The dictatorship that followed incurred massive human rights violations that shocked the world. Uruguay moved to military control of the government in 1973 as well, and Argentina in 1976.

The dictatorships of the Dominican Republic, Nicaragua, or Paraguay didn't challenge the ideological tenets of democracy but rather adopted its trappings, staging rigged elections and forming sham parliaments. In contrast, the dictatorships that developed in the south of Latin America had a sense of mission: to defeat an internal enemy that they thought wished to introduce Communism through the back door. They ruled as institutions, not with a single man governing, but this made them no less ruthless; they felt they had to be tough to save Western civilization from a treacherous ideological foe.

In October of 1973, I joined a group sponsored by a coalition of churches. Initially there were 6 of us but within a few months we were more than 150. I was in charge of the defense of political prisoners. Of course, in the context of a dictatorial government and a subservient judiciary, our legal work was not conducive to judicial rulings in our favor. Rather, it was a means to stand by the families of the victims and to gather information. We hoped for the effect of a drop of water constantly falling on a rock until eventually it might produce a crack. After two and a half years of that effort, I was put in prison. I was released, imprisoned again, and then exiled abroad.

I was in prison for a total of three months; I was not tortured. They reserved torture and death for people they considered to be hardcore militants. We, the lawyers, were deemed mere troublemakers and marked for imprisonment and exile. I was exiled in 1976, two and a half years after the military coup, and was allowed back in 1986, four years before the end of the military government. In 1988, the military government held a plebiscite on the continuing rule of Pinochet and lost it. A year later there were competitive elections, and in 1990, democracy was returned to Chile.

At that time, as part of the political and moral reconstruction of the nation, it was necessary to address the legacy of massive human rights violations left by the dictatorship. One of the ways we addressed it was by forming a truth commission. Truth commissions have been established in the last three decades in countries all over the world that are moving away from dictatorships or civil war. These truth panels investigate and report on the worst political crimes and make recommendations for reparation and justice. Only seven or eight of these truth commissions have been reasonably successful, and Chile's effort is generally viewed as one of them. I was a member of the truth commission in my country and have participated in several other similar human rights initiatives in Chile and abroad since then.

The truth commission in Chile produced the names of over 3,000 victims of political crimes or politically motivated violence. It was not a court of law, so we did not administer criminal justice. However, once our report was widely publicized, it created a climate of public opinion that favored justice. In the years since, many former military men have been convicted of grave crimes and made to serve time in prison.

In the '60s, Chile was divided into three political factions, and each block proposed a program that the other two-thirds utterly loathed. In normal times, political rivalries do not rip a country apart. Yet in Chile in the early '70s, we came close to a civil war. We have learned the lesson of extreme politics and today a vast majority of the Chilean people favor democracy, human rights, social justice, an open economy, and rule of law.

JOSÉ ZALAQUETT (b. 1942) is a Chilean lawyer and law professor who led the legal defense of victims of human rights violations during the Pinochet dictatorship (1973-1990). Imprisoned and then exiled by that government, he subsequently became the charismatic Chairman of Amnesty International, inspiring the promotion of human rights worldwide. After his return to Chile in the late 1980s, he has continued to work on transitional justice issues—the need to build or rebuild a fair political system in a post-conflict situation. He has received a MacArthur Foundation award and the UNESCO prize for the teaching of human rights.

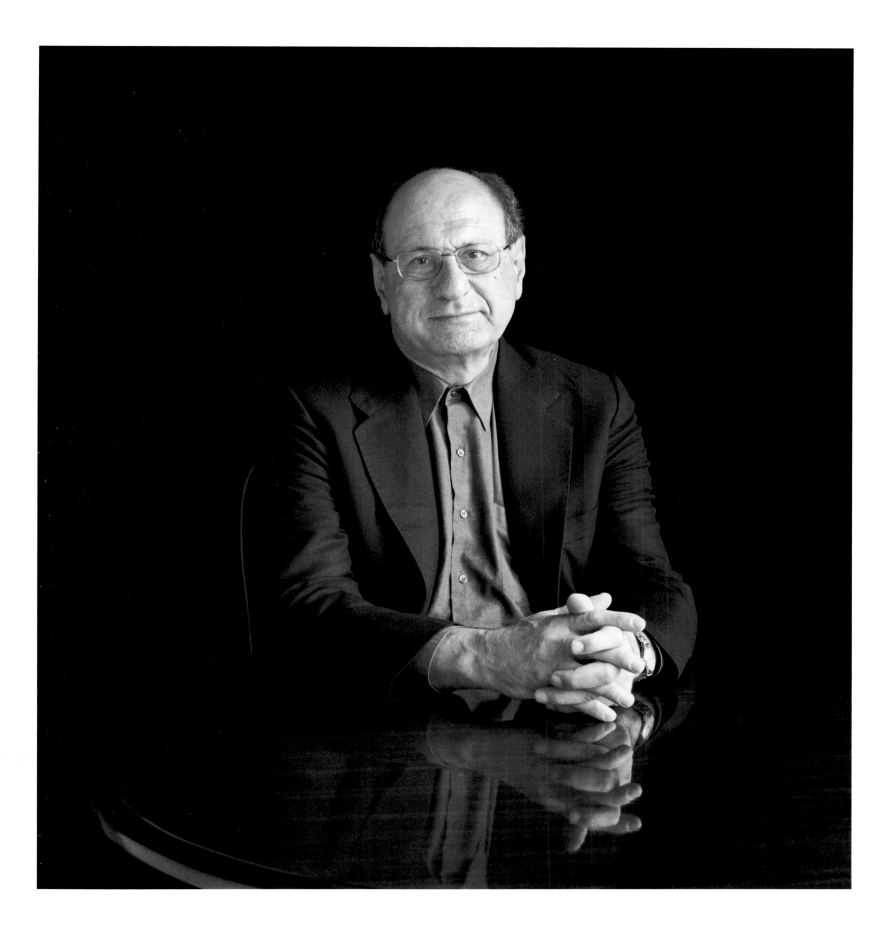

JACK GREENBERG

UNITED STATES — LAWYER

I'VE OFTEN BEEN ASKED how a white lawyer from the Bronx came to a career devoted to the rights of black people. My parents weren't involved in civil rights or even passionate about politics. But they did help me develop confidence in my ability to choose my own way. I grew up prepared to rely on my own feelings to tell me if what I was about to do was right.

My mother was a very disciplined woman. She saved 50 cents a week at the Metropolitan Life Insurance Company so that I would have tuition to go to Columbia, the only school she ever considered. My father, an immigrant from Lowicz, Poland, was opposed to the "system" and suspicious of all received wisdom. When he went to synagogue, he spent most of the time outside, on the steps; he did not seem to care to be identified with those at the very center of things. I've sometimes wondered: did this iconoclasm serve as a model for me later in life—encouraging me to stay just within society's boundaries as a lawyer fighting some of its most deeply entrenched institutions? Over the course of my career, I argued 40 civil rights cases before the U.S. Supreme Court. The first few times I was there, I was full of awe; it was an almost tactile feeling. The first time I was in the court, I felt as if I were in a synagogue and reached to see whether I had a yarmulke on.

My wartime service also affected my career. I participated in the invasion of Iwo Jima, where I saw what death really looked like—real bodies blown apart. After that, I felt I could handle anything. In 1946, I entered Columbia Law School, where I enrolled in a civil rights seminar called "Legal Survey," working on social justice cases. I knew it was the work for me.

After graduating, I joined the Inc. Fund, which would later become the NAACP Legal Defense and Educational Fund. I was already familiar with the fund's work from highly publicized cases such as that of Rosa Lee Ingram, a woman who had been sentenced to death with her two teenage sons, for killing a white farmer who pressured her to submit to him sexually. I stayed at the fund for 35 years. The first 12, I worked under the guidance of Thurgood Marshall, and then, when President Kennedy appointed him to the Court of Appeals, I became director of its civil rights strategies in the courts. Marshall was a true mentor, and I always sought to emulate his style to the extent that I was able.

My work at the Legal Defense Fund allowed me to tackle pressing civil rights issues. One year out of law school, I won the first case to establish the right of a black student to attend a segregated college in the South. Then, in the early 1950s, I became one of the lawyers to try the Delaware and Topeka cases constituting *Brown v. Board of Education*. I argued the Delaware case in the Supreme Court. I was only 27 at the time. People ask me: Weren't you terrified? The answer is no. We'd prepared and prepared, and we knew we were right. Still, when the court handed down our victory, we were stunned.

By the time I became director of the Legal Defense Fund in 1961, the civil rights movement was taking off, and we were able to mobilize on behalf of sit-in demonstrators and protest marchers, and then to fight for the enforcement of the Civil Rights Act. Later, our focus expanded to prisoners' rights. We explored ways to attack the death penalty for rape—a campaign that led to a full-scale war on capital punishment. We launched the effort because almost 90 percent of the 455 defendants executed for rape since 1930 were blacks convicted of raping white women.

In 1972, I argued the case of *Furman v. Georgia* before the Supreme Court, defending three black men who were on death row due to the inconsistent and racist application of the death penalty. Unexpectedly, we won. The court held that the death penalty as it was then applied was a violation of the "cruel and unusual punishment" clause of the Eighth Amendment. But this victory quickly unraveled: thirty-seven states passed new death penalty laws to overcome the court's concerns. By 1975, death row, which *Furman* had essentially cleared, was back up to a population of 400. Capital punishment had proven to be politically unstoppable.

This still troubles me. Of all the countries we resemble in our values and political system, we alone have capital punishment. The biggest executioners in the world are China, Iran, Iraq, Syria, and the United States. Perhaps, as we move further from our racist past, the hold that capital punishment still has on the American public will diminish.

JACK GREENBERG (b. 1924) was the only white legal counsel for the NAACP Legal Defense and Educational Fund in 1949, and succeeded Thurgood Marshall as its Director-Counsel. He argued 40 civil rights cases before the Supreme Court, including the Delaware case that was part of *Brown v. Board of Education*, as well as *Griggs v. Duke Power Company*, which led to the end of discriminatory hiring practices, and *Hamm v. City of Rock Hill*, which exonerated thousands of civil rights protestors. He was Dean of Columbia College and is currently the Alphonse Fletcher Jr. Professor of Law at Columbia University's Law School. His autobiography focuses on the legal battles of the civil rights movement and is entitled *Crusaders in the Courts*.

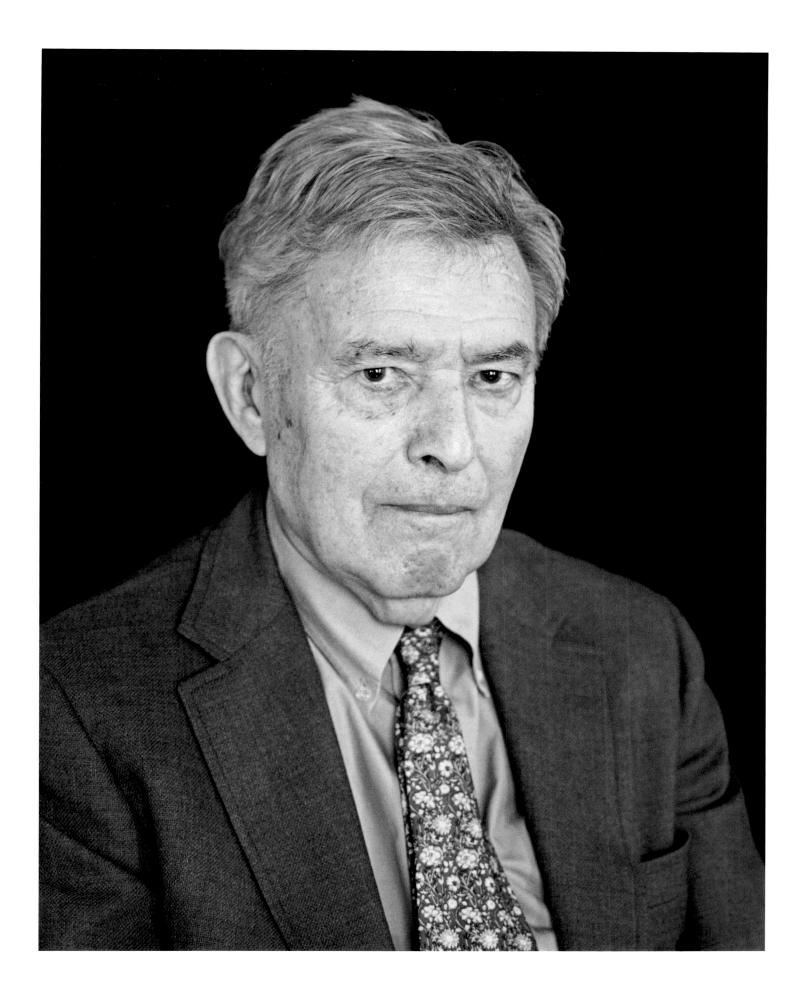

PATRICK LOZÈS

FRANCE — ACTIVIST

I WAS NOT PREDISPOSED TO FIGHT THIS BATTLE. I am a pharmacist. My father was a doctor and a French senator, my mother a midwife. Our family came to metropolitan France in 1976, when I was 14. I lived first in Creil, then Villepinte and Tremblay-en-France in Seine-Saint-Denis before moving to Paris. I studied in schools where I was often the only black person in my class. I got my baccalaureate in the Parisian suburbs and studied pharmacy in one of the most prestigious districts of Paris.

Diploma in pocket, I embarked on a happy career in the pharmaceutical industry. But I was caught up in politics during the 1988 presidential elections. I have thought a lot about the coming of that moment. Politics have not left me since. The idea of truth advocated by the former Prime Minister Raymond Barre left a mark on me. "I want to tell the truth to the French people," he said.

I adopted this concept and planned to participate in politics and tell the truth to the French people. I quickly became a card-carrying member of the UDF, a centrist party. In 2002, I would find myself a parliamentary candidate for the first division of Paris. I campaigned in a pocket of diversity in the third district; in other words, a corner inhabited by blacks. It was during the course of this election that everything changed, and that I found myself face-to-face with the "black issue."

An impressive number of blacks came to me, and I asked them to vote, since they felt excluded from the Republic of France. But I saw that I could not respond to all of their requests as I could to questions about health or the economy posed to me by other voters. The republic had not taught me to respond to these questions. I was not prepared. Blacks came to confide in me because they thought I would understand them better, but I was as lost as they were. They spoke to me of their malaise, a feeling of not existing; of housing discrimination; of the lack of response after job interviews and hundreds of job applications; of their inability to find an internship; of taking refuge in jobs as security guards despite having advanced degrees. So many challenges, in the face of which I was totally defenseless. I understood that this despair would blow up quickly if we did not attend to it. Young and old, African and Caribbean, all the blacks that came to see me experienced discrimination that did not fit in with the follower of the republic that I was, with my uncompromising republican convictions.

During the campaign, I met the Paris bureau chief for *The Washington Post*, Keith Richburg. He had written an article about me in his paper because I was one of the very few black candidates in the election of 2002. Keith told me that he had not seen any black journalists since he arrived at the Elysée. He had seen many technicians, but not journalists for major national media outlets. He lived above the Picasso Museum and told me he was surprised not to see any black children among those visiting the museum. I did not believe him. I thought this was impossible, so I watched for myself. He was right.

What to do? I could continue in politics as before, or I could tackle the black issue. I could try to awaken the conscience of this country to the question: What does it mean to be black in France today? To convince the population that this "black issue" is a key issue for French society as a whole, for the republic. This is an issue of justice, of equality and brotherhood. I thought I had to get there for myself, but also for those I could have helped before; those of Creil and Villepinte, where I lived, and for all of these black friends who told me about their victimizations—ordinary acts of racism that I could not accept. During the 2002 election campaign, I decided to fight. Not alone, but alongside all the blacks and whites who, like me, felt the need for this fight.

For my son and for all the adults of tomorrow, I implore that France's values become truly universal, that they become applicable to all French citizens—which is to say, also to the black population. I am striving to mobilize as many people as possible to show France the discrimination that persists in employment, housing, and health. I implore France to fight racism not just by trying to reform racists, but by protecting minorities and people suffering prejudice, so that real solutions to discrimination are found.

PATRICK LOZÈS (b. 1965) campaigns for equal rights and fights discrimination in France. He was born in Benin and immigrated with his family to France in 1979. He was originally trained as a pharmacist but became the Founder and former President of *Conseil Rèpresentatif des Associations Noires en France* (Representative Council of Black Associations in France), which was the first umbrella organization of its kind in the country. He has long been an outspoken advocate against discrimination, having founded *Cercle d'action pour la Diversité* (Circle of Action for Diversity) in 2003, which combats all forms of discrimination affecting, among others, blacks, homosexuals, and Jews.

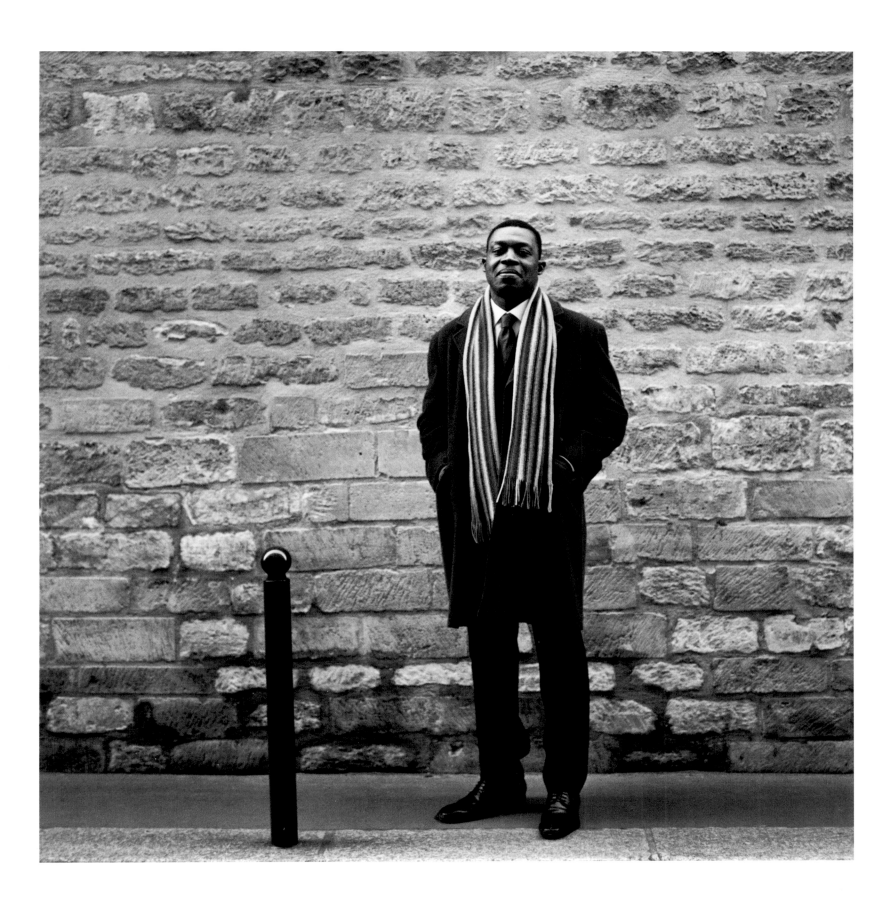

XIAORONG LI

CHINA/UNITED STATES — ACTIVIST

I GREW UP DURING THE CULTURAL REVOLUTION IN CHINA. People fought against one another, often violently, to prove who had the greatest loyalty to Mao. The chaos lasted for ten years, beginning when I was eight years old, from 1966 until 1976. I learned nothing at school. We would go to farms, factories, or army camps to learn from the workers, farmers, and soldiers. We studied political propaganda materials, mostly of Mao's quotes. There were many political parades, and I remember spending lots of time preparing the floats with my classmates.

People were purged and put on parade. They were made to wear sharp cone hats, their hands tied behind their backs, and they were forced to kneel in front of the crowd. Then there were speeches to denounce what they had done. My father was among them. He was locked up in a makeshift jail in a factory and beaten up. His arm was twisted so hard it broke. These were very disorienting years.

Mao dictated that all young people had to go to the countryside for "re-education" by hard work when they graduated from high school. I spent almost two years in a mountain village without electricity or running water. The local people lived in huts and did not have enough to eat.

Mao died in 1976. Peasants were already chipping away at the collective system. Farmers in our village leased land to families, who quickly produced abundant food. Deng Xiaoping attempted to salvage the economy by quietly approving "anti-socialist" but fruitful experiments in some rural communities, which released the enterprising energy of the people and began China's rise in economic power. I went to the university, where real education resumed in the 1980s. It was a period of enlightenment. Western books and films became available.

The period known as "thought liberation" lasted until 1989, when the government used bullets and tanks against pro-democracy protesters in Beijing and other cities. I was in the United States pursuing my doctorate in philosophy at Stanford—and, until that moment, largely unengaged politically. For most Chinese living in the West, the images of the military crushing peaceful protesters were shocking. Rather than relying on open-minded individual leaders to prevail or end their own power, we realized that fundamental changes to the authoritarian government had to take place. Chinese students on university campuses in the United States began organizing—demonstrating in front of the Chinese embassies and consulates, and collecting donations to support students on hunger strike in Tiananmen Square. The internet age was just beginning, and Chinese students used e-mail to update Americans and the press.

In 1989, many of my friends and I became aware of human rights—both as a concept and as an existing mechanism for advocacy. This new interest and my studies in political philosophy became mutually enhancing; they have defined my professional life for the past 20 years. In the aftermath of Tiananmen, with a group of Chinese students and the generous help of an international human rights organization, we founded a Chinese human rights group in the United States. Fifteen years later, when some citizens in China began to push actively for human rights protection, I helped establish another organization that focuses on empowering activists there. I draw my inspiration from the perseverance of those Chinese citizens who take great personal risks in pursuit of justice and freedom.

The February 2011 online call for Tunis-style "Jasmine Revolution" protests in China has so far resulted in the harshest recent crackdown on activists: the government instituted a zero-tolerance policy and has abandoned any pretense of rule-of-law reform. Fair procedures to seek remedies to the rampant official corruption and social injustice do not exist there. Anyone who criticizes the violation of human rights by the government faces police retaliation, which ranges from interrogation and intimidation to arrests, disappearances, and torture.

China's modernizing economy and technology is a double-edged sword for the authorities. The internet provides the best tool for civil-society activism; despite the government's sophisticated online surveillance, it is impossible to completely stop the spread of information among China's more than 400 million "netizens." China's export-driven economy depends on technological communication, and the government's legitimacy depends on the economy: if officials were to block internet access altogether, it would be like picking up a boulder and dropping it on their own feet. In spite of the substantial economic growth—and often because of the inequalities created by it—visible discontent is increasing. As the Chinese become wealthier, they also become more assertive and resourceful in making themselves heard. This inevitably clashes with the system of monopolized power and one-party rule.

XIAORONG LI (b. 1958) is a human rights activist and a noted human rights researcher. In addition to her work on reproductive rights and gender issues in developing nations, she works with a group that collects and disseminates the most reliable and comprehensive information on human rights development in China. She has been barred from returning to China because of her support of Chinese pro-democracy protesters and her peaceful advocacy of human rights. When she attempted to enter China on a valid visa in 1998, she was detained and deported.

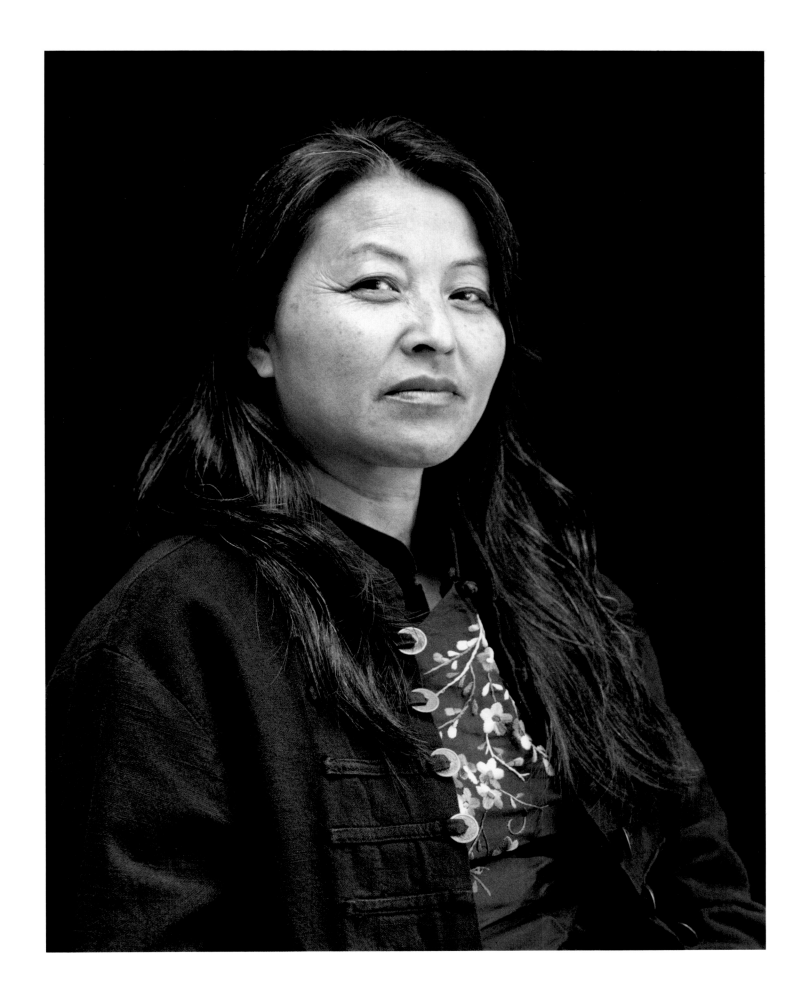

MICHAEL KIRBY

AUSTRALIA — JUDGE

MATHEMATICIANS AND SCIENTISTS search for objective truth. The world I live in, and lived in as a judge, is a world which is much more problematic, uncertain, opinionated, and affected by values. It demands introspection and awareness of the values you give effect to, consciously or unconsciously. Searching for justice is an uncertain journey in this world, but it is a journey we all have to make. Justice is a matter of trying to find what is fair for an individual but also for the society in which they live. Reconciling those elements is often a challenge.

I grew up in Sydney, Australia, with young and loving parents. I discovered, round about puberty, that I was homosexual. That was not a good discovery at that time. In fact, it was a very bad discovery, about which I was supposed to be very ashamed. However, I could never really feel completely ashamed because that was just who I was. And I soon discovered that Alfred Kinsey, a scientist in the United States, had produced a report on human sexuality in the male in 1948, and in the female in 1953. His reports gave me insight into the scientific truth about the variety of human sexuality. I was not alone. Being gay was like left-handedness. No big deal. Certainly not the big deal that society and the world was making it, and certainly not the big deal that churches and others were making it. Scientific objectivity encourages social understandings of justice to evolve.

The law commonly involves a person standing up in a court and speaking for another person. You are often acting. You're pretending. You advocate and express the point of view of others. Perhaps that is why the law, like the stage, attracts so many gay people. In my personal life, I gave up pretending. I never had a "walker"—somebody I pretended was my girlfriend. I thought that was terribly demeaning to women. When I was appointed to the highest court in Australia, the prime minister said to one of his advisers, whom he knew to be gay, "Well, Bill, there's one for you." And Bill said to him, "Prime Minister, have I got news for you!"

Being aware of discrimination against gay people from my very earliest days taught me about injustice. It also taught me that the law is not always just. Judges can't ignore the law. They must give effect to it. But they can make an effort to be sensitive to the way law and society look from the point of view of the people who are on the receiving end of injustice. That approach has made me more conscious of injustice to women,

ethnic minorities, people of color, minority religions, refugees, prisoners, and people with disabilities of various kinds.

I was a barrister and then a judge in Australia at 35, quite an early age. Several opportunities opened my eyes to the international aspects of justice. In 1988, Anthony Lester, now Lord Lester, organized a big meeting in India, together with the great Indian judge P.N. Bhagwati. They taught that, in today's world, the domestic judge can reach for international principles in giving effect to the values that shape the decisions of their courts. This is part of the growing influence of international human rights law on the entire world of law. This borrowing is not terribly controversial in most countries of the world. However, it is still controversial in Australia, and it is very controversial in the United States. Ours are countries that are a bit isolationist, self-satisfied, and resistant to international influences. Still the tide of international law comes, ever comes.

As life has panned out, I have had more than my share of good fortune. I have enjoyed a wonderful relationship with my family and with my partner, Johan van Vloten, for 43 years. Our partnership has given me great stability and strength. And courage. If I have done anything unusual in my life, it is to have been honest about my sexuality in the highest court of my country. There have always been gay judges and lesbian judges, but generally they've been very quiet about it. I have no interest now in being quiet. I speak out because truth, and knowing the variety of humankind, is part of the transparency of a good judge. It helps teach society to get over its demons and to face the scientific reality of our world. And that is the best foundation of justice for all. The good thing about the search for justice is that it never stands still. It is constantly evolving. Every judge must contribute to the evolution.

MICHAEL KIRBY (b. 1939) is an adventurous reformer who has always defied others' expectations and followed his own moral compass. In 1975, he was the youngest man appointed to the federal judiciary in Australia and went on to become a Justice of the High Court of Australia from 1996–2003. A leader in law reform and human rights, he was the first Australian to serve as a Special Representative of the UN Secretary-General for Human Rights. In 1991, he received Australia's highest civil honor as well as the Human Rights Medal. While serving on the Gleeson High Court, he was often at odds with his colleagues and staunchly asserted that a judge's role includes making the law rather than merely applying it.

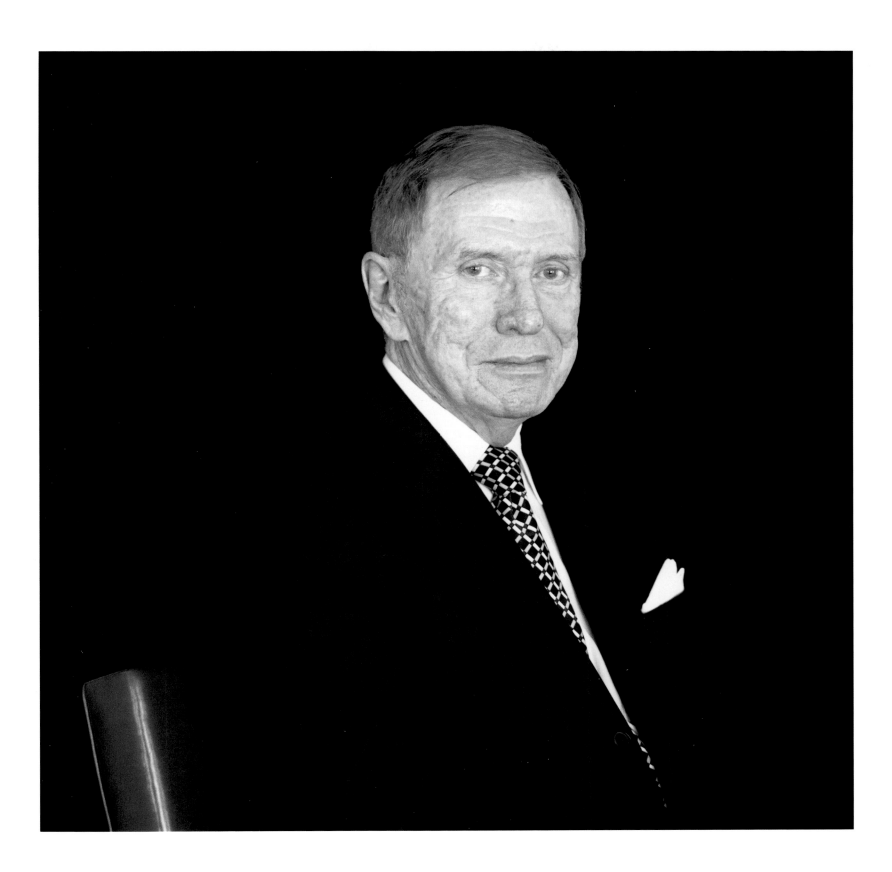

ROBERT L. CARTER

UNITED STATES — JUDGE

THROUGHOUT MY LIFE, I have worked to eradicate racial discrimination in the United States; this effort continues to affect how I think, what I do, and who I am.

I was born in Careyville, Florida in 1917, the youngest of a large, close-knit family. Shortly after my birth, we moved to Newark, New Jersey, part of the Great Migration of blacks to the industrial North. My father, a factory worker, died when I was a year old and my mother went to work as a domestic. We lived in a largely black world, with the exception of school. My experiences in high school toughened me for later battles against racism. During that time, the New Jersey Supreme Court outlawed segregation in public school facilities. Despite the fact that I could not swim, I integrated the swimming pool at East Orange High School.

My desire for education inspired me from an early age. I attended Lincoln University, one of the oldest predominantly black institutions of higher learning in the United States. I earned a scholarship to Howard University Law School, where I benefited from the pioneering work of Charles Houston, who had transformed the law school into the premier institution specializing in civil rights law. After receiving my law degree, I pursued graduate work at Columbia University. I studied the First Amendment and considered becoming a scholar. Shortly after completing a master of law in the spring of 1941, I was drafted into the armed services.

Service in the Jim Crow army marked my first confrontation with raw racism. I realized I was just as vulnerable to destruction through racial discrimination as the poorest and most unlettered black person. The experience instilled in me a fierce determination to fight against racism with all of my intellectual and physical strength.

In the fall of 1944, I joined the legal staff of the NAACP. We were a small operation trying to use the law to revolutionize race relations by seeking to have the Thirteenth, Fourteenth and Fifteenth amendments given their desired effects. As Thurgood Marshall's chief assistant, I conceptualized legal strategies and supervised the preparation and filing of briefs. I also tried cases in every state of the former Confederacy, where the courtroom served as a form of public theatre. Black people crowded in to watch black lawyers challenge the legal foundations of segregation.

By 1950, the groundwork was in place for a direct attack on segregation. An all-out challenge to the "separate but equal" doctrine in schools, however, required a novel legal approach. I turned to contemporary social science and discovered psychological and sociological studies that demonstrated the deleterious effects of segregation on children, leading me to the work of Kenneth and Mamie Clark. We introduced evidence of the psychological harm inflicted by segregation, and it became the pivot on which a unanimous Supreme Court ruled on May 17, 1954 in *Brown v. Board* that "separate educational facilities are inherently unequal."

Brown initiated a decade of heightening black protest and massive white resistance, which aimed to crush civil rights protest and drive the NAACP from the South. In countering these attacks, I drew on the First Amendment work I had done at Columbia and won two major Supreme Court rulings that secured First Amendment protection for civil rights organizations.

In the early 1960s, after I had become general counsel of the NAACP, we broadened our focus. Our small staff of lawyers mounted a campaign in communities across the nation to eliminate "de facto" school segregation by expanding the application of *Brown*. While we won several victories in lower courts, the U.S. Supreme Court held to a narrow interpretation of *Brown*, limiting our ability to reverse the pattern of school segregation in the North.

In 1972, I was appointed to the federal district court in Manhattan and served as a judge for more than 35 years. While the nature of my relationship to the legal system changed, I continued to write and speak out against discrimination on and off the bench.

I am proudest of my role as a chief legal strategist in *Brown v. Board of Education*. What I hoped to achieve was equal educational opportunity for all African-American children. While that has not yet been realized, this ruling remains the key to achieving racial equality and justice in the United States. In guaranteeing equality to all persons in our society as a fundamental tenet of basic law, *Brown* stands at the highest pinnacle of American judicial expression, because it espouses the loftiest values.

ROBERT L. CARTER (1917-2012) had studied to be a First Amendment legal scholar, but after service in the segregated armed forces during World War II he devoted himself to the fight against racial discrimination. He joined the NAACP Legal Defense Fund in 1945 and was a lead strategist in the campaign that culminated with the *Brown v. Board of Education* decision in 1954. As NAACP General Counsel, he orchestrated a broad challenge to the entire apparatus of racism in the United States. Carter won 21 of the 22 cases he argued before the U.S. Supreme Court, securing First Amendment protection for civil rights organizations, expanding federal protection of voting rights, and strengthening equal access to housing and employment. Carter served as a Federal District Judge in the Southern District of New York. He is the author of *A Matter of Law: A Memoir of Struggle in the Cause of Equal Rights.*

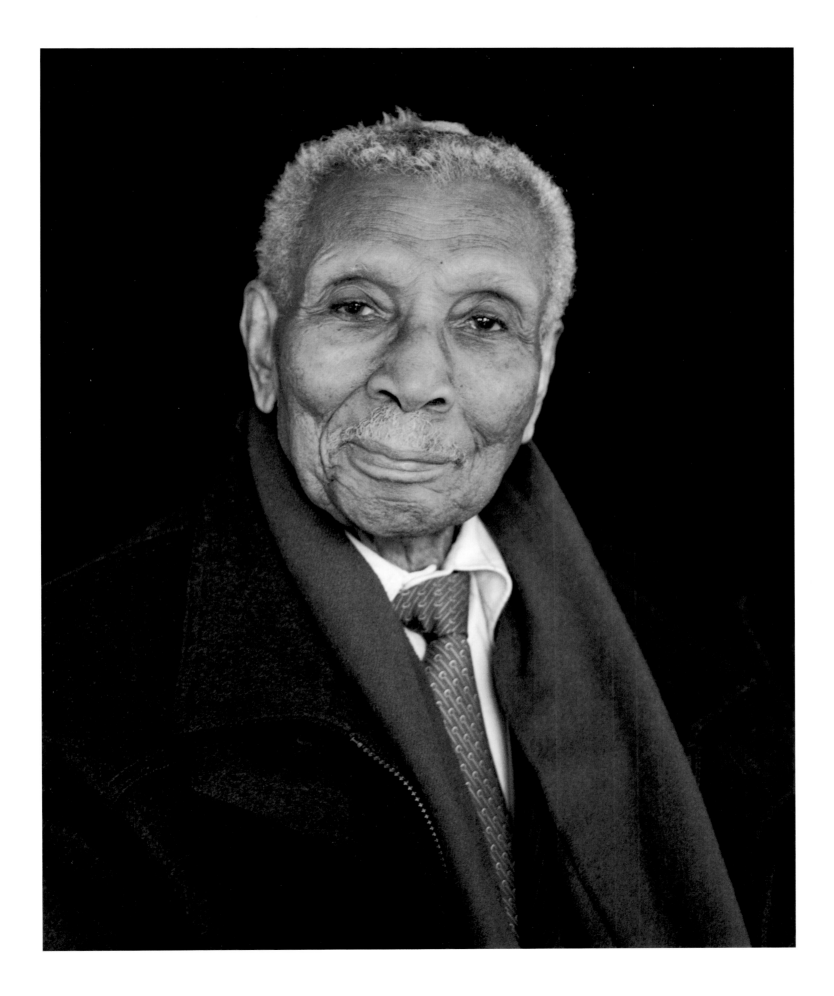

SHIRIN EBADI

IRAN — LAWYER

I WAS BORN INTO A CULTIVATED and modern Muslim family. My father was a professor of law, and we talked about justice and the law at home. I believe in justice and equality—I learned it from my parents.

After graduating from law school, I became a judge because I thought I could serve justice better. I was a presiding judge in 1979 when the revolution toppled the Shah. The motto of the revolution was Freedom and Independence. At the beginning, I supported it, but we soon discovered the new government was not keeping its promises. Many people were executed, and the executions were based on 10-minute trials. The wearing of veils and head scarves had been optional under the monarchy. After the revolution, it became mandatory. The new regime did not permit women to be judges; my colleagues and I were demoted to administrative positions. Unable to accept this, I asked for early retirement and applied for a license to work as an attorney. Unfortunately, the Bar Association had become an agency of the judiciary; it took eight years for my permit to practice law to be issued. During that time, I wrote books in lay language so that the people in Iran would understand what was happening to the legal system in our country and how our current laws contradicted human rights' standards.

I began my practice but discovered that the judiciary had lost its independence entirely. I decided to defend victims of human rights' violations, specifically political prisoners. Usually, they didn't have the money to retain a good attorney, and attorneys themselves feared they might become targets of the government. I worked pro bono for whoever wished to retain me, but I couldn't take effective legal action on their behalf: the Ministry of Intelligence makes a decision, and the courts enforce that decision. Instead, I began my defense in the society. Through numerous interviews, inside and outside of Iran, I talked about my clients and brought their situation to the attention of the world.

The government learned of my interviews, and I was called to the Ministry of Intelligence. They said, "We have provided you with a license to practice law. That means in court. Why do you make so much trouble?" I replied that I was raising people's consciousness. I was kept in solitary confinement for 25 days, sentenced to a year and a half in prison, and barred from practicing law for five years. I appealed, and because of the international attention around me, the court reduced my sentence to a fine.

In Tehran there were other attorneys who were doing the same kind of work. I brought everyone together and we formed the Center for the Defense of Human Rights, to represent political prisoners and help their families. Approximately a year and a half later, I won the Nobel Peace Prize. Using the funds from the prize, I purchased an apartment for the center's headquarters. The organization became a place of hope for many Iranians. Unfortunately, in December 2008, the government raided us and closed us down without any legal justification, seizing the apartment and its contents.

The day before the 2009 presidential elections, I left Iran to participate in a three-day conference in Spain. Three days later, Iran had totally changed. A few of my colleagues had been imprisoned, and others were in hiding. All the foreign journalists had been expelled, and over a thousand people had been apprehended. A number of people had been killed on the streets. I was advised not to return. My colleagues asked me to go to the high commissioner for human rights in Geneva. They asked me to go to the United Nations in New York. I met with Ban Ki-Moon at the United Nations, the high commissioner for human rights, the European Parliament, the European Union, and numerous journalists. I told everyone I could what had happened in Iran.

To this day, I am told I can be more useful outside Iran. My husband, sister, and brother, none of whom engage in any political activities, were apprehended and interrogated by the police. My sister, a dentist, was kept for three weeks and developed heart disease from the stress. They let her go because they didn't want the bad publicity if she were to die in prison. Both she and my husband have been barred from leaving the country. The revolutionary courts have frozen all our bank accounts and confiscated our property. The government even insists that I pay taxes for the Nobel Prize, although, pursuant to Iranian tax laws, prizes are exempt from tax. Every day, interest accumulates on the amount that I owe. The amount due now is $1,300,000.

When governments feel weak, they resort to violence. A government elected by the people does not have to resort to violence.

SHIRIN EBADI (b. 1947) is an Iranian lawyer and Founder of the Defenders of Human Rights Center in Iran. In 1975 she became the first woman to serve as judge of an Iranian legislative court, but in 1979 the Islamic Revolution banned women from serving as judges, and she was demoted to a secretarial position in the same office where she once presided. She retired early, wrote a series of books and articles, and finally regained her right to practice law in 1993. Ebadi boldly speaks out against the oppressive regime despite death threats. She received the Nobel Peace Prize in 2003 for her advocacy of human rights and democracy.

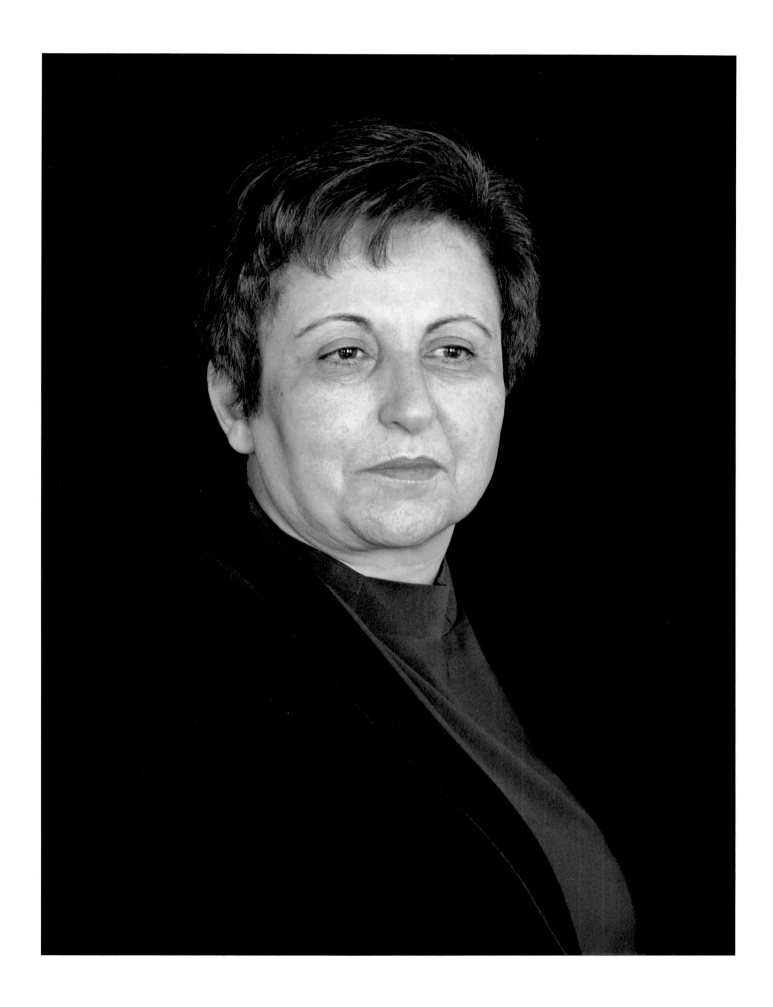

STEPHEN BRIGHT

UNITED STATES — LAWYER

I HAVE HAD THE GREAT PRIVILEGE of representing the accused, the condemned, and the imprisoned in the pursuit of life, liberty, and dignity. My clients have been the poorest, the most powerless, and often the most despised people in our society. That put them at a tremendous disadvantage in our costly, complex legal system.

Most were denied their most fundamental right—the right to a competent, caring lawyer—because of their poverty. The legal representation provided many poor people accused of crimes is a national disgrace. People have been sentenced to death in cases in which their lawyers were asleep, intoxicated, or under the influence of drugs. We have challenged poor representation in cases, written about it, worked to create public defender offices in places that do not have them, and taught in programs that help public defenders learn to be better advocates for their clients.

Many clients were further disadvantaged by their race. Law enforcement officials, prosecutors, judges, and jurors all exercise discretion at points in the process, and often race is a factor in making those decisions—in a police officer's decision to detain a person, a prosecutor's decision to seek the death penalty, a jury's decision to impose it. The exclusion of people of color from positions of authority—as judges, prosecutors, and jurors—contributes to the discrimination.

The United States has 2.3 million men, women, and children in prisons and jails—the highest incarceration rate of any country in the world. We bring lawsuits to deal with the worst abuses in jails and prisons, such as failure to protect inmates from rapes and deadly assaults, denial of medical care to people who are HIV-positive, and horrific conditions. A federal judge commented that one jail we sued was more like a slave ship than anything out of modern times.

I have been fortunate to be a member of teams with exceptionally gifted and dedicated people working on these cases and causes. Many have been my colleagues at the Southern Center for Human Rights—our lawyers, investigators, and administrative personnel. Others have been students—students who interned with the Southern Center or students from classes I have taught at Yale, Harvard, and other law schools. They have made immense contributions, and many of them are now doing this work in their own careers. I am very proud of them.

I had the great fortune to grow up during the civil rights movement. I took away two essential lessons from Dr. Martin Luther King Jr.—that nothing is more important than ending racism and poverty and nothing is less important than one's income. Dr. King called on us to be "drum majors for justice." A life in the law provides this opportunity.

I also learned a great deal from my parents. In the community in Kentucky where I grew up, everything was segregated. That changed, but only after great controversy and struggle. My parents, Robert and Patricia Bright, had four children by the time they were 30. My father worked from sunup to sundown on the family farm, as had his father and his grandfather. My mother managed our home. The further away I am from that time, the more remarkable it seems that my parents, when they were so young and so busy, were involved in efforts to end segregation and achieve racial equality in our community. The vast majority of white people in the community resisted racial integration—some of them bitterly. Many others simply avoided the controversy. It was someone else's fight. They did not want to alienate anyone.

But my parents strongly believed that people should not be treated differently because of the color of their skin. It is such a simple, inescapable truth, but it escaped so many people then, and it continues to escape so many people today. I learned from them not to remain silent just to get along but to stand up for what I believe. I also learned that to accomplish anything we must do more than just talk about what is wrong; we must do something to change it.

STEPHEN B. BRIGHT (b. 1948) is a well-known opponent of the death penalty, advocate for prisoners and poor people accused of crimes, and President of the Southern Center for Human Rights—a nonprofit law firm focused on protecting the civil and human rights of people in the American South's courts, jails, and prisons. The center, through litigation, reports, and advocacy, contributed to the creation of a public defender system for Georgia. He has written extensively on racial discrimination, the right to counsel, judicial independence, and the failings of the criminal justice system. He firmly believes that "the death penalty is imposed not on those who have committed the worst crimes, but rather on those who have been unfortunate enough to have the worst lawyers."

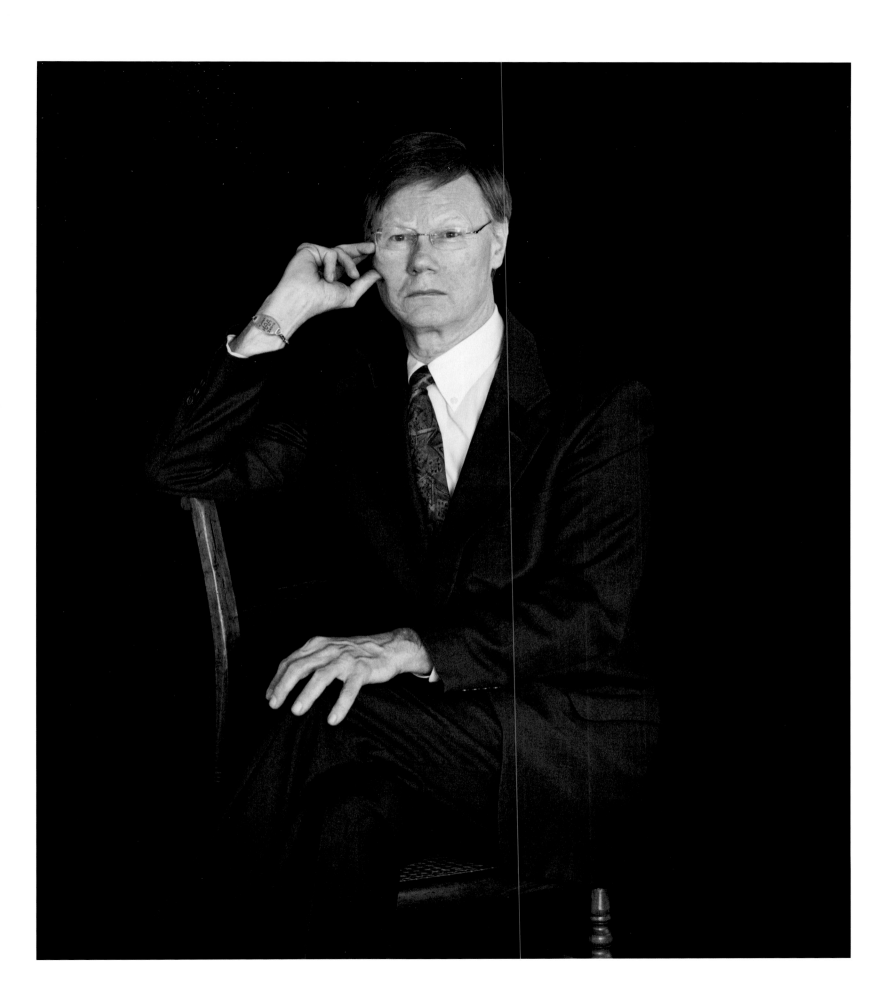

JOHANN KRIEGLER

SOUTH AFRICA — JUDGE

I AM CULTURALLY AN AFRIKANER—proudly so—but there is much in the politics and practices of my people that I have rejected all my thinking life. Although I grew up under a Nationalist government that had enshrined apartheid as state doctrine, I was raised in a faith that respected the equality of all human beings. Likewise, although the British had subjugated our people by barbarous means, my family never followed the road of bitterness and Afrikaner ascendancy. We sought, instead, reconciliation and dialogue.

As an undergraduate in politics at a doctrinaire Afrikaner university, I easily slotted in with the dissident minority that opposed apartheid on both moral and pragmatic grounds. The 1950s was a time of all-pervading Nationalist hegemony, and the climate in Pretoria, where I'd grown up, was particularly oppressive. Upon my graduation in 1959, I set up practice as an advocate in the relatively liberal Johannesburg, where I became active in Bar politics and human rights work.

Though I opposed the government and its repressive regime, I never supported the African National Congress (ANC). While endorsing the demand for all South Africans to participate in governing the land of their birth and understanding the ANC's need to accept Soviet backing, I was implacably opposed to Communism and could see no benefit in exchanging one totalitarian regime for another. Besides, I was a human rights lawyer, not a revolutionary.

Over the years, I participated in initiatives aimed at derailing, or at least slowing, the ostensibly invincible Nationalist juggernaut. I was the founding chair of Lawyers for Human Rights, to this day a moral rallying point for the legal profession, and I joined with Arthur Chaskalson, Felicia and Sydney Kentridge, and others in founding the Legal Resources Centre (LRC), the first public-interest law firm in the country. By strategic litigation, the LRC caused the first statutory cracks in the granite façade of apartheid.

In 1983, I serendipitously made representations to the minister of justice on behalf of a political prisoner. The minister, a pragmatic Nationalist who subsequently became a leading figure in the transition negotiations, not only procured the release of my client but also persuaded me to accept an appointment as a judge—notwithstanding both his government's and my own misgivings. Thus, some time later, I could risk arranging for him to meet George Bizos privately to explore possible confidential talks between the government and George's client Nelson Mandela. What effect these exploratory meetings had I cannot say, but perhaps we made some contribution when things were deadlocked.

How the deadlock was resolved is a story for another day. Suffice it to say that Ronald Reagan not only bankrupted the Soviet Empire but also appointed a conservative ambassador to Pretoria in the person of Herman Nickel who helped convince the government that apartheid was no longer supportable. So it came to pass that—once again serendipitously—the ANC lost its Soviet backing at the same time that the major foreign backers of the apartheid regime lost their pretext for propping up an anti-Communist bastion in Southern Africa. With the Soviet Union in rapid decline, it could no longer be necessary for the West to support the South African regime as a counter to Cuba's hold on nearby Angola. A negotiated settlement was on the cards.

An essential step in the transition from apartheid to democracy was universal-franchise elections. These were to be administered by an ad hoc electoral body drawn from across the political spectrum. Presumably because I was equally acceptable—or unacceptable—all around, I was appointed to chair this ragtag team of amateurs. More by good luck than good management, we pulled off successful elections and a breathless world could witness the peaceful inauguration of President Mandela in 1994.

Those elections were the start of a new career for me. While serving as a justice of my country's first Constitutional Court, I headed the creation of a permanent electoral management body. This, in turn, led to my involvement in various electoral missions across the developing world. I've been privileged to witness the tentative emergence of several societies from oppression, from East Timor to West Africa. Representative democracy is admittedly an unsatisfactory form of government, but thus far it's the best that human ingenuity has devised. In an emergent democracy, every election that is perceived to be a genuine test of the will of the people boosts popular confidence and builds administrative know-how for the next election.

I can do nothing about a country's security situation, its socioeconomic status, or the ethos of its government. But I *can* do something about electoral competence and integrity, so I work at that. Seeing the humble and the meek express their essential dignity through the ballot makes the effort worthwhile.

JOHANN KRIEGLER (b. 1932) has dedicated his life to the promotion of democracy. His career as a trial lawyer, human rights advocate, and judge culminated in his appointment as a founding justice of South Africa's post-apartheid Constitutional Court. Since leading his country's watershed elections of liberation in 1994—and especially since retiring from the court—his professional interests have expanded to advising on problematic elections around the globe. He fills the gaps between elections with arbitrations, advocacy training, and charitable human rights and rule of law work.

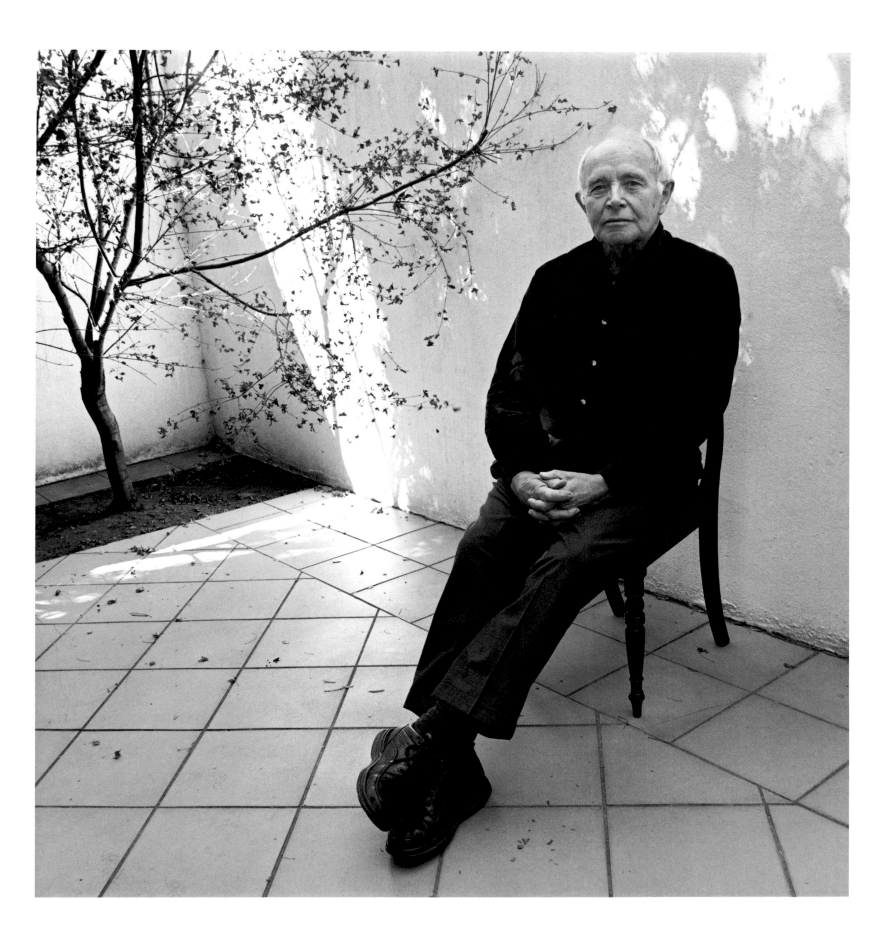

JIMMY CARTER

UNITED STATES — ACTIVIST

I GREW UP IN AN ISOLATED COMMUNITY IN GEORGIA. All my neighbors were African American at a time when racial discrimination was legalized in the United States in the "separate but equal" ruling by the Supreme Court—a ruling that was supported by the churches, the American Bar Association, and all the state governments. No one thought of challenging racial segregation. My mother was a registered nurse and was impervious to pressures from her peer group to treat African Americans as inferior. She treated them as equals, and I learned that possibility from her. Later, as I became older, I saw that the racial discrimination legalized in our country was a devastating handicap for both black and white people.

In my 1971 inaugural address as governor of Georgia, I said quite frankly that the time for racial discrimination was over. Never again would a black child be deprived of an equal right to education or any similarly basic need. It was a very brief speech, but it was so momentous that two weeks later I was on the front cover of *Time* magazine.

As President, I said that America did not invent human rights: human rights invented America. I also announced that human rights would be the foundation of U.S. foreign policy, and my administration set an example that was later adopted and pursued. Ronald Reagan, who succeeded me, said that this stance was a sign of weakness, and he sent his UN ambassador to Chile and Argentina to tell them that Carter's human rights policy had ended. In the succeeding months, however, Reagan abandoned his initial position and our country was enticed to resume its role as human rights champion.

The Carter Center was established a year after I left office because governments and private organizations weren't doing enough to protect their citizens and further their causes. We advocated two changes in the United Nations, beginning in 1993. One was to create a High Commission on Human Rights, a proposal that the incumbent secretary-general opposed very strongly. The second was the establishment of the International Criminal Court (ICC), which is primarily a deterrent to dictators who may be tempted to abuse their own people in a gross fashion. Both proposals have been adopted.

The use of the rule of law in human rights is imperative, but it has its limitations. Last year I went to The Hague and met with the judges on the ICC. They described the overwhelming burden of new cases that were being presented to them; the court serves more as a deterrent than a sure punishment for someone who has already committed a crime. At the same time, many leaders in the world are reluctant to step down from office because they are afraid they might be arrested by the ICC and punished. Impunity is therefore an argument that has arisen in the last 25 years among key human rights activists around the globe. I think impunity can be acceptable for the sake of protecting people, but other human rights activists, in their more pure way, feel differently.

I keep a copy of the Universal Declaration of Human Rights on my desk. The U.S. government's current policies are violating eight of the thirty human rights commitments that were made in 1948. The turning point was 9/11, when Bush began to circumvent basic human rights principles. President Obama has expanded George W. Bush's agenda by proceeding with policies that violate the fundamental human rights commitments we had previously made. In the past, many countries were deterred from committing violations out of fear that the U.S. would condemn them in international public forums. Tragically, these countries now view the United States' lapse in human rights enforcement as permission to commit atrocities that they would otherwise have been too afraid to carry out.

We must realize that we are blessed people in America, and with privilege comes a responsibility to ensure that the same benefits are offered to others around the world. We must remember that we are all created equal. The poor people whom we tend to denigrate as inferior because they don't have a proper home, adequate health care, decent education, or money in the bank, are no less intelligent, hardworking, and ambitious than we are. Their family values are just as good as mine.

While some of us look on human rights as a theoretical and impractical form of idealism, we soon find, almost inevitably, that it is the most practical foundation for improving human life.

PRESIDENT JIMMY CARTER (b. 1924) was the 39th President of the United States, serving from 1977 to 1981. Following his presidency, he established the nonpartisan and nonprofit Carter Center to promote democracy, protect human rights, prevent disease, and resolve conflict. The center's health programs have led the international effort to eradicate Guinea worm disease, which is poised to be the second human disease in history to be completely eliminated. He and his wife, Rosalynn, volunteer for Habitat for Humanity, a nonprofit organization that helps needy people in the U.S. and in other countries renovate and build homes for themselves. He received the Nobel Peace Prize in 2002 for his decades of work on human rights, conflict mediation, and the promotion of economic and social development.

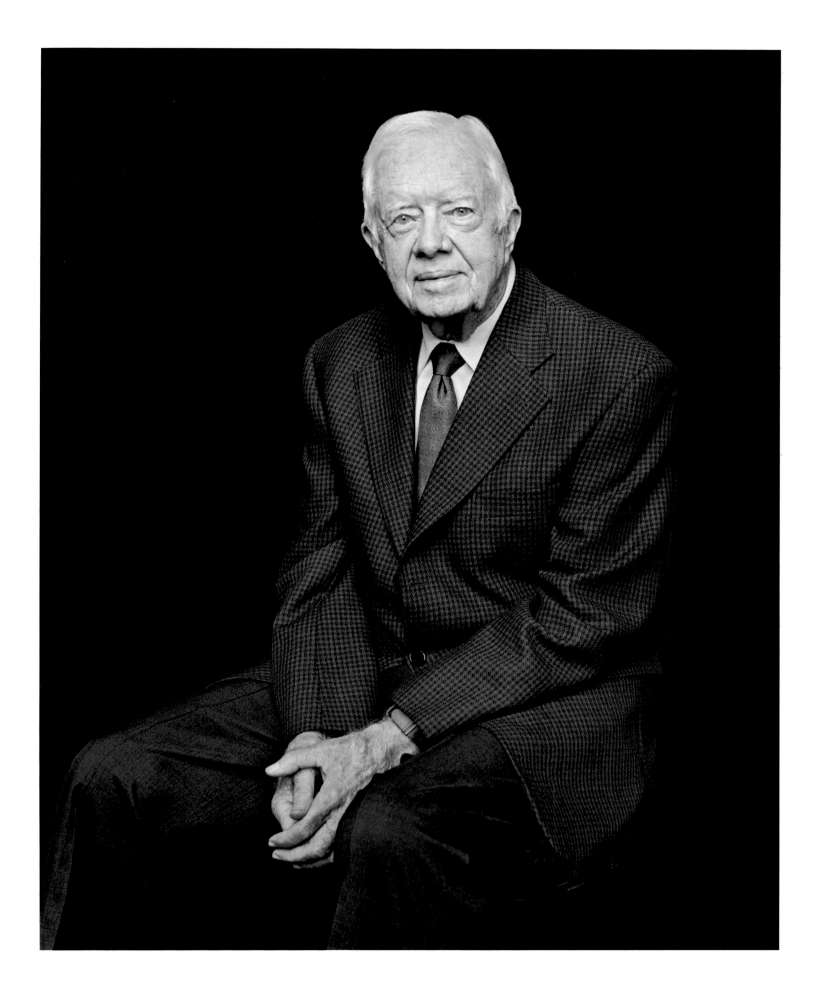

THERESIA DEGENER

GERMANY — LAWYER

I DECIDED TO STUDY LAW because of my belief in law as a tool for changing and shaping society and as a great resource for values and principles. My interest in law and politics was already evident when, as a high school student, I was involved in school politics as well as the women's and disability movements. I was born without arms.

Initially, for me, politics was more important than law. During my first year of studying law I helped organize the "Cripple Tribunal 1981," which was a protest campaign of radical disability advocates who accused the German government and welfare organizations of human rights violations against disabled persons. It was the United Nations International Year of Disabled Persons, but at that time I did not believe in the United Nations and its human rights mechanism. My attitude changed when I studied at UC Berkeley from 1987 to 1988 as a postgraduate law student. Frank Newman, an inspiring teacher and scholar of international human rights law, brought me to Geneva to attend a subcommission of the Commission on Human Rights and introduced me to the international network of human rights defenders.

Human rights law is an answer to experienced injustice. I could see that when I attended classes in U.S. Constitutional Law or sex-based-discrimination law or disability rights law at UC Berkeley. The cases were full of wonderful stories about people with different layers of identity—be they color, ethnicity, gender, sexual identity, or disability—fighting for equal rights.

My personal experience as a disabled person also taught me how important it is to fight injustice and protect human dignity. My early experiences ranged from institutionalization for the purpose of forced treatment with arm prostheses to my parents' fight to get me into mainstream education.

Disability human rights law became my field of research in the 1990s. One major outcome was a study Gerard Quinn and I wrote with others for the UN Office of High Commissioner of Human Rights, showing how disability was a neglected topic in UN human rights law. The study served as a background resource for the drafting of the UN Convention on the Rights of Persons with Disabilities (CRPD), which was adopted in 2006. I had the opportunity to actively participate in the drafting and negotiation of this modern human rights treaty, which was one of the most formative experiences in my life as a human rights scholar.

Hundreds of experts in disability rights and international human rights law were involved in this process—many of them disabled persons from the international disability rights movement. With more than one hundred state parties from all regions of the United Nations participating in the negotiation process, the challenge was to find consensus on issues that at first glance only had to do with disability but in fact had global political implications—for poverty and development, armed conflict, rule of law, the right to freedom, solidarity, and above all discrimination on various grounds.

My motivation to teach, research, and practice human rights law stems from my belief that the international catalogue of human rights offers a wonderful set of values and principles that includes all, transcends the boundaries of religion and culture, and is the only basis for freedom, peace, and equality. Human rights treaties need to be used as tools; otherwise they remain just words on paper. They can change the world or they can merely be given lip service. For my term as member of the United Nations Committee on the Rights of Persons with Disabilities from 2011 to 2014, my vision is to help make the CRPD instrumental in triggering legal and political reform in national, regional, and international disability policy.

THERESIA DEGENER (b. 1961) is a German law professor and a leading expert and advisor on international human rights, disability, discrimination, bioethics, and gender laws. Born disabled, she has forged a remarkable career as a human rights advocate, including serving as Germany's delegate to the United Nations Ad Hoc Committee, which drafted a convention on the rights of persons with disabilities. She has contributed seminal research on the issue of violence against women with disabilities. In 2010 she was elected a member of the UN Committee on the Rights of Persons with Disabilities.

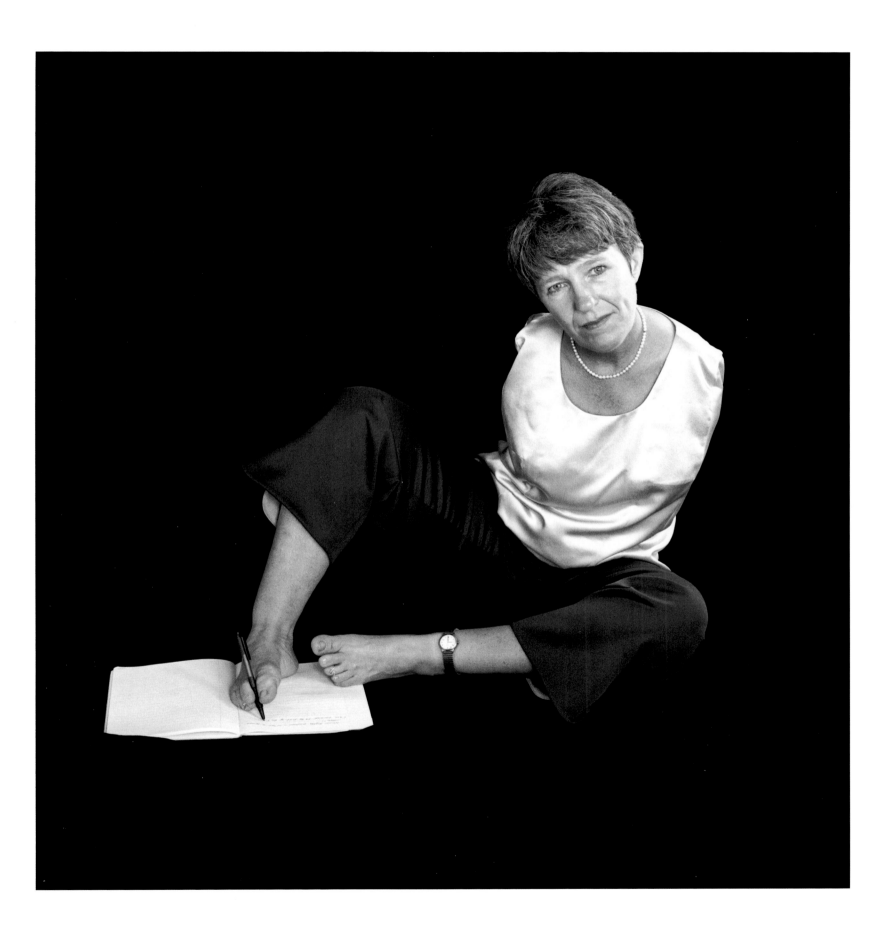

ROGER ERRERA

FRANCE — LAWYER

MASS KILLINGS ARE AS OLD AS HUMANITY. The first genocide of the 20th century, often overlooked, was in 1906 in what is now Namibia, Africa, when the Germans destroyed the Herero. The only person in Europe to denounce that was Rosa Luxembourg. No one cared. The real turning point, if one had to date it, was in 1915, with the genocide of the Armenians by the Turkish government.

I was born in 1933. Becoming an adult in Europe in the second half of the 20th century meant that you were bound to reflect on the meaning of totalitarianism, in its twin Nazi and Communist forms. Nazism lasted 12 years and undertook the genocide of the Jews. The Soviet regime lasted 80 years, three generations. All the elites were killed, "disappeared," exiled.

Totalitarian regimes destroyed not only civil liberties; they destroyed private life. The Soviets invented the denunciation of parents by their children and gloried in it. The Stasi in East Germany used thousands of people to spy on one another— not just informers but family members might betray you. It caused the utter destruction of private life. By contrast, when Dostoyevsky was sent to Siberia, he went there with his servants, who gave him his tea every afternoon. The Nazi death factories and the Soviet camps were not like that.

I was for many years a member of the Conseil d'Etat, France's supreme court for administrative law, where judicial review of administrative action involved the protection of civil liberties. During the 1950s and '60s, there was a war in Algeria which saw atrocities and substantial restrictions of freedoms on both sides, with no adequate judicial response. It led me to reflect on the vulnerability of the liberal legal order. In the 1960s and '70s, I studied closely the nature of Nazi totalitarianism, in particular the genocide of the Jews and how it was achieved. The reading of Hannah Arendt's *The Origins of Totalitarianism* and *Eichmann in Jerusalem* was seminal for me. I wrote about her, published two of her books in France, and, in 1973, interviewed her for French television.

Then, the Communists: I read most of the writings of Russian, Polish, and Czechoslovak dissidents. During the spring of 1968, I visited Poland and Czechoslovakia and witnessed the hopes of the Prague Spring. From 1973 to 1977, my wife and I spent the end of each year in Prague, where we met people who had paid a heavy price to keep their integrity and self-respect in a regime that did everything to destroy both. I remember the day in January 1977 when we met people who were about to launch the Charter 77 movement: Vaclav Havel, Jan Patocka, Jan Vladislav, among others. This led me, with Vladislav, to publish Havel's political essays, weeks before he became President.

During my visits to Central and Eastern Europe I saw vividly how one of the aims of the Communist dictatorships was to falsify the history of the country—to create an amnesia. That is why the dissidents sought to preserve national memory, which is part of national culture and identity.

If we have learned one thing it is that freedom has enemies. It is the duty of democratic regimes to name these enemies and combat them with the law. Their aim is to destroy the very values we cherish. The rise of xenophobia and of outcries against immigrants, Muslims, and foreigners everywhere in Europe is a prime example. One criterion in judging a country is how it treats its minorities.

We see some positive developments today: the rise of constitutionalism in Europe; the creation of international courts and criminal tribunals. In courts, the law responds to realities. That is why people are indicted in the Yugoslav Criminal Tribunal in The Hague for rape, which is now a war crime, a consequence of the mass rapes in Bosnia and elsewhere. The concept was not invented abstractly in the safety of a law school; it was created because they happened, just as the Allies created the concept of genocide as a crime when they set up the tribunal in Nuremburg.

The contemporary fight against terrorism, necessary as it is, has had menacing consequences. We have seen official legal memos and law professors justifying the use of torture, and substantial public opinion condoning it. Detention without trial is becoming common. We live in dark times. Hence the paramount importance of legal oversight to avoid "black holes" in the law, to quote Lord Steyn. The liberal legal order is a fragile one; once again, we are experiencing that truth. In such critical times, the final choice for courts is not between excessive deference to politicians and "judicial activism." It is between abdication and the exercise of the courts' constitutional mission.

ROGER ERRERA (b. 1933) is a French legal scholar and former senior member of the Conseil d'État, France's supreme court for administrative law. He has authored many essays and articles on Nazism, Communism, civil liberties, judicial review, aliens and refugee law, freedom of speech, privacy, religious freedom, judicial independence and accountability, as well as having served on the UN Human Rights Committee. He was a visiting professor at the Central European University, Budapest, and has taught at institutions in both France and the U.K. He is the author of an interview with Hannah Arendt, which can be found on his website: www.rogererrera.fr.

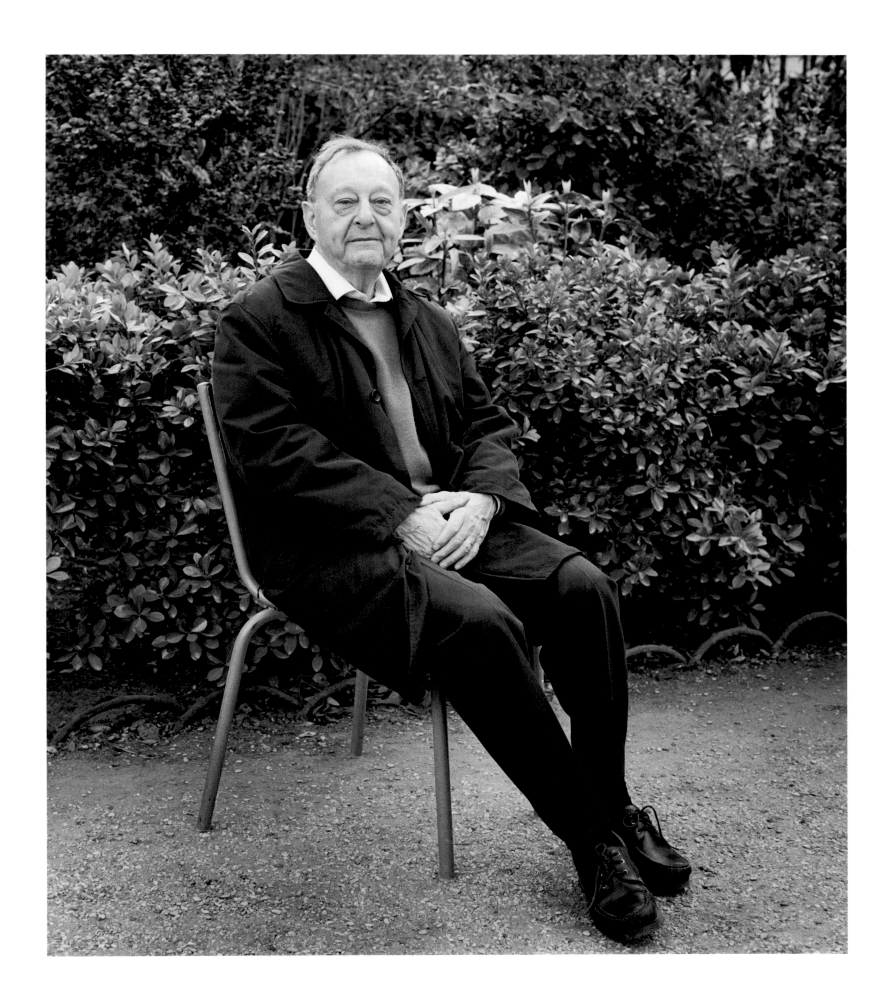

ANTHONY GUBBAY

ZIMBABWE — JUDGE

IT WAS WHILE AT THE UNIVERSITY OF CAMBRIDGE that I became acutely aware of the prevailing injustices committed by some governments upon the majority of their subjects. Since it was my intention, upon graduating, to immigrate to Southern Rhodesia, I joined a body of students from Africa who spoke knowledgeably of the oppressive regimes in their countries. It was impressed upon me that my duty as a lawyer would be to contest the constitutional validity of laws, or administrative acts, which infringed the fundamental rights and freedoms of all persons. Southern Rhodesia afforded scope for such an approach.

Early in 1958, I commenced practice as an advocate. The opportunity to pursue my aim occurred the following year with the declaration of a state of emergency. One hundred members of the African National Congress were arrested and imprisoned without trial. Six advocates were briefed to challenge the detentions before a tribunal headed by a senior judge. It was my function to interview the detainees, and I represented a few of them before the tribunal. Joseph Msika, who decades later became a vice-president of Zimbabwe, was one of those I appeared for. A solitary detainee was released. The others remained incarcerated for long periods.

The banning, in 1960, of the African National Congress led to riots in Bulawayo, and to the arrest of many protestors. I was briefed to defend many of them. Only a few were acquitted.

The formation of the National Democratic Party soon followed. With it came the restriction, to remote areas of the country, of senior party officials influential in the spread of African nationalism. I was instructed to challenge the constitutionality of the government's action. At this time a considerable part of my practice was devoted to defending African nationalists facing a variety of offences under the notorious Law and Order (Maintenance) Act and the Unlawful Organisations Act. And so it continued, until I was appointed a judge of the High Court in May 1977.

After the country attained independence in 1980, I was able, in small measure, through judicial decisions, to protect the constitutional rights of Zimbabweans from abuses inflicted by legislation or administrative action. It was this type of work that I most enjoyed, especially during the 11 years when I presided over the Supreme Court as chief justice. The court enjoyed the confidence and respect of the people, though not of government. Yet its most far-reaching decisions were downgraded by constitutional amendments.

In 2000, law and order in the country became severely compromised, with invasions of white-owned agricultural land by war veterans and land-hungry followers. There was substantial government involvement in carrying out such a process. This countrywide occupation of land prompted an application to the Supreme Court for an order declaring that the presence of uninvited persons on commercial farming property was unlawful. Although granted, the order was totally ignored. The official stance was that land distribution was a political and not legal matter.

The perpetual harassment of judges now commenced. War veterans demanded that judges should resign or face removal by force. On November 24, 2000, close to 200 war veterans and their cohorts invaded the Supreme Court building. They shouted slogans and called for the judges to be killed. There was no official condemnation of this disgraceful incident. It exemplified absolute contempt for judicial process.

The War Veterans Association responded to the land ruling by giving the judges "14 days to resign, or else." At the end of a year that had witnessed one political killing after another, such a threat could not be taken lightly. I wrote to the President seeking protection for the judges. The response was an invitation to attend a meeting with him. The judiciary's predicament evoked no sympathy. It was said to me: "You say you feel threatened by the war veterans, but they are being threatened by your judgments; you are not giving the right direction to your judges." The meeting ended with the accusation that by protecting white farmers, I was aiding and abetting racism.

In June 2001, I left office with much disappointment. Clearly the judiciary was about to suffer radical change. I bear no resentment at having been forced out by threats upon my life or at the unwarranted perception of my being responsible for the breakdown in the relationship between the judiciary and the executive. I shall always regard it a privilege and an honor to have been appointed the country's chief justice, a position I never expected to attain. I have been extremely fortunate in having chosen a profession which has proved both challenging and fulfilling, one that has afforded me, as a long-serving judge, the opportunity to contribute to the development of law in Zimbabwe. For that I remain truly grateful.

ANTHONY ROY GUBBAY (b. 1932) was the Chief Justice of Zimbabwe, presiding over the Supreme Court, before being forced into early retirement after months of intimidation by the Mugabe regime. His career has been characterized by his courageous insistence that it is the judiciary's duty to protect and enforce basic human rights and freedoms for all citizens. He angered the Zimbabwean government by refusing to blindly rule in favor of ministers and challenged the government's use of special decrees to circumvent the Constitution. In 2001, he was awarded the Gruber Justice Prize. He regularly addresses law societies and legal conferences in many countries. In 2012, he immigrated to Canada.

BRENDA HALE

UNITED KINGDOM — JUDGE

IN 1960, AT THE AGE OF 15, I decided to read law at university. Who knows why? No one in my family or in my school, a small girls' grammar school in the north of England, had ever gone into the law. I knew very little of what it meant or the intellectual challenges involved. There were very few women lawyers in the country and no full-time women judges; the first was appointed in 1962. It was not the glamour and excitement of criminal court advocacy in the style of Perry Mason, then regularly appearing on our black-and-white TV screens, that drew me to the law. It was the study of constitutional history, the struggle between the king and Parliament in the 17th century and the development of parliamentary democracy in the 18th, 19th, and 20th centuries; the idea that law was not only a way to exercise power but also a way to limit and control it.

We had nothing resembling human rights law then. Parliament could pass whatever laws it liked and the judges would have to enforce them whether they liked them or not. There was nothing about human rights in either our Constitutional or our International Law courses when I was a student or for some years after I began teaching law at the University of Manchester in 1966. Yet the protection of human rights had been one of the founding principles of the United Nations; the Universal Declaration of Human Rights had been adopted in 1948 and the European Convention on Human Rights in 1950.

Nor was there anything then which resembled an equality law. In theory everyone was equal before the law, but there was nothing to stop employers, businesses, officials, or the law itself from treating people less favorably for no other reason than their race or sex. Women could be required to leave their jobs upon marriage, paid less than men for the same work, refused mortgages, and excluded from buying drinks at the bar, simply because they were women. Women barristers who joined the northern circuit had to be admitted at a business meeting because they were not allowed to attend the Bar mess dinners where the men were sworn in.

The 1960s was a pivotal decade both for human rights and for women's rights. In 1966, the United Kingdom allowed individual victims to petition the European Court of Human Rights in Strasbourg. If the U.K. was found to have violated a person's convention rights, something had to be done about it, not just for that person but to prevent similar violations happening in future. No longer did our liberties entirely depend upon the goodwill of Parliament. U.K. lawyers became remarkably successful in persuading Strasbourg that U.K. laws were not as human rights compliant as had been thought. Eventually the Human Rights Act 1998 gave U.K. courts the power to rule upon whether public authorities, including Parliament, had adhered to convention rights (although it stopped short of allowing them to strike down incompatible Acts of Parliament).

In 1968, women machinists at Ford's factory in Dagenham, east of London, went on strike because they were classed as unskilled workers, whereas men doing the same work were classed as skilled and paid much more. The Equal Pay Act 1970 was a result, and there have been many more laws against discrimination, on many more grounds, since then. These laws are not based on the theory that there are no differences between women and men; rather, that those differences are almost always irrelevant to the question in hand: whether this particular woman should be treated less favorably than a man would be treated in the same or similar circumstances.

Human rights and equality laws have transformed our constitutional democracy. We have always prided ourselves that "It's a free country, isn't it?" We have always been free to do anything that is not prohibited. But we had no protection against prohibitions imposed by Parliament, no matter how much these intruded upon our fundamental rights. And we had no protection against laws or practices which refused to recognize the equal value of each individual human being whatever their race or sex. Now at least we have the tools to examine the issues.

I am astonished to be a member of the highest court in the United Kingdom because, for many years, it never crossed my mind that this might be a possibility. I also feel immensely privileged to be a member of that court at a time when there is so much more that the courts can do to protect and enhance the equal value of everyone within our jurisdiction.

But we are all the servants of the law, sworn to "do right to all manner of persons after the laws and usages of this realm, without fear or favour, affection or ill-will." These words of the judicial oath are engraved on the glass screen which greets visitors and users of the Supreme Court of the United Kingdom as they come through our doors: an ever-present reminder of what the rule of law is all about.

LADY BRENDA HALE (b. 1945) is the United Kingdom's most senior female judge and the first woman to be appointed a Law Lord. She became a U.K. Supreme Court Justice when it was created in October 2009. Educated at Cambridge University, she has had a varied career, first as a university law teacher, then as Law Commissioner, where she helped pass vital reforms in family law as the first woman and the youngest person ever appointed to the Law Commission.

ARTHUR CHASKALSON

SOUTH AFRICA — JUDGE

I WAS BORN IN 1931 IN SOUTH AFRICA, where I grew up in a white middle class Jewish family. Disenfranchised, the black population was marginalized and oppressed. By accident of birth I was privileged and entitled to all the benefits that whites enjoyed in South Africa at that time—a good home, a good education, and opportunities to prosper in my chosen profession, the law. Had I been born in Germany, my privileged childhood would have been very different. I would have been a victim of the Nazi laws, forced into a ghetto or a children's concentration camp, and denied the opportunity to practice law or engage in any other fulfilling occupation. As I grew older, I gradually came to understand the full implications of this—and also to understand how different my life would have been in South Africa if my parents had been black and not white.

I matriculated in 1948, the year in which the Afrikaner-based National Party came to power and introduced its policy of apartheid. Apartheid became a powerful ideology, based on the false assumption that blacks formed an inferior race. It was institutionalized in the legal system and affected all aspects of life in South Africa, entrenching the privileged position of whites and further marginalizing and disempowering the black population. It was enforced by the application of harsh and unjust laws, including draconian security laws, which were condemned internationally as gross violations of basic human rights.

This was the environment in which I practiced at the Johannesburg Bar, which I joined in 1956. Witnessing the oppression and injustice of apartheid, it was not possible to be neutral; one had either to support or tacitly accept its policies or distance oneself from them. I had no doubt as to what my choice should be; it had to be against oppression. That is what initially drew me into defending political activists and other victims of apartheid.

I had the great privilege of being part of the defense team in the historic Rivonia Trial at which Mr. Mandela and other leaders of the African National Congress were charged with offences for which the death sentence would have been a competent verdict. The accused acknowledged that they had broken apartheid law; theirs was a classical political defense, in which they sought to justify their actions. That was their attitude from the beginning. When called upon to plead, Mr. Mandela said, "The government should be on trial, not me," and his colleagues followed suit. They put apartheid on trial, drawing on the Universal Declaration of Human Rights, its demand of respect for the dignity of all people, and its message that "if man is not to be compelled to have recourse, as a last resort, to rebellion against tyranny and oppression . . . human rights should be protected by the rule of law." They challenged the oppression and injustice of apartheid—its denial of fundamental human rights to the majority of South Africans—and contended that they had been left with no option other than to resist in the way that they had. In the court of world opinion, their defense succeeded and had a significant impact in shaping attitudes to the policies of the South African government. In the South African court, however, they were convicted—but they were not sentenced to death: the sentence was life imprisonment.

I continued to defend political activists when asked to do so, and in 1979, I was one of the founders and the first director of the Legal Resources Centre, a nonprofit organization that offered legal services to victims of apartheid. We challenged apartheid practices and illegal actions of the security forces through the courts. I was exposed in my day-to-day work to the stark realities of the impact that apartheid had on black people.

I remained at the Legal Resources Centre until the new Constitution came into force. I took part in the negotiation of the Constitution, which made provision for an open and democratic society entrenching all internationally recognized human rights. It established a Constitutional Court at the apex of the judiciary, a new court with no links to apartheid, to be the guardian of the Constitution. I was appointed the first president of our new Constitutional Court and later chief justice of South Africa—a position I held until June 2005, when I retired.

The founding values of our new constitutional order are dignity, equality, and freedom—values which apartheid had denied to the black people of South Africa. Our task as judges of the Constitutional Court was to reshape the law, wrench it from its apartheid past, and establish a just legal order. A daunting task—but what a privilege to be given it.

ARTHUR CHASKALSON (b. 1931) was the first President of South Africa's post-apartheid Constitutional Court and continuously defended members of the liberation movement. He served with Bram Fischer, Vernon Berrange, and George Bizos as counsel in the Rivonia Trial in the defense of Nelson Mandela and his fellow activists. In court, he proved to be an unyielding force against apartheid, repeatedly blocking the implementation of discriminatory practices. He helped establish the Legal Resources Centre—a nonprofit organization that used the legal system to pursue justice and human rights in South Africa. He was a major contributor to the drafting of constitutions for Namibia and South Africa.

MIMI DORETTI

ARGENTINA — FORENSIC ANTHROPOLOGIST

I WAS 16 WHEN THE DICTATORSHIP IN ARGENTINA BEGAN. My mother was a journalist who received tons of death threats. At university, we weren't permitted to read the books normally read in the study of anthropology. We couldn't read Freud—probably because Buenos Aires has a very strong psychoanalytic community that was associated with the left in the minds of the military. And we weren't permitted to read Claude Levi-Strauss, because he recognized Marxism as one of his sources of inspiration. The police and military were a constant presence at school, checking our bags daily. This last military dictatorship was particularly brutal. At least ten thousand people were disappeared by the state between 1976 and 1983. That experience has marked the rest of my life.

I became a biological anthropologist. In that branch of anthropology, we learn about human diversity in relation to biology and in terms of time. It is applied mostly to the study of evolution but also centers on the analysis of bones. We apply many of the same techniques that are used to study skeletal remains in forensic medicine. I am part of an NGO that does forensic work only on human rights cases. Typical forensic pathologists work with fresh cadavers, but often we don't have access to the remains at the time of the disappearances, massacres, or extradition executions. We have access later, but by then the remains have decomposed. That's why the knowledge that we gain from bones is particularly helpful.

At the beginning of democratic rule in Argentina, an American delegation of forensic specialists arrived to help with the problem of finding the remains of disappeared people. Dr. Clyde Snow from Texas was among them. He had never worked on human rights, but he had been recruited by the American Association for the Advancement of Science, which is based in Washington, D.C. He made a very strong impression on me. Until he arrived, my classmates and I had no idea what forensic anthropology was. We believed in human rights, but it never occurred to us that we, as anthropologists, could do anything to support them.

The local forensic doctors had worked with the police and the judiciary, but the families of the disappeared didn't trust them. The doctors also had the technical problem of not being familiar with exhuming skeletal remains. Exhuming a mass grave of skeletons is a complicated thing. When Clyde came, finding the remains of disappeared people was a big mess. It was known that they were in cemeteries as John Does and Jane Does, but the exhumations were being done in a terrible way; all the remains were being mixed together and broken up with bulldozers. Clyde called for archaeologists and anthropologists to get involved. They didn't want to be involved, so he asked for students: that's how we started. He trained us and helped us form our NGO, the Argentine Forensic Anthropology Team. He went on to form other teams in Chile, Peru, and Guatemala. We still work with him. He is the father of this movement.

I enjoy the connection that my work gives me to historical, political, and social events. It is very different to work on an archaeological site that is ten thousand years old than it is to enter a cemetery. There was something very bizarre about digging up people who had disappeared 10 years before and were basically our age. And even though we survived the dictatorship, there was always the fear that if a new military government took over we would have to leave the country. Given the history of Argentina, there was no guarantee that democracy would last more than a few years. Trials were taking place, and we were determined to provide evidence for justice. Nonetheless, we were frightened, and we decided we would do this work only until the trials ended—then we would return to academia.

That hasn't happened.

MIMI (MERCEDES) DORETTI (b. 1959) was a student assistant to the forensic anthropologist Clyde Snow, who provided crucial testimony at the trial of the generals following the restoration of democracy in Argentina. She founded the Argentine Forensic Team in 1984, which conducts exhumations of the victims of human rights abuses worldwide. Today she is the leading international figure in the field of forensic anthropology, instructing a great many others in how to conduct such exhumations and continuing to perform forensic work uncovering human rights abuses in other countries. Her efforts demonstrate that science can be a potent tool in the pursuit of human rights by laying the dead to rest and bringing the truth to light.

BARRY SCHECK

UNITED STATES — LAWYER

I GREW UP IN QUEENS AND THEN MANHATTAN. My father didn't finish high school. He learned to tap dance from a black janitor in a bank on the Lower East Side, and at first he earned a living winning Charleston contests. The people in show business at that time were committed to civil rights, so a strong political orientation was a natural part of our household. My father thought it would be a good idea for me to have a license to practice law. I didn't want to go to law school—I was looking for the revolution. But I got into law school at the University of California, Berkeley. It was $453 a semester, which I could make playing poker at the local parlors.

I returned to New York in 1975 and started working at the Legal Aid Society in the South Bronx. About a year later, I met Peter Neufeld, who had done a number of cases in the area of serology—a kind of blood-typing that was the precursor of DNA testing. The forensic science being used was unreliable, and I began litigating cases up to the appellate courts.

During this period, the case of Marion Coakley came to our attention. He was an African-American man from South Carolina who couldn't drive and barely knew his way around the city. He had been convicted of raping a woman, as well as robbing her and her boyfriend, in a motel in the Bronx. The victim identified Coakley through photographs, but she had described her assailant as having a Jamaican accent. This guy was from Buford, South Carolina. And the crazy part is that Coakley had been at a prayer meeting, and had 17 alibi witnesses.

There was testimony about blood group substances being in the semen of the rapist. Eighty percent of people are secretors; blood group substances can be found in their saliva, semen, or vaginal discharge. Coakley was a secretor, but when they did the serology, they found no evidence of Coakley's blood type. That should have been airtight proof excluding him as perpetrator, but the prosecutor asked if the amount of blood group substances in the semen of low-level secretors could go undetected, and the serologist admitted that could happen. The serology evidence was nullified.

Peter and I had just left the Legal Aid Society, and we thought this would be a perfect case to work on with the students in our criminal-law clinic. With the help of Bob Shaler, who directed the first forensic-DNA laboratory in the United States, we tested Coakley's sample: he was not a low-level secretor. There had not yet been any criminal cases making use of DNA in the United States; Peter and I were interested in pushing the envelope.

We wanted to show that, no matter the circumstance under which Coakley ejaculated, you would always see his ABO blood group. We got a court order to allow him to masturbate in prison at Attica and provide 30 random samples of semen, at all hours of the day; the specimens were then analyzed. Every single time, we could see his ABO blood group, type B. This proved that he was not a low-level secretor, and that evidence won the case. The Coakley example is emblematic of a lot of the work we do; Coakley wasn't released on the basis of serology alone, but the forensic evidence gave us the opportunity to discover other things that were problematic in the original case, and in turn greatly strengthened his claim of innocence.

We realized, however, that DNA was only going to be able to correct a small number of injustices, since biological evidence is not always available. By deconstructing the cases where there *was* forensic proof, we hoped to determine what holes in the criminal justice system would permit an innocent person to be convicted in the first place. Ultimately, we found that 25 percent of our cases involved false confessions, 80 percent involved mis-identifications, and 15 percent involved snitches.

When you have DNA exoneration, *everybody* agrees this person is innocent. In half our cases, we discovered the real perpetrator, who invariably had committed other violent crimes in the interim. If you do it better, you'll get the bad guy instead of leaving him on the street.

We now have a network of 56 Innocence Projects around the country, which is really a burgeoning civil rights movement. This is a very powerful tool in the international movement for the rule of law. So many countries borrow ideas from the United States; if we could change our own system with these innovations, then they would be exportable, making criminal justice around the world more reliable.

BARRY SCHECK (b. 1949) is renowned for his landmark litigation in partnership with Peter Neufeld, setting standards for forensic applications of DNA technology. Since 1988, their work in this area has shaped the course of case law across the country and led to an influential study by the National Academy of Sciences on forensic DNA testing, as well as important state and federal legislation. Scheck is a member of the New York State Commission on Forensic Science and served as President of the National Association of Criminal Defense Lawyers. As the Co-Director of the Innocence Project, Scheck continues to race against time—as biological evidence disappears, is destroyed, or thrown away—to reform the legal system so that no innocent person faces prison or death for a crime that DNA can prove he or she did not commit.

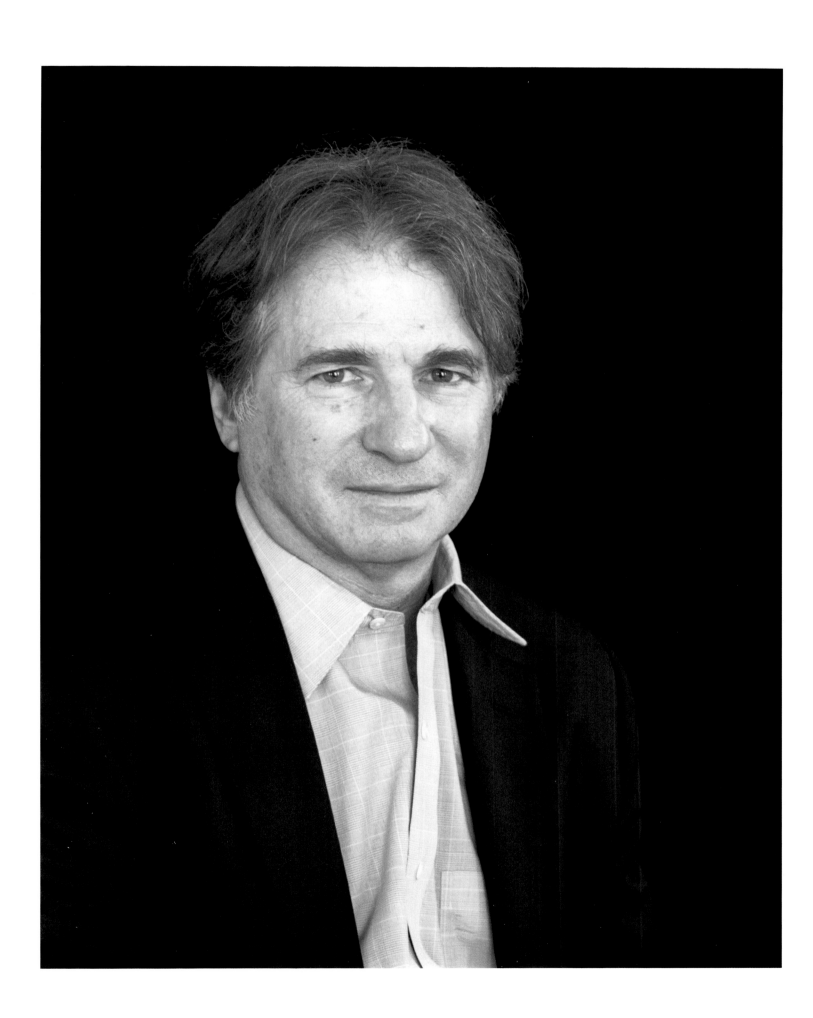

NICHOLAS KRISTOF

UNITED STATES — JOURNALIST

PEOPLE ARE ALWAYS A BIT MYSTIFIED that a *New York Times* columnist, and a man to boot, should write so much about women's rights around the world. When I lived in Asia, however, as a foreign correspondent for *The New York Times*, I repeatedly saw extraordinary injustices that were primarily about gender.

In particular, I remember stumbling into a Cambodian village in the late 1990s and seeing young girls for sale, as openly as if they were slabs of meat. I interviewed a couple of girls imprisoned in a brothel; the older one was comforting the younger one, whose virginity was on the market. The older one, who had already been sold, was trying to reassure her terrified companion that it wouldn't be so painful.

Then I met a 15-year-old girl in another brothel who had been kidnapped by a neighbor and sold to it. After searching all over Cambodia, her mother had finally walked into that red-light district, and into that brothel, and they had had a joyous reunion. I naively asked the girl why her mother had not rescued her, and she explained simply: The brothel owner said she had paid good money for me, and my mother would have to buy me back. My mother didn't have the money.

This seemed pretty much like slavery to me. The more I was awakened to this kind of injustice, the more widespread it turned out to be. Indeed, while in an equal society there are more females than males (because women live longer), in practice there are substantially more males than females on our planet. That's because parents selectively abort female fetuses or withhold food and medical care from daughters. It's not so much that they deliberately allow daughters to die; it's rather that if they get hold of a chunk of meat, they give it to the son, not the daughter. And if the son is sick, they take him to the doctor; if the daughter is sick, they decide to wait another day.

Another reason to focus on women's rights is that when women are marginalized, birth rates are very high—leading to a "youth bulge," which is one of the factors most linked to social instability. Sociologists have long noted that male-dominated societies (like the American West in the 19th century) are disproportionately violent. If we want to bring about change in countries like Afghanistan and Yemen, one of the more cost-effective strategies is to promote girls' education and a larger role for women in the formal labor force. It's certainly not a quick fix, but it seems to work at least as well as military solutions. That is the main reason my wife, Sheryl WuDunn, and I wrote our book about global women's rights, *Half the Sky*.

In the developing world, laws often don't mean very much outside the capital. Yes, we need new and better laws, but I sometimes think that if some of the energy now going into improved laws and United Nations covenants were applied to building schools, we'd see more change. For example, there has been a major effort since the 1970s to pass laws banning female genital mutilation, but this campaign has had negligible impact. In contrast, there are some grassroots initiatives within countries to change practices, and they seem highly successful.

My work has also been shaped by how I have come to believe journalism can elicit progress. When I first became an op-ed columnist in 2001, I thought: Wow! I'll be changing people's minds over breakfast twice a week! But that's not how the world works. If I write about any issue that people have already thought about, I change almost no one's mind. Where a column unquestionably has impact is in its ability to shine a spotlight on a neglected issue and make people face up to some injustice. We can project issues onto the global agenda—and that's the first step toward bringing about change.

The issues I'm proudest of covering are strife in Darfur, human trafficking, obstetric fistula, and maternal mortality. On those issues, I think journalists and activists can make a difference, if only by shaming the world into action. Once people see the costs of inaction, they tend to grudgingly take steps to improve the situation.

Readers expect women to fuss over women, but they're surprised to see a man do so. But as long as women are the only ones complaining about the abuse of women, the issue is immediately marginalized. Just as gay rights were advanced when straight people began raising the issue, just as it was critical for whites to participate in the civil rights movement, so it's important that men as well as women treat the abuse of women as an intolerable abuse of human rights. We all have a role to play.

NICHOLAS KRISTOF (b. 1959) is an American journalist, author, op-ed columnist, and a winner of two Pulitzer Prizes—the first for his coverage of China's Tiananmen Square democracy movement and the second for his commentary on the Darfur conflict. He writes an op-ed column for *The New York Times* and is widely known for exposing human rights abuses in Asia and Africa, such as human trafficking. Archbishop Desmond Tutu of South Africa has named Kristof an "honorary African" for his courage in bringing the world's attention to human rights conflicts.

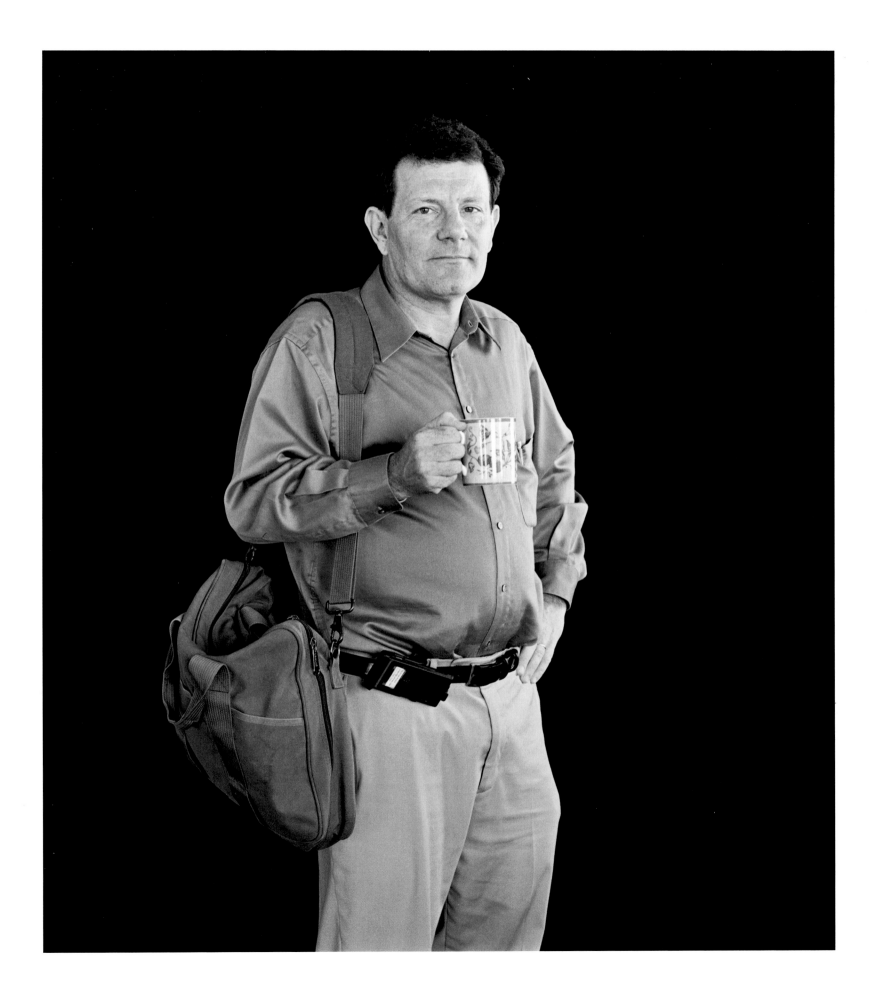

BRYAN STEVENSON

UNITED STATES — LAWYER/ACTIVIST

MY GRANDMOTHER WAS THE DAUGHTER OF SLAVES. Her parents were born into slavery in Virginia in the 1840s, and she was born in the 1880s. She was a powerful, loving, and influential force in our family. Her daughter, my mother, believed strongly in fighting against the bigotry and racial subordination we experienced growing up. These women also taught me to believe in equality and justice, even if we did not always see it in our lives.

I was born in a poor, racially segregated, rural community in the South. The schools became racially integrated after I finished the first grade, when lawyers came into our community to enforce the Supreme Court's landmark decision in *Brown v. Board of Education*. Seeing the way black people and the poor were often excluded, devalued, and humiliated in my community had a profound impact on my world view. I was often frustrated and angry. However, I was also highly motivated to succeed. I did well in high school and went to Eastern University, a small Christian college. At Eastern, I was encouraged to believe that the ideas in my mind mattered, but that they had to be fueled by conviction in my heart. After graduating in 1981, I went to Harvard Law School, where I earned my law degree and a graduate degree in public policy from the Kennedy School of Government.

I began my legal career at the Southern Center for Human Rights in Atlanta, Georgia, where I was energized by the extraordinary needs and challenges I found among condemned men and women on death rows across the Deep South. I was inspired by the faith, complexity, and humanity of many of my clients. I was also nurtured by my fellow advocates—many of them pioneers in the civil rights movement—who were brilliant, tactical, and relentless.

In 1989, we began a nonprofit law project in Alabama which has grown into the Equal Justice Initiative (EJI). My life and work at EJI have at times been overwhelming. There is a profound absence of hope in many of the jails, prisons, courtrooms, and communities where I have worked. I've seen many despised and broken people destroyed by fear, anger, and ignorance. I've seen bigotry and discrimination undermine justice and fracture the lives and aspirations of too many people. I've also seen violence and despair create tragedy and needless victimization.

I have come to believe that each person is more than the worst thing he or she has ever done. Our value as human beings cannot be reduced to a single act, even an act with profound and devastating consequences. Throughout my career, I have sought to provide legal assistance to condemned prisoners on death row and to challenge extreme sentences imposed on marginalized and disadvantaged people, especially the poor, children, and people with disabilities.

Mass incarceration and the politics of fear and anger have made America's criminal justice system unreliable, less responsive to error, and frequently vulnerable to the abuse of power. My work attempts to aid people who are wrongly convicted or sentenced and seeks reform of a system that contributes unnecessarily to inequality and injustice. I have come to realize that there are economic, social, and political conditions that perpetuate extreme poverty that must be reformed to create a just society.

Dostoyevsky wrote that "truth crushed to Earth shall rise again," and I have witnessed that phenomenon in some of our cases. Martin Luther King proclaimed that "the moral arc of the universe is long but it bends toward justice," and I have experienced that in our struggles to help the poor and the condemned. Jesus said that one day "the first shall be last and the last shall be first," and I have seen that in communities where hope has been resurrected and the powerless have found their voices.

It is a privilege to advocate for human rights and to fight for the dignity of every human being. My life has been enriched by people whose humility and perseverance know no measure. I have been the beneficiary of untold acts of kindness and mercy. I have been granted more grace than I deserve.

I feel very fortunate to stand with incarcerated people, the poor, the disabled, and even the despised and rejected on death row. I am persuaded that you judge the character and civility of a country not by how it treats the rich, the privileged, and the powerful but, rather, by how it treats the poor, the imprisoned, and the condemned. And, so, the work goes on.

BRYAN STEVENSON (b. 1959) was a child when the civil rights movement toppled the Jim Crow system in the American South. As a law student at Harvard during the early 1980s, he interned with the Southern Center for Human Rights, where he confronted the legacies of segregation and persistent racism in the criminal justice system. In 1989, Stevenson founded the Equal Justice Initiative in Montgomery, Alabama, a fitting home for an organization that continues the work of Martin Luther King Jr., whose final days were dedicated to tackling the systemic inequities that were beyond the reach of direct action protests and civil rights legislation. As director of EJI, and through his work as a litigator, law professor, and activist, Stevenson has mounted a sustained challenge to the inhumanity and injustices experienced by the poor and people of color at all levels of the justice system in the southern United States, saving lives, mobilizing public sentiment, and securing elemental changes.

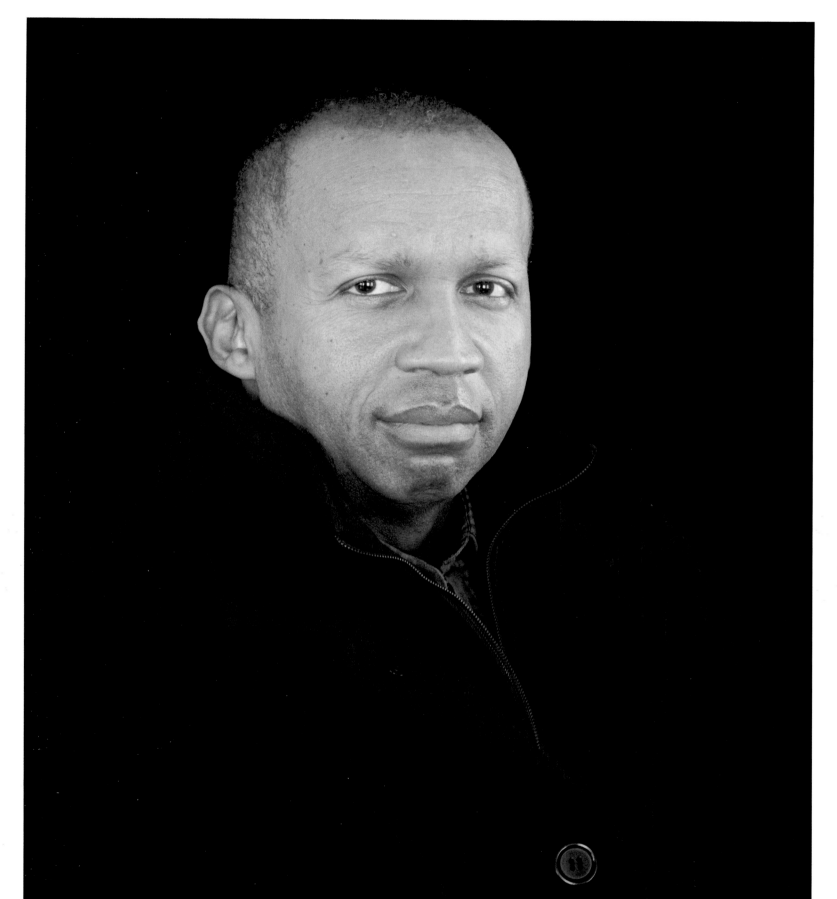

CHARLES SWIFT

UNITED STATES — LAWYER

I SERVED FOR SEVEN YEARS IN THE NAVY as a surface warfare officer. After law school, I joined the Navy's Judge Advocate General's Corps, where I served as a defense counsel for sailors and marines charged with crimes under the Uniform Code of Military Justice and defended the Navy's legal interests in the Caribbean. In 2003, I had been selected to attend Temple University's Master of Law program in trial advocacy. After graduating, I expected to spend the remainder of my career defending the Navy in complex civil litigation. Those expectations were changed by a request from the Judge Advocate General's office: would I be willing to accept a temporary assignment to serve as defense counsel for one of the detainees in Guantánamo Bay?

Like most Americans, I was only vaguely aware of the detention camp in Guantánamo Bay. I presumed that it was a prisoner-of-war camp similar to those the United States had maintained since World War II. I was unfamiliar with the history of military commissions but presumed that they would be similar to a court-martial, a system of justice in which I had the utmost faith. Still, I hesitated.

I presumed that the unknown client had probably played a central role in the abominable crimes of 9/11. As I pondered this possibility, my mind turned to a question that I was often asked by friends who were not lawyers: how can you defend someone that you believe is guilty? My answer was always the same: I believed in the law, and the law presumed my client was innocent. If attorneys were not willing to defend the guilty, then the presumption had no meaning. So I said yes. I did not expect that I would be defending the lofty principles that underlie our system of justice, or that I would be defending someone who was innocent.

To my surprise, all of my presumptions turned out to be wrong. Guantánamo Bay was not a prisoner-of-war camp, but rather a betrayal of the principles, articulated by General Marshall, that "the United States adheres to the letter and spirit of the Geneva Conventions and follows the rule of law as that term is understood in the United States." I discovered that the military commissions proposed for Guantánamo Bay bore more resemblance to the infamous Star Chamber than to a court-martial. And, finally, the man I had been assigned to defend, Salim Hamdan, was not an architect of mass slaughter but a desperately poor, softhearted father of two who, in an effort to provide for his family, had worked as a driver for Osama bin Laden.

The odyssey took us to the Supreme Court, where the court's decision in *Hamdan v. Rumsfeld* affirmed the applicability of the Geneva Conventions, thereby ending secret detention and extraordinary interrogation and requiring the military commissions to provide basic due process to the accused. But it was another two years before a group of officers put aside their fears and demonstrated their independence by acquitting Salim of any involvement in the 9/11 attacks, finding him guilty only of having driven bin Laden—something that Salim had admitted from the beginning. Salim's freedom came five months later, after he had completed the sentence awarded to him by the commission. He was reunited with his family in January 2008.

None of this was accomplished by my efforts alone. My greatest privilege was to work with Professor Neil Katyal of Georgetown Law, who was the architect and lead counsel on behalf of Salim in the federal courts; attorneys Harry Schneider, Joe McMillan, and Charles Sipos of the law firm of Perkins Coie, who worked fearlessly in the federal courts and at Guantánamo Bay on Salim's behalf; and finally LCDR Brian Mizer and Andrea Prasow, who joined in Salim's defense before the commission.

Salim was my last assignment in the military. I finished his defense as a civilian, since I was required to retire when I was passed over for promotion. I'm often asked if, knowing what I know now, would I do it again? The answer is, absolutely. I look at the defense of Salim the way John Adams viewed his defense of the English soldiers tried for their role in the Boston Massacre. Adams called it the greatest service that he had provided his country, for to have convicted those men would have been as great a stain on the country's honor as the Salem witch trials. The manner and means by which the government sought to try Salim would have been no less a stain, and I am honored and privileged to have served my country.

CHARLES SWIFT (b. 1961) worked for 13 years in the Judge Advocate General's Corps (JAG) in addition to his service as a Surface Warfare Officer, for which he received numerous decorations and medals. While in the JAG Corps, he worked principally in the area of criminal defense, earning a reputation as a premier trial attorney. Most noteworthy was his defense of Salim Ahmed Hamdan, Osama bin Laden's former driver; in the landmark Supreme Court case *Hamdan v. Rumsfeld*, Swift successfully argued that the military commission trying Hamdan for terrorism was illegal on multiple grounds. Only weeks after his victory (later overturned by the Republican Congress), he was passed over for promotion and was forced to retire in accordance with the U.S. military's "up or out" policy; the timing seemed all too convenient. He currently practices law in Seattle, Washington, at Swift & McDonald, P.S.

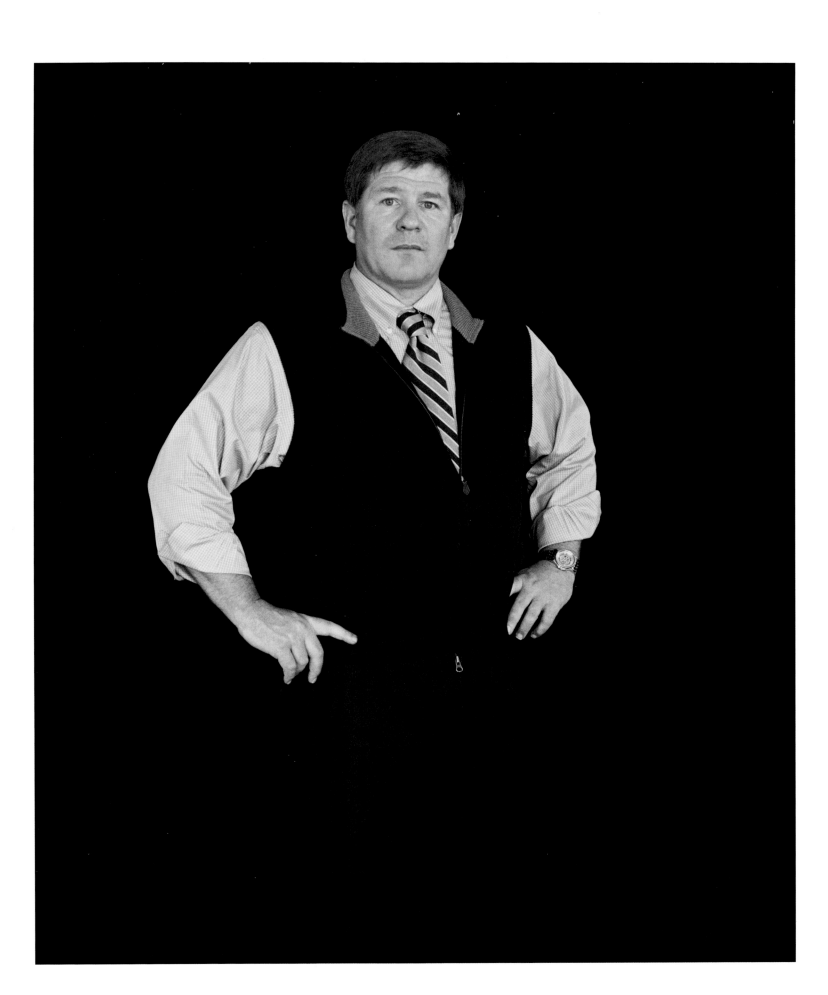

ALBERTO MORA

UNITED STATES — LAWYER

THE EARLIEST MEMORY I CAN DATE IS FROM 1956, when I was four. I was sitting on the floor of my parents' bedroom in Havana, Cuba. Mother was making up the bed while the radio played. I remember her tossing the folded sheets over the bed, smoothing them, and tucking them in tightly—all this was familiar. Then I realized that tears were streaming down her face. This was not familiar, and I recall my confusion. The radio, she explained, was reporting on the Soviet Union's invasion of Hungary—her homeland—and the demise of the Hungarian Revolution. I did not understand, but it was my first exposure to anguish, and my first lesson on the ability of governments to inflict pain.

I can tie a second early memory to January 8, 1959, the date Castro's revolutionary army made its triumphant entry into Havana after Batista's defeat. That day was one of the most joyful of my life. We had been invited to watch the event from the balcony of a friend who lived on the Malecón, the broad avenue overlooking Havana harbor. Confetti rained down on the rebels as they took bullets from their cartridge belts and threw them to the crowd as souvenirs. I still remember diving for the bullets, and the hoarse, unbridled exuberance of everyone present.

And then there is a third memory. The Cuban revolution quickly turned to Communist orthodoxy, and my parents, unwilling to raise their two sons in such a system, fled into exile. But Abuelo Pepe—a gruff tobacco farmer who had lovingly raised my father and ten other children, despite the early loss of his wife and eldest son—stayed behind, becoming gravely ill soon after our departure. We were living in a small, shabby apartment in Miami when we learned, in 1960, that my grandfather had died in Havana. Father, who had revered his father, collapsed to his knees in tears, his despair compounded by his rage that he had not been at his father's side in his final days. A physician and a scholar, my father had been classified as an "enemy of the revolution"; return to Cuba would have meant imprisonment. This was my second lesson in a government's ability to inflict pain. I was eight years old.

During the 20th century, many suffered more than my father and mother. But their pain—direct, vivid, and enduring—helped shape my beliefs about the fragility of men and women, the law and human rights, and the relationship between an individual and the state. It also imbued me with the conviction that the United States must sustain civil and human rights internally and project power externally to expand the democratic community. When employed consistently with our national values, American power defends individual human dignity by fostering freedom under the rule of law. Human dignity is our cause and our narrative—it defines the arc of our history.

I became the general counsel of the Department of the Navy, which included both the Navy and Marine Corps, a few months before 9/11. It could have been predicted, perhaps, that the nation's allegiance to our values would be tested after the attacks: our loss of life was high, our fear was great, and the desire for retribution was intense. In late 2002, the Department of Defense and the CIA, acting with the approval of the Department of Justice and the President, endorsed "enhanced interrogation techniques" that led to the application of cruel, inhumane, and degrading treatment—even the frequent application of torture—against "unlawful combatants."

For the first time in modern American history, and contrary to our constitutional principles, our laws, and our values, the United States adopted the use of cruelty as official policy. With each use of the waterboard, we proclaimed that a person's right to be free from cruelty was no longer a basic human right. A foreign policy that for more than 60 years had pivoted on the centrality of individual human dignity and had consistently espoused the pursuit of human rights had been rendered incoherent. The nation had tragically adopted a weapon of war whose very use threatened the same liberties we sought to protect.

These were not policies I could support. I could not—as an American, a lawyer, and Defense Department official—help apply policies that corroded our liberties and weakened our defenses. Nor could I—as my parents' son—in good conscience support policies in my country that echoed, even distantly, the harms they had suffered in their own.

ALBERTO MORA (b. 1952) is an American lawyer born in the United States of Cuban and Hungarian parents, and raised in both Cuba and the United States. He worked at the State Department as a Foreign Service Officer and served in Portugal and Washington before entering the practice of law. From 2001–2006 he served as General Counsel of the Department of the Navy, and he was in the Pentagon building on September 11 when it was hit by the hijacked plane. In late 2002, he investigated allegations of detainee abuse in Guantánamo. After confirming that brutal interrogation techniques had been authorized and applied, he helped marshal opposition within the Department of Defense against these practices, declaring that they were unlawful. In recognition of these actions he was awarded, among other honors, the John F. Kennedy Profile in Courage Award. Mora is now the General Counsel of a major corporation and serves on the boards of Human Rights First and Freedom House.

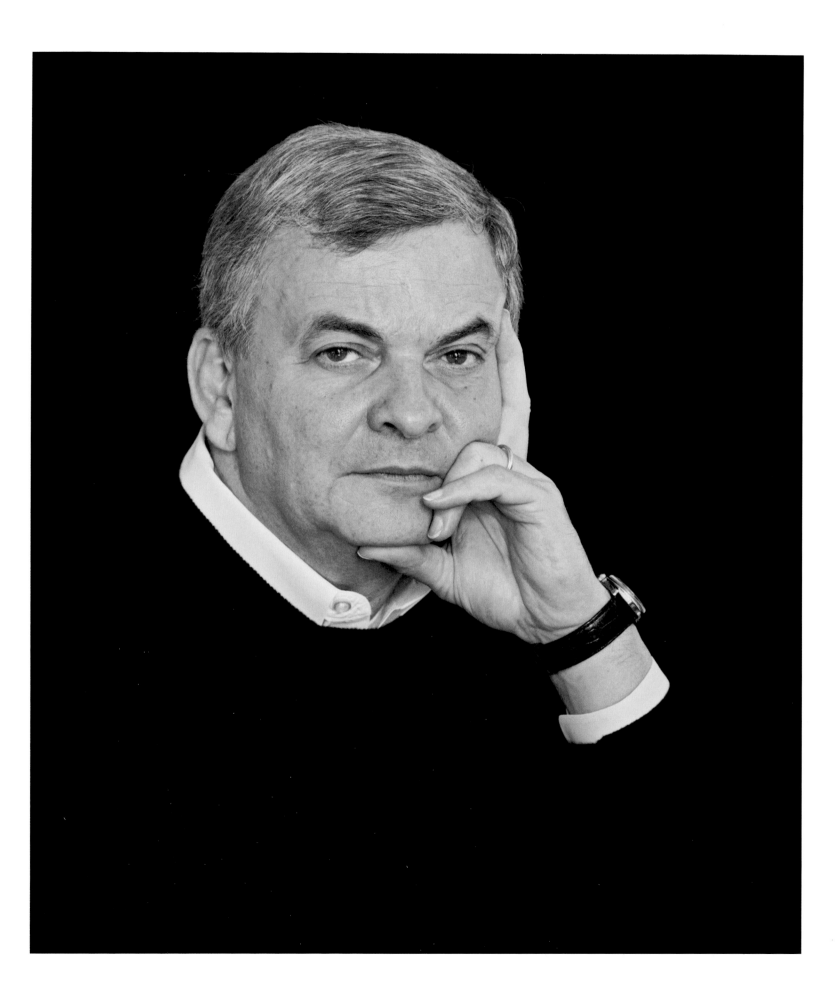

JESSELYN RADACK

UNITED STATES — WHISTLEBLOWER

I GRADUATED FROM YALE LAW SCHOOL IN 1995 and joined the Justice Department through the Attorney General Honors Program, eventually becoming a legal adviser to the department's new Professional Responsibility Advisory Office, which had been established to render ethics advice.

Shortly after September 11, 2001, I received an inquiry from a Justice Department counter-terrorism prosecutor regarding the ethical propriety of interrogating "American Taliban" John Walker Lindh—a U.S. citizen allegedly fighting on the enemy's side in Afghanistan—without a lawyer present. I had been informed that Lindh's father had retained counsel for his son. Accordingly, I responded that interrogating Lindh was not authorized by law; the FBI proceeded to question him without an attorney anyway. When I was contacted again, I recommended that Lindh's confession might have to be sealed and could only be used for national security and intelligence-gathering purposes, not for criminal prosecution.

Five weeks after the botched interrogation, Attorney General John Ashcroft announced that a criminal complaint was being filed against Lindh. "The subject here is entitled to choose his own lawyer," Ashcroft said, "and to our knowledge, has not chosen a lawyer at this time." I knew that was untrue. Three weeks later, Ashcroft announced Lindh's indictment, saying that his rights "have been carefully, scrupulously honored." Ashcroft's statement was contradicted by a trophy photo that was circulating worldwide of Lindh—naked, blindfolded, and bound to a board with duct tape.

The next month, my supervisor gave me a blistering evaluation, despite my having received a performance award and raise a few months earlier. It did not mention the Lindh case by name, but it questioned my legal judgment. I was told to find another job, or the review would be put in my official personnel file. I had planned on being a career civil servant because I believed that public service was an important calling, and federal employment was the only way I could obtain health insurance as someone with multiple sclerosis.

On March 7, 2002, the lead prosecutor in the Lindh case informed me that there was a court order for all of the Justice Department's internal correspondence about Lindh's interrogation. He said that he had two of my e-mails and wanted to make sure he had everything. I was immediately concerned because the court order had been concealed from me. Although I had written more than a dozen relevant e-mails, the Justice Department had turned over only two of them—neither of which reflected my concern that the FBI's actions had been unethical and that Lindh's confession, which formed the basis for the criminal case,

could not be used. I checked the hard-copy file on Lindh and found that it had been purged. With the assistance of technical support, I then recovered 14 e-mails from my computer archives, gave them to my supervisor, and resigned. I also took home a copy of the e-mails in case they "disappeared" again.

As the Lindh case proceeded, the Justice Department continued to assert that it didn't know Lindh already had a defense attorney at the time of his interrogation. I heard a National Public Radio broadcast stating the Justice Department had never taken the position that Lindh was entitled to counsel during his interrogation. I did not think the department would have the temerity to make public statements contradicted by its own court filings if it had indeed turned over my e-mails, as per the court's order.

After hearing the broadcast, in accordance with the Whistleblower Protection Act, I sent the e-mails to a journalist who had been interviewed in the radio piece. He then wrote an article about the missing e-mails, which sparked a pretextual "leak investigation" against me. Shortly after my disclosure, on the morning that Lindh's suppression hearing was to begin, Lindh pleaded guilty to two relatively minor charges. The surprise deal, which startled even the judge, averted the crucial evidentiary hearing that would have probed the facts surrounding his interrogation. Commentators widely agreed that the Lindh prosecution had "imploded."

In retaliation, the Justice Department placed me under criminal investigation without ever informing me of the alleged charges. It referred me to the state Bar authorities where I was licensed to practice law, based on a secret report I was not allowed to see, and I was placed on the "No-Fly List." Senator Kennedy took up my cause, stating: "It appears Radack was effectively fired for providing legal advice that the Justice Department didn't agree with." Bruce Fein, a conservative constitutional scholar and a top Justice Department official under Ronald Reagan, represented me pro bono.

I now write extensively on the plight of "enemy combatants" in the war on terrorism and have dedicated my career to representing whistleblowers who dare to speak truth to power. I live in Washington, D.C., with my husband and three children.

JESSELYN RADACK (b. 1970) served as an Ethics Advisor to the Justice Department during the first terrorism prosecution following 9/11. Later, she served on the D.C. Bar Legal Ethics Committee and now represents whistleblowers as the National Security and Human Rights Director of the Government Accountability Project. Her 2012 book *TRAITOR: The Whistleblower and the "American Taliban"* became a best seller among human rights books.

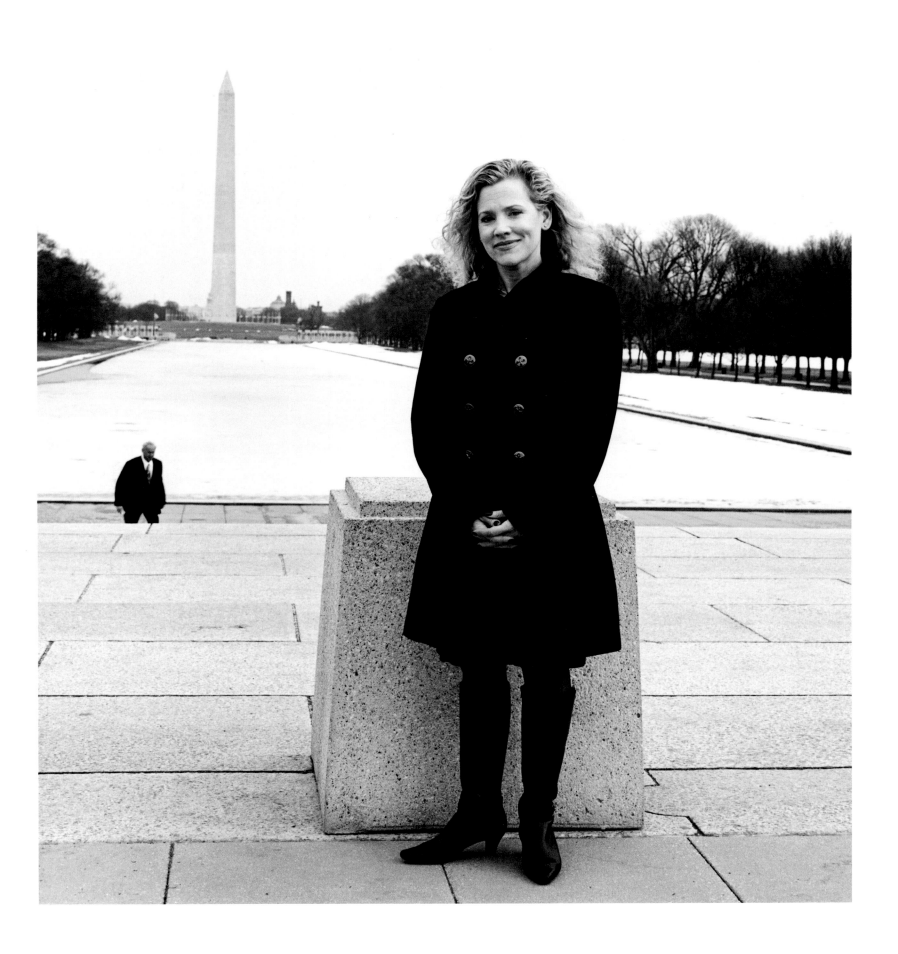

AMRIT SINGH

INDIA/UNITED STATES — LAWYER

I DID NOT PLAN ON BEING A HUMAN RIGHTS LAWYER. I was supposed to be a development economist. I grew up in India, at a time when 40 percent of its population lived below the poverty line, and economics, as the science of wealth, appeared to hold the solution to alleviating human deprivation. So I embarked on a study of the subject, driven by a desire to contribute to social justice and make myself useful to humanity. Somewhere in the middle of doing my PhD, I realized that I was a long way from making myself useful. The hours spent solving mathematical equations—either trying to prove something totally obvious or attempting to get a counterintuitive result that might never manifest—were not working. I needed to find a more direct way of being useful to other people through my work, so I decided to go to law school.

Law was a better fit for me than economics. Here was a discipline that allowed one to squarely address whether something was just or unjust. And even better, law was incredibly practical—it gave me concrete tools with which to *do* something about an injustice. I had always been drawn to civil rights law, on account of belonging to the Sikh minority in India, as well as my experiences of racial prejudice in the West. My first job as an advocate involved litigating racial justice issues at the ACLU. I found this work deeply engaging. Among other cases, I was involved in a challenge to the racial profiling of brown-skinned passengers by airlines after September 11, 2001. I also worked on a class action lawsuit challenging the failure of the state of Montana to provide constitutionally sufficient indigent defense services.

I remained at the ACLU for seven years, continuing to litigate issues relating to immigrants' rights and the Bush administration's post–September 11 national security policies. We litigated a number of cases challenging the prolonged and potentially indefinite detention of noncitizens in immigration detention—in some ways, this was the most satisfying work of all, because we were able to secure freedom for our clients. In another case, we were able to stop the U.S. government from deporting a man to Egypt without any kind of prior legal process, based on flimsy "diplomatic assurances" from the Egyptian government that it would not torture him, despite its record of systematically engaging in torture.

We had some success in uncovering government records relating to the Bush administration's torture program through our freedom of information lawsuit, *ACLU v. Department of Defense*. However, we were unsuccessful in obtaining redress for victims of this torture. After September 11, U.S. courts have largely declined to address the merits of substantive challenges to government abuses in the face of the executive branch's asserted national security imperatives.

My work at the Open Society Justice Initiative has focused on the next generation of legal challenges seeking accountability for human rights violations associated with the CIA's secret detention and torture program. These cases are brought not in U.S. courts, but in other jurisdictions where courts have not closed their doors to victims of torture, against non–U.S. governments that participated in this program. They include lawsuits before the European Court of Human Rights against the governments of Poland and Romania on behalf of Guantánamo prisoner Abd al-Rahim al-Nashiri. Mr. al-Nashiri was held incommunicado and tortured in secret CIA prisons on Polish and Romanian territories before being transferred to Guantánamo, where he now faces the prospect of an unfair trial by military commission and a possible death sentence.

More generally, my current work at the Justice Initiative is global in scope, and is directed at stemming the tide of exceptionalism that accompanies national security and counterterrorism policies worldwide. It has allowed me to gain a comparative perspective, to see the continuity in abuses associated with these policies across countries, and to work with local partners in crafting country and region-specific strategies for addressing these abuses. There is no doubt that in many instances, terrorism presents a real threat, and requires an appropriate law enforcement response. But governments around the world are suppressing dissent, discriminatorily targeting minority populations, arbitrarily detaining, killing, and torturing people and depriving them of due process, all in the name of national security.

In this context, I am grateful to have the opportunity to work towards ensuring that national security and counterterrorism policies and practices worldwide are consistent with human rights protections and the rule of law.

AMRIT SINGH (b. 1969) is the Senior Legal Officer for National Security and Counterterrorism at the Open Society Justice Initiative, where she directs litigation, documentation, and advocacy on counterterrorism-related human rights violations worldwide. Among other cases, she is counsel in *al Nashiri v. Poland* and *al Nashiri v. Romania*, challenges before the European Court of Human Rights to Poland's and Romania's complicity in the CIA's secret detention and rendition program. Prior to joining the Justice Initiative, she was an ACLU staff attorney, where she litigated racial justice, immigrants' rights and post-9/11 civil rights cases, including *ACLU v. Department of Defense*, a landmark lawsuit which yielded public disclosure of the infamous "torture memos," among countless government records about the Bush administration's torture policies. She is co-author (with Jameel Jaffer) of *Administration of Torture: A Documentary Record from Washington to Abu Ghraib and Beyond.*

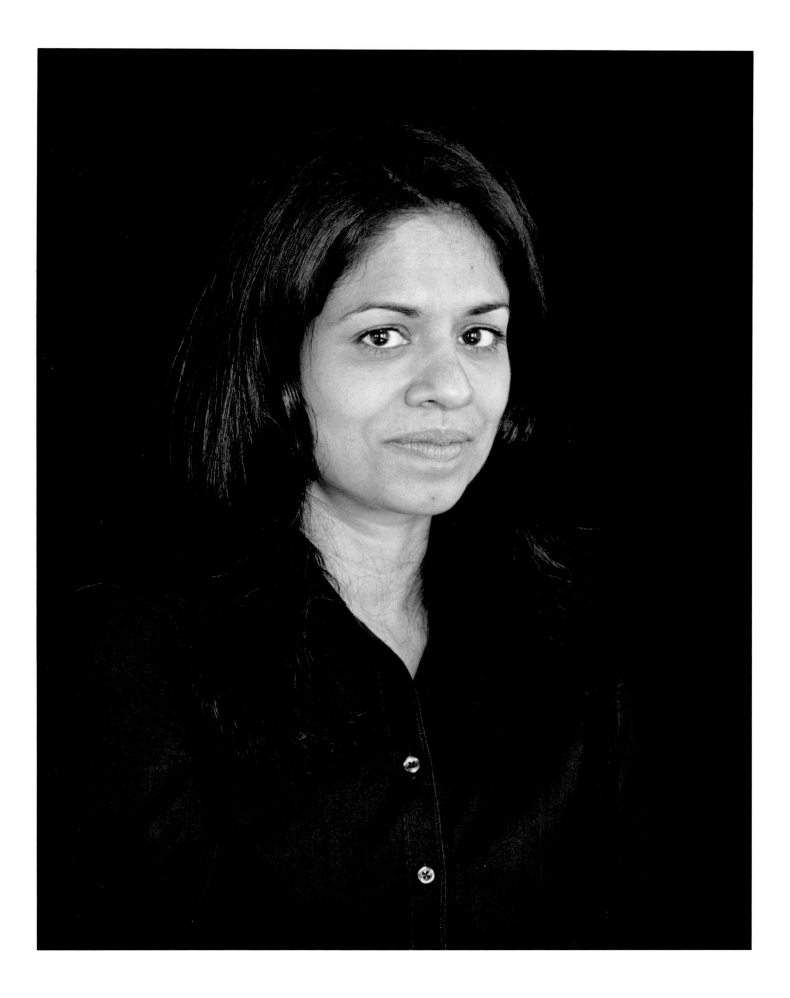

ABDUL TEJAN-COLE

SIERRA LEONE — LAWYER

I AM FROM FREETOWN IN SIERRA LEONE. My 10-year-old daughter, Hawa, was named after one of my favorite aunts, Umu Hawa Tejan Jalloh, who happens to be the chief justice in Sierra Leone at the moment. I come from a family of lawyers; my father is a lawyer, my brother, aunts and uncles—so many lawyers.

Sierra Leone is a very small country in West Africa. We've got a population of five to six million people. It used to be a British colony, so English is our official language. It has a checkered history in terms of government and politics, as well as military intervention. We had a very brutal civil war from 1991 to 2002. Since the end of the war, we have had a stable democratic government. In the last elections, the opposition party won the election and the ruling party handed over power peacefully; in Africa, that's a huge achievement.

Economically, Sierra Leone is a relatively poor country. We have a lot of diamonds, but the diamonds haven't been used to benefit the people in the country. The film *Blood Diamond* with Leonardo DiCaprio is about Sierra Leone's civil war and the impact of diamonds on the war. A lot is being done now to improve the economic plight of the people. With democracy came representation. People are pushing for their rights, and governments are more responsive to their needs. We are beginning to see some progress.

At university, I studied international business law and intended to become a corporate lawyer specializing in shipping law. But as I began my practice in commercial law, I read every day in the newspapers about women being raped, arms and limbs of men and boys being chopped off, etcetera. I put aside my commercial law practice and went fully into human rights. As one of the very few lawyers in the country at that time, it was important to play a leading role in working with the human rights NGOs to ensure that the violations of the rights of the people of Sierra Leone were documented. It was also important that they be reported to a broader audience, because it was the international community that eventually helped us end the atrocities.

I was the head of the Anti-Corruption Commission in Sierra Leone. During my tenure, we prosecuted several cases of corruption, bringing charges against the ombudsman, the minister of health, and the minister of marine resources. In all three cases, we got a conviction, clearly sending a message that no one was above the law.

My job was not only about litigation but also prevention and education. We waged a campaign to educate people about the ill effects of corruption in our society. We set up "integrity clubs" in a number of schools in Sierra Leone and worked with kids to build the integrity of the next generation of students and leaders. We hope they will not follow in the footsteps of some of our senior citizens. We also looked into areas where corruption is likely and recommended how things could be changed so as to prevent it. This work is integral to human rights, in the sense that freedom from corruption is part of the economic and social rights of the citizens.

Corruption ensures that we are unable to provide the basic amenities for people in our country. The fact that Sierra Leone has one of the highest infant and maternal mortality rates in the world is largely because of corruption in the health sector: mothers who go to hospital are charged a fee higher than what they're supposed to pay—or a fee that they're not supposed to pay at all. Many pregnant women who cannot afford to pay therefore receive no prenatal care and have their children at home, with midwives and grandmothers who do not have the expertise to deal with complications. Such corruption violates the rights of so many people in our country.

In the education system, there was and still is discrimination against the girl child, particularly in the north of Sierra Leone. It is a huge issue. Women are underrepresented in government. Overall, the government has waived fees for girls to attend school, but in some parts of the country, girls are still being charged a school fee by corrupt officials. We want to get the educational system functioning in such a way that everyone has access to good schooling.

None of this is an easy fight, but we are happy with the progress we have made in the past few years. We are pleased with the feedback we are getting from the local communities and the people generally. We are moving in the right direction.

ABDUL TEJAN-COLE (b. 1966) is the Regional Director for Africa at Open Society Foundations. He served as President of Sierra Leone's Bar Association at an early age and is the leading human rights lawyer in the region. Prior to his appointment, he served as Commissioner of the Anti-Corruption Commission in Sierra Leone from December 2007 through April 2010. His previous positions include: Appellate Counsel in the Special Court for Sierra Leone; and Deputy Director for the International Center for Transitional Justices' (ICTJ), Cape Town Office. He served as Board Chair of OSIWA from 2002 to 2007 and has also served as a member of the board of the Open Society Justice Initiative.

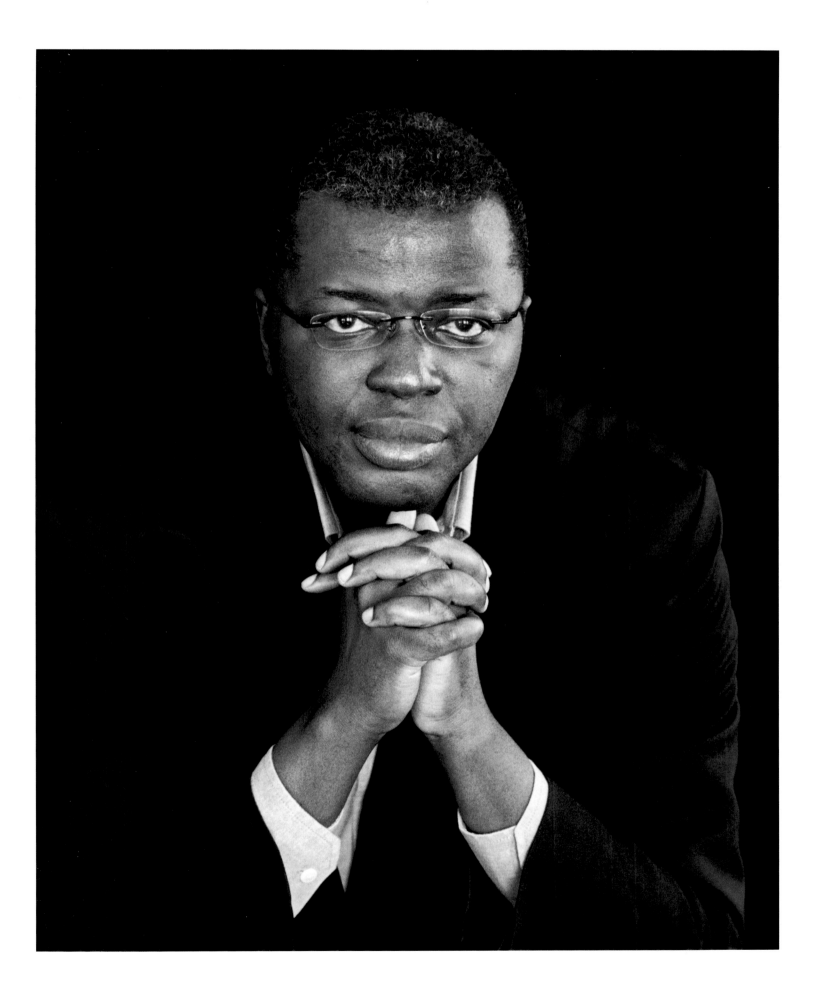

ADAM MICHNIK

POLAND — HISTORIAN/JOURNALIST

I GREW UP WITH ALMOST NO EXTENDED FAMILY. Most of my relatives had perished during the war, so only my parents' generation was around. My father, Ozjasz Szechter, was born in Lviv, Ukraine, to a very poor Jewish family. His father was a butcher, but during the time of Communism, the Polish newspapers declared that my grandfather was a rabbi. If that had been true, my father would certainly not have joined the Communist Party at 18 years old, but he was angry about World War I. When the Russian Revolution appeared on the horizon, it seemed magnificent and inspiring against the absurd backdrop of events that had led to 1914.

My father was an ardent supporter of the Communist Revolution and maintained his faith in it for almost 20 years. He was one of the main defendants in the famous 1934 trial of Communist leaders and suffered brutal interrogations and torture—and yet he did not seek revenge. This was the remarkable spirit in which I was raised.

My mother was brought up in a totally secular Jewish family in Kraków, Poland. Polish, not Yiddish, was spoken at home, and before World War II, she received a doctorate in early Polish history at Jagiellonian University. She was a true Polish patriot. After the war, my father was convinced that the Communist power in Poland had been imposed from the outside and did not approve of it, while my mother was an enthusiastic supporter of the revolution happening in Poland. My father could only see Soviet coercion, while my mother celebrated social changes. Strangely enough, my father joined the Communist Party but refused to allow my mother to do the same.

I can remember the death of Stalin in 1953 and my bewilderment at my father's lack of participation in the sense of terrible distress that seemed to grip the entire society. I was genuinely irritated that my father did not join in the general mourning. As a seven-year-old child at that time, I was intent on rebelling against everything my father represented. He was intense and possessed a very strong personality, which made it quite difficult for me to begin asserting my independence.

1968 was a very important year in my life, because it extinguished any political illusions that I had and revealed to me the true totalitarian nature of the Communist system; it was the year that I came to the shocking realization that, in some fundamental respects, Communism and fascism were the same. We did not believe anymore that the system could be reformed or humanized. My friends and I were described as "dissidents." This is what the newspapers of democratic Europe and of the United States called us, although we did not like the term. A dissident is a rebel, a renegade, a rare bird, whereas we were revolting against a dictatorship that we understood as the rule of a group of criminals over the majority of society—and we believed that we represented the overwhelming majority of the nation.

By 1976, the movement of dissidents had assumed the institutional form of the Committee for the Defense of Workers (KOR). It was one of the precursors of the Independent Self-governing Labor Union Solidarity, which was founded in August 1980. We invented something like an alternative society. First KOR was created, then independent workers' unions emerged, along with publications printed and distributed illegally. It was at that time that Jacek Kuroń formulated his famous principle: Don't burn party committees—create your own! We believed in national emancipation, in a state without ethnic discrimination, a state that would not be a victim of conquest but at the same time would not become an oppressor of another nation. We thought that the religion that was persecuted and discriminated against, while at the same time providing a refuge for human dignity, would naturally become a priceless component of democratic order. We believed in the emancipation of the world of labor, of which the multimillion-strong Solidarity Union was to be the seed. We believed in the emancipation of citizens, in freedom—which is not chaos.

A great change took place, and this change was undoubtedly positive. But the wielding of power requires capacities different from those needed for anti-totalitarian opposition. It requires more professionalism than idealism, more brains than courage, more accomplishment than heroism. In the epoch of dictatorship, intellectuals were the ones who spoke in the name of the gagged nation. Today the nation is not gagged and therefore intellectuals are no longer its guides. Does this mean that intellectuals are not needed anymore? Or to put it differently: what remains from those years? Today nothing is easier than pragmatism and cynicism, despair and melancholy. I believe that what remains with us from those years is the heroic, stubborn effort to inspire hope.

ADAM MICHNIK (b. 1946) is a legendary Polish former dissident, historian, writer, and academic, who has served as Editor-in-Chief of Poland's largest newspaper, *Gazeta Wyborcza*, since it was first published in 1989. Although raised in a family of staunch Communists and an early supporter of the cause, he soon became one of its most zealous opponents and spent six years in prison for his anti-Communist activities. He was instrumental in the Round Table Talks that convinced the Communist regime to hold elections, which were ultimately won by Solidarity. He continues to be an influential voice in the Polish political arena.

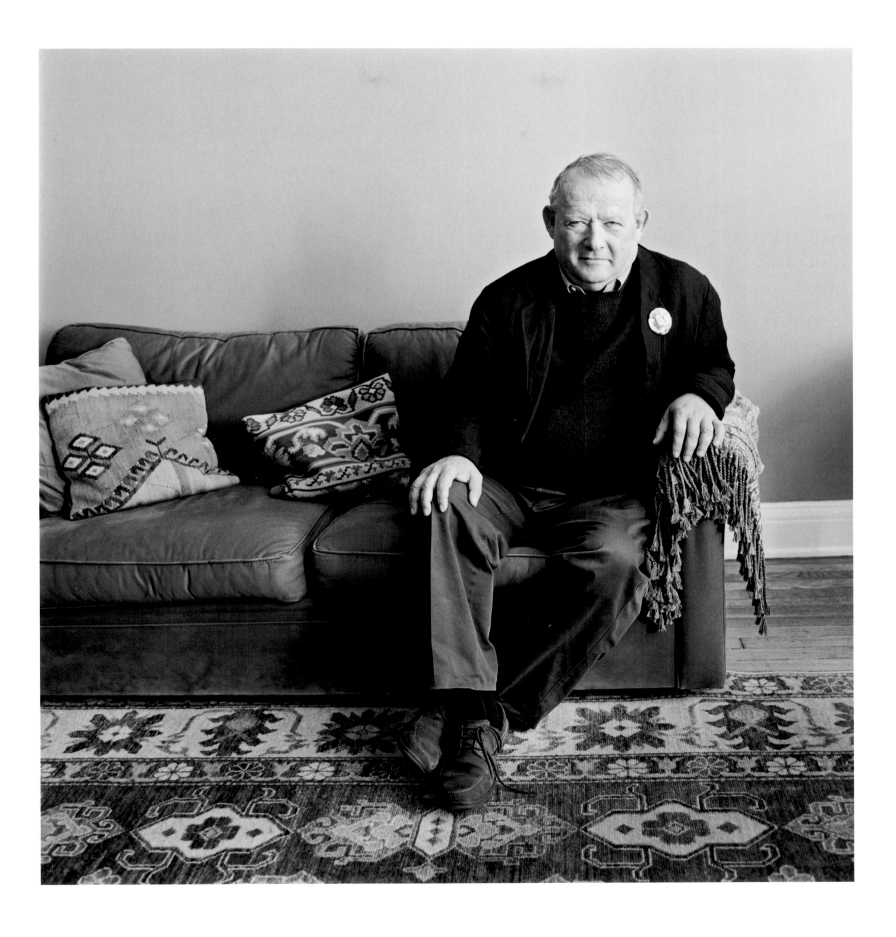

GAY MCDOUGALL

UNITED STATES — LAWYER/ACTIVIST

WHEN I WAS BORN IN ATLANTA over 65 years ago, "Jim Crow" laws were fully in force. It was a society of total racial apartheid, and we were all—individuals, communities and institutions—fundamentally shaped by that reality. Every aspect of our lives was contoured by the lack of choices that Jim Crow imposed, and bad things happened to black people who crossed the line or forgot the rules or just happened into trouble. It was a courageous act for an African American to demand to be treated with simple dignity and respect—not to suffer the customary demeaning from white people.

But I also grew up in Atlanta in the midst of the civil rights movement. Role models were all around me. Martin Luther King lived around the corner. The office of the Student Nonviolent Coordinating Committee (SNCC) was down the street. The movement taught me that injustice could be opposed—that you could speak truth to power and force societies to change. There was an atmosphere of urgency and a sense that it was time to stand up.

And there were so many ways to stand up. There was great dignity in walking, rather than taking the segregated buses. Wearing old clothes to church rather than buying a new Easter dress at the white stores we were boycotting. Sitting down at white lunch counters. Persuading people that they really could register to vote. And, also, for me at least, walking by myself—profoundly alone—onto the campus of an all-white college to break the barrier against African-American students.

There were also constant lessons about the costs of standing up. There were arrests, physical attacks, the bombing in Birmingham. You had to confront not just the "white community" but often the black community, and at times your own family too. And there were so many people who dropped out along the way. Still, living in those times taught me that being courageous was something that ordinary people could do, close to home, on ordinary days. That chance comes to all of us—often. We simply have to make that choice.

Years later, I got an opportunity to participate in the struggle against apartheid in a way that few Americans did. For 15 years, I worked with lawyers inside South Africa and Namibia to get political prisoners out of jail. We got thousands released. We filed cases to challenge apartheid laws, and a number of them were overturned. We helped families resist being evicted from their homes to distant bantustans, which were territories designated for blacks under apartheid.

I was personally inspired by the courage these South African lawyers and activists showed daily as they strategized how to gain justice in their country. Two of the lawyers I worked with were brutally assassinated—hacked to death by government agents—in retaliation for their representation of political prisoners. But the most important lesson I learned from the struggle in South Africa was the critical value of linking those individual acts of valor into a strategy and a movement. The greatest power that comes when one person stands up to injustice is that it gives others the courage to also stand up.

Later, I served on the South African governmental body that ran the elections there in 1994. I had the tremendous privilege to stand beside Nelson Mandela when he achieved one of his great ambitions—being able to vote for the first time in a democratic nonracial South Africa.

Since then, I have worked in some pretty tough places: Rwanda right after the genocide, the killing fields in Cambodia, scenes of mass slaughter in Sierra Leone and Bosnia, the remote battlegrounds of the civil war in Colombia. All of my later experiences have reinforced the lessons I learned in Atlanta and South Africa: that the true forces for justice come from inside each society and that real change is never achieved by one individual—even though individual acts of courage and determination are essential. Profound and sustainable social change always requires a critical mass of people willing to work together to reach the tipping point that will alter history and achieve justice. Most important, I learned that it is possible to win.

GAY MCDOUGALL (b. 1947) began her life in the segregated South and came of age in the midst of the civil rights movement in Atlanta, Georgia. She integrated Agnes Scott College and attended Yale Law School, anticipating a career as a civil rights lawyer in the United States. Her work with the National Conference of Black Lawyers in the early 1970s drew her to the anti-colonial and anti-apartheid movements in southern Africa. As Director of the Southern African Project of the Lawyers Committee for Civil Rights, McDougall helped organize the international anti-apartheid movement and coordinated aid for thousands of political prisoners in South Africa and Namibia. She was one of five international members of the Independent Electoral Commission that supervised South Africa's first democratic election in 1994, and stood beside Nelson Mandela as he cast his first vote. In 2005 the High Commission for Human Rights appointed McDougall as the United Nation's first Independent Expert on Minority Issues. Her experiences in the United States and South Africa provided the foundation for her illustrious career at the forefront of the global human rights movement.

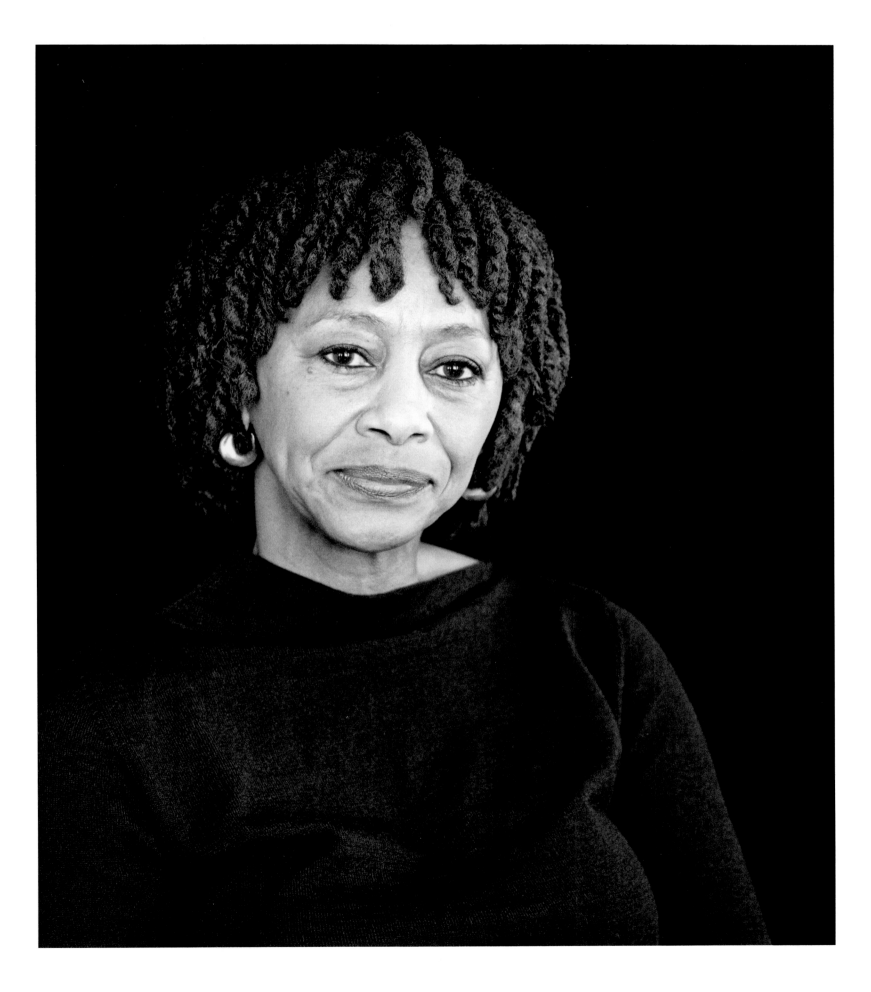

TEO SOH LUNG

SINGAPORE — LAWYER

I GREW UP IN A FAMILY OF EIGHT CHILDREN. My late father, a self-taught photographer and businessman, had a great influence on my life. He never discouraged me from doing anything, even if he didn't agree with it. When I was young, I had it all worked out. I was going to become a sort of barefoot lawyer, working for anyone who got into trouble with the law and could not afford legal fees. My father did not quite agree with my plan, but when I set up my law practice in a little room on the second floor of a ceramic tile shop in a light industrial area, he gave me an Olympia manual typewriter.

And so my law firm became the first in Singapore to be established outside the city district. The firm expanded when two friends joined me. We moved to bigger premises in a district noted for its colorful red lights. We worked closely with a church-based community organization, rendering legal aid to foreign workers and ex-offenders.

The rent was much lower outside the city, and we had two floors to work in. We could afford to invite friends for a home-cooked lunch or wine and ruminate on the affairs of the day. It was during those idle sessions that the idea of a criminal legal-aid scheme germinated. We wanted to provide aid to people who were in trouble with the law, since the government had refused to supply it. A few years later, the Singapore Law Society decided to set up such a scheme, and I was happy to serve as a member on the first committee in 1985.

This involvement marked the beginning of my participation in the activities of the Law Society, which was and still is a very conservative organization. I didn't agree with the prevailing ethos that a lawyer should only be occupied with the law and disregard the policies and laws that the People's Action Party (PAP, which had an overwhelming majority in Parliament) was ramming through whenever it encountered obstacles in its path. The opportunity to be more active in the Law Society came when, in 1986, Francis Seow was elected its president. He was forward-looking and saw the role of lawyers as being one with a responsibility to society at large. A legislation subcommittee was formed to examine and comment on various laws, and I was the chairperson of the subcommittee.

That same year, we were asked to review the Newspaper and Printing Presses Amendment Bill 1986. Its aim was to ensure that no foreign newspaper or magazine could criticize the government. I didn't view our commenting on that piece of legislation as something so sensitive that it would result in the Legal Profession Act being amended shortly after: these amendments not only deprived the Law Society of its statutory duty to comment on legislation but also terminated the presidency of Francis Seow.

Several members of the society and I were summoned to appear before a parliamentary committee. Its members included ministers and the then-prime minister, Lee Kuan Yew. I was questioned at length by Lee. That hearing was the prelude to my arrest and detention without trial under the Internal Security Act a few months later, in 1987.

There is a Chinese saying, "Slaughter the chicken to teach the monkey." My friends and I were the chickens that were slaughtered in 1987 to tell the PAP's more formidable adversary that we must accept everything the government did as being for our own good. Released after four months, eight former political detainees and I issued a press statement rebutting the government's accusations that we were "Marxists intent on overthrowing the government." We were re-arrested and detained a day after its publication. I spent another two years in solitary confinement.

The political scenario in Singapore today is somewhat different from the 1980s. Younger Singaporeans, knowing little about the arbitrary arrests and detentions in our earlier history—in part because former detainees were cowed into silence—have little fear of or regard for authority. Affected by the recent waves of recession, they participated in the May 2011 general election with an enthusiasm not seen since 1963. Inspired by their energy, I too stood as an opposition candidate. I lost, but it was the beginning of my return to society as an active citizen after more than two decades of silence. My candidacy in the general election was perhaps also memorable in that I have not been re-detained, sued for defamation, or charged with any criminal offense (as had happened to former detainees in past elections), although I was prepared for all these contingencies.

Freedom is elusive if we do not take it upon ourselves to retain what we have and to reclaim the rights that we have lost. It is almost a truism that no government will ever give away its power, especially the power of arbitrary arrest. It is the people who must be vigilant against abuses of power at all times.

TEO SOH LUNG (b. 1949) was detained without trial for more than two years in Singapore for defending the independence of the press and the legal profession. She helped found the Criminal Legal Aid Scheme of the Singapore Law Society in 1985 and emerged on the political scene as an opposition candidate in Singapore's 2011 general election.

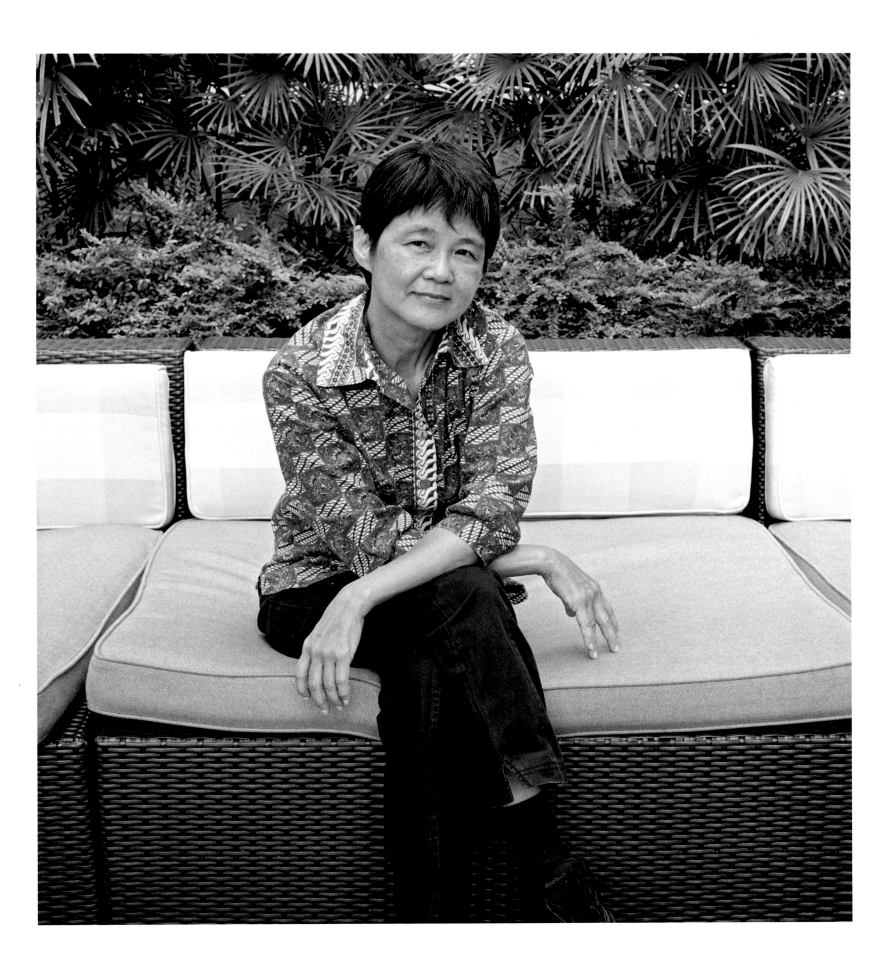

NAVI PILLAY

SOUTH AFRICA — JUDGE

MY FOREBEARS WERE SUGARCANE CUTTERS. My father was a bus driver, and my mother a homemaker. We were poor. My grandfather, whose arms were accidentally sawn off in the sugar mill, had predicted that I would one day be a lawyer. For years this was a family joke, but it stayed in my mind and was reinforced by my mother, who believed that knowledge could avert oppression.

When I was 16, I wrote an essay on the role of South African women in educating children on human rights. My essay was published, and my community raised funds in order to send me—whom it saw as a promising young woman—to university. It was understood that education was one of the paths out of poverty and discrimination.

When I entered university during the apartheid regime, however, everything was segregated. The registrar discouraged me from pursuing legal studies, arguing that I could not expect white secretaries to take instructions from a person of my color and background. Still, I persevered. From then on, I have worked hard to ensure that other women would be given the same opportunities to make their mark.

I was the first woman of color to serve as a judge in the High Court of South Africa. I left it in 1995 when I was elected by the United Nations General Assembly as a judge of the International Criminal Tribunal on Rwanda (ICTR). Subsequently, I served as a judge on the International Criminal Court at a time when conflict was being "privatized" into small but violent wars between militias or internally between the state and well-armed rebels, and large-scale humanitarian campaigns were being launched in response to the atrocities.

We had to start from scratch. At the Rwanda tribunal we had no courtrooms, offices, or libraries in the first years. It was a logistical nightmare to be based in a remote town declared a hardship area by the UN. But there was the determination to make it work; we believed that an international court could be successfully hosted in Africa. I am particularly proud of the jurisprudence on rape achieved in 1998 with the case of *Akayesu*, when we defined rape as a "physical invasion of a sexual nature committed in circumstances which are coercive." This was the first judgment on rape emanating from the ad hoc tribunals. I hoped that this ruling would remove the age-old practice of focusing on the conduct of the woman victim in order to establish the guilt of the perpetrator.

Another significant case—known as the "Media Case" and decided by the ICTR in 2003—concerned three media executives who were convicted of "crimes against humanity" for their role in the genocide. The tribunal considered that "hate speech that expresses ethnic and other forms of discrimination violates the norms of customary international law prohibiting discrimination." This was the first judgment since the conviction of Julius Streicher at Nuremberg after World War II in which the role of the media was examined in the context of international criminal justice.

In my life, I have alternated between the deliberate pace of legal proceedings and the passion of public advocacy. As high commissioner for human rights, I pursue both, but I often find myself in highly politicized contexts that contrast starkly with my experiences as a judge. I have carried all my judicial instincts over into my public advocacy endeavors. I do not rank rights, and in my office, everyone is given a fair audience. I start from the premise that human rights norms provide uniform and universal standards that help us ensure that all are held to the same measure. In the United Nations' system this is sometimes a challenge. I believe that the credibility of my office—and of human rights undertakings in general—depends on impartiality.

One of my priorities as leader of the United Nations human rights mechanisms—and as a good listener—is crafting more intelligible and compelling messages, as well as making the avenues to redress more accessible, attractive, and responsive. To this end, I reach out not only to victims of abuse and to like-minded states, thinkers, and activists, but to all those constituencies whose efforts are contiguous with our advocacy and can become our "partners in rights." At the same time, I spare no effort to persuade those reluctant states and nonstate actors to join the fold of rights as well, the respect of which ultimately serves the best interest of all states, groups, and individuals.

Having served as a judge in the prosecution of genocide for many years, I urge the international community to focus on prevention, particularly regarding the most heinous crimes: we must help states address the root causes that make these atrocities possible in the first place. Nelson Mandela has taught me that keeping an open mind toward other people's experiences and points of view—no matter how different from one's own—and preserving open channels of communication may serve the interest of justice and human rights better than strategies that leave no room for negotiation.

NAVI (NAVANETHEM) PILLAY (b. 1941) is UN High Commissioner for Human Rights. After many years practicing as a rights lawyer in South Africa, she served as a judge and then President of the International Criminal Tribunal for Rwanda, and as an appeals judge at the International Criminal Court. She has developed pioneering jurisprudence on rape as an element of genocide, and was the first woman of color to be appointed as a judge by Nelson Mandela.

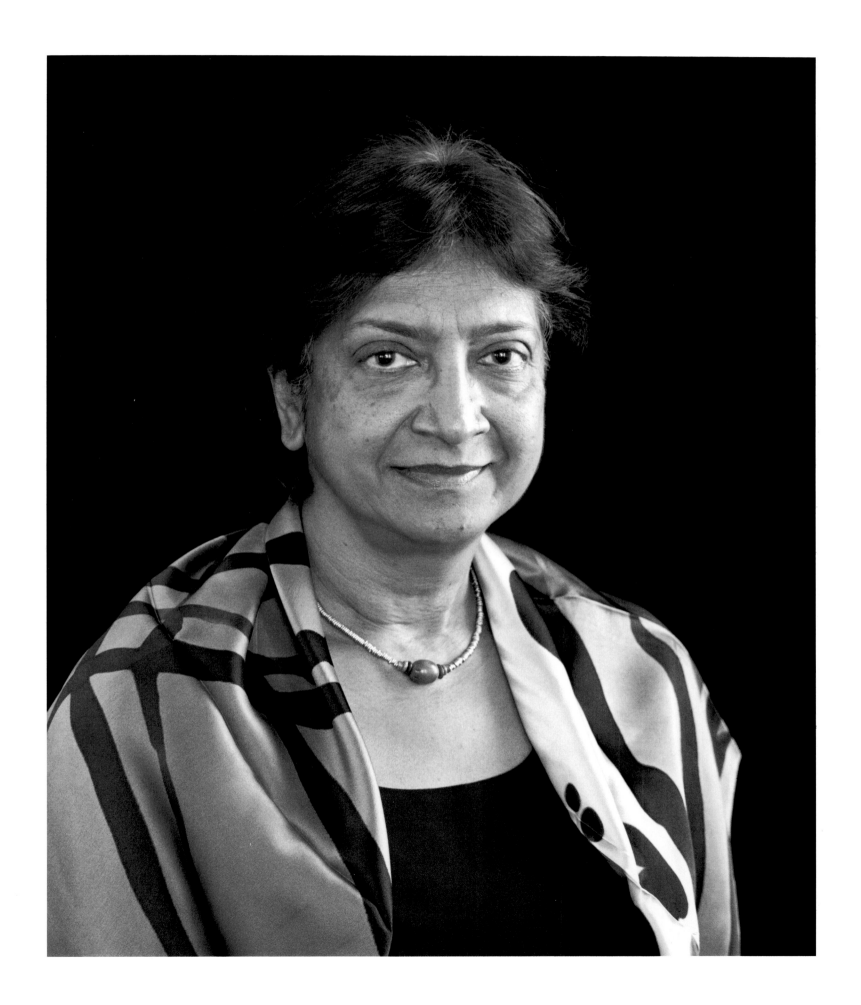

KOFI ANNAN

GHANA — DIPLOMAT

THE INTERNATIONAL COMMUNITY, in the years prior to the establishment of the International Criminal Court (ICC), repeatedly failed to take forceful action against the perpetrators of the gravest crimes in recent history. From Rwanda to Cambodia, Bosnia to Uganda, those responsible for widespread suffering and the deaths of hundreds or thousands went unpunished. Their victims were denied justice and, worse, the persecutors were emboldened by the world's apathy and inaction.

As under-secretary-general for the United Nations Department of Peacekeeping Operations, I was in a unique position to bear witness to this suffering, and will never forget the tragedies of Somalia, Srebrenica, or Rwanda. So when I became secretary-general I was determined, at the institutional level, to press for a better way to protect civilians and strengthen peacekeeping operations. On a personal level, I became convinced that the voice of the secretary-general should be one that constantly called out in defense of human rights and fundamental freedoms. I threw myself into the struggle to create the first International Criminal Court and to improve the legal norms available for the protection of civilian populations.

With the ratification of the Rome Statute in 1998, the international community solemnly pledged to end the culture of impunity, to stand against indifference to human suffering, and to answer the voices of the past as they called for justice from the bloodied fields of Rwanda and the shallow graves of Srebrenica. In my judgment, the establishment of the ICC plugged a gaping hole in international law. It brought an end to the days when a man who killed one person could be locked away yet the tyrannical heads of state and murderous generals responsible for the deaths of thousands often went free.

The state parties to the Rome Statute took a stand for those victims, present, past, and future, and tipped the balance in favor of justice. They declared that, from that point on, their default position would be to demand accountability for genocide, crimes against humanity, war crimes, and crimes of aggression.

I consider it a privilege that I have been able to play a part in this process. It was an honor to work with the activists and lawyers, the government representatives and UN staff members, to create an institution that would put an end to the culture of impunity. They have every reason to be proud of what has been achieved thus far—especially when one considers the opposition of powerful governments to the court.

As of July 2012, 121 states have now ratified the Rome Statute, 28 individuals have received indictments, and there are currently 15 cases in the trial or pre-trial phase. In March of 2010, the court's prosecutor for the first time initiated an investigation into the post-election violence in Kenya, and has done so with the cooperation of the Kenyan government.

A further success in the fight against impunity was the adoption of the doctrine of Responsibility to Protect. Even though I first raised the issue during the UN General Assembly session in 1999, it was not until 2005 that the Summit of Heads of State and Government in New York formally and unanimously resolved that states have a responsibility to protect their populations from war crimes, genocide, ethnic cleansing, and crimes against humanity, and to prevent such crimes, including their incitement, through appropriate and necessary means. They also declared the readiness of the international community to take collective action in accordance with the UN Charter, should peaceful means be inadequate and if national authorities are manifestly failing to protect their populations from these crimes.

That decision made it clear that governments can no longer brutalize their people behind the shield of sovereignty. But it also imposed obligations on those of us outside these countries—on governments as well as individuals. We cannot remain indifferent or unresponsive: some crimes are so shameful that we all must act to counter them. Today, I am encouraged that the principle of Responsibility to Protect has been invoked by the international community as a basis for taking action.

The fight against human rights abuses is never won; we have to wake up every day ready to fight it again.

KOFI ANNAN (b. 1938) was the seventh Secretary-General of the United Nations, serving two terms from 1997–2006. He was jointly awarded the Nobel Peace Prize with the UN in 2001. Kofi Annan played a key role in the establishment of the Global AIDS and Health Fund, and has continued to work on behalf of the neediest and most vulnerable people in the world, particularly in Africa. He remains active in mediation and conflict resolution through the Kofi Annan Foundation and continues to be a strong advocate for good governance, the rule of law, and human rights.

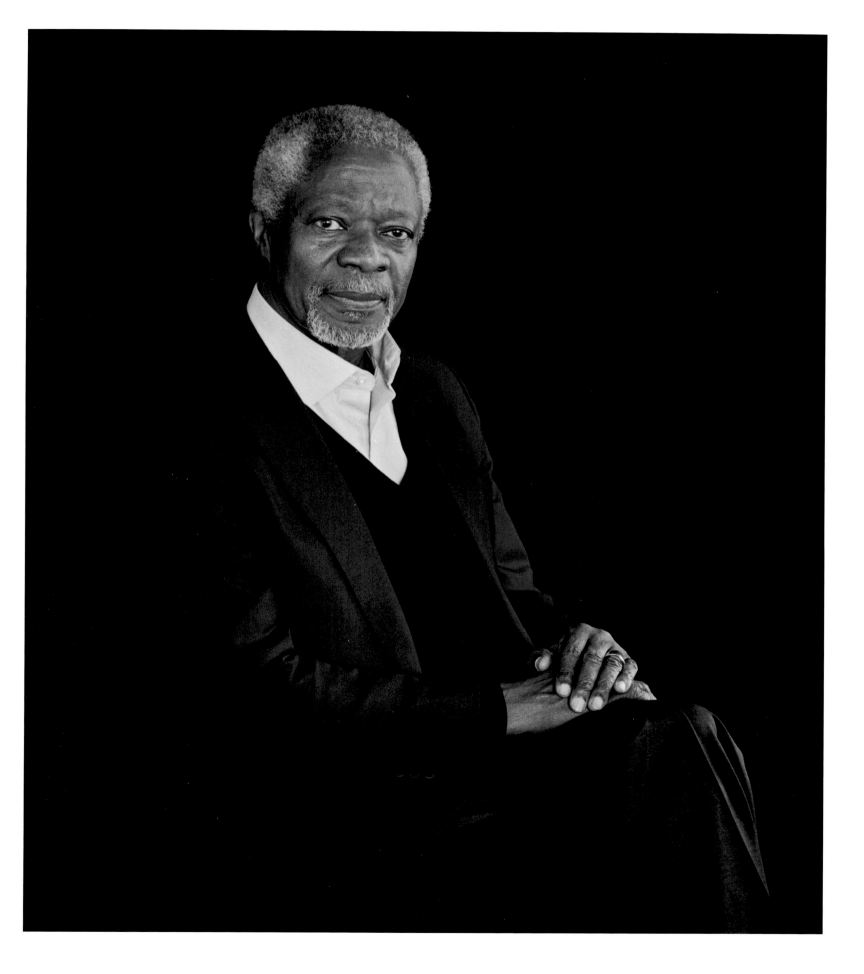

ROBERT M. MORGENTHAU

UNITED STATES — LAWYER

WHEN I INTERVIEW LAWYERS to work in the D.A.'s office, I always tell them that I'm not looking for gunslingers. I'm looking for people who do the right thing. If they have to dismiss the charges, then so be it. I'm looking for intelligence and also for humility. The lawyers who work in the district attorney's office have a lot of power, and they've got to use it wisely and with discretion. You can be the most skillful trial lawyer in the world, but if you can't get people to testify you're not going to get very far. I'm looking for people who can relate to victims and listen to witnesses. No matter how guilty we think the defendant is, I don't ever want to put a witness on the stand who is going to lie.

We should investigate and prosecute without fear. Nobody should be treated better than anybody else. I remember the first day I was in office as a United States attorney—I got a call from a congressman from the Bronx. He said, "I want to come and see you right away about a case." And I said, "No point coming to see me about a case, because it's my first day and I don't know anything about a case." He said, "No, no. It's very important. I appreciate your seeing me." He came to my office and said about the defendants, "These are constituents of mine." I asked him for their names and addresses. I checked and none of them were constituents of his. Then he came in again and he said, "All I'm asking you to do is to kick this case around for about six months." I said, "Well, I don't know much about the job, but I doubt that I can do that." And he said, "Well, your predecessor did it for a year." So I told him, "I promise I'll look at it and give it careful consideration." After he left, I told my assistant, "I think there's only one thing we can do, and that's put this case up to the grand jury right away." We did, and we had an indictment within 48 hours. He called me up screaming and said, "Couldn't you at least have kicked the matter around for thirty days so I could collect my fee?" I soon found, if you don't do anybody any favors, after a period of time, nobody expects any. Never open the door for these guys.

Some crimes are more serious than others. Rape is a close second to murder. DNA has made a huge difference in rape cases—both in convicting the guilty and in exonerating the innocent. We had a series of rooftop rapes in East Harlem, all involving 13- and 14-year-old girls. In the first case, the victim identified a guy. He was indicted and awaiting trial. Then there was a second rape, and that victim identified the second guy and he was arrested. And then there was a third rape and a murder. When we checked the DNA in all three cases, we found all the rapes had been done by the last guy. We had to dismiss the charges against the other two. Don't get me wrong: they were both bad guys, but they hadn't committed these particular crimes.

In 1974, I ran for district attorney. I was opposed to the death penalty, which was a minority view at that point. I declared the death penalty unconstitutional before the highest court in the state did the same. One of the curious things was that these executions were always done at midnight, so that the fewest possible people would know about it. I said to a couple of the legislators, "You ought to put a provision in the bill that anybody who votes for the death penalty has to witness it, and it should be on the steps of the Capital at high noon." Of course, that didn't get through, but all the people who voted for the death penalty would not have been too pleased to be present.

It used to be that there were a few corrupt people in a company, but now you see companies totally dominated by corrupt activities; not only the principal executives, but the accountants, the lawyers, and everybody else seems to want a piece of the pie. My father's words always come back to me: "Crime in the suites is just as important as crime in the streets."

ROBERT M. MORGENTHAU (b. 1919) is a veritable New York institution; he has navigated the grimmest corners of the city and emerged with an untarnished reputation and respect from both critics and supporters alike. President John F. Kennedy appointed him United States Attorney for the Southern District of New York, where he worked until the Nixon administration pressured him to resign in 1969. Morgenthau established a special unit to investigate securities fraud and prosecuted highly publicized bribery cases against city officials and IRS attorneys and accountants. He was the District Attorney for New York County (Manhattan) from 1975 until his retirement in 2009 and was among the first to oppose the death penalty in New York State. He gained national recognition while serving in what was technically a local office, in part because of his dogged pursuit of white-collar crime.

JOHN DOAR

UNITED STATES — LAWYER

IN THE SPRING OF 1960, sit-ins were occurring in North Carolina. That May, Harold Tyler, a friend from Princeton, called me. He had been appointed to head the Civil Rights Division of the Department of Justice. When he could not find anyone to become his first assistant, he offered me the job. Together with five or six lawyers in the Civil Rights Division, we were to concentrate on enforcing the 1957 Civil Rights Act, which prohibited discrimination or intimidation on account of race against anyone who tried to register or to vote.

In the fall of 1960, I went to western Tennessee to verify allegations that white landowners were systematically evicting black sharecroppers who registered to vote. I then went to East Carroll Parish, Louisiana, where I verified that local cotton ginners had refused to gin the cotton of an independent black farmer who had testified at a Civil Rights Commission hearing about his inability to register to vote. In the days that followed, I observed a relentless determination by white people in Louisiana, Mississippi, and Alabama to maintain a caste system. The scheme was not haphazard. I concluded that the United States had lived for almost one hundred years under a dishonest system of self-government.

The Civil Rights Division undertook to challenge this system. In 1961, voter discrimination suits were brought in Bullock, Dallas, and Montgomery counties, Alabama; East Carroll, Ouchita, Plaquennies, and Madison parishes, Louisiana; Clark, Forrest, Jefferson Davis, Walthall, Panola, and Tallahatchie counties, Mississippi. We worked to learn all the tricks until we understood the truth. Qualified black residents were systematically kept from voting for allegedly failing literacy or intelligence tests; whereas if you were white, a resident, and breathing, you voted.

In September 1962, the Fifth Circuit Court of Appeals sent three judges to Hattiesburg, Mississippi, to hold a five-day hearing on a contempt citation of the Forrest County clerk and registrar of voters. That hearing educated Judge Wisdom and Judge Brown of the Court of Appeals. We also filed suits against the states of Louisiana and Mississippi challenging their voting laws and their administration.

In November 1963, Judge Wisdom declared the Louisiana laws respecting the interpretation test unconstitutional as a sophisticated scheme to disfranchise black residents, and he enjoined the use of all literacy standards. Earlier in the year, Judge Brown dissented when two Mississippi judges dismissed the suit against the state of Mississippi. Judge Brown insisted that literacy standards be judged in light of the wide disparity in the quality of education Mississippi afforded its white and black children.

During these same years the civil rights organizations SCLC, CORE, and SNCC worked to eliminate segregation in the South. History has recorded their efforts, from the Freedom Riders in early 1961 to Selma in early 1965, and their bravery in such places as Amite, Pike, and Walthall counties, Mississippi; the University of Mississippi; Greenwood and Jackson, Mississippi; Birmingham, Alabama; the University of Alabama; and in 1964 throughout the Delta and in Neshoba County, Mississippi. These events measured the progress of the civil rights movement.

Change finally came after the events at Selma when, on March 8, 1965, the U.S. Supreme Court upheld Judge Wisdom's decision in *U.S. v. Louisiana* and reversed the decision in *U.S. v. Mississippi*. Within 10 days, the Justice Department introduced legislation in the House of Representatives that would open the voting booths wide for blacks. Ten days later, similar legislation was introduced in the Senate. On August 5, 1963, President Johnson signed the 1965 Voting Rights bill into law. On March 7, 1966, the U.S. Supreme Court upheld its constitutionality.

On May 3, 1966, in the first post-Voting Rights Act election held in Dallas County, Alabama, the key race was for sheriff. The contestants were Jim Clark, the segregationist sheriff, and Wilson Baker, the sensible, moderate police chief of the city of Selma. Jim Clark was defeated and Wilson Baker was elected the sheriff of Dallas County. Before that time, about 6,500 persons usually voted. Almost all voters were white. In the May primary 17,400 voters voted. With that election, the United States had finally achieved an honest system of self-government and the world changed.

In 1960, the United States faced a problem that was considered to be unsolvable; by 1966, thanks to the efforts of a great many people, its solution seemed inevitable.

JOHN DOAR (b. 1921) joined the Civil Rights Division of the U.S. Justice Department toward the end of the Eisenhower administration. He was the first Justice Department attorney to go south to investigate the denial of voting rights to blacks, initiating a transformation that would be completed under Robert F. Kennedy. Doar helped put the federal government fully behind the fight for voting rights and was centrally involved in major civil rights developments, including the desegregation of the University of Mississippi. His courage and dedication won him the trust of activists in the most violent parts of the Deep South. He served as Assistant Attorney General for Civil Rights from 1965 to 1967 and then became Director of the Bedford Stuyvesant Development and Service Corporation, a major antipoverty project founded by Robert Kennedy.

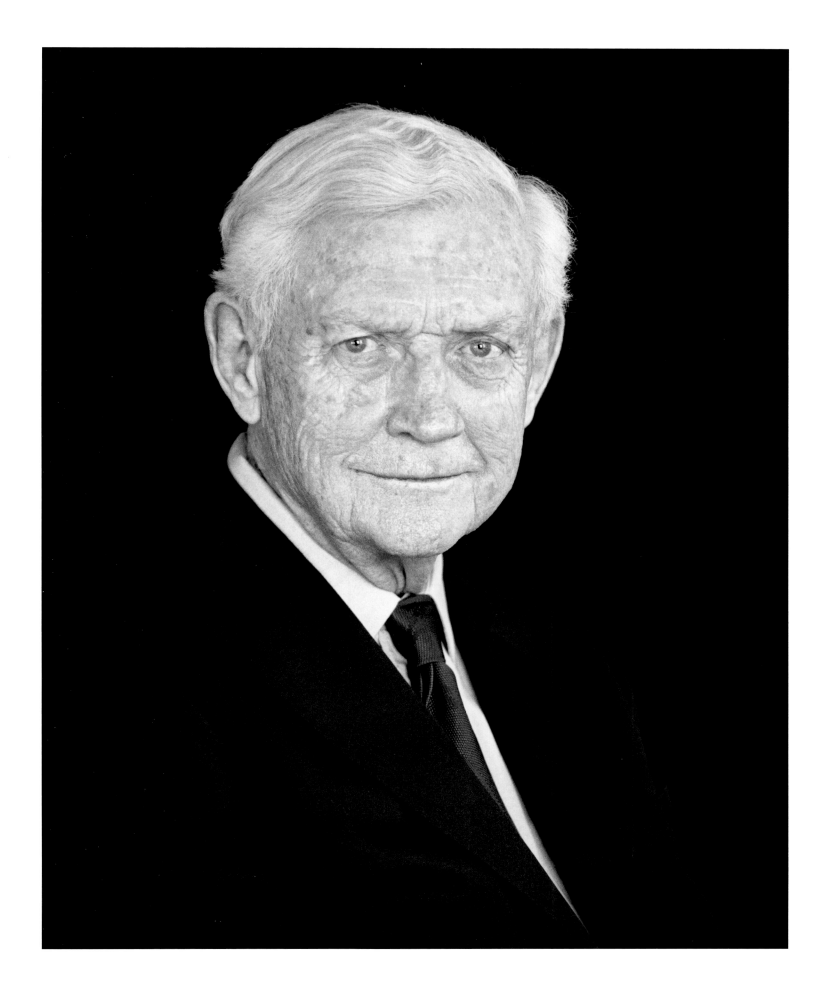

NADER NADERY

AFGHANISTAN — ACTIVIST

Dear Mariana,

I would love to write for your book, but the coming three weeks are very hectic for me. It was a very bad last two weeks here for us. A suicide attack took the life of one of my colleagues with her children. Another one took the life of my other friend in Kandahar province. It was a week of tragedy. I am struggling to get back to my normality.

Nader, February 5, 2011

IN THE SPRING OF 1998, the Taliban government summarily imprisoned me for advocating an end to the conflict that had killed almost two million people since 1978 and gutted Afghan society from within. As a 22-year-old law student at Kabul University, I had drafted a peace plan with other students and approached representatives of the United Nations for help. For this I was bound, kicked, beaten on my feet, and interrogated for weeks by Taliban guards. At night, I and other prisoners slept on plastic sheeting and huddled together for warmth. Relief came after my parents bought my freedom. Exiled to Pakistan, I planned my return to Afghanistan and made forays across the border. My relatives begged me to follow my siblings to the West, but my months as a political prisoner had only sharpened my convictions. One day, the regime would fall and its victims would need advocates.

On October 7, 2001, American jets appeared in the sky and commenced a bombing campaign in retaliation for the Taliban government's hosting of Al Qaeda. I had come to believe the war wouldn't end without outside military intervention, but the fact that it would take the lives of more civilians worried me. A little over one month later, Kabul fell to U.S.-supported anti-Taliban militias. American and European soldiers emerged in the streets of Afghanistan's ruined cities, to the bewilderment of the frail population.

In the prisons, secret schoolhouses, and tubercular refugee camps, Afghans had dreamed of a better life. Surely, now there would be the overdue reckoning for the leaders responsible for filling the mass graves and driving half the population into the shadows. Power would change hands through peaceful elections and the rule of law would replace the gun, as it had been at the time of my father. Human rights would be protected, and the international community would invest in Afghanistan's recovery.

After I served as the spokesperson for the Grand Traditional Assembly, the transitional government appointed me a commissioner of the newly established Afghanistan Independent Human Rights Commission (AIHRC). Previously a hunted dissident leader working through clandestine networks, I was now a public figure with an office. Less than a decade before, I had risked my life to shove handwritten atrocity reports under the gates of the UN compound in Kabul. Now, diplomats were knocking on my door. I pushed hard—recklessly so, in the opinion of some—to hold the powerful to account. We soon found the new ruling class barely more amenable to criticism than the old one. When I denounced a land grab by government officials, including the then minister of justice, one of the minister's bodyguards called me and threatened to chop me into five pieces: one for each of the minister's new plots.

I had believed the international community would politically sideline the warlords at the end of the interim administration. Instead, it allowed men responsible for human rights violations across two decades to entrench themselves in every state institution, consigning Afghanistan's progressives to the margins once again. Human rights commissioners quickly became despised figures, and threats against our lives multiplied.

Raising her nine children in the midst of civil war, my mother had told us, "No wrong goes unpunished forever." Her words never left me. Inspired by the Conflict Mapping Project that created a record of crimes against civilians in Sierra Leone, I began a mapping project for AIHRC in 2006. Over the next five years, our mapping team interviewed tens of thousands of Afghans, creating the most extensive record to date of 23 years of war in Afghanistan.

The international mission in Afghanistan faltered. Unchecked corruption rotted the state. The Taliban captured large areas of the south and southeast and reappeared in the north, bringing their brutal rule with them. Old militias rearmed and new ones formed. Civilians were besieged from all sides. After evidence of insurgent detainees being tortured in Afghan and international custody surfaced, I unhesitatingly condemned the abuses. I spoke up with equal intensity against Taliban crimes.

Today, I fear the Taliban's return to power and the increasing conservatism of the government in Kabul. I believe that powerful countries have a moral responsibility to ensure that Afghanistan does not fall into mayhem. Recent violence here has robbed me of close friends, yet I have no intention of leaving. There are many fights left. I am bound to this land to the end.

NADER NADERY (b. 1975) chairs the Fair and Free Election Foundation of Afghanistan, an organization he founded in 2004 and had been Commissioner of the Afghan Independent Human Rights Commission (AIHRC) until he was ousted in 2011 by the Karzai government. Prior to his appointment at the AIHRC, he worked as Country Director for Global Rights. He chairs the Open Society Afghanistan Foundation board and teaches at American University. He is a regular commentator on Afghanistan for *The New York Times*, the BBC, and other international media.

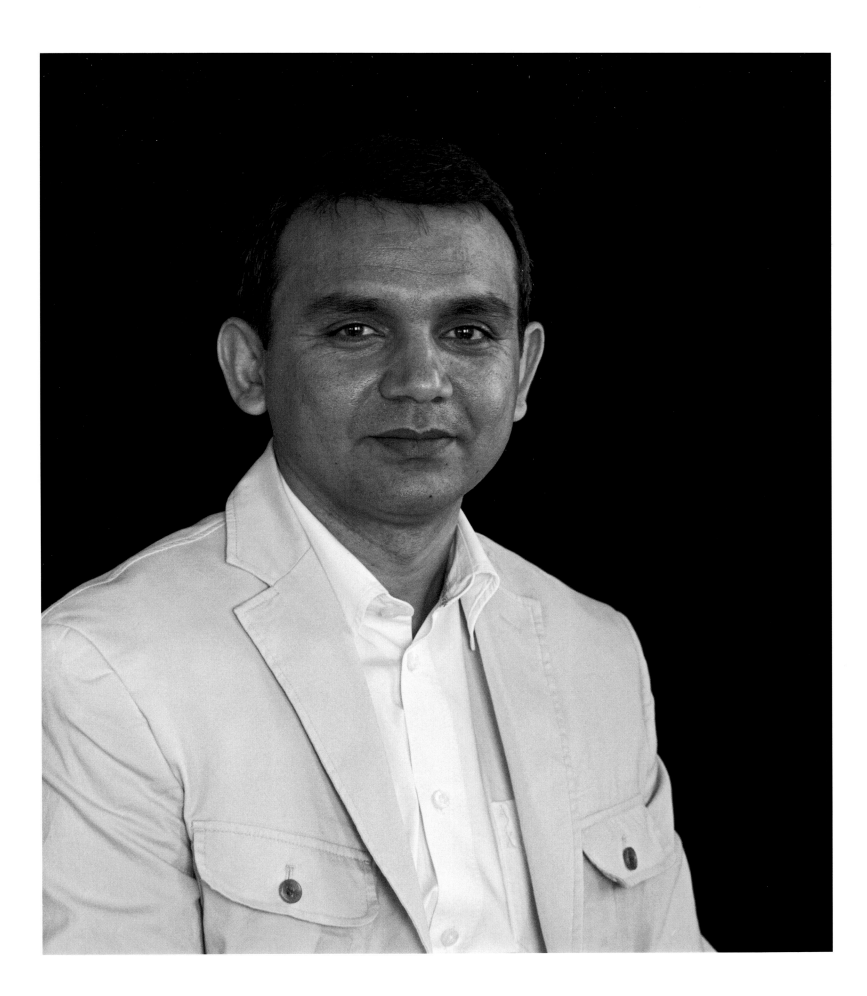

SHAMI CHAKRABARTI

BRITAIN — LAWYER/ACTIVIST

MY FIRST BIG POLITICAL MEMORY is from over a quarter of a century ago. I say "political" as if it were about a momentous demonstration or a general election, but it was actually much smaller and more personal—like most politics, in fact. It was evening, and I was watching the television news in my parents' suburban semi. The hunt was on for the Yorkshire Ripper, a sadistic murderer who preyed on young women in the north of England in the late 1970s, and the dark story had run on the news for many nights on the trot.

I don't remember my precise words that evening. Perhaps I am now too ashamed of them. Something about what "they should do to an animal like that when they catch him." I must have heard this kind of talk somewhere before, but that's no excuse. The comment was not thought out or even really heartfelt, just something churned out to seem grown up and in control. My father's response was uncharacteristic, for he has never struck me as a particularly reflective or nonjudgmental man. He had a quick temper, a loud voice and a big heart, but never in my experience had it been a bleeding one.

"You can't believe in the death penalty?" It was almost a whisper. "Why not?" I said. "I mean, for someone like that?" I felt wrong-footed and embarrassed by his response—that special adolescent feeling when you've gone a little out of your depth and don't know a safe way back. "No criminal justice system in the world will ever be perfect," he replied. "You have to imagine that you are the one innocent person in a thousand—no, a million. You've been convicted of the most heinous crime and you have to imagine your final walk to the gallows or the electric chair. 'God!' you think. 'They say I've done this terrible thing. I know I haven't, but even my family and friends won't believe me and now they are going to kill me.'"

This was how I learned about the presumption of innocence—the easy way. Not the way others of my generation held in Guantánamo Bay would learn about it, incarcerated without charge in a foreign land, but at home from a loving father—the accidental one-time evangelist for the cause of liberty. In later life, my dad heard this story and mentioned to me that he had no recollection of the incident whatsoever. He was no Atticus Finch—just this once. But sometimes once is enough.

There are many arguments in favor of our evolved notions of justice, but human fallibility has long been my favorite—an individual frailty that can become systemic imperfection, and one that requires prompt charges, defense lawyers, presumed innocence, and proof beyond reasonable doubt to redress it. In England these essentials are older than running water and

should be undeniable. But the fear of terrorism has been like the fear of a thousand Yorkshire Rippers, and the political response has been more about effect than effectiveness.

Professionally, I came of age at a time when Britain's hard-won civil liberties and freedoms were under great pressure from within. The Blair legacy in Home Affairs was strangely contradictory. On the one hand, his government gave the United Kingdom its modern Bill of Rights by way of the Human Rights Act. On the other, the poorly labeled "war on terror," sweeping police powers, and denigration of asylum seekers have threatened to poison our race relations. Lessons from Northern Ireland forgotten, Muslim terror suspects were subject to years of internment in Belmarsh prison and languish now under effective house arrest through the unfair, unsafe, control order regime. Our pre-charge detention period for terror suspects until recently was, at 28 days, the longest in the free world. And if there hadn't been a parliamentary revolt against capitalizing on our fears, that period might have been three months.

The most inexcusable act was the previous government's willingness to turn a blind eye to torture. It refused to investigate reasonable suspicions that our airspace and airports have been part of the web of kidnap and torture called "extraordinary rendition." It sought to rely on information gleaned from foreign torture in U.K. courts and to deport foreign terror suspects to countries known to employ torture rather than trying those suspects in Britain.

The role of Liberty is to fight these authoritarian tendencies in British politics, to protect the vulnerable from becoming scapegoats for society's suspicions and prejudices, and to broaden public understanding of the universality of human rights. We need to persuade politicians not to play politics with home affairs, law and order, anti-terror policy, and asylum. Populist policy doesn't actually solve crime or terrorism, because it doesn't deal with complex root causes. But it does leave us with an impoverished constitutional legacy and a statute book littered with corrosive laws that eat into our hard-won human rights and fundamental freedoms.

SHAMI CHAKRABARTI (b. 1969) is a lawyer whose bold leadership is paving new roads for the well-established organization Liberty (officially known as the National Council for Civil Liberties). She has garnered media attention in the U.K. for her passion, quick wit, and articulateness. She was one of the main opponents of Gordon Brown's plan to detain terrorist suspects for 42 days without charge and deserves substantial credit for the plan's subsequent defeat.

THOMAS HAMMARBERG

SWEDEN — DIPLOMAT/ACTIVIST

MY INTEREST IN HUMAN RIGHTS CAME EARLY. Born during World War II in the north of Sweden, I saw the documentary films on the Holocaust as a teenager at our local cinema—the systematic mass extermination of Jewish children, women, and men. My life changed. The boyhood dream of becoming a professional football player—or at least a forester—became irrelevant. Instead, I began to read about the repression of blacks in South Africa and wrote to the local newspaper suggesting that readers should stop buying goods imported from the apartheid regime. I was not alone; many people of my generation felt that injustices the world over were a personal challenge. We believed we could have an influence.

The year after the Wall was built, I began to understand what life under Communism really meant. Meeting with students in East Berlin, who wanted nothing more than to cross to the other side, made a strong impression on me. Seeing that many other activists of my generation ignored the repressive side of Communism, I learned more about the Soviet Union. It became obvious that justice must be genuinely universal—irrespective of political systems and ideologies. We still were living with the Cold War, and the risk that the human rights cause would be used for purely political purposes was blatant.

This understanding led me to join a new organization that had just been founded a couple of years earlier in London: Amnesty International. I was attracted by its impartiality and reliability regarding facts—its professional approach put the propagandists to shame.

My enthusiasm for the Amnesty cause led me to Athens soon after the military coup in April 1967. Some of my contacts had already been arrested and others were in hiding. In spite of this, I managed to collect some testimonies about gruesome torture that I sent to the Amnesty Secretariat in London. I underestimated the security apparatus of the colonels; when I returned to Athens in December, I was arrested at the airport and later deported. I was pleased when the Nordic governments brought a complaint against the Greek junta to the Council of Europe's Commission for Human Rights. Perhaps intergovernmental organizations are not useless after all.

When chairing the executive committee of Amnesty International, I was asked to go to Oslo to receive the Nobel Peace Prize on behalf of the membership. The Norwegian committee had noticed our work against torture and the death penalty. Two years later, I moved to London as secretary-general of Amnesty International, which took me and my colleagues to countries like Peru, Sudan, Iraq, and Vietnam—always following through with critical reports.

After six years, I joined Save the Children as their secretary-general. This gave me a chance to fully engage in the cause of children's rights—an aspect of human rights which had so far been largely ignored. The UN had decided to start drafting a special UN convention on the rights of the child, and the non-governmental child rights community was given an opening to influence it—which of course we used.

When the treaty was adopted by the General Assembly, I was elected into the 10-member monitoring committee. Meeting at least 12 weeks per year, the committee scrutinized the performance of one country after another on their implementation of the convention. This exercise turned out to be more effective than we had hoped; the convention and the monitoring process have improved the lives of many children.

I wish I could offer a similar positive remark on two other engagements: representing the United Nations on human rights in Cambodia and representing the Swedish government in the multilateral peace process in the Middle East. At long last, a decision was taken to bring the surviving Khmer Rouge leaders to trial, but more recent killings and other human rights violations have only been partly addressed. Even the humanitarian efforts in the Middle East have ended in further frustrations.

When coming to Strasbourg and the Council of Europe in April 2006, I was determined to seek ways to contribute to concrete improvements, not only to make statements. I have been inspired by two women whom I knew personally: Katarina Taikon, who was a brilliant Roma rights campaigner and writer in Sweden, and Anna Politkovskaya, the brave and relentless investigative reporter in Russia. Both set an example for all of us. The two others whose thoughts and ideals I continue to consult repeatedly are Andrei Sakharov, the visionary Russian human rights activist, and Janusz Korczak, the Polish medical doctor and writer, who better than anyone else conveyed the very idea of the rights of the child. I have their pictures on my wall in Strasbourg, and continue to seek their advice.

THOMAS HAMMARBERG (b. 1942) is a Swedish human rights activist who has spent decades working for the advancement of human rights worldwide. He has held many noted positions, including serving as Secretary-General of Amnesty International (1980–86), where he was instrumental in the growth of both the reputation and influence of the organization. He received the Nobel Peace Prize on behalf of Amnesty in 1977. He was UN Envoy for Human Rights in Cambodia 1996–2000. He served as Commissioner for Human Rights of the Council of Europe from 2006–2012, and continues to publish and lecture extensively on a wide range of human rights issues, including the rights of children.

KHATUN SAPNARA

BRITAIN — BARRISTER/JUDGE

BOTH AS A BARRISTER AND AS A JUDGE, I routinely handle cases in which the state intervenes to safeguard the welfare of children where there are allegations of serious physical and sexual abuse. These proceedings are highly sensitive and involve a difficult balancing exercise between the competing human rights of all members of the family. I have a special interest in cases involving so-called "honor-based" violence, and I assisted in drafting legislation to provide protection and relief to victims of forced marriage.

I was born in a village in what was then East Pakistan. I retain vivid memories of the civil war that led to the creation of Bangladesh in 1971. The war was fought for economic equality, political inclusion, and against linguistic discrimination. The atrocities perpetrated by the Pakistani army included genocide, rape of women, and persecution of minorities and intellectuals. The men in my family were members of the Mukti Bahini—freedom fighters—in the guerrilla war against the Pakistani forces. My father was stuck in England, where he was earning money to support the extended family back home. He helped mobilize efforts to raise funds for the freedom fighters. We were targeted and forced to flee. The Pakistani soldiers burned our home and our possessions.

It was a complete culture shock to arrive in England. We lived in a largely white, working-class area. For the first time we had electricity, running water, and television, but we were isolated and spoke no English. We experienced physical and verbal abuse from members of the majority white community. Ironically, the people we most closely identified and associated with were Pakistanis, because we were all deemed "pakis" (a derogatory term) and we were also all Muslims. The far right was on the rise in England. When black and minority ethnic (BME) people were racially assaulted and they acted to defend themselves, the police would routinely arrest these victims and take them into custody rather than ensuring the real perpetrators were brought to justice. Some high-profile murders, as well as lesser instances of racism and discrimination, led to my involvement in campaigns for justice.

I found myself becoming an advocate for members of the community in their dealings with the authorities simply because I could read, write, and speak English, and argue for the rights of individuals to be heard and respected. At the same time, I was active in projects to assist Asian women and help them achieve independence via recreational facilities and skills classes. We also established refuges to meet the specific needs of Asian women victims of domestic violence. This brought me into direct conflict with the men in the Asian community who abused and intimidated us, regarding our efforts as corrupting influences bringing shame and dishonor upon their community. I would later experience a period of ostracism from my family and the Bangladeshi community when I divorced my first husband and later remarried a man who is of a white, English, Catholic background.

These experiences served to heighten my awareness of the various forms of injustice and to understand the power of knowing one's rights and being able to articulate them with courage. It was not common for anyone from my social background, let alone a woman, to go to university; my parents and I faced considerable opposition from the community. I read law at the London School of Economics and was called to the Bar in 1990. I declined the offer of a pupillage with some high-profile barristers in order to help set up a chambers (barristers' offices), which was one of the first outside the traditional Inns of Court. Based in East London, at the top of Brick Lane, it was in the heart of the Bangladeshi community. I later returned to chambers in the Temple. The English Bar and judiciary remains a bastion of white upper-middle-class men. I had to battle to secure a successful practice.

I have always prioritized, where possible, the representation of the least powerful litigants. Hence I have tended to represent individuals against the state; employees rather than employers; tenants rather than landlords; women and children victims of domestic violence. I believe passionately in a diversity within the legal profession that reflects modern society and allows litigants to feel heard within the legal system. Experience teaches us that if people are to have respect for the law, the law needs to respect the people.

KHATUN SAPNARA (b. 1967) is a London barrister who specializes in family law and a judge who presides over both family and criminal law cases. She was born in Bangladesh and is a practicing Muslim fluent in Bengali and Sylheti. In 2004 she was appointed by the Lord Chancellor to the Family Justice Council to advise the government on all aspects of the family justice system. Sapnara was the first person from a minority background to be elected to the Committee of the Family Law Bar Association. She regularly undertakes diversity training of the judiciary on behalf of the Judicial Studies Board. She is the Chair of Ashiana, a refuge and support agency for female victims of domestic violence and forced marriage from South East Asian, Turkish, and Iranian backgrounds. She has expertise in honor-based violence and assisted in drafting the Forced Marriage Act of 2007.

HELENA KENNEDY

BRITAIN — BARRISTER

PEOPLE IN ADVANCED DEMOCRACIES like to believe that the abuses happen elsewhere; that the horrors summoned up by the very words "human rights"—disappearances, torture, persecution of political opponents, the stoning of women—are invariably associated with totalitarian regimes. There is a reluctance to acknowledge that, while our own failings may be of a different order, we too fall from grace.

Germany during World War II demonstrated how an entire political system could be corrupted. Judges and lawyers provided a veneer of legality for the incarceration of Jews, homosexuals, and many others, thereby legitimizing a nation's surrender of its moral compass. These authority figures destroyed law and justice, all the while saying their role was simply to put into effect the laws which were passed by government.

After the war there was a growing international acceptance that laws had to be tested against some other standard. Setting such a standard was the legacy of Eleanor Roosevelt, whose role in the creation of the Universal Declaration of Human Rights is still a source of inspiration. With jurists from around the world, she fleshed out one of the greatest documents of all time. Judges and lawyers have to become whistleblowers when the state oversteps its mark, alerting the public so that the slow process of corruption is cauterized. The challenge, however, is to create a set of principles that will act as a backbone within every legal system. Our civil liberties may be vested in us as citizens, but our human rights are vested in our bare humanity. Even when our civil and political rights are removed, we should be able to appeal for protection on the basis of our rights as human beings. How many of our systems pass that test?

Terrorism is one of the greatest challenges to the rule of law. The temptation to erode human rights and civil liberties is great in the face of such provocation. This is precisely the repression terrorists seek to stimulate; if care is not taken, the emergency measures to combat terrorism will undermine the very freedoms we value.

Bad law is counterproductive. Internment without trial in Northern Ireland was the best recruiting sergeant the IRA ever had. In the aftermath of 9/11, just as the United States created the legal black hole of Guantánamo Bay, we in Britain created indefinite detention without trial for aliens suspected of links with terrorism. We enabled rendition, the subcontracting of torture to regimes with fewer scruples; we were prepared to use evidence extracted under torture; we returned people to countries that condoned torture. After long legal battles, our courts intervened when we invoked human rights law. What is now graven on my heart is that abandoning legal principle leads to miscarriages of justice. Security is never secured by sacrificing liberty.

The Human Rights Act became United Kingdom law in 1998. It incorporated the European Convention of Human Rights, providing a new intellectual framework for legal practice in Britain. It should never again be possible for the state to claim democratic legitimacy or majority will for behavior that denies any person's humanity. And it takes the protection of rights to a new level by requiring the state to prevent oppression from other sources: private companies or battering husbands or communities exhibiting cruel behavior.

I was brought up in a large working-class Catholic family in Scotland; my mother was a great source of support to women in our community, and my father was a trade unionist who fought for decent wages. I saw how lives could be blighted by poverty and double standards. I had a visceral reaction to the courts' failures to provide justice for women—whether as victims or as defendants. I have represented many women who have killed their partners after years of abuse, and dealt with cases where women from minority communities have endured racism, forced marriages, honor killing, or genital mutilation.

The struggle to create internationally binding norms is greatly undermined when long-established democracies refuse to accept constraints on their own behavior. Rights have to be given the force of law; it is how we link our dreams to the acts of daily life. Human rights provide us with a new language for discussing our relationships with each other and with the rest of the world. For me, it is where the law becomes poetry.

LADY HELENA ANN KENNEDY (b. 1950) is a noted criminal lawyer who frequently defends alleged enemies of the state. She acted in many of the largest IRA trials: the Brighton bombing of Margaret Thatcher's Conservative Party conference; the Balcombe Street Siege, which was the culmination of 35 bombing and shooting incidents aimed at the British establishment in London; and the Guildford Four appeal, where defendants spent 17 years in jail for crimes they did not commit. She is the Chair of Justice on the International Commission of Jurists and a maverick Labor politician whose passion for human rights, civil liberties, and constitutional issues makes her a force to be reckoned with in the House of Lords.

NICHOLAS KATZENBACH

UNITED STATES — LAWYER/ACTIVIST

RACIAL DISCRIMINATION FLOURISHED after the Civil War, despite the constitutional amendments abolishing slavery, giving blacks the right to vote, and guaranteeing them due process and equal protection of the laws, and in the Deep South a caste system based on rigorous segregation and denial of equal status was enforced by state governments. Gradual change began in the 1930s with groups such as the NAACP, which fought to enforce the Civil War-era constitutional amendments. The biggest breakthrough came from a unanimous Supreme Court in *Brown v. Board of Education* declaring schools segregated by local laws to be a violation of the Equal Protection and Due Process clauses of the Fourteenth Amendment—and therefore unconstitutional. *Brown* opened the door to the civil rights movement led by Martin Luther King.

When I joined Bobby Kennedy in the Justice Department in January 1961, Dr. King and his followers were "sitting in" at restaurants and stores that refused them service, marching in protest, and suffering police violence and mass arrests as a consequence. Demonstrators understandably demanded federal protection, from local police as well as racist groups acting in violation of the constitution. The Justice Department responded with lawsuits designed to produce court orders demanding compliance, but southern authorities refused to comply with rulings they did not like—a complete breakdown of our federal legal system. Enforcing a court order required actual use of force, as President Eisenhower had discovered at Little Rock when it took the army to get black children admitted to school. Thus President Kennedy was faced with the danger of violent confrontations between federal and state law enforcement.

The refusal of Governor Barnett and the University of Mississippi to comply with the order of the Supreme Court to admit James Meredith, a qualified black citizen of the state, to the university as a student resulted in a riot. Over 20,000 federal troops were dispatched by the President to secure order and Meredith's admission. Two people were killed and scores wounded by gunfire from racist groups. I was there, and—like others in the Justice Department—saw the riot as a failure of law enforcement. Many, including many Southerners, saw the refusal to accept the law as the governor's failure, not ours. In retrospect, Ole Miss was a turning point.

A few months later, Alabama Governor George Wallace similarly refused to admit two black students, Vivian Malone and James Hood, by "standing in the schoolhouse door" at the university. Unlike Governor Barnett, Wallace provided substantial law enforcement to prevent disorder, and only yielded when President Kennedy ordered the Alabama National Guard into federal service. The President was sufficiently encouraged to commit his administration to seek effective legislation to ensure blacks equal protection of the law—a difficult commitment for a Democrat politically, and one that might well fail to secure passage in Congress.

To pass the Civil Rights Act required support from the Republican Party. There were not enough non-Southern Democrats and liberal Republicans to get a majority. In the House, the key was to gain the support of the senior Republican on the Judiciary Committee, William McCullough, a conservative from a conservative Ohio district. He told Burke Marshall, the architect of Kennedy's civil rights policy, that he would support a "reasonable" bill provided we agreed not to give away any provisions in the Senate, as had occurred with all prior civil rights bills. We agreed; we really had no choice.

When President Kennedy was assassinated, President Johnson took over. After ups and downs in the House, we finally got a strong bill enacted with support from the Republican leadership. Thanks to McCullough, the longest filibuster in history was finally defeated, permitting possibly the most important law of the century to be enacted. A year later, the Voting Rights Act was passed.

Of course, the two acts did not put an end to racial bias, but they did make it less overt: race no longer trumps equal justice under law.

NICHOLAS KATZENBACH (1922–2012) inherited his interest in public service and government from his family, especially his mother. He left college to volunteer for the Armed Services during World War II and survived being shot down over North Africa. When John F. Kennedy was elected in 1960, Katzenbach, then a law professor, was determined to join the new administration. His legal brilliance and political talents thrived in the tumult and camaraderie of Robert F. Kennedy's Justice Department, where he served as Legal Counsel and then Deputy Attorney General; he succeeded Kennedy as Attorney General (1965–66) and served as Undersecretary of State (1966–68). Katzenbach played a leading role in shaping and implementing the Justice Department's civil rights policy, from the Freedom Rides through the enactment of the Voting Rights Act. His work "on the ground" during the bloody battle over the desegregation of the University of Mississippi and in a showdown with George Wallace at the University of Alabama illuminate the skills and courage that attended the desegregation of those Deep South institutions. Katzenbach's memoir, *Some of It Was Fun: Working with RFK and LBJ* is a captivating chronicle of the spirit and possibilities of government service during that transformative era.

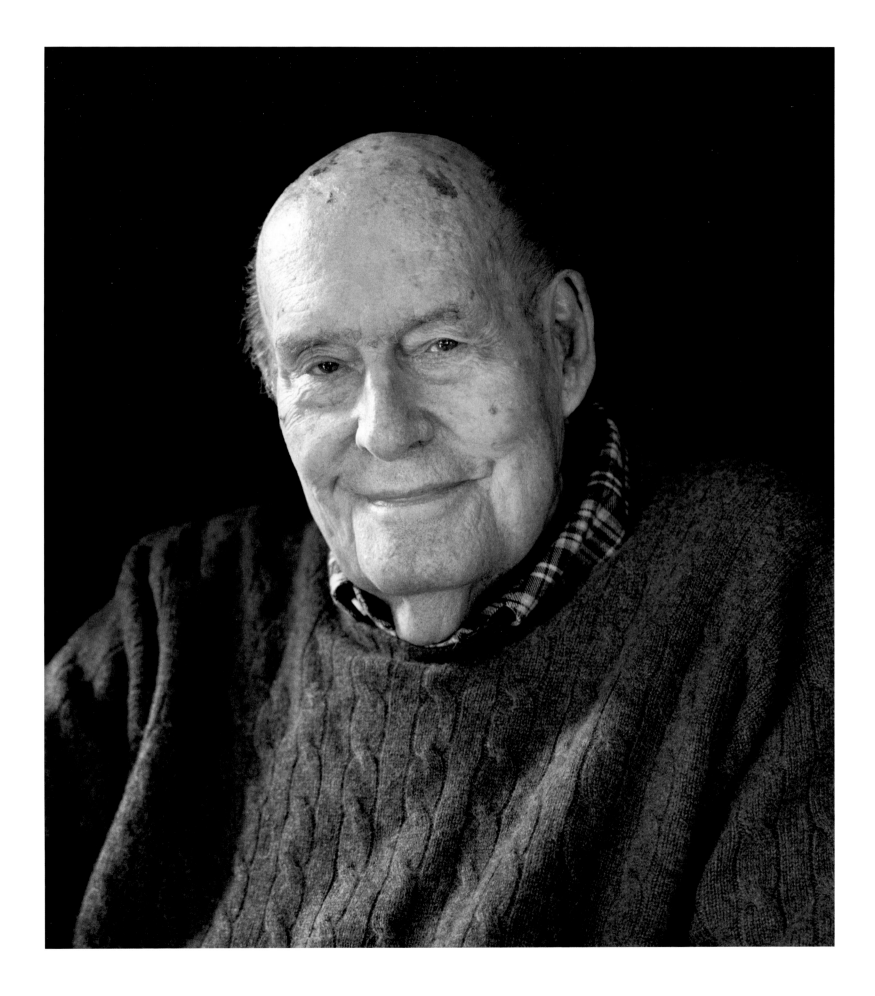

AHARON BARAK

ISRAEL — JUDGE

I WAS BORN IN KAUNAS, LITHUANIA. In July 1941, when I was five years old, Operation Barbarossa began and Nazi German soldiers marched on Kaunas. Like the rest of the Jews, my father, my mother, and I were sent to the ghetto. The world closed up around us. Our freedom was denied. Our lives became worthless. Shortly after the Jews were sent to the ghetto, we were instructed to gather in the ghetto's main square—dubbed "Democracy Square." Once in the square, we were randomly sorted—a German officer sent one family to the right and another to the left. Our half remained standing in the square. The other half was removed from the square and its members were executed in the valley of death for the Jews of Kaunas, the Ninth Fort.

So began my life in the ghetto. It was a life of humiliation and murder. However, we held on to our human dignity. In the ghetto, there was mutual assistance and there was self-rule. In July of 1943 the "children's operation" came into force. All children under age nine were captured by Nazi soldiers and killed. Only by a miracle did I survive. My mother and I were smuggled out of the ghetto, and a Lithuanian farmer with a heart of gold put us up in his home. He treated a number of other families who were able to escape from the ghetto with the same kindness. Once our numbers had increased, and my mother and I had to leave, he sent us on to another Lithuanian farmer, who had a wife and four children. They, too, put their lives in danger in order to save ours. We lived there, in very difficult conditions, until the end of the war.

My father remained in the ghetto and miraculously survived. Our family was reunited, but the Russians learned shortly after that my father was a Zionist and he was arrested. We had to flee from Kaunas. We were given the false identities of Greeks returning to their homeland. We wandered across Europe. Ultimately, we reached Rome, where we were finally treated humanely. We remained in Rome for two years, as we were not permitted to come to Palestine. Only in May of 1947 did we finally make *aliyah* and immigrate to Israel.

As a judge, I have been asked numerous times whether my legal and judicial philosophy regarding human rights has been affected by my personal history. I am not sure, but I believe there is a connection regarding the following three elements. First, I learned from my history the importance of the state of Israel to the Jewish people. I am convinced that if we had possessed a state when the war began, the Holocaust would not have been carried out to the same degree. The state is not only a source of human injury; it is also a source of protection. I have always seen it as part of my role to protect the state's existence and its security. Second, I personally experienced the grave consequences of a limitation of human rights. The Germans took our lives, but they wanted more: they wanted to destroy our dignity. I recognize the importance of every individual, and I believe that every judge's role in a democratic society is to protect each individual's rights. Third, there is constant tension between these two elements, which cannot be solved by preferring one element over another. The state should not be sacrificed on the altar of human rights, nor should human rights be sacrificed on the altar of the state. National security should be protected while protecting the individual. There must be a correct balance between the two.

My judgments have recognized the need to ensure security while also ensuring human rights, which includes the rights of minorities. Jews were a minority as we wandered the world. The equality we asked of others should be upheld in our country. We must ensure the rule of law. The rule of law is not just the law of rules. The rule of law is the rule of the *proper* law—the law that balances properly between the individual and the general public, between the citizen and the state. In its battle against terror, the state cannot use the means that terror does. Democracy must manage the battle against terror with one hand tied behind its back. However, it still has the upper hand, as the rule of law is on its side. Indeed, democracy is majority rule. Democracy is also the individual's right. Democracy balances between the two, and a judge's role in a democracy is to protect the democracy. My personal experience has taught me that if we do not protect democracy, democracy will not protect us.

AHARON BARAK (b. 1936) was Justice of the Supreme Court of Israel for 28 years (1978-2006), of which 11 were served as its President. As a judge, he developed the Israeli common law and contributed to the Israeli constitutional revolution, which recognized the constitutional power of the Basic Laws—first and foremost Basic Law: Human Dignity—and the existence of judicial review. In his judgments he championed human rights and has done a great deal to preserve, develop, and protect them.

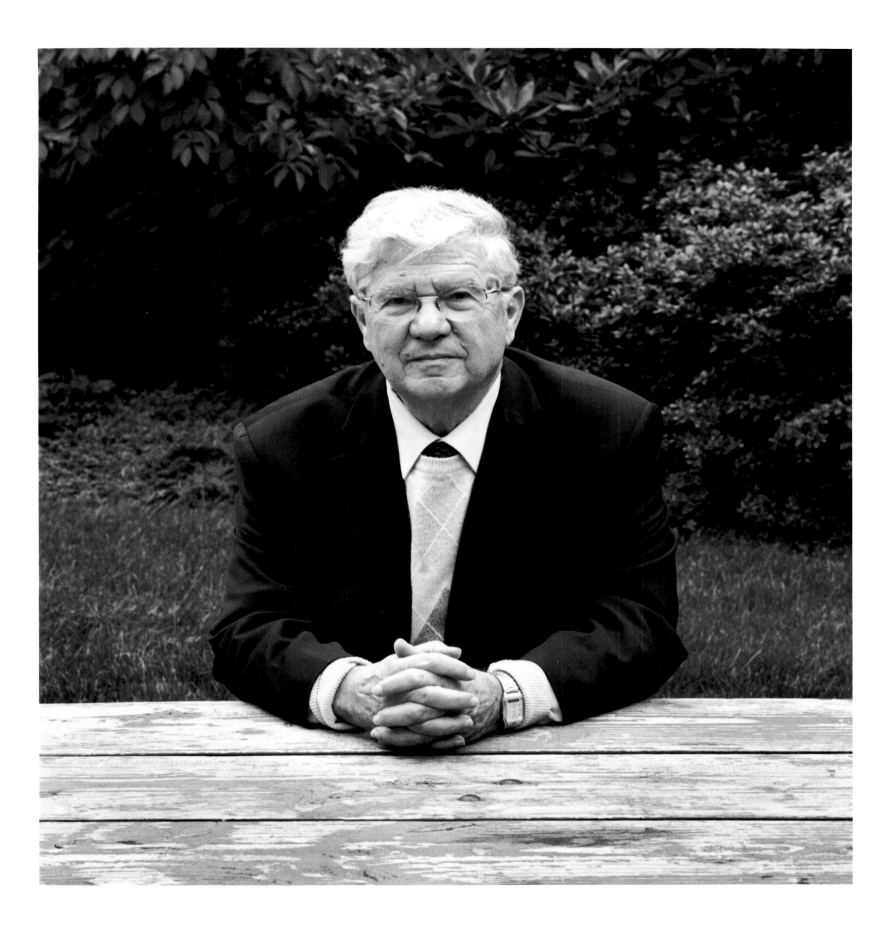

SONIA PICADO

COSTA RICA — JUDGE/AMBASSADOR

I HAVE GREAT ADMIRATION FOR MY FATHER, and in many ways I have tried to emulate him. He was born in a humble house in the countryside of Costa Rica. When he won a scholarship to go to the city to study, people in his town collected money to buy him shoes and a uniform. Later, he was awarded foreign scholarships to go to law school. He was very successful, and after his death he was named "Distinguished Father of the Homeland," the highest honor in Costa Rica. He taught me that the most important thing in life is to help others. If you are not committed to other people, then what is the meaning of success?

As a woman, I paid a high price for the right to think and the right to study. When I decided to go into law, not even my father was happy. He felt that it would be made very difficult for me and that I should think about a different career. And it *was* difficult. I had two children while I was studying and nobody made it easy. I have had to sacrifice a lot for my career and for personal fulfillment. Only after my second divorce did I learn to be comfortable on my own. A woman by herself could not do anything in Costa Rica. When I came to New York to teach at Columbia in 1991, I learned to be by myself. I learned to go to restaurants, to the theater, to symphonies—I gained a self-assurance that I am grateful to New York for.

Throughout my career, I have fought hard for women's rights. In the '70s, I fought in Congress with a group of women to change the family code in Costa Rica. The legislation we had treated women like children and idiots. It was said that women always had to be under the protection of a man. This was true in France and Spain, which is the legislation we inherited. In France, women could not open their own bank accounts until 1965, and a man had to testify with them. In Spain, they could not own property until the '70s, after Franco was dead.

I was elected dean of the law school of the University of Costa Rica in 1980, and while I was there I met Thomas Buergenthal, who was dean of the American University Law School. In 1984, he proposed my appointment as executive director of the Inter-American Institute of Human Rights, an institution that trains judges, lawyers, and NGOs on human rights and civil liberties issues. These were very difficult times for Latin America. In the Southern Cone, the military regimes were attacking civil society, torturing people at will, with the policy of "the state's national security." Thirty years later, they are reopening cases of political persecution, and women who had never wanted to testify before are now willing to speak against the generals who

killed their husbands and children. They want justice, no matter how late it is. I think it's important to help these people, but it's not easy, since most of these governments declared amnesty.

Probably the worst human rights situation I ever lived through was what happened in Timor in the late '90s. The Timorese were fighting for independence from Indonesia, and so Indonesia offered them a plebiscite to vote on whether they wanted to be autonomous or fully independent. Ninety percent of the Timorese voted for independence, and the Indonesians responded by coming in and killing everybody—all the men that were there. You would see women and children with no arms, no eyes. Where there had been ranch houses, all you could see were circles of ashes.

I was appointed president of the Commission of Inquiry in East Timor. There were three women in the group of five on the commission: myself, a German woman, and a Nigerian woman. We interviewed women in Timor. They told us how they had been beaten, but none would admit to being raped. Of course they *were* raped, but they didn't want the dishonor of admitting it. The commission wanted to go to West Timor, where many prisoners had been taken. The Indonesians tried to keep us out at first, and when they finally let us in, they tried to convince us that all the devastation had just been the Timorese fighting among themselves. They had set up a Human Rights Court of their own—but what kind of justice would that be? So we called for a Truth Commission.

No matter what I have done, being a woman has been hard. I feel proud that in every position I have ever filled I have been able to help women, and women continue to need great amounts of help. I would say this remains one of the greatest challenges in the future of human rights.

SONIA PICADO (b. 1936) was the first female to serve as Dean of a law school in Latin America (University of Costa Rica, 1980). She is Chairman of the Board of the Inter-American Institute of Human Rights, a former member of the Costa Rican Legislative Assembly, and former President of the National Liberation Party. In 1999, she led the International Commission of Inquiry on East Timor that investigated human rights abuses. She was the Costa Rican Ambassador to the United States from 1994 to 1998 and the Executive Director of the Inter-American Institute of Human Rights from 1984 to 1994. From 1988 to 1994, she served as the first female judge and Vice-Chair of the Inter-American Court of Human Rights. In 1993, she received the UN's Human Rights Award in recognition of her human rights work in Latin America.

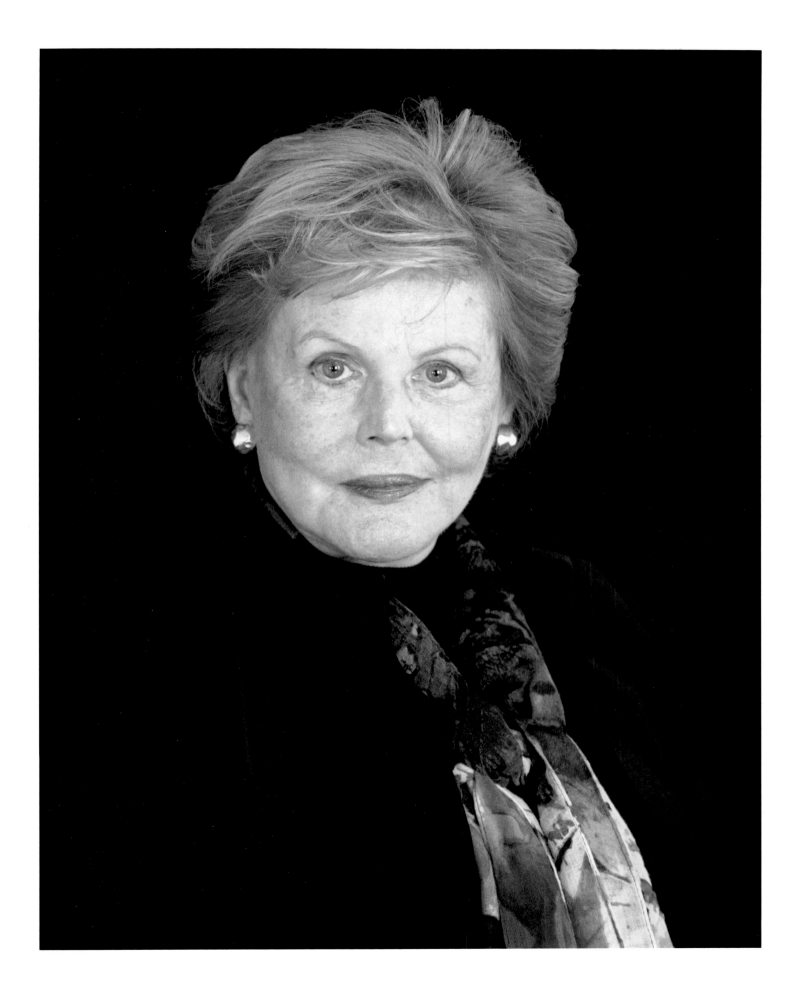

HINA JILANI

PAKISTAN — LAWYER/ACTIVIST

MY ENGAGEMENT WITH HUMAN RIGHTS in Pakistan began in 1979 as a young lawyer struggling to uphold fundamental freedoms in the face of martial law. The policy of the so-called "Islamization" of the state—which this regime enforced as a measure to legitimize the unlawful derailment of the democratic order—proved to be extremely harmful for the right to equality for women and non-Muslim citizens. Special laws that reinforced social and cultural biases and imposed cruel, inhumane, and degrading punishments were used as a tool to instill fear in the population and silence dissent.

The military regime solicited the support of religious groups and rewarded them with an influence over state policy that was totally disproportionate to their support amongst the population. These groups were then used to inflict violence on anyone who did not comply with their notions of morality or religion. It is in this environment that a few women and men launched a movement for human rights. On the one hand, we challenged religious precepts and the legitimacy of a regime that negated democracy; on the other, we educated the population on their rights and freedoms, which the state has a fundamental duty to protect. It was the first time in Pakistan that women's rights became prominent in a movement for democracy, with women leading and having the opportunity to set the agenda.

The military in Pakistan reacted by using violence on peaceful demonstrators; arbitrary arrests; trials by military courts; imprisonment and vilification of human rights defenders. These retaliatory measures became an unavoidable part of my life for several of the 11 years that the regime lasted. I had no illusions about the rule of martial law in Pakistan, however, which made such measures somewhat easier to endure.

I had grown up in a house where politics was as intrinsic to life as food. I had learnt my lesson of "protecting justice and freedom at all cost" from a father who had been to jail repeatedly for his opposition to military and civil dictators. More remarkable for me was the courage and resilience of my fellow advocates, who were also bearing these tribulations—especially the women who had led lives relatively free of any direct repression.

Looking back over these three decades of work, I consider every difficulty we faced and every action we took, whether in courts of law or in the streets, to be worth the struggle. Today, Pakistan can be proud of the human rights community and the vibrant civil society which the initiative of a few inspired. Human rights, particularly of women, are now an intrinsic part of the manifesto of all political parties. The defense of rights in Pakistan has given me a better understanding of how they can be promoted at the regional and international level. We not only forged durable outside support networks but also contributed a southern perspective to the development of global human rights policy.

Lingering problems of our past are a continuing challenge. Poverty, bad governance, religious intolerance, terrorism, counterterrorism, increasing militarization, weak institutions, and ineffective systems of justice undermine the gains made by civil society. Many organizations—whether they are state-controlled or adverse to it—find this an ideal environment to promote their agendas of hate, exploitation, and violence. Those who advocate economic justice, tolerance, and peace remain the first targets of these organizations.

At the same time, the reinstatement of a political process and freedom of the media has given the public access to information and exposure to a variety of political views, which was not possible in the past. If these developments can promote human rights, and bring peace and security to the country, we may yet overcome the menace of terrorism and religious extremism that has become the major threat to stability and development in Pakistan.

Of course, external factors also affect Pakistan's prospects. The situation in Afghanistan, the strategic interests of countries such as the United States, the balance of power within South Asia, and the progress in Pakistan-India peace initiatives are all issues of current concern. It is in this context that regional and international initiatives on strengthening human rights, democracy, and peace have gained importance here.

HINA JILANI (b. 1953) has been an Advocate of the Supreme Court of Pakistan since 1992 and was the Special Representative of the Secretary-General on Human Rights Defenders from 2000 until 2008. Jilani was appointed Advocate of the High Court of Pakistan in 1981, and in the same year she established Pakistan's first all-female law firm. Her cases have set the standard for human rights in Pakistan. Throughout her career, she focused on the rights of women, minorities, children, and prisoners. In 1999 she was honored with the Human Rights Award by the Lawyers Committee for Human Rights, and in 2000 she received the Amnesty International Genetta Sagan Award for Human Rights. As the Special Representative of the UN Secretary-General on Human Rights Defenders from 2000 to 2008, she has been part of critical human rights investigations undertaken by the UN in places like Darfur and Gaza. Her sister, Asma Jahangir, is President of the Supreme Court Bar Association of Pakistan and was the UN Special Rapporteur on Freedom of Religion or Belief from 2004 to 2010.

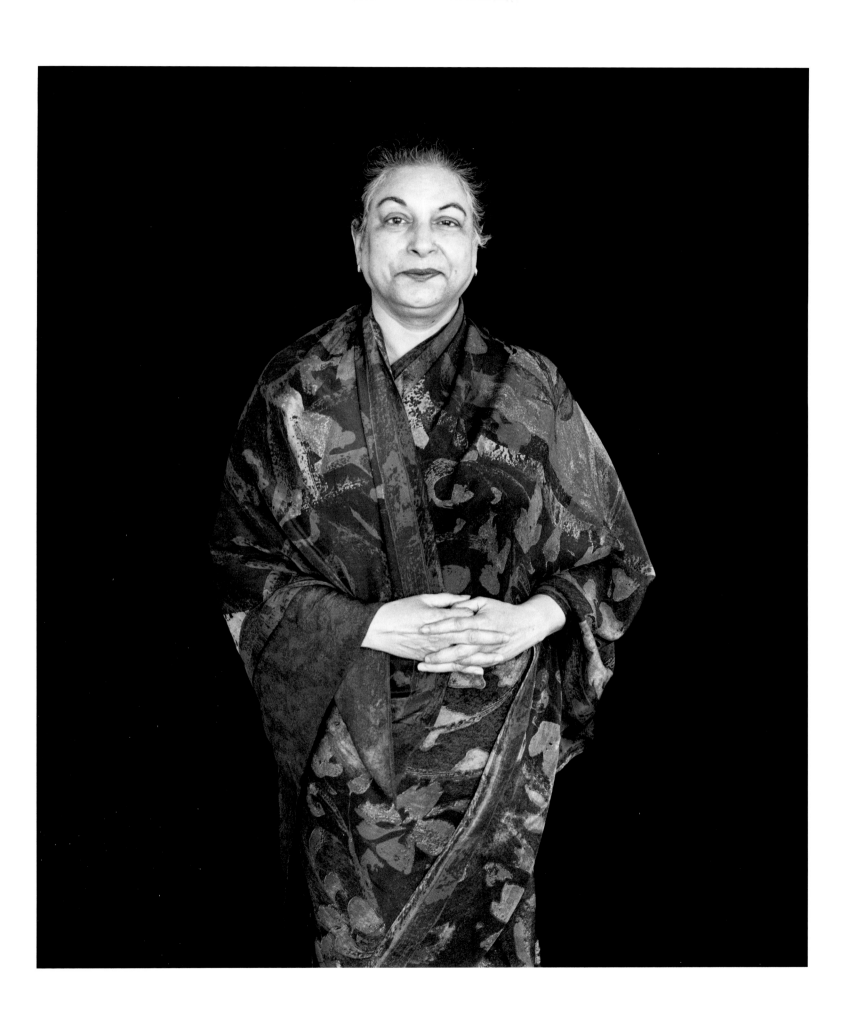

MAMPHELA RAMPHELE

SOUTH AFRICA — ACTIVIST

I WAS BORN IN POLOKWANE, in Limpopo Province, on the border with Zimbabwe. It is the poorest part of the country. Many of my friends hardly saw their fathers because the fathers worked in mines as migrant laborers. My parents were both teachers, so they were above the grim bottom level of poverty, but apartheid confined them. I was sent to a teacher-training school at age 14 where the black students were not allowed to shake teachers' hands. I decided to become a doctor to be my own mistress, free of the boundaries on blacks and women. I managed to borrow money and go to the medical school of the University of Natal. I started practicing as an activist physician in the Eastern Cape.

At that time, black people used to go through back doors to doctors' offices. We set up a new health center that embodied the respect and the care and the empowering approach that we thought was needed. Doctors back then would examine you and give you a prescription, and you were supposed to be grateful. Instead, we related to the patients as fellow citizens, told them how to stay healthy, and made clear that they were responsible for their own well-being. The clinic is still going strong. Sadly, the nursing sister in charge told me that three out of every five people they test for HIV/AIDS have it. Seventeen years ago, our life expectancy was close to 67 years. It is now under 50. How can you sustain a society with that?

I was banished to Tzaneen, a poor, bleak, and distant place because of the medical treatment I was providing for blacks. Everything I did as a professional was a political statement. I was 29 years old and pregnant with my first son. His father, Steve Biko, and I had met at medical school, but he dropped out because his focus shifted completely to political activism. He was arrested, tortured, and killed by the security police in 1977, shortly before our son was born.

I was forced to live in Tzaneen, where I set up another medical clinic and a youth center. But when my banning order was lifted, after seven years, I was exhausted from community activity. I went to the University of Cape Town with the help of Professor Francis Wilson. I wanted to write about my experiences, and that brought me to the Department of Anthropology, where I obtained a PhD. Francis and I published a book on poverty in South Africa.

For those black people who managed to escape from poverty since the end of apartheid, the situation has changed a lot. But the tragic story of post-apartheid South Africa is that we have created an environment in which the rich get richer and the poor are left behind. When we wrote our book, South Africa and Brazil were at exactly the same level of development. Look at Brazil today!

The difference is in Brazil's choices on education: the focus on quality education, no excuses for mediocrity. We chose a school curriculum that is the ruin of us. The African National Congress (ANC) made that choice on advice of experts, but the lack of accountability made correction hard when failures occurred. At least during the apartheid era, those who went to school could read and write and had reasonable levels of competence to be able to improve their own learning. Now they can't read. They can't write. The majority of our primary school teachers have not even finished high school. My children and all of the politicians' children and grandchildren go to private schools, or schools in what were formerly white suburbs. You see what happens! The gap widens.

The ANC continues to be elected because of its association with liberation, not its performance in government. You don't have the feedback that works in normal democracies. The legacy of apartheid is severe. Our biggest problem is that the ANC is a governing system focused on patronage—to take care of our own. In practice, we just don't have the resources to provide free housing, education, and health care for all those who need it.

It is important to remember that blacks were not *liberated* by the ANC. They liberated themselves, because people were activists in the streets—whether they were educated, uneducated, trade unionists, church people, you name it. And that's what made it imperative for the National Party government to settle. But that understanding is not there. As long as people in South Africa believe the ANC has liberated them, they will continue to vote for them.

If Steve Biko were alive, the important contribution he would make would be to provide a reasoned alternative voice. He had the persuasive powers to get across to people, so he probably would have been able to persuade President Mandela to go a different route, and that could have been crucial. As you see, I am a critic—a critic with a vision of what my country should be.

TAKNA JIGME SANGPO

TIBET — POLITICAL PRISONER/ACTIVIST

I WAS BORN IN 1932. Tibet was a country with a population of about six million people. We had a king, a bank, an army, and courts. The Chinese arrived in 1949. In 1959, the Chinese military attacked Chamdo, a region of eastern Tibet. On March 10, 1959, the Tibetans rebelled against the Chinese. But the uprising failed.

One of Tibet's two supreme leaders, his Holiness the Panchen Lama, wrote a 70,000-character petition to China's Mao Zedong on behalf of the Tibetans, and as a result the Chinese branded him a separatist and sent him to prison. When I chose not to denounce him immediately, they imprisoned me as his follower. I was in prison for three years and released in 1968, at the beginning of the Cultural Revolution. I had been a teacher of Tibetan language and culture for children aged 7 to 12, and I was upset by China's campaign to cleanse the schools and region of anything Tibetan. I became a spokesman for Tibetan freedom. This time I was put in prison for 10 years; the year was 1970.

At Drapchi prison, I was treated very badly—they beat me, hitting my back and aiming right for my kidneys. The guards would stand on either side of me, holding me steady as one of their compatriots took a belt and whipped me hard. They also used a chain to tie my hands together so it was very difficult for me to lift up even a cup of tea to drink. They kept me bound that way for six months. For several years, they put chains around my upper arms and attached me to a wall. The chains were so tight they bit into my arms. They never killed me, because I was considered a political prisoner. I had done nothing wrong—committed no crime, killed no one—my only fault was to be an advocate for Tibetan freedom.

I first heard about the concept of human rights in 1992. At that time there were also Chinese prisoners with us. Some of them would say to the police, "We prisoners are humans!" When I heard this I thought it was funny and wondered, "Well, of course we are humans!" The Buddhist religion taught us to love and have compassion for others, but not this political concept of "*human* rights." That's when I understood that the Chinese never considered me a person. Between 1959 and 1967, many of my fellow Tibetan prisoners had starved to death, committed suicide, or died of exhaustion from forced hard labor because they weren't afforded basic human rights.

China is intent on removing every remnant of Tibetan culture and religion. In Lhasa (the Tibet Autonomous Region in China), members of the Tibetan community are barred from using their own language, and Tibetan is not even taught in school. There are some colleges that claim to have Tibetan class, but it's all for show, as in a museum. These days the village schools are changing because Tibetan children are sent to China for higher education. They leave to study, and when they return as teachers they speak Chinese to the Tibetan children. The Chinese pay them what is considered a high salary for Tibetans in rural areas—two to three thousand yuan per month (about 300–500 U.S. dollars), to ensure the eradication of Tibetan culture and language.

There is still hope that Tibet will be free one day, and it is because of this hope that I endured so many years in prison. Even if we don't gain full independence, I believe if we follow the "Middle Way" approach of the Dalai Lama we will certainly gain more freedoms. Perhaps if China someday becomes a democracy, the people will then gain equality and power and Tibetans can live freely without fear.

Altogether, I was in prison for 37 years. In 2001, I was told that I could go to America, but I had to promise that I would not return. I refused. I was subsequently locked in a tiny room measuring eight-by-four feet and kept there for a year under the constant observation of a Chinese guard. There was no air in the room; it had one small window that was always closed and covered with glass. It was hard to breathe. I often wondered if they were going to kill me or send me to China. In retrospect, they were probably watching me very carefully because an American named John Kamm was working on my release.

John Kamm came to see me in June of 2002 accompanied by a policeman and a Chinese officer. They spoke about sending me to the United States, where the Americans would be kind to me. I was very excited because the chief of police of the Tibet Autonomous Region was there. The news spread all over Lhasa. I left Drapchi prison on July 10, with a new Chinese passport in hand.

America was really famous among Tibetans at that time, and they talked about how cars there moved around like ants. As soon as I arrived in Chicago, I saw this for myself and was amazed. Even though in some ways I sacrificed my whole life for Tibet, in the end I feel that my life has turned out well. I've become a very happy person. I have gained freedom, and it is very good.

TAKNA JIGME SANGPO (b. 1926) was first sentenced to three years of "re-education through labor" by the Chinese in 1964 for teaching Tibetan history, culture, and language to children. He spent 37 years as a political prisoner—the longest prison term served by a Tibetan—until he was released on medical parole in 2002 at the age of 76. He was known as "one of the most determined and intransigent political prisoners in Drapchi... highly respected by other political prisoners." He now lives in Switzerland as a political refugee.

JOHN KAMM

UNITED STATES/CHINA — BUSINESSMAN/ACTIVIST

MY FATHER WAS A WHISKEY SALESMAN—a "purveyor of alcoholic beverages," as he put it. I learned salesmanship on his knee. I went to Macau and then Hong Kong in 1972, the year Nixon visited China, and made four trips to the mainland before Chairman Mao died. I am one of the few Americans left who remembers what China was like during the Cultural Revolution.

I got in on the ground floor of the China trade. In 1979 I opened some of the first foreign offices in Chinese cities, and ran the first advertisement for foreign products in a Chinese newspaper. A salesman is someone who convinces you to buy something that you don't think you need. For the last 20 years I have been selling human rights to the Chinese government. Initially, they felt they didn't need them. Gradually, occasionally, they've come around to thinking they might need them.

I didn't become a human rights advocate gradually. It happened in an instant, in a flash. In May of 1990, as president of the American Chamber of Commerce in Hong Kong, I was about to leave for Washington to testify at the first hearings of the debate on China's trade status in Congress. In those days, China's trade status had to be renewed every year. Before my departure, I and other leaders of the American business community were invited to a banquet by the senior Chinese official in Hong Kong. During dinner, my host raised his glass and thanked me on behalf of his government and his people. I stopped him and said, "Thank you very much. But what are you going to do for me?" Everyone must have thought I was asking for some kind of a deal, like "Buy a boatload of caustic soda." He said, "The Chinese government has done everything it can to promote good relations with the United States." I told him I disagreed. He asked, "What would you have us do?"

In the car on the way to the banquet that very evening, I had heard a report on the radio from the mother of a Hong Kong student who had been a leader in the Tiananmen protest in Shanghai. She was weeping because she had just learned that her son was being tortured in a detention center. We had heard many terrible stories, so it wasn't a shock, but it made an impression. So I asked this official, "Why don't you release that young Hong Kong student?" He exploded at the audacity of my request, but I persisted. "Five minutes ago, you were telling me what a great friend I am," I said. "I ask you to show some mercy to a young man, and now I'm no longer your friend?" My host could see the exchange spinning out of control, so he said, "All right. I'll see what I can do."

When I stood up, everyone thought I was leaving. I said, "Minister, I need to use the men's room." He snapped his fingers, and a waiter stepped forward to escort me through the villa's winding halls. The waiter was in front of me and then suddenly he stopped—perhaps where he knew there were no microphones—and turned to look at me. He was weeping. He hugged me and said, "Thank you for that." That's when my life changed.

If Congress had stripped China of its trade status, there would have been no Chinese economic miracle because they would have lost access to the American market. I testified in support of maintaining the relationship. I also called on the Chinese government to release young Hong Kong people in Chinese prisons. I told Congress that whatever capital I gained from my stand, I would gladly spend in the effort to lobby Beijing to release political prisoners. A few days after I returned to Hong Kong, I was informed that the young man whose name I had raised would be released. That was the first time the Chinese government had released a political prisoner in response to a foreigner's appeal.

I focus my attention on prisoners the Chinese police call the "two illegals"—those imprisoned for "illegal speech" and "illegal association." I have intervened in more than a thousand cases and have helped about half of those: either to obtain early release, better medical care, access to books, or more family visits. I have established a foundation—Dui Hua—in San Francisco that also has an office in Hong Kong. In "open source" publications, we find the names of hitherto unknown prisoners—6,000 so far—and put them on lists, which I then submit to the Chinese government. I'm in the prisoner-list business. I believe that being on a list increases one's chance of early release and better treatment. Milan Kundera has written, "The struggle of man against power is the struggle of memory against forgetting." My work is a testament to his words.

JOHN KAMM (b. 1951) was a business leader in Hong Kong when he first intervened on behalf of a political prisoner at a business dinner hosted by a senior Chinese official. In the ensuing 20 years he has helped hundreds of political and religious prisoners. He received the first Best Global Practices Award in 1997 from President Bill Clinton, and the Eleanor Roosevelt Award for Human Rights in 2001 from President George W. Bush. He is the only businessman to have been granted a MacArthur Fellowship for his work.

HAROLD KOH

UNITED STATES — LAWYER

THE EVENTS THAT MOST SHAPED MY LIFE happened not to me but to my parents. My late father, Dr. Kwang Lim Koh, grew up in Cheju, South Korea, under Japanese colonial rule, and was forbidden to speak Korean or even to use his Korean name. When the country was divided, my mother, Dr. Hesung Chun Koh, and her family were trapped in North Korea. In desperation, they hiked for days before they finally made it back to the South.

In the 1960s, South Korea briefly enjoyed democracy, and my father joined the diplomatic corps. But one day, his government was overthrown by a coup d'état. On the night of the coup, my father met with his colleagues at the South Korean embassy, and they all took an oath never to serve the military dictatorship. But over the years, everyone but my father broke his promise. Alone with his principles, my father was exiled to America.

My parents had met in America as students, where they shared a love of education, family, and freedom, which they savored like fresh air. One day, I asked my father whether he regretted not having served the junta. He turned to me furiously and almost shouted, "There will always be people who give up their principles to serve power! But who will remember anything about them, except that they stood for nothing?" My father loved John F. Kennedy, Fred Astaire, and Ted Williams. Driving down the road, he would turn and exclaim: "This is a great, great country. Here, we can do what we want."

During the summer that Nixon resigned, I was a college student visiting Seoul. Someone tried to assassinate Korea's President and he declared martial law. I called my father and marveled that Korea had never enjoyed a peaceful transition of government. Meanwhile, the world's most powerful government had just changed hands without anyone firing a shot. He said, "Now you see the difference: in a democracy, if you are President, then the troops obey you. In a dictatorship, if the troops obey you, then you are President." At that moment, I understood the difference between the rule of individuals and the rule of law.

And so I studied law, became a law clerk, a private and government attorney, and finally an international law professor at Yale. In 1989, I acceded to my students' pleas to start a human rights clinic at Yale. Before the Supreme Court, we challenged the repatriation of Haitian and Cuban refugees from Guantánamo prison to repressive regimes. It dawned on me that I was fighting for the very principles that had brought us to this country. To do such work was why I had become a lawyer, diplomat, and professor—unexpectedly following in my father's footsteps.

As the decade ended, the President I had sued asked me to be the top human rights official for the State Department. I traveled to scores of countries. Everywhere I went—Haiti, Indonesia, China, Sierra Leone, Kosovo—I saw in the eyes of thousands the same fire for freedom I had first seen in my father's eyes. Once an Asian dictator told us to stop imposing "Western values" on his people. He said, "We Asians don't feel the same way as Americans do about human rights." I pointed to my own face and told him he was wrong.

As my time in government ended, I traveled to North Korea. In the eyes of children, workers, and government officials I saw the lifeless, unfocused stares I had first read about in Orwell's *1984*. I saw people whose aspirations had been crushed by a government that would not provide for their most basic needs. As we flew out of a darkened Pyongyang, I looked down to see where my mother had crossed the border so many years ago. As we approached Seoul, suddenly the landscape glowed with millions of lights. The only differences between the bright futures to the South and the dark futures of the North were the governments that ruled them.

September 11 happened two weeks after I returned to academia. While dean of Yale Law School, I found myself again speaking out about Guantánamo, this time challenging the treatment of Al Qaeda detainees. And when Barack Obama was elected President, his Secretary of State, Hillary Clinton, asked me to be her legal adviser, a job my old professor had once called "holding the country we love to its own best values and principles." Every day has challenges. But whenever I feel challenged, I remind myself of how blessed I am. For, unlike my father, I can revere human rights and the rule of law, and still serve the government of the country I love.

HAROLD HONGJU KOH (b. 1954) was appointed by President Barack Obama as the 22nd Legal Adviser to the United States Department of State in 2009. From 2004 to 2009, he was Dean of Yale Law School, where he has been a professor since 1985, and he served as U.S. Assistant Secretary of State for Democracy, Human Rights and Labor from 1998 to 2001. Koh is a leading expert on public and private international law, national security law, and human rights. He has argued before the United States Supreme Court and other international courts and has often testified before the U.S. Congress. He has received dozens of awards for his human rights work, which includes litigating the notable case of *Haitian Centers Council v. Sale* that eventually led to the freeing of Haitian refugees held at Guantánamo Bay.

SERGEI KOVALEV

RUSSIA — ACTIVIST

THE MOST IMPORTANT QUESTION to ask anyone who has lived in a totalitarian society and openly opposed it is: "Why did you consciously risk prison instead of keeping silent?"

This question became relevant in the USSR after the 20th Communist Party Conference in 1956. With the "Khrushchev thaw," it dawned on people that even a totalitarian regime needs some support from society to survive. The absolute ban on discussing the government broke down and the world didn't collapse. Dissent was no longer limited to the thoughts of scattered individuals or the muffled conversations of conspiratorial groups. Despite repression, public consciousness did not allow critics to disappear without a trace, as before. Critical analysis of the Soviet regime found an audience.

The main reason I and those who shared my views risked prison was our striving for self-respect—to escape the shame that silence would cause. We also hoped that our protests might have some effect far in the future. We lived by the maxim "Do what you must, let be what will be." Most of us chose a term of imprisonment over the extreme self-abasement required to avoid it.

Many of us had a hazy idea that our actions might lead to a serious political struggle, but only Andrei Sakharov saw clearly what was needed to bring about positive changes in our political system.

The Western political model clearly contradicts Soviet totalitarianism. I never idealized the Western model, but I valued—and still value—its remarkable capacity to evolve. However, the Western model, like the Soviet model, is prone to deceptions that affect its fundamental principles. The Western model is the product of Christian European culture and its basis is individual freedom constrained only by the rule of law. Freedom and law are proclaimed to be universal values, but they often have no influence on political practice—an inconsistency pointed out by Machiavelli hundreds of years ago. Instead we have hypocrisy. Falsehood. Might makes right. Special interests. In a word, *Realpolitik*, the strategy for survival in a Darwinian world where every man is at war against every man.

Realpolitik has turned universal values into propaganda tools instead of using them to serve the higher purpose of the world community. To make this point, one need mention only the atom bombs dropped on Hiroshima and Nagasaki, the political machinations involved in the Nuremberg Trials, and the millions of people in Eastern Europe abandoned to tyranny after World War II.

Every year, the world's problems become more urgent, dangerous, and difficult, and *Realpolitik* and its instruments—including the United Nations—are incapable of resolving them. In the 20th century, Bohr, Einstein, Russell, Sakharov, Gorbachev, and many others have appealed for thorough political reform. A fundamentally new political paradigm is necessary to moderate the clash of interests and make the rule of law, founded on universal values and backed by global legislation, a priority.

It is quite possible to draft the foundations of such legislation. It is more difficult to propose a model for a just universal political system governed by this legislation. But how will our embittered, complacent world, composed of nations that both envy and despise their neighbors, agree voluntarily to unite in such a structure? Is it a fantasy to attempt to use universal legislation to reconcile incompatible beliefs and customs that are supported by passionate popular emotions? Such skepticism seems warranted by the difficulties of the European Union.

There are, however, examples of small actions leading to significant results. Catalysis in chemistry is one. In physics, a tiny patch of nonhomogeneity may cause a phase transition to develop like an avalanche. In biology, the mutation of a single gene may produce major evolutionary changes. Some religions have emerged and spread with the speed of lightning. And finally the European dissidents, so few in number, have left their indelible traces on history.

The time has come for a moral choice. If we do not want *Realpolitik* and the clash of national egoisms to lead us further and further away from an answer to the great and terrifying challenges of history, we must accept the priority of higher values—let us call it "political idealism." This course may or may not be practical, but there is no third way. The choice is ours.

The choice is easier for religious believers who rely on the will of the Lord. It's more difficult for atheists and agnostics. They must follow the advice of an ancient Chinese poet: follow your spirit, since you have nothing else to guide you. I am such a person, and I believe I have made the right choice.

SERGEI KOVALEV (b. 1930), a biophysicist and prominent advocate for human rights and justice since the earliest days of the Soviet dissident movement, co-founded the very first civic association to defend human rights in the USSR; he also co-edited the legendary *Chronicle of Current Events*, a clandestine bulletin of human rights violations. He was punished with 10 years in the gulag and internal exile. After the fall of the former Soviet Union he turned to politics, serving in Parliament and chairing a presidential commission on human rights, which he quit in protest against the war in Chechnya. He remains a gadfly of the Kremlin, criticizing its authoritarianism and human rights violations.

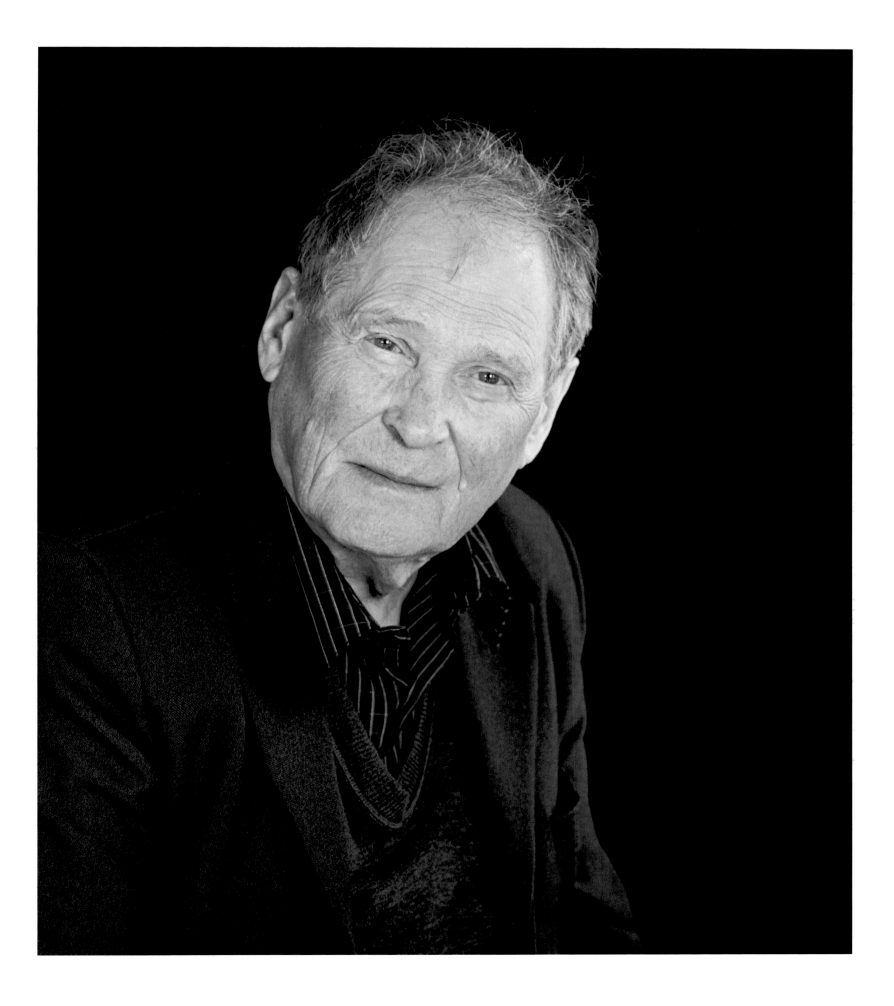

KWAME ANTHONY APPIAH

UNITED STATES — PHILOSOPHER

IN 1961 MY FATHER AND HUNDREDS OF OTHERS were imprisoned without trial in the new Republic of Ghana. Luckily, Amnesty International had just started. Their first fact-finding mission was to Ghana, and my father became one of their first prisoners of conscience. My mother had three young children; love had brought her to a foreign country, with none of her own family nearby. Despite that, I don't remember being too scared. My English mother—who was quite as extraordinary as my Ghanaian father—radiated confidence that our campaign to get our father freed would succeed. She knew that all around the world there were people on our side. That sense of *people on your side* is one thing that keeps prisoners of conscience and their families going. A year and a half later, the international campaign prevailed and Pops was released.

Imprisoning people without trial for speaking their minds is not a difficult moral case: those who do it know it's wrong and so does everybody else. And it's good to start with these clear cases. But our world is full of harder moral problems, and to make a world where all of us can lead dignified lives, we have to do more than organize and act: we have to think. As a philosopher, that's my vocation. My privilege is to work with people who study the many intellectual problems connected with creating a world that upholds human dignity for all. I'm the general editor of a series on International Global Ethics, created in celebration of Amnesty's 50th anniversary. One of the hard problems the series addresses is recognizing the limits of law, both domestic and international, in guaranteeing all of us the rights and the dignity that are fundamental human entitlements.

I grew up in a family that believed profoundly in the law as an instrument of social change. My father developed the first pro bono practice in the country, litigating cases for political prisoners after independence. When defendants received no bill from him, their families would often show their gratitude by bringing us gifts of food: yams, a sack of rice, a chicken, or—if we were very lucky—a sheep. The animals would live in the backyard until it was time for the cook to slaughter them, and my mother would share the meat with the household. My father also worked with international organizations in support of the development of global standards for the rule of law. This meant that as a child I got a Brazilian kite when my father returned from a lawyers' meeting in Rio; only years later did I understand that he and others were laying the groundwork for one of the great moral achievements of my lifetime—enshrining basic legal rights in domestic law and creating human rights' treaties. Having the

right laws, however, is only the beginning. There are more than a thousand honor killings of women in Pakistan each year, for example, even though both Islamic and Pakistani laws condemn the practice. We also need to change our cultures.

That process of cultural change means developing a sense of pride in the fact that we—we Pakistanis, we Americans, we Ghanaians—have a society that is respectful of these fundamental rights. People will then feel ashamed when they discover their country has failed to respect them. I feel a profound shame as an American citizen when I think about Guantánamo. Many of us Americans believe that our country must honor its commitments to human rights, which prohibit torture, imprisonment without trial, or assassinations of individuals in foreign countries with which we are not at war. As the Nobel Literature Laureate John Coetzee wrote in his novel *A Diary of a Bad Year,* "the issue for individual Americans becomes a moral one: how, in the face of this shame to which I am subjected, do I behave? How do I save my honor?" Well, by working to right the wrongs.

I often think about how to mobilize a sense of national honor through the PEN American Center, which works with literary communities around the world to protect the rights to free expression. Recently, with our colleagues in the Independent Chinese PEN Center, we have protested the unjust imprisonment of Chinese writers. In writing to the Chinese government in support of Liu Xiaobo, who won the 2010 Nobel Peace Prize, we point out that his imprisonment breaches not only international treaties but also the guarantees of free expression in the Chinese Constitution. Not long after Liu got the Prize, I spoke to a Chinese exile in Washington, D.C., and, entirely unprompted, she spoke of the shame she felt about what her country was doing. Her shame at Liu's imprisonment, mine at Guantánamo: we understood each other.

KWAME ANTHONY APPIAH (b. 1954) is a Ghanaian-British-American moral theorist and philosopher, descended from a long line of politicians. His father, Joe Appiah, was a member of the first Ghanaian Parliament; his maternal grandfather, Sir Stafford Cripps, was Labor Chancellor of the Exchequer (1947–50); and his great-grandfather was Charles Cripps, the Labor Leader of the House of Lords (1929–1931). Appiah was President of the PEN American Center from 2009–2012, and is a professor of philosophy and African-American studies at Princeton. An influential voice in the debates about Afro-centrism and cosmopolitanism, he argues that we are bound to others by obligations that transcend sharing citizenship and that we should continually be educating ourselves about the practices and beliefs of others.

GEORGE BIZOS

SOUTH AFRICA — LAWYER

I WAS BORN IN SOUTHWESTERN GREECE IN 1928, in a village called Vasilitsi. When I was 13 years old, I fled with my father, who was helping seven New Zealand soldiers escape Nazi Germany's occupation of Greece. We set off in an open boat toward Crete, not knowing that the island was soon to capitulate to the Nazis. Fortunately, we sailed into an Allied fleet and were rescued. My father went to a refugee camp in Cairo, and I spent three months at an orphanage for Greek children in Alexandria.

In 1941, my father and I left on an enormous ship to seek safe haven in South Africa. A teenage refugee who spoke no English, I got off to a rocky start there. The person who eventually set me on the right road was a wonderful teacher named Cecilia Feinstein. When I met her, I'd been working in a grocery shop, and I hadn't been to school for three years. She calmly told my father that she'd be there Monday morning to pick me up—which she was. Not just that, but she would take me back to her house and give me extra lessons. One person believing in you can change your life.

My life changed again when I went to university, where I met Nelson Mandela and other student activists. It was 1948, which turned out to be a momentous year in two respects: first, the UN Declaration of Human Rights came into being and, second, the Nazi sympathizers in South Africa won the whites-only election. That victory officially introduced the apartheid principle. It also led to my radicalization as a student activist.

After I graduated with law degrees and was called to the Bar, my interest in human rights led me to the practice of Mandela and his law partner Oliver Tambo. I represented many of their clients during the 1950s, which marked the beginning of my long friendship and collaboration with Nelson. The courtrooms had two entrances, one for whites and one for blacks. I always tried to make a small point by walking through the section reserved for blacks. The looks I got from the prosecutor and the policemen betrayed their thoughts: what sort of white man is this that has no pride in his own race?

When Nelson and 18 other African National Congress leaders were arrested in Rivonia in 1963 and 10 of them charged with 221 acts of sabotage against the apartheid system, I joined the defense team. Death sentences seemed likely. When Nelson showed me a draft of his speech, which said he was prepared to die for a democratic and free society, I raised my fear that his words would be taken as an invitation, and he said, "Well, I'm going to say it." I said, "Well, could you add the words, 'if needs be' before you say that you are prepared to die?" He thought about it and said, "Yes, I am prepared to put those words in." I suppose those words are my contribution to the struggle.

Even as a prisoner, Nelson kept his sense of dignity. On my first visit to see him in prison, he was brought to the consulting room by eight warders. Prisoners do not usually set the pace at which they move with their guards, but there was Nelson, leading the way, head held high. I stepped past the two warders in front and embraced him. I think that this was the first time that the warders saw a white man embracing a black man, and they were absolutely stunned. Nelson returned my greeting and immediately asked, "How are the children?" Then he pulled back and said, "You know, George, this place has made me forget my manners. I haven't introduced you to my guard of honor." He proceeded to introduce each one of the warders by name, and they actually behaved like a guard of honor. Each one shook my hand.

Don't let anyone bully you, that is what Nelson and others taught me. When I was defending the courageous Afrikaner lawyer Bram Fischer—for conspiracy to commit sabotage—the prime minister's counsel came to see me with a message that my "rope was getting shorter." Yes, I was scared. But nothing was going to stop me. I just didn't tell my wife.

I am reputed to have done more political trials than anyone else in the world—not just those of Nelson Mandela, Walter Sisulu, Govan Mbeki and others at the Rivonia trial, but also heroic men whose names go unrecognized. And people continue to ask me, "Why didn't you give up?" I say, "Would you have given up, if most of your friends were either in jail or in exile?" And I say, "I defended a man who got 10 years, and his wife shouted out from the back of the court, '10 years is nothing, my husband, I'll wait for you.'" Would I have been able to look at myself in the mirror if I had given up? No.

There is no age when you should stop fighting for what is right. Today, when I'm in court, I don't think of my age. The other day, a judge asked me if I would like to sit down while presenting a case. My response was, "The day I have to do that, I'll retire."

GEORGE BIZOS (b. 1928) was one of Mandela's lawyers and his closest friend during his imprisonment at Robben Island. After Mandela's release from prison in 1989, Bizos played an important part in helping him establish relations with the new South Africa. At Mandela's request, Bizos drafted the law setting up the Truth and Reconciliation Commission. He was an integral force in drafting amendments to the Criminal Procedures Act, which ensured that fundamental human rights were granted to all citizens of South Africa. He holds leading positions in nongovernmental organizations formed to advance human rights.

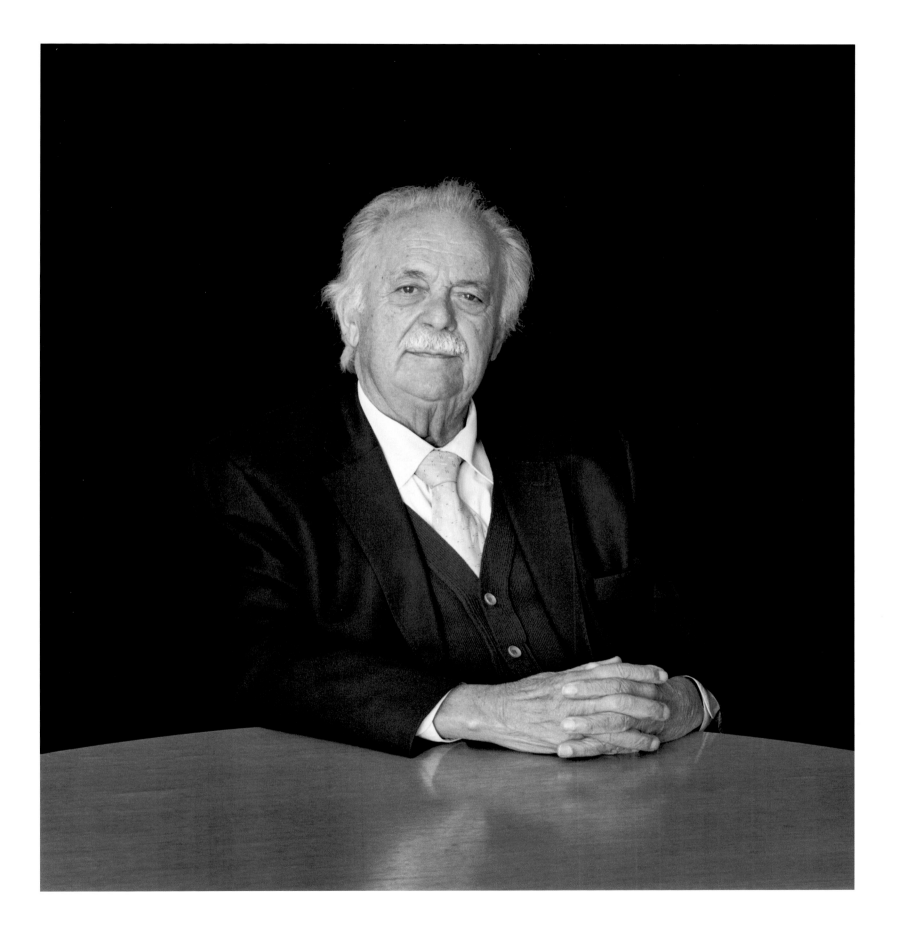

EDWIN CAMERON

SOUTH AFRICA — JUDGE

MY WORK AS A JUDGE integrates my personal and professional history. I came from a disrupted family background, spending five early years in a children's home. My father was a catastrophic alcoholic—he drank until near obliteration. My mother was co-dependent in this destructive pattern but nurtured a fierce belief that I should get a good education. The government boys' school she got me into was—and still is—superb. That was my big break. It changed my life, putting me on course to receive a Rhodes Scholarship and an Oxford education.

My mother's fierce plan for me was boy-specific—my sister's education was treated as being of lesser importance. The school and university I attended were all white. My opportunities were defined by and created with privilege and exclusivity. That awareness has stayed with me, deeply shaping my social insights and commitments.

It simply seems wrong that so many with the same capacities and capabilities as I have, the same yearning to be different, to be free from poverty and struggle, are in material circumstances that stifle their fulfillment. This belief is not abstract. It is visceral. It comes from somewhere below the heart, from knowing pain and exclusion, and from getting the opportunities that changed my life, opening it up to richness and fulfillment.

Exactly this awareness of privilege led me in 1999 to go public with my HIV status. Just months before, a poor woman living in a Durban township, Gugu Dlamini, had been stabbed and stoned to death after announcing that she was living with HIV. I had started anti-retroviral treatment in 1997, and felt my medication had given my life back to me. From facing death, I exulted in renewed energy and life plans. Behind my suburban palisade, enjoying job protection as a judge, paying for my medication with my judge's salary, I could not continue to remain silent, fearing as I did only stigma and rejection, when Gugu had paid with her life. So I spoke out.

You cannot rest peacefully as a judge in a system where you don't think that you are achieving justice. If you don't think you are helping bring the law closer to justice in the decisions you give, then you must ask why you are there.

Being a judge doesn't give you free rein, but it does offer enormous opportunities to shape cases and outcomes every day, to find justice or injustice, and to track the law's path. There are constraints. Legal language imposes limits, and history and institutions confine. But a judge's mission must be to bring the law closer to justice—closer to some sense of what is morally, normatively, publicly defensible as just and not merely conforming to the law.

We are a society of such extremes—such dispossession, such poverty, such disparity of resources. It is very difficult to be a judge without a sense of wanting to change that. Justice lies partly in alleviating the sense of need, disparity, and exclusion that people experience in an unjust and unequal society. Injustice is a state of need for reparation. It is a state of need for minimum material conditions of life. And it is a state of need for *rebalance,* from injury or dispossession.

I think that mission of providing and protecting basic human rights is very clear in the South African Constitution. The values the Constitution embodies are broad, generous, and encompassing. And the duty to fulfill them rests not only on Parliament and government, but on every judge too. I rejoice in the privilege of having this job.

EDWIN CAMERON (b. 1953) is a judge on the South African Constitutional Court. He was the first senior South African official to publicly declare that he was living with HIV/AIDS. He had already established himself as an expert in human rights law when he decided to break his silence about living with the disease. He has been a prominent voice in the fight for gay and lesbian equality and HIV/AIDS issues, campaigning against the political denial of an epidemic, drafting the Charter of Rights on AIDS and HIV, co-founding the AIDS Consortium (a national affiliation of nongovernmental organizations working in AIDS), and founding and directing the AIDS Law Project. His work heralded the express inclusion of sexual orientation in the South African Constitution.

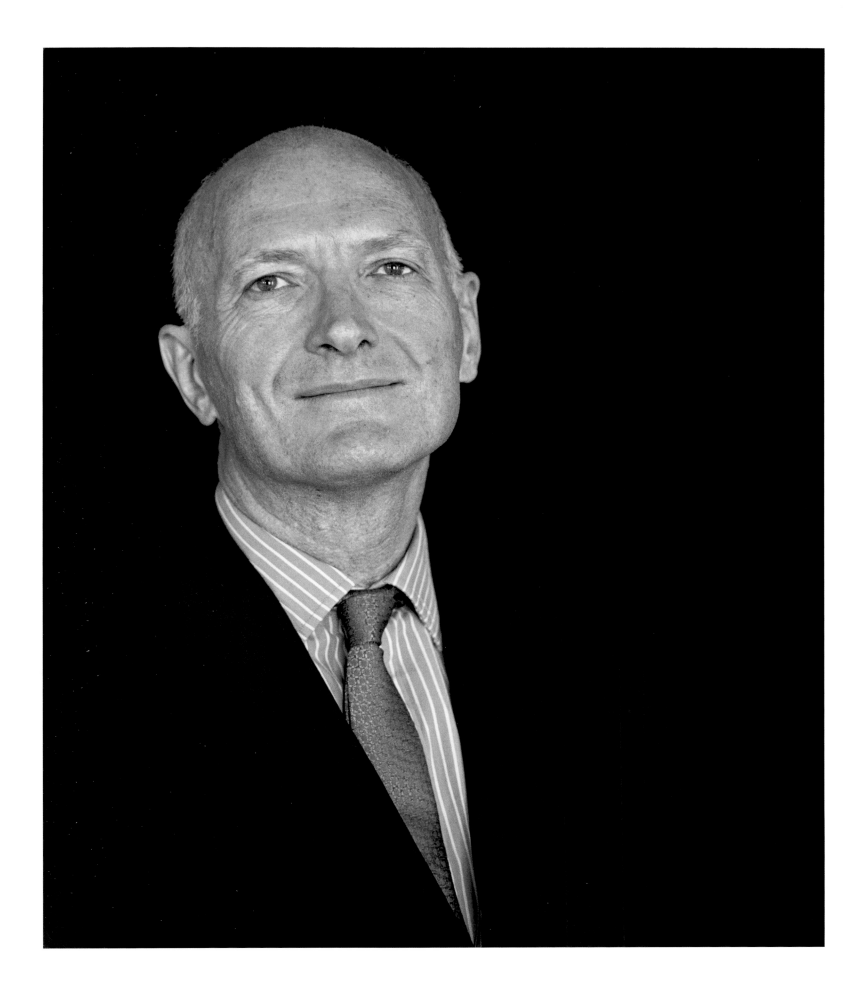

ROBERT BERNSTEIN

UNITED STATES — PUBLISHER/ACTIVIST

THERE WERE SEVERAL IMPORTANT EXPERIENCES in my early years that may have contributed to my passion for human rights. I vividly remember my grandfather, who didn't have the heart to evict the nonpaying tenants from the Harlem real estate he owned during the 1933 Depression. He lost his properties because of it, and his children supported him from then on.

My grandfather got it into his head in the early 1930s that he had to get his friends out of his hometown in Randegg, Germany. He was an older man; a dapper dresser in a coat with a velvet collar and a carnation. When he walked into the U.S. immigration office with his silver-handled walking stick, they didn't ask him if he had money. This man obviously had money. He signed the necessary papers promising his friends' support. When they arrived in America, he admitted he couldn't support them! They asked, "What are we going to do?" And he replied, "You're going to get a job. I had to get you out of there." But he added, "I want to be sure you have one good meal a day, so anybody who calls us by 3 P.M. is welcome for dinner." At 5:30 my grandfather brought out scotch and gin. On the table, there were hors d'oeuvres and cheese. Usually the dinner was pot roast, potato pancakes, applesauce, and lemon cake. And soup, always soup. Big thick soup. Three to six refugees came to dinner every night. On my grandparents' 50th wedding anniversary, *The New York Herald Tribune* wrote an article about my grandfather, a man without a nickel who successfully saved 68 people. By then it was '38 or '39 and Hitler was a disaster. That must have impressed me.

I attended the Lincoln School of Teachers College, a brilliant school run on a grant from the Rockefeller Foundation and based on the philosophy of John Dewey: Learn by doing. I began publishing in the 10th grade. The English teacher had us put out a newspaper called *The Public Press*. I don't remember why, but I didn't like the editorial policy of *The Public Press*. I started *The Private Press*. At about the same time, there were efforts to recruit high school students to communism, but when I went to my first meeting, I disagreed with a few of their ideas: they told me if I was going to join their party, I had to do it their way. That frightened me, and I never went back.

In 1946, I became an office boy at Simon and Schuster. Fired from there in 1956, Bennet Serf, founder of Random House, hired me and when he retired 10 years later, I became president and CEO. In 1973, I was among four publishers who persuaded the Russians to join the International Copyright Convention. Urged by the Soviets to publish their books, I signed Andrei Sakharov, their most prominent scientist who had turned human rights activist and been stripped of all his honors. For this I was banned from the Soviet Union. That wasn't the kind of book the Russians wanted published.

To get the American Association of Publishers to support dissident writers in the Soviet Union, I founded the Soviet-American Publishing Committee, which led to the founding of Helsinki Watch. The Random House group began publishing dissidents: Axionoff, Amarig, Jilidsi, the two Redeviev brothers, Mandelstam, Sakharof, Sharanski, and Orlov. And then Havel. Nothing made a lot of money, but we became a place where well-known authors wanted to be published. And certainly people wanted to work for us.

One of the most influential books we published was *Prisoner Without A Name, Cell Without a Number* (1981), Jacobo Timerman's memoir of his imprisonment during Argentina's Dirty War. I had learned about Timerman because we'd started America's Watch. We also started Asia Watch and Africa Watch. Finally it made sense to merge them all into Human Rights Watch. This was what I did besides publishing.

In my view, human rights organizations should work on the closed societies that are committing the major atrocities. Open societies are not perfect but they contain other forces that will rally and try to keep democracies on a good path—a free press, the judiciary, and elected government. The idea that human rights organizations aren't yelling and screaming every day about what a large part of the world is doing to women is unconscionable; that they have any time to look into open societies with that problem existing is unfathomable to me. There is a huge difference between open and closed societies, and that difference can be stated in two words, "Free speech." If you secure women's rights and free speech, a lot of the other things will take care of themselves.

ROBERT L. BERNSTEIN (b. 1923) champions free speech and human rights. During his long tenure as President and CEO of Random House, he became a prominent publisher of dissidents. In 1978, he founded Helsinki Watch, which eventually became Human Rights Watch, an organization he chaired until 1998. He remains an active board member of Human Rights in China. In 2011, at age 88, he founded Advancing Human Rights, an organization that, among other things, promotes free speech and women's rights in closed societies and fights state-sponsored hate speech. Now an influential online presence with Cyberdissidents.org and Movements.org as part of the organization, AHR has become an important player in international policy debates. President Clinton presented Mr. Bernstein with the first Eleanor Roosevelt Human Rights Award in 1998.

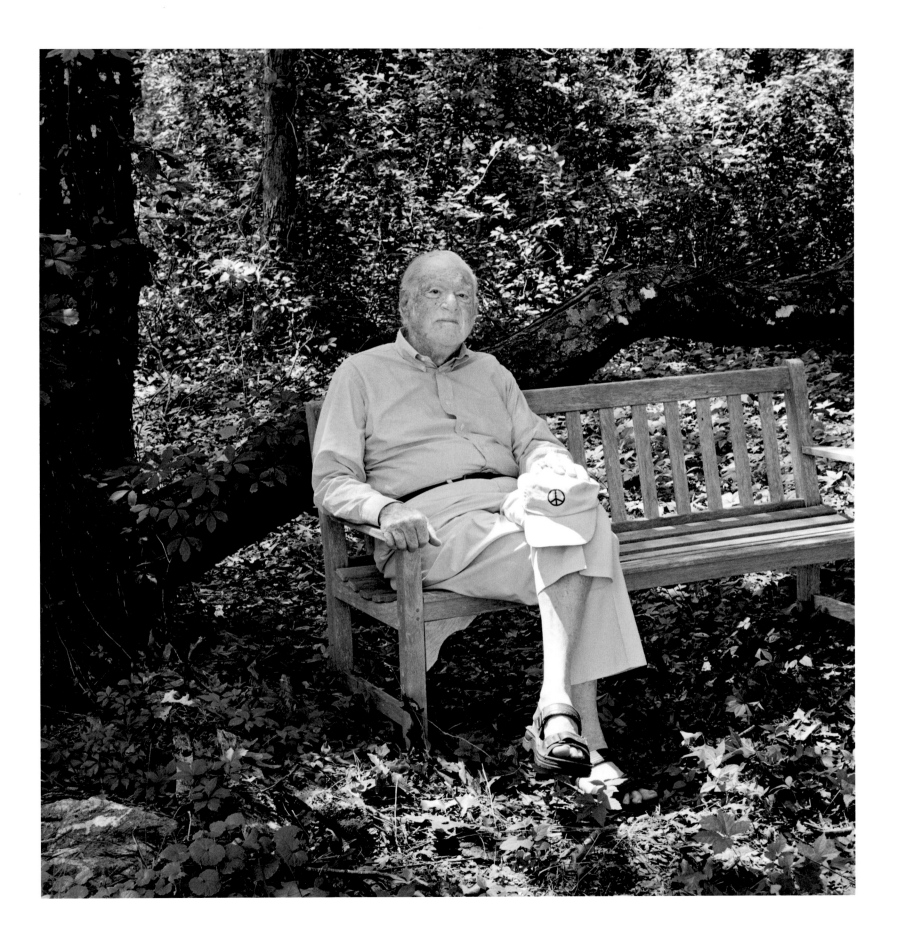

HOSSAM BAHGAT

EGYPT — ACTIVIST

I WAS STUDYING POLITICAL SCIENCE at Cairo University in the late 1990s when I got a job reporting for an independent news magazine. One day, I was sitting in the office when someone came in and wanted to tell his story to a reporter. I was the only one there. So this man started taking off his clothes and showed me the cigarette burns and bruises on his body. And I thought, how many lives have been broken in this country by that crime?

I developed an interest in this line of reporting: topics ranging from prosecutions of political activists to prison conditions to discrimination against women. In 2001, I made the shift from journalism to human rights work full-time.

My decision to establish the Egyptian Initiative for Personal Rights (EIPR) in 2002 was motivated primarily by a realization that more needed to be done to protect and defend the rights to privacy, personal autonomy, religious freedom, and bodily health and integrity. I also saw a clear need to create a space for vibrant young activists who wished to contribute to the fight for justice and rights in Egypt. The work of the EIPR is currently led by a dynamic team of young activists who use research, advocacy, and litigation to expose and end violations that are committed in the name of national security, public morality, or public order.

The Egyptian regime believed it was firmly supported by the Western world because it helped ensure stability in the region. But we shouldn't have to choose between this stability and the rights of Egyptian citizens. The United States is the single biggest foreign donor to Egypt, and it has an important role to play here. The Obama administration had to send a very strong message that it would not support any crackdown by the Egyptian government. Eventually, the United States ended its support of Hosni Mubarak. The Egyptian army refused to suppress the popular protests, and the government fell.

The most important thing that Americans can do to support human rights in Egypt is to support human rights in the United States. When the attorney general appears before Congress to defend military commissions; when President Obama says the U.S. will continue to hold Guantánamo detainees without charge; when we hear in Egypt that there will be no accountability for torture in America, that sets us back. It is a hundred times more difficult for us to do our advocacy work when the U.S. administration is publicly flouting these values.

HOSSAM BAHGAT (b. 1979) is an Egyptian activist who created what is arguably the most effective domestic NGO in North Africa—the Egyptian Initiative for Personal Rights (EIPR). He works on issues that few others will touch, including the rights of religious minorities (such as the Bahá'ís), alleged terrorists, domestic violence survivors, and the right to personal autonomy and privacy for all. When Hosni Mubarak's government and Egypt's powerful security forces committed major human rights violations, he was a fierce critic and an integral force in the Egyptian revolution that began in January 2011. Bahgat and EIPR documented violence against protesters and prisoners, and spearheaded a movement against military trials of civilian protesters. When President Mubarak was forced out, Bahgat fought even harder for new laws and concrete changes to build a better Egypt.

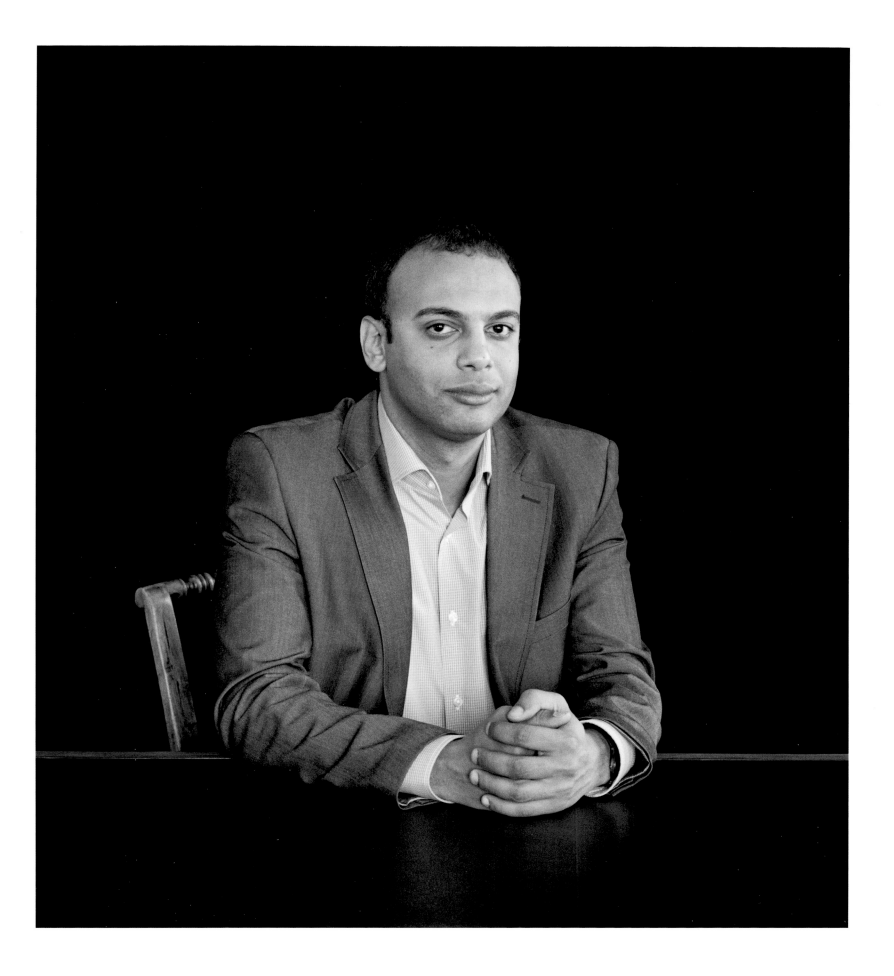

ROBERT M. BELL

UNITED STATES — JUDGE

READING ERLE STANLEY GARDNER BOOKS when I was growing up was what first piqued my interest in the law; I was always struck by how effective the lawyer was. And, of course, Perry Mason was an extraordinary lawyer. Mason was not only a lawyer, he was the investigator: he was everything. I admired how he helped his clients, and I wanted to do that. I was not suddenly propelled toward the law in high school. It was something that I had already decided to do.

In 1960, at the end of my junior year, the civic-interest student group from Morgan State College in Baltimore decided to initiate a downtown desegregation effort, and for the first time they encouraged high school students to participate. The effort was to desegregate lunch counters and restaurants, and my job was to recruit students for the cause. First of all, they wanted students who would have enough money to pay for whatever they ordered, should they be served. The students also had to have their parents' permission, because they might be arrested. Finally, they had to possess a particularly calm temperament so that they would not hit back if somebody struck them. We got a busload of people to go to downtown Baltimore, where we walked into Hooper's restaurant and sat at different tables. Police were called in, and they read us the trespass statute. We refused to leave. Finally, the police officers arrested the 12 of us.

They arranged an accommodation: We would be arrested, constructively, but not go in physically that night—this was a Friday afternoon—instead reporting to the central district police station bright and early Monday morning. We would then be processed and charged with trespass. We were tried as adults, convicted of trespass, and fined 10 dollars plus costs.

We were offered probation before judgment, which would have prevented the appeal, but we refused. The case was therefore sent to the Court of Appeals—the same court on which I now sit—because there was no intermediate appellate court in those days. That court affirmed the conviction. A petition for writ of certiorari was filed with the Supreme Court of the United States. The writ was granted and the case was heard in the Supreme Court as one of a group of sit-in cases. The group was called by the name of the first case, *Bell v. Maryland*. I was Bell.

Between the time of the convictions in 1961 and the events at the Supreme Court in 1963, the law of Maryland had changed. Public accommodations laws had been passed both at the state and city levels, so what we'd done in '60 was no longer a crime. We asked the Supreme Court to decide whether a state violated the Constitution if it used a trespass law that was neutral on its face to enforce a racially discriminatory practice. But the court never reached that issue. Three justices, led by Hugo Black, wanted to affirm the trespass convictions. Three others, led by William O. Douglas, wanted to reverse them. But the position that carried the day was established in an opinion by Justice William Brennan who relied on the settled doctrine that you avoid constitutional questions if you can. Brennan said, "Let's send the case back and allow the Court of Appeals to take a second look at it, in light of the changed circumstances, and see how they come out." It was sent back, and the court affirmed its prior decision. On motion for reconsideration, filed by one of our lawyers some months later, the misdemeanor conviction was reversed, but the deeper issue that we were seeking to litigate in *Bell v. Maryland* was never resolved.

As chief judge, what I have seen is the need to ensure equal access to justice. That is where I have had the most impact. First of all, by taking the long view and looking at the system as a whole, to ensure that not just prosecutors but also defendants and those who can't afford to pay are in fact given access. Justice does not exist without access. I also devised a proposal that requires every lawyer in Maryland to report his or her pro bono service, so that we can strategize as to how to make the best use of what they're doing.

Unlike the legislative and executive political branches, there is not a whole lot of tangible power you can ascribe to the judiciary. We have judgment, but that judgment means nothing unless it has an impact on the people we serve. Alexander Hamilton said that what we have is good judgment and—this is the most important piece of it—the trust and confidence of the people. If you don't use judicial judgments to inspire trust and confidence in the people, then you have no power at all.

ROBERT M. BELL (b. 1943) began his life in the law when he was arrested at age 16 for sitting in at a Baltimore restaurant to protest its exclusion of blacks. He went to Harvard Law School and then held judgeships on various Maryland courts until his appointment in 1991 to the state's highest, the Court of Appeals. In 1996 he became Chief Judge in the court where he once appeared as a defendant in *Bell v. Maryland*.

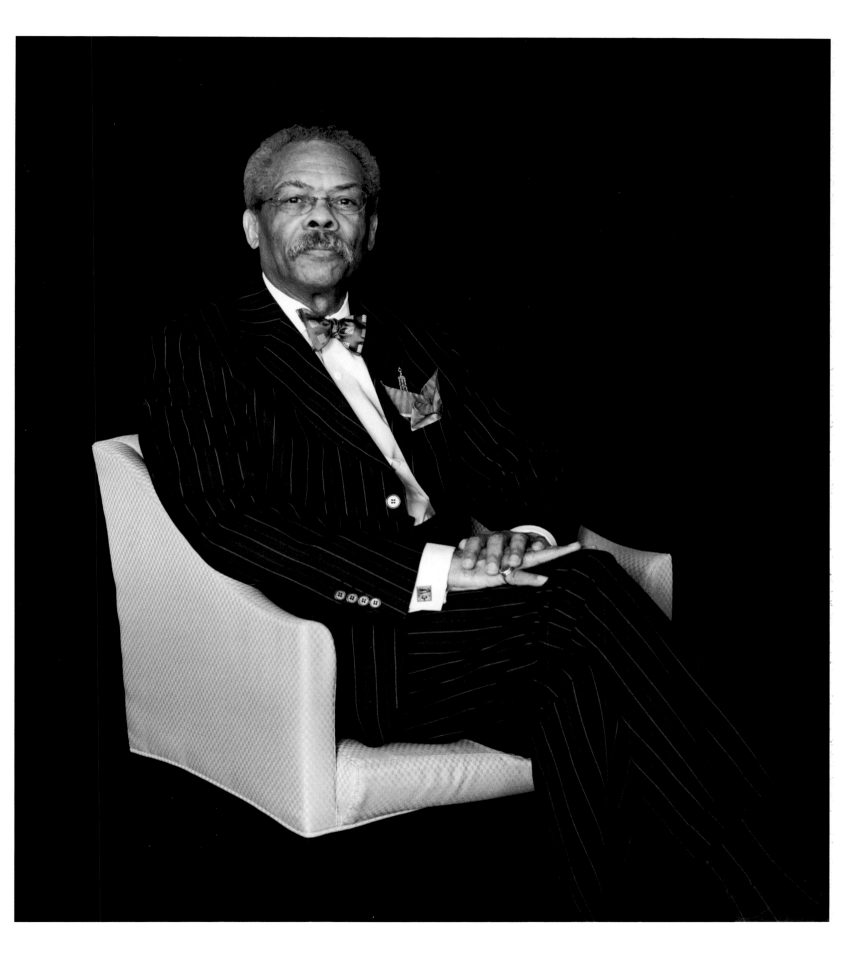

SARAH HOLEWINSKI

UNITED STATES — ADVOCATE

EACH MORNING, WHEN I WAKE UP, I try to find out just how many civilians were killed the night before. A roundup of the morning's news usually includes something like this: 5 killed by shelling in Somalia, 13 killed in air strikes in Pakistan, 3 children found among the rubble in Afghanistan. The need to fight for justice for these victims is always with me; their interests are mine.

Our world has changed dramatically over the last century. We have seen important changes in how people think about the conduct of war. Most nations now agree that landmines and cluster bombs are too dangerous. Now we accept the fact that rape should not be used as a weapon. We agree that children should not be soldiers. Armies should avoid civilians—like me—in war. All of these concepts are intended to restrict the harm that people, and especially people in armies, can do to one another.

There is one group for whom these ideas offer little comfort. These are the people already harmed by war—the "collateral damage," the victims. They are in the wrong place at the wrong time. They live next to weapons caches, or get shot on the way to the market. There is no law, no doctrine, no treaty that says to warring parties, "You must explain what happened, compensate for losses, and learn from this. You must acknowledge that this family existed and was devastated."

I find this intolerable.

It is one thing to have a belief that something is wrong, but quite another to work to make it right. So my time is now spent cajoling generals and government officials to do the right thing, do the smart thing, which is to not walk away from civilian suffering.

I love this work because I may be able to change what someone in a decision-making position thinks about war and its civilian costs. If he or she decides to rebuild a destroyed village instead of leaving it broken, hundreds of people may gain the chance to rebuild their lives. If one of those hundreds gets to live the life she wanted instead of being a war victim, that's success.

What will they do with the rest of their lives? I don't know; I don't get to say. The point is, maybe their lives will be a little better.

None of the big ideas that we now take for granted as being part of our humanity came easily: spare women, protect children, don't raze the fields, don't bomb the whole town. I expect a long, hard haul to a world in which every war victim is helped and dignified.

We're getting there. In Afghanistan, international forces saved countless lives by being more careful and, in many cases, helped civilians harmed by their bullets and bombs. In Libya during the revolution, opposition leadership began a program to help anyone suffering losses. In Somalia, African coalition forces are working on a plan to make amends to civilians caught up in the fighting. More warring parties are realizing they cannot ignore the harm they create.

There is still no universal belief that war victims should get help. There is still no universal obligation for warring parties not to walk away. We're going to have to make it work in one war after another, and convince the powerful that this is how we define humanity.

SARAH HOLEWINSKI (b. 1977) actively advocates for war victims and is Executive Director of the Center for Civilians in Conflict, which persuades military forces to avoid civilian casualties and make amends to the families of victims. Her predecessor and the founder of the group, Marla Ruzicka, was killed by a suicide bomber on Airport Road in Baghdad, Iraq. Holewinski is frequently consulted by major media outlets on current armed conflicts and was formerly a member of the White House AIDS Policy team under President Clinton.

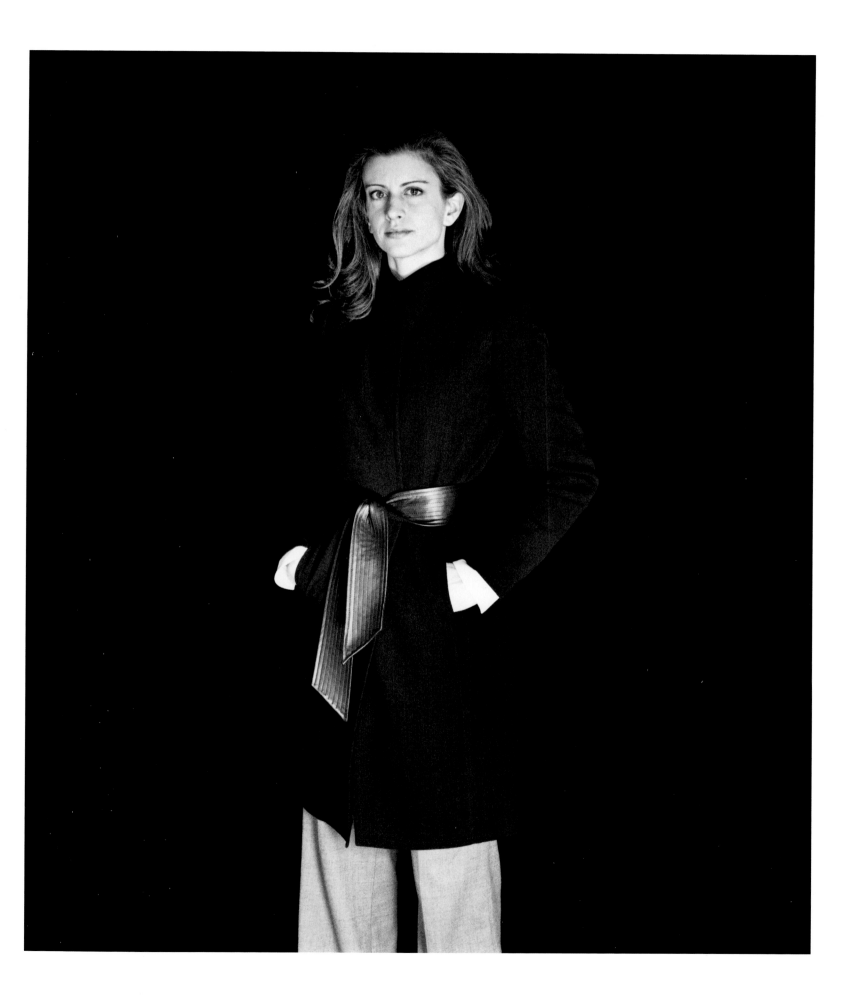

HOWARD MOODY

UNITED STATES — MINISTER

THERE WAS A GROUP OF CLERGY that met monthly to discuss social issues and theological problems, and so the issue of reproductive freedom became very important. Some of us decided that we were going to try to do something to help women. We felt the best way to do that was to help them find safe and secure abortions. The situation at that time was just horrible. It was the most humiliating, frightening prospect for women that you can imagine.

We talked to women who had been through it. What did they need? What would have been helpful to them? And, of course, most important was a good doctor that was safe and secure.

We decided that the thing to do was to open up a counseling service. We called it the Clergy Consultation Service on Abortion. We could not be underground because we would be in trouble with the law. It opened in May 1967 with a front-page story in *The New York Times.*

We had 26 rabbis and ministers. In order to find those doctors, my colleague Arlene Carmen, the program associate of the church at the time, would go out and pretend to be pregnant. She'd go into the doctor's office and observe the cleanliness, observe the people who were there. Then when she was up on the table and her legs were in the stirrups, she'd tell him what she was about; she represented a group of clergy who were referring women for abortions. She told the doctors that the women would be counseled, not only about the moral and ethical questions the women might have, but also about the physical procedure of the abortion itself. If she saw women mistreated in any way on her visits, even with abusive language, that was it, no way. We picked the best doctors, and there weren't very many.

In some of the places Arlene went, the waiting room was a mess. It was dirty. That was a criterion. Were there sterilizing machines? Where were they? And how did the doctor speak? He had to be competent, because we'd cut him off in a minute if something happened to the women. And they had to keep their price down.

As soon as we opened that door, women came from all over the country. They came by plane and train and bus and car, and we were deluged. Even though there were 26 ministers and rabbis, we were overloaded. I did counseling six hours a day, five days a week, sometimes six. I'd call Philadelphia and I'd say to my friend, "Look, why are all these women coming to New York to get this information? Why can't they get it there?" And he said, "You mean, you want me to do . . . ?" I said, "Yeah, I

want you to do it." And so then they got trained. It was a very heavy-duty emotional issue, and having religious institutions affirm these women's decisions was very important at that time in history.

If a woman decided that she couldn't do it, we'd help her have the baby and give it up for adoption if that's what she wanted. There were people in the congregation who had been through this, and the congregation, men and women, were absolutely supportive. I don't remember a single voice raised against what we were doing. I couldn't have done it without the church.

I think what we did was a real lesson in social change. It's very hard for people to change their minds about issues like this. I felt then and I feel now that the church has a certain obligation to do something about changing the laws that are on the books, which are so unfair and unreal—that's our penance. I've been swimming upstream a lot of my ministerial life. Although it may not have been an opinion shared by many others in the church, I wasn't interested in wasting my time debating about abortion as long as women didn't have the right to an abortion.

It was one of the most important ministries I did at Judson Church. And a lot of ministers have told me in retrospect that the most significant years of their ministry were the years when they were counseling these women, because it led to women's freedom of reproductive choice. We set models for counseling and established models for clinics that would rise up after the law changed. I wouldn't say that we had the most impact, but we did have an impact, which I don't think any other group except religious institutions could have done.

—Edited transcript from *Voices of Choice.*

REVEREND HOWARD MOODY (1921–2012) was an ex-Marine Baptist pastor from Texas who became Senior Minister of Judson Memorial Church in Greenwich Village in 1956. Moody's ministry spanned three decades of exciting and turbulent times in artistic, cultural, and political life. He led Judson Church to be at the forefront—advocating compassion for drug addicts; working with prostitutes and for decriminalization of prostitution; fighting for LGBT rights; pioneering medical advocacy; and seeking critical care for AIDS patients. Perhaps most important, he played a crucial role in legalizing abortion by establishing the Clergy Consultation Service, which recruited other ministers and rabbis to advise women on how to find safe abortions at a time when abortion was against the law. He advised the authorities of what he was doing, but he was never prosecuted; he continued to significantly participate in many other struggles for rights during the 1960s and 1970s.

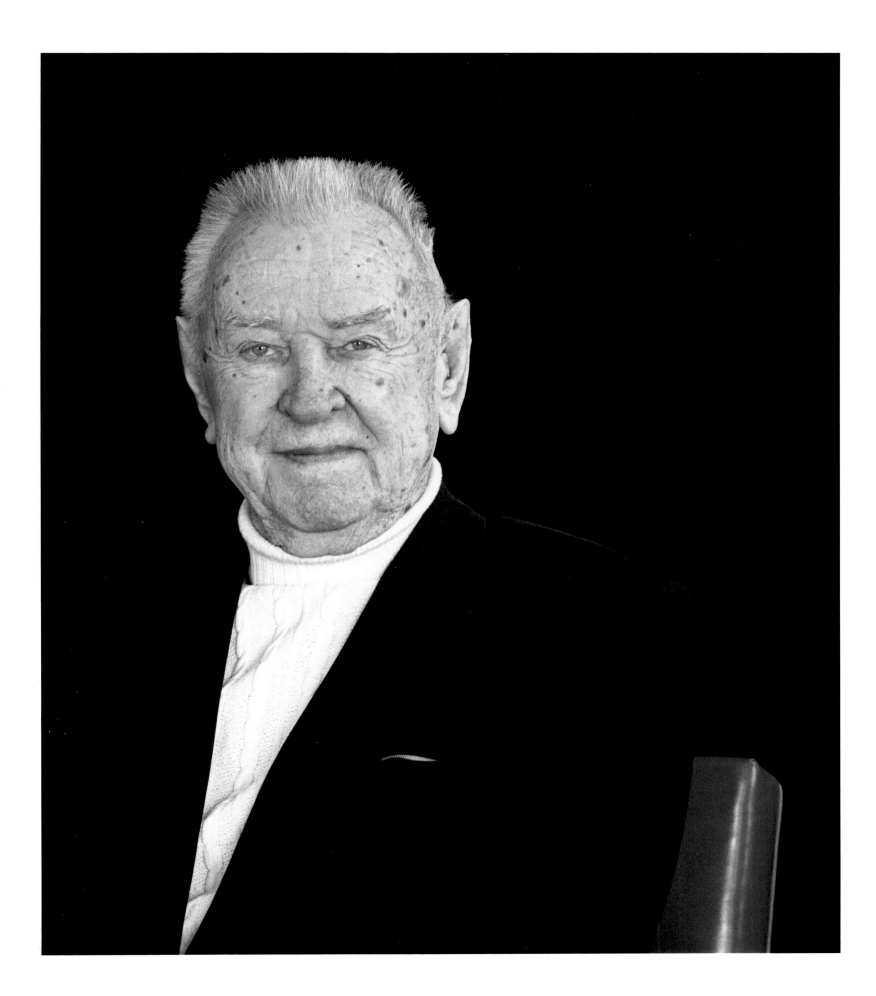

WILLIAM T. COLEMAN

UNITED STATES — LAWYER

SOME MAY CONSIDER ME a quintessential eastern establishment figure: a moderate Republican, a graduate of Harvard Law School, a partner in a national law firm who is always dressed in a suit, vest, and tie. Despite these characteristics, however, the color of my skin has left an indelible mark on my life—as it has for most people of color.

I was born in Germantown, Pennsylvania, in 1920. In junior high school, I once made a speech that so impressed my white teacher, she said, "Gee, Bill, you're going to make somebody a great chauffeur someday." I swore at her and retorted, "Someday, you may be driving a car for me." My comment got me kicked out of school, and my parents had to straighten out the situation.

During World War II, I was one of the Tuskegee Airmen, which was the first group of black aviators in the American military—men who had surpassed the strictest standards for enrollment that had been instituted as a means of deterring the integration of blacks into the Air Force. Discrimination, however, was still rampant. When I disembarked from the train in Biloxi, Mississippi, where I'd been sent for training, a white sergeant yelled, "Hey, nigger, where're you going?" I kept on walking. He said, "Hey, boy." So, I settled for being called "boy." Later on, a group of my fellow black officers, who served valiantly in defense of their country, insisted on being allowed to enter the white officers club, and they were arrested. I helped defend them, since I had been a law student.

The charges against all but three officers were dropped, but those initially arrested were still sent reprimands for expressing a "stubborn and uncooperative attitude" and lacking the "higher standard of teamwork" that was expected of them. Some officers responded with their own letter, declaring racial bias un-American and directly contrary to the ideals for which they had risked their lives. Little by little, we chipped away at the hypocrisy and injustice we encountered in those who wished so desperately to keep us docile.

After my military service, I served as a law clerk and then clerked for Supreme Court Justice Felix Frankfurter in 1948. While working at the law firm Paul Weiss, I took time off to help Thurgood Marshall in *Brown v. Board of Education*—the case in which the Supreme Court held that school segregation was unconstitutional. We lived at the Wardman Park Hotel for two weeks, and I sat next to Marshall in court. I have a deal with Lou Pollak that if I die first, he can say he wrote the brief. If he dies first, then I will say I wrote it.

I often advised or appeared in court on behalf of the NAACP Legal Defense Fund. One case challenged a Florida statute that made it a crime for a man and a woman of different races to go into a room for the night. I argued the case in the Supreme Court. A justice said to me, "Mr. Coleman, if people of different sexes who aren't married stay in a room and have sex, that's a crime in many states." I responded, "Oh, no, you don't understand the statute. These people could have been there all night reading Dylan Thomas." I won the case—eight justices to one.

Perhaps one of the greatest honors I received in recognition of my lifelong commitment to racial justice was my appointment by the Supreme Court in 1982 to argue the case of *Bob Jones University v. the United States*. The university, a religious institution, had refused to admit black students who advocated interracial marriage or dated whites. For that reason, it was denied a federal tax exemption. The Reagan administration refused to defend that federal action in court. I was appointed to argue that the denial of tax exemption was lawful. I managed to persuade eight of the nine justices.

Although blacks have made great strides, much impressive black history remains unacknowledged: innovators like Charles Drew, who developed blood plasma, for example, or the Russian writer Alexander Pushkin—whose great-grandfather was black. The key to preventing prejudice and effecting change is not only securing opportunity but also ensuring the teaching of black history. It is only with that awareness that we can continue to move towards a more just world.

WILLIAM T. COLEMAN JR. (b. 1920), a brilliant legal mind and strategist, played a formative role in the preparation of the brief for *Brown v. Board,* and he personally cracked the color line at the highest levels of power and prestige. Coleman, who grew up in racially segregated Philadelphia, became the first African American to work as a clerk for a U.S. Supreme Court Justice in 1948, serving as a Law Clerk to Felix Frankfurter. His knowledge of the mind of one of the court's preeminent jurists proved invaluable to Thurgood Marshall and the NAACP legal team in their successful challenge to more than 50 years of legal precedents supporting segregation in American life. Coleman went on to serve as President and then Chairman of the NAACP Legal Defense and Educational Fund for many years. During his distinguished career, Coleman was also the first black Director of Pan American Airways and Secretary of Transportation under President Gerald Ford—the second African American to serve at the cabinet level.

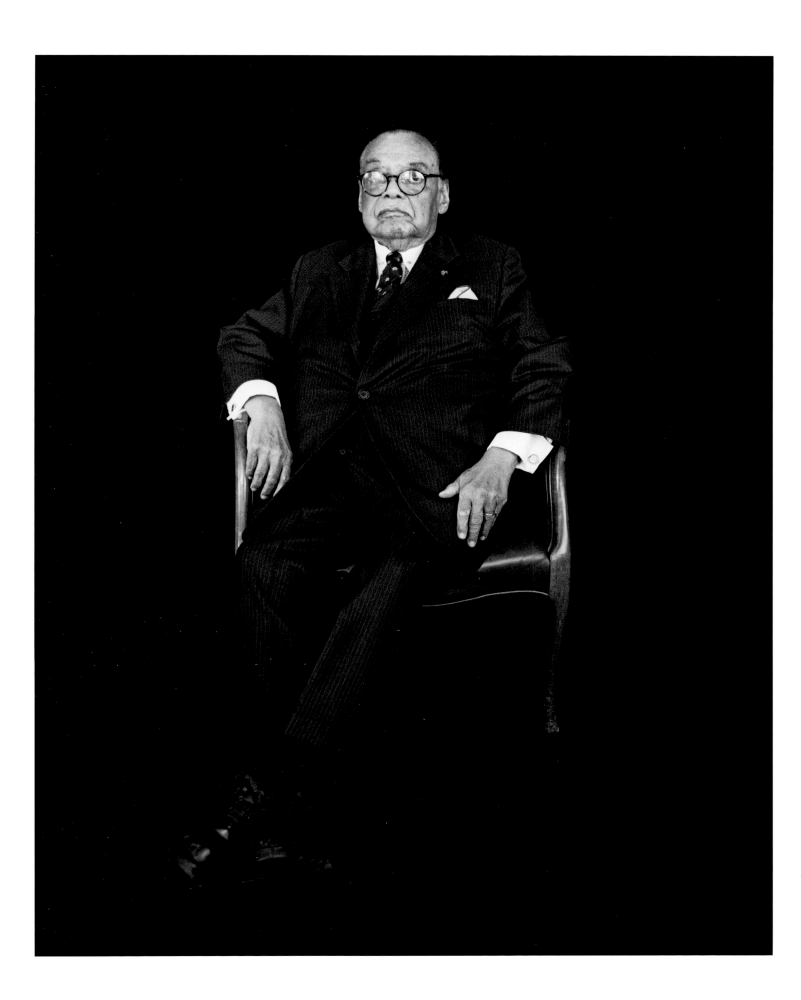

NICOLAS BRATZA

BRITAIN — JUDGE

ON A BLEAK AND BITTERLY COLD DAY in January 2011, a small ceremony was held at the entrance of the Council of Europe in Strasbourg to commemorate the victims of the Holocaust and to mark the anniversary of the liberation by Russian forces in 1945 of the largest Nazi concentration camp at Auschwitz-Birkenau.

The site of the ceremony was an appropriate one, the Council of Europe having itself risen from the ashes of a Continent ravaged by the horrors of World War II and being born of the shared conviction that the massive atrocities so recently witnessed should never be allowed to occur again. The European Convention on Human Rights, which was adopted in 1950 and came into force in 1953, occupies a unique place in the achievements of the council; it was designed not only to provide for the collective enforcement of certain fundamental civil and political rights, set out in the Universal Declaration by an international commission and court of human rights, but also to permit such rights to be directly invoked by any individual claiming to be a victim of their violation by one of the member states.

After an uncertain start, with a membership of 10 states, the convention has developed into a human rights protection system of unparalleled effectiveness. The collapse of Communism and the emergence of the new democracies in the early 1990s led to a dramatic expansion in the council's membership and a corresponding increase in the parties to the convention, currently numbering 47 states and covering an area stretching from the Atlantic to the Pacific, with a total population in excess of eight hundred million.

With the accession of new states has come an explosion in the caseload of the court, to which I am privileged to belong as one of 47 judges drawn from the member states and assisted by a registry of some 650 members. Although it is currently deciding over 40,000 applications per year, the court is confronted with a relentless rise in the number of applications; the figure of pending cases has reached 150,000, and the number of applications is growing at a rate of 1,800 each month.

If the court's role in affording individual justice to applicants whose rights have been violated has been the hallmark of the convention system, it is the court's constitutional role in setting and enforcing human rights standards throughout the Continent that will prove its most enduring achievement. The court has played a central role in strengthening the rule of law within the member states, and the influence of its judgments in reinforcing the protection of fundamental rights and freedoms throughout Europe has been profound. Views will differ as to where the court's impact has been the greatest, but I would single out the following achievements: its resolute stance that the death penalty can no longer be regarded as an acceptable form of punishment in a civilized society; its requirement of prompt, independent, and effective investigations into deaths at the hands of agents of the state and into allegations of ill-treatment of persons in custody; its shielding of those facing deportation or extradition to a state where they run a real risk of death or torture or inhumane treatment; its insistence on the need to control all forms of detention by a judicial body satisfying the requirements of independence and impartiality; its strong protection of respect for private life against interferences by state authorities in private sexual relations or through secret forms of surveillance—the court requiring that any system of covert surveillance should provide effective safeguards against abuse; its robust defense of the freedom of the press, particularly when fulfilling its watchdog role and its strict scrutiny of all forms of prior restraint on publication by the media; and its increasing focus on prohibiting all forms of discrimination in the enjoyment of convention rights.

The risk that the court will become submerged by the ever-rising tide of its own caseload is unquestionably a real one but, regrettably, this is not the only cause for concern about its future. The movement by certain governments to clip the wings of the court is currently a strong one and represents a serious threat to its continued independence.

Will the convention system survive? My answer is that it must. If the need for an effective collective guarantee of fundamental rights and freedoms within the democratic states of Europe was strong in 1950, it is no less strong 60 years later. Democracy and the rule of law still enjoy a very fragile hold in many parts of the Continent, as the size of the court's caseload so graphically illustrates. That caseload is also a testimony to the unique place in the protection of human rights occupied by this institution, which continues to serve as a beacon of hope for the many whose national systems have failed them.

SIR NICOLAS BRATZA (b. 1945) was President of the European Court of Human Rights until 2012. He advises various groups as a human rights specialist. His father was the well-known Serbian concert violinist Milan Bratza. In his years on the Strasbourg court, he has remained a vigilant supporter of human rights issues such as a prisoner's right to vote, even in the face of public opposition. In 2005, he was a member of the European Court's Grand Chamber when it decided that convicted ax murderer John Hirst should have been allowed the right to vote while in prison.

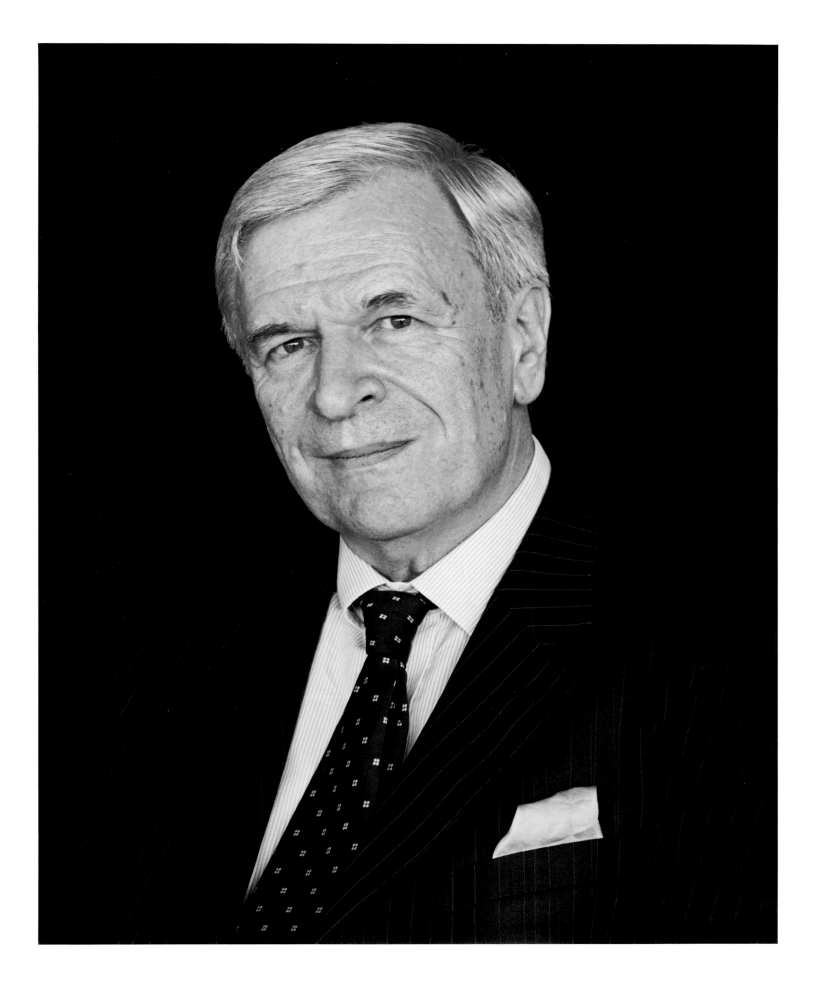

JAMEEL JAFFER

UNITED STATES — LAWYER

IN LATE 2001, I WAS WORKING for the equity derivatives group of a law firm in New York City. I was drafting contracts for banks. One evening I went to hear a talk about raids that the FBI and the immigration service were conducting in New York and New Jersey. The government had detained hundreds of men—most of them Arab or South Asian, and almost all of them Muslim—saying only that the men had been arrested in connection with the 9/11 investigation. After more than a thousand men had been detained, reporters began to question whether so many men could really have been involved in the attacks, and the government stopped publicizing the arrests.

I began working as a volunteer with the ACLU to connect the detainees with lawyers who could represent them. It was a frustrating process. We didn't have a complete list of the men who'd been detained or where they were being held. We'd spend days trying to find a particular detainee only to discover, when we finally arrived at the jail we thought he'd been taken to, that he'd been transferred somewhere else the night before. One of the men we eventually tracked down at a jail in New Jersey had been transferred six times through detention centers in four states. He was never charged with a crime, and he spent almost eight months in detention before he was finally brought before a judge. His story was pretty typical. Of the hundreds of men who were swept up in those immigration raids, most were held for months before being brought before a judge, only a handful were charged with crimes, and none were charged with anything having to do with terrorism.

I learned a lot from the experience of interviewing the detainees. For one thing, it made me much more skeptical of government officials. I was genuinely astonished by the chasm between what I was seeing and hearing in the detention centers and what the government was saying to the public.

I was also learning a little bit about the experience of individuals who get pulled into the system. Detention centers are dehumanizing, and the ones we visited—Passaic, Elizabeth, Middlesex, Bergen, Hudson—were no exception. The detainees were identified by number rather than name. Virtually everything—meals, showers, lights-on, lights-off—was regulated. The detainees complained that no official seemed to have the authority or desire to make even the most inconsequential decision. It was the system, rather than any particular official, that had the authority to grant dispensations from general rules; and it was the system, rather than any particular official, that was assigned responsibility for things that went wrong.

Many of the detainees were upset because no one seemed interested in the particulars of their cases—that they had entered the country lawfully, that their papers were in order, that they had children who had been born in the United States, that they had family members who were sick or elderly and needed care, that they had friends and colleagues who would vouch for them. To officials at the jails, they were simply "special interest detainees," and nothing else mattered. The system had flattened them.

We helped the detainees navigate the system, and we were able to improve their lives in small ways. Many of the detainees hadn't been able to contact their families; we convinced the wardens to let them make phone calls. Some of the men were being held in dirty and overcrowded facilities; we pressured the wardens to move them. Probably the most important thing we did was simply listen to the detainees tell their stories, and pass those stories on to other people. We spoke to the detainees about their families, their jobs, their histories, and then we told their stories to the media, the courts, and eventually the United Nations as well. We tried to correct the stories that government officials were telling, and we tried to get the world to see the detainees as individual human beings.

Not long after I started volunteering for the ACLU, I was given the opportunity to join the organization's staff. Since then I've spent nine years at the ACLU, mainly litigating cases relating to the government's counterterrorism policies—cases relating to the detention of prisoners at Guantánamo, for example, and the CIA's "targeted killing" program, and the torture of prisoners in the CIA's black sites. In some ways the work is quite different from the work we did in the New Jersey detention centers, but in some important respects it's the same. We try to be skeptical of government claims, and to narrow the distance between official narratives and unofficial ones. And we try to persuade people to see the victims of human rights abuses not as "suspects" or "terrorists" or "enemy combatants" but as individual human beings with complex histories, motivations, and commitments. We try to restore dimension to what the system tries to flatten.

JAMEEL JAFFER (b. 1971) was one of the architects of *ACLU v. Department of Defense*, a landmark lawsuit that resulted in the release of voluminous information about the Bush administration's torture policies, including the "torture memos" written by lawyers in that administration's Office of Legal Counsel. He is Deputy Legal Director at the ACLU, which deals with issues of national security, human rights, privacy, free speech, and technology.

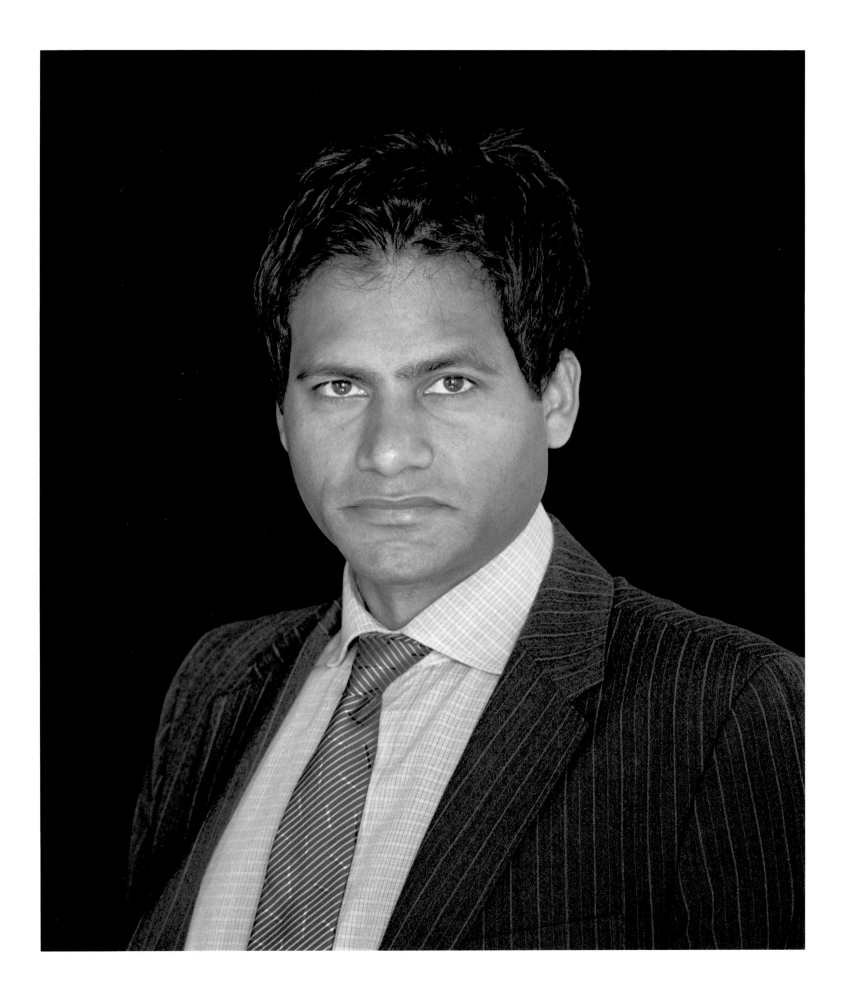

FRANK KAMENY

UNITED STATES — ACTIVIST

I AM VIEWED BY MANY as one of the founding fathers of the gay movement. I initiated gay activism and militancy nationally in 1961, and if I'm remembered for no other thing, in 1968 I coined the slogan "Gay is good."

My childhood began in the 1920s, which was—on this question as on so many questions—an utterly different era from the present. Homosexuality, gayness, was simply not in the air. As I moved into puberty, the theory of the day was that homosexuality was a phase that everybody went through. I was not socially adept anyway, so I just assumed that I was going through it more slowly than other people.

When I enlisted in the army at the height of World War II, three days before my 18th birthday, they asked—and I didn't tell. Though I'm proud of my military service, I resent the fact that I had to lie in order to serve in a war that I strongly supported. On my 29th birthday, I met a 17-year-old boy who had far more experience than I had. It was only then, fairly late, that I moved into the tiny gay community—in fact, "tiny" overstates its size.

I had a normal social life: I went to gay bars, met people. There were five or six gay organizations in the entire country, but none here in Washington, D.C. I had a job with the Army Map Service. As a result of senatorial committee hearings during the McCarthy era, there was a relentless pressure on the Metropolitan Police Department to ferret out gay people and send their names to the Civil Service Commission; late in 1957, I was fired for being gay. With the assistance of the ACLU, I took it to court. After we lost at the lower two court levels, I wrote my own legal brief for the Supreme Court—which was, to my knowledge, the first gay rights legal brief ever filed by anybody anywhere. And I must say, after half a century, it still reads pretty well. The Supreme Court, as they have done with most of the petitions filed, turned it down in 1961. That ended my formal case.

The few gay organizations in existence then didn't suit my personality; they were too defensive and apologetic. In 1961, I founded the Mattachine Society of Washington. The first gay movement, founded by Harry Hay in Los Angeles in 1951, was called Mattachine, the name of a guild of court jesters in medieval times in Italy. The members of the guild had worn masks and costumes and were permitted, as others were not, to speak pointed personal, political, and social truths. So the idea of truth from behind a mask was adopted when the movement was founded in '51.

Having been fired from the civil service, I made a project of tackling the Civil Service Commission, which is now called the Office of Personnel Management (OPM). I created test cases. It took me 18 years, but, in 1975, I got them to reverse their ban on the employment of gays. Clinton issued an executive order in 1997 establishing a nondiscrimination policy. And, finally, in 2009, I received a beautiful letter from the head of the OPM, apologizing after 52 years for the government's firing of me because I was gay.

I have a wall full of memorabilia of every possible kind. As the years progressed, I became a self-styled paralegal, handling all kinds of government cases. I kept track of the average lawyers' fees of the time, which rose to somewhere around $250 an hour. I arbitrarily cut that in half and charged people $125. In the 1980s and early '90s, I became the authority in the country on security clearances for gay people. There was a 1953 Eisenhower executive order that denied clearances to gay people, but we gradually wore down its application; ultimately, Clinton issued another executive order, which effectively reversed Eisenhower's. With the change in policy on civil service employment and on security clearances, openly gay groups grew up in many different agencies. For example, there is now a very open group of gay CIA employees.

Another project took just over 30 years—I got the District of Columbia's sodomy law repealed. Every state in the country and D.C. had anti-sodomy laws, which prohibited, among other things, oral and anal sex. In 1954, the American Law Institute proposed a moral penal code. States began overturning the sodomy laws, either legislatively or through their state-level supreme courts. Keep in mind that over 90 percent of all American adults—not gay ones—engage in oral sex. These laws made habitual recidivist felons out of essentially the entire U.S. population. Beginning with Illinois in '61, the sodomy laws were gradually struck down, ending entirely with the Supreme Court's decision in *Lawrence v. Texas* in 2003.

FRANK KAMENY (1925–2011) was an American gay rights activist. In 1957, he was fired from his job as an astronomer in the Army Map Service for being homosexual. Kameny argued his case to the Supreme Court, which denied his petition. He, however, continued to advocate for gay and lesbian civil rights, spearheading a new aggressive era in the movement, leading public protests and demonstrations, and continually pressing for equal treatment of gay citizens. Kameny founded a number of gay rights organizations including the Mattachine Society of Washington, D.C., which led the first public demonstration at the White House in 1965.

YURI ORLOV

RUSSIA — PHYSICIST/ACTIVIST

I WAS BORN IN 1924 into a family of peasants and workers. The Civil War had left my mother a 10-year-old orphan and street urchin. Collectivization drove my father's family into poverty and factory jobs in Moscow. Yet I never heard them criticize the regime. Luck and their prudent silence kept us safe from arrest and, like my passion for Russian literature, insulated my soul against Soviet propaganda. Mindlessly, I wrote school essays on Our Great Leader and later became a candidate member of the Party. I noticed surreal features in Stalin's Russia but knew not to ask about them.

Such puzzles soon got eclipsed by the war. My first serious political discussions were with fellow officers shortly before our demobilization. Although they were exciting, my chief concern was to make up all the years of high school I had lost to Hitler. I did that on my own and then, at university, became absorbed in physics.

By the time of the famous "Khrushchev thaw," I was a young theoretical physicist in Moscow with critical views on the Soviet system. In 1956, out of a sense of patriotic duty, I made a speech at my physics institute calling for "democratization on the basis of socialism." I didn't know much about human rights concepts then. The Politburo itself ordered the institute to fire me and my fellow speechmakers. They even wanted to arrest us. Khrushchev saved us from that.

The only job I could get was at the physics institute run by my boss's brother in Armenia. Separated from my family, I worked there for 16 years doing accelerator physics, becoming a professor, head of a laboratory, and member of the Armenian Academy of Sciences. When Larisa Bogoraz and six other incredibly brave people protested the invasion of Czechoslovakia in 1968, I felt shame that I had done nothing. By then I understood the idea of human rights and knew all about figures such as Andrei Sakharov. Yet I had no answer and couldn't bear the thought of being expelled again from the science I loved for some ineffectual idea or gesture.

Finally back in Moscow, in 1972, I found a job in an unrelated field of physics and immediately got involved in the human rights movement. The next year I was fired for becoming a founding member of the Soviet section of Amnesty International, organized by my old friend Valentin Turchin. That was the last time I worked as a physicist in my country. I fed my family by freelance work like editing scientific filmstrips, and through the generosity of Solzhenitsyn (then exiled in Zurich), Yelena Bonner, and fellow scientists who secretly sent funds from Moscow, Armenia, and Siberia.

In 1976, I conceived the idea of the Moscow Helsinki Group to monitor the USSR's compliance with the human rights provisions of the 1975 Helsinki Accords. Our group then helped form similar groups in Ukraine, Georgia, and Lithuania. In the U.S., Helsinki Watch was created to support us, eventually growing into Human Rights Watch. Despite my being under 24-hour KGB surveillance, no one but me thought I would be arrested. That happened nine months after our group began its work. Getting the maximum sentence (seven years' hard labor, plus exile) didn't astound me either.

Labor camp was rather unpleasant, especially after Sadat and Begin received the Nobel Peace Prize. I had been nominated for it, and the Politburo mounted an intensive campaign in opposition. Now everybody could relax and concentrate on breaking or compromising me. Some KGB genius had heard of "carrots-and-sticks," so they offered me a private room for writing scientific papers, which I would then turn over to them. I refused but managed to smuggle out a couple of scientific articles and various human rights appeals. Halfway through my Siberian exile, Ronald Reagan traded a Russian spy for me and an American reporter, Nicholas Daniloff. Stripped of Soviet citizenship and put in a custom-made suit, I was flown to New York like a package.

Unlike many dissidents, I was able to build a new life in the profession I loved, doing physics research at Cornell University and consulting at Brookhaven National Laboratory. Today I teach quantum mechanics one term, human rights the other—a funny combination. But, then, so is my life.

I visit Russia periodically to see friends and family and participate in human rights activities. The system of justice remains scandalous. The defense of human rights has become physically dangerous. However, the Soviet Union is gone, and innumerable defenders of human rights work openly throughout the country. Taking the long view, I see progress. And I firmly believe that someday Russia will become a democratic country.

YURI FYODOROVICH ORLOV (b. 1924), a physicist, founded the influential Moscow Helsinki Group in 1976 to monitor Soviet compliance with the Helsinki Accords. Its written reports gave Western governments concrete legal grounds to challenge the USSR about its human rights violations. An inspiration to Solidarity and Charter 77 and a model for monitoring groups elsewhere in the USSR, and eventually throughout Eastern Europe and the West, the Moscow group (like the groups in Ukraine, Lithuania and Georgia) was decimated by government persecution. After nearly 10 years of prison and exile, Orlov was deported to New York in 1986, where he resumed his work. He is Professor of Physics and Government at Cornell University.

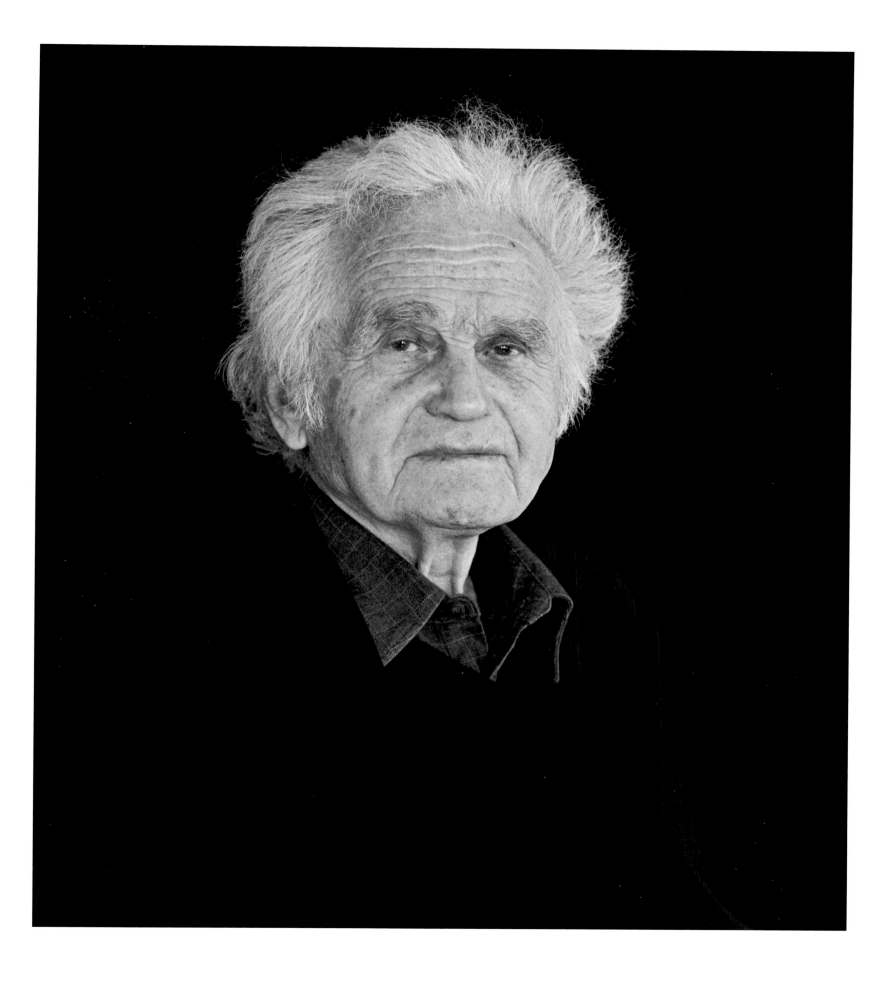

MICHELLE BACHELET

CHILE — PHYSICIAN/POLITICIAN

PUBLIC SERVICE was an essential part of my upbringing. The concepts of equality, justice, and personal responsibility must have been in my milk bottle because they are precisely the things that move me. I was born in 1951, just after the Declaration of Human Rights—when the violation of people's rights was not spoken of as "human rights," as it is today, but the concept was beginning to emerge.

When one person's rights are being violated, there is a possibility that it can happen to all humanity. Because of my father's belief in the rule of law, he did not support the coup d'état; he was taken to prison, tortured, and ultimately died in prison. My mother and I were also imprisoned because we were working to restore democracy. We weren't doing anything dramatic. We were not terrorists. We worked on the human rights commission. After we were taken to the secret jail, my mother was expelled from the country. I was 23 years old and had just ended my fifth year as a medical student. I was held with many other young women who had been tortured terribly. I wanted to be a psychiatrist at that time and hoped to understand what makes people do such things. When I was released, I left the country. My mother and I returned to Chile again in 1975.

In Chile, one of the training exercises in the army was to raise a little dog from when it was a puppy and then cut its throat when it was an adult. While such training may be necessary for psychological preparation to kill in war, serious problems arise when political adversaries are considered enemies. In the past, national security superseded everything; people were tortured and put in secret jails, telephones were tapped, and the rule of law was disrespected. The military did not understand that in a democracy people are not only entitled to but should have differences; those differences should be part of the enrichment of their society.

I was elected the first female President of Chile in 2006. One of the first things my administration did to foster democracy was to change the curricula of the armed forces, which ensured that rule of law was the guiding principle. Soldiers were held accountable for building a better society. We couldn't change the past but we could shape the current situation and the future. As defense minister, I had worked on how we dealt with the past, so the cleaned scar would heal, which meant upholding the pillars of truth and justice and considering the possibility of no impunity.

One of the essential questions of today is, how much truth? How much justice? How much reconciliation? If you want a divided nation to reconcile, some believe that we should forget the past and focus on the future. Our experience shows that, in the end, the scar opens and conflict arises again—as has happened in Uruguay, where they are suddenly backpedaling on their amnesty law and digging up graves. The young people in Egypt, Tunis, and Bahrain are thinking about these things because the first natural emotion is retaliation. But will retaliation by killing permit a nation that has been divided to reconcile? Probably not. How do you rebuild a country after something like that? It takes time, but it also needs wise people who can determine what amount of truth, justice, and reconciliation a country is able to live with.

Politics is the surest way to advance people's rights and transform societies because it actively tries to effect change. When politicians lose sight of the fact that politics is of the people, by the people, and for the people—to echo Abraham Lincoln—it loses its credibility and reliability. Human rights have to be concrete—in the form of social, economic, cultural, and political rights. When my presidency ended in 2010, I was appointed the first executive director of UN Women, which seeks to empower women and girls across the globe. I believe that women's rights are human rights and that women can be powerful forces of positive change, but they have not been given their fair due by humanity. Furthering women's rights is the greatest contribution we can make to the world and society in the 21st century.

As a politician, I strive to ensure that everything I do is in the collective interest and done with the people's welfare in mind. For me, that's the reason to be in politics: to change people's lives for the better, nothing else. It is the only reason that I am interested in participating.

PRESIDENT MICHELLE BACHELET (b. 1951) is a single mother and self-described socialist. Her early interest in politics became far more dangerous after the military coup of September 1973 that brought about General Augusto Pinochet's regime. She was elected the first female President of Chile in 2006 with 53.5 percent of the vote, and had an 84 percent approval rating when she left office in 2010. She was the first woman in Latin America to earn that title by her own merits and not by virtue of being the wife of a former head of state or leading politician. Although trained as a doctor, she was appointed Health Minister and then Defense Minister before swaying Chilean voters with her refreshing warmth and character. In 2010, she was appointed Executive Director of UN Women.

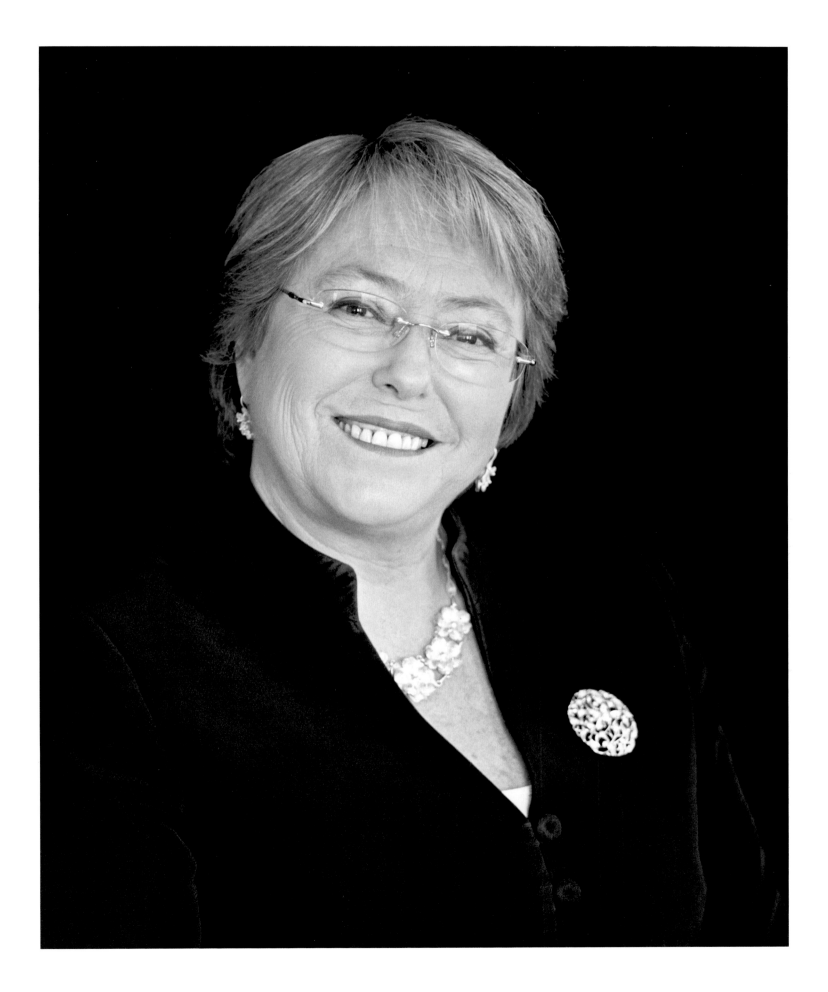

TIANCHENG WANG

CHINA/UNITED STATES — ACTIVIST

IN CHINA, the Communist government tried to control people's thinking. As a little boy, I knew nothing about democracy. As a middle-school student, I did not have an independent mind. University life was very important for me because I could read many books. I changed. A new world appeared before my eyes. I still remember the moment when I first came across the Civil and Human Rights Declaration issued in the French Revolution. It's a great document—the same document that inspired the Declaration of Independence—and had been translated into Chinese. I read more books and learned even more about the outside, including the Constitution of the United States.

In 1989, millions of Chinese people had taken to the streets demanding democracy and human rights. This was the protest at Tiananmen Square. At that time, I was completing my law degree. I stayed in my room that night, so I survived the massacre. In the same year, I became a teacher of constitutional and administrative law at Peking University, which enjoys a very sensitive and unique position in modern Chinese history because many influential student protests have begun there. After the massacre, we faced a problem, a question—how to continue the struggle for democracy? Many of my friends shared the idea that we should organize and associate ourselves more closely. Fear was everywhere in China. We had to do something underground.

In 1991 we founded the political party called the Liberal and Democratic Party of China. We composed statements about human rights and gave them to foreign reporters. We posted an article in two thousand factories, calling for an independent trade union. In 1992, to commemorate the protest at Tiananmen Square on its third anniversary, we printed six thousand copies of an article and planned to drop them onto the square from a remote-controlled aircraft we'd gotten from Hong Kong. Unfortunately, a few days beforehand, the crackdown on our party began. A few of my friends were arrested, and I was arrested some months later, just one day before I was scheduled to leave for West Germany to be a visiting scholar. When friends and family looked for me, they were told I'd already left for Germany, when in fact I was in the detention house.

Fifteen of us were tried in Beijing. We were called the Beijing Fifteen. The conditions in prison are awful, especially in the detention house. Every day, you have to sit on the floor and are not allowed to stand. The food is terrible. The worst thing is that you have no chance to see the green leaves. Every day you just look at the wall. A barren wall. In the daytime, you are not allowed to talk. After supper, the prisoners can play cards and talk with each other.

Before my release, I was asked to promise not to commit the same crime again. I refused because I had not committed any crime, so there was no need for me to promise I wouldn't do it again. They didn't like that response and threatened not to set me free. But I insisted that the law agreed to set me free. I think they respected the fact that I did not give them the promise. Upon my release, I was placed on the "blacklist" and not allowed to go abroad. I applied for a passport several times, but my requests were denied. In 2006, I decided to apply again and if rejected, to sue them. I would bring the case to the court and meet foreign reporters. In fact, I applied at a good time because the Olympic Games were approaching. Several dissidents were granted passports.

There are Chinese security agents in America. They monitor dissidents as well as Chinese students and scholars living in America. They pretend to be reporters. I think the FBI knows of their existence, but it's very hard to find a formal reason to expel them. People like me know that. I was invited to dinner by such a "reporter," who asked, "Are you feeling comfortable here in the United States? I think you better stay here." They don't want me to return to China to cause trouble.

I am very pleased to be in the United States. I can do research, and I'm working on a book about democratic transition. I think such a transition is possible. If we ask for it, it will happen. The Chinese economy is developing very fast, and every year the government's revenue improves. The government also becomes increasingly corrupt. It doesn't want to change. But something different is happening in China: a civil society is growing. More and more people are becoming courageous. The fear in people's hearts is declining.

TIANCHENG WANG (b. 1964) is an eminent academic and pro-democracy activist from China. In 1991, while serving as a law lecturer at Peking University Law School, he co-founded the Liberal and Democratic Party of China. In 1992, he was detained and charged with actively taking part in "counterrevolutionary" activities. He was sentenced to five years in prison, after which he published prizewinning papers on the rule of law and constitutionalism in China and publicly declared that China's policy toward Tibetans should be reconsidered. With the assistance of the Scholar Rescue Fund and Scholars at Risk at Columbia University and Northwestern University, Wang was able to come to the United States in January of 2008. Since then he has been a Visiting Scholar at Columbia University and Northwestern, and has authored the book *The Grand Transition: A Research Framework for the Strategy to Democratize China*.

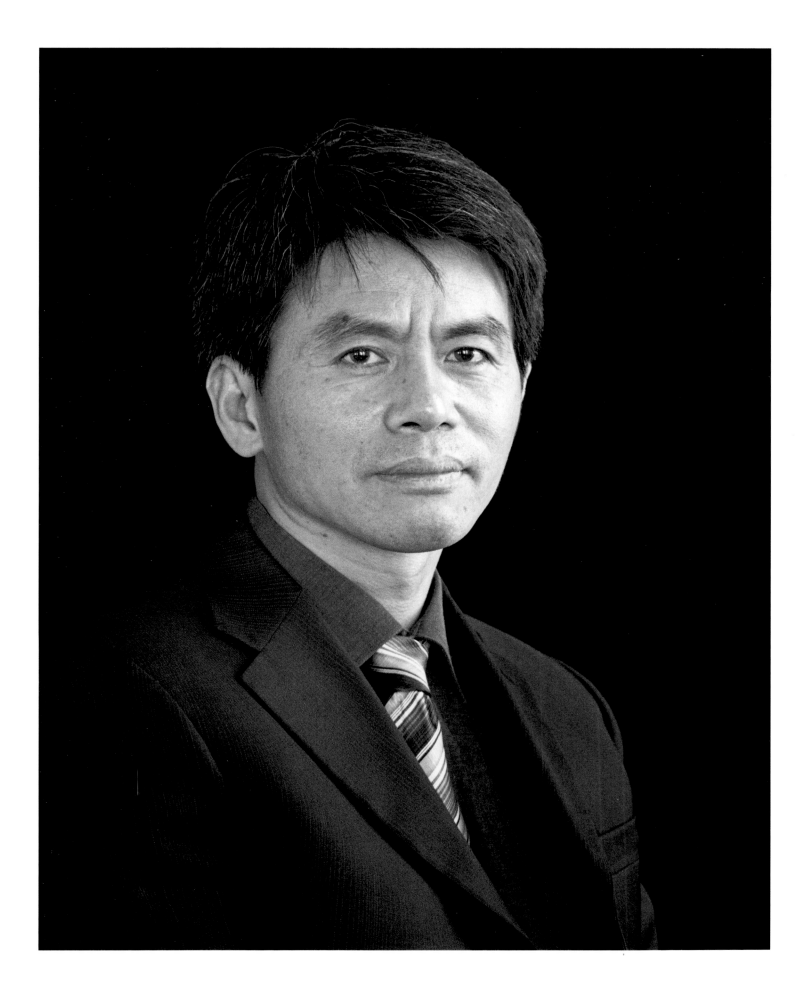

PIUS LANGA

SOUTH AFRICA — JUDGE

LANGA IN ZULU MEANS "THE SUN" OR "THE DAY." There has been a succession of popes called Pius, so I imagine my parents expected me to be devout, serious, and good. I grew up in South Africa, north of Durban, where my father was a minister. Both my parents were deeply religious and very strict. They expected all their children to embrace their religion and the principles of Christianity.

I recall vaguely the agitation around the country when the National Party came into power in 1948. There were frightening stories about what its members would do to black people, so I was immediately wary of this new government that insisted on a separation between black and white. One of my abiding childhood memories is of seeing a young black man collide with a huge white man as they walked by the side of the road. The white man grabbed the black man and started beating him for not having given way. It shaped the way I looked at the world, the way I behaved myself, and the way I regarded people of other races—the white race in particular.

A spirit of rebellion began to develop in the townships. We formed organizations, even at school, against government policies. Those people who supported the police and the government we regarded as traitors to the cause of freedom. Our heroes were people who had already left the country to establish resistance abroad, and those inside the country who were brave enough to speak up. My younger brothers were part of that rebellion; they were arrested and kept in detention and solitary confinement. They finally left the country, but our family continued to be harassed by the security police; they would knock on our door in the middle of the night, looking for banned literature or to see if we were hiding anyone regarded by the government as an enemy of the state.

Quite early on, I decided that I would like to be a lawyer, and I began to study privately. Never having the good fortune of being a resident student, I taught myself through a long-distance learning program available through the University of South Africa. After finishing my first and second degrees and receiving a bachelor of laws, I began to practice as an advocate, representing people who were charged with treason, sabotage, or terrorism. My services were required throughout South Africa, so I often traveled to Capetown, Port Elizabeth, and Johannesburg.

We established the United Democratic Front in the early 1980s. I organized lawyers to assist the liberation movement, both inside and outside South Africa. In addition to working with community organizations in townships, I was president of an organization called the National Association of Democratic Lawyers. It became quite an important part of the general movement of resistance against the apartheid government.

In 1990, Mandela was released from prison, together with the contemporaries who were with him on Robben Island. We had formed a reception committee and received him back into society. Talks to resolve the political impasse were held under his leadership and a new Constitution was drafted. In 1994, a new dispensation was ushered in with apartheid finally outlawed, and a new government: Mandela was elected President of a democratic South Africa under a new Constitution.

Previously, judges had been appointed by the executive, the minister of justice, and the state president. In order that the new legal order and judicial system should have the trust of the majority, it had been decided that we needed a new court, which was going to be the guardian of the new Constitution with a bill of rights. The new Constitution established the Constitutional Court. At the same time, the Judicial Service Commission was formed to begin a new way of selecting judges. I was one of the first of the 11 judges to be appointed to the Constitutional Court.

Our job in the Constitutional Court was to ensure that the principles of democracy, justice, and human rights were the guiding lights for the new society. The 11 of us on the first court were great colleagues—very committed, with exceptional talents and a wonderful collegial spirit. As one who had gone through apartheid, it was fascinating to be in the new constitutional dispensation as an ordinary human being.

What happened in South Africa was a miracle. A veritable revolution had taken place, and in parallel situations one would have expected a lot of bloodshed. We still have problems, both racial and socioeconomic, but there is political freedom. There are discussions about transformation and about reconciliation. And I do believe, as long as people are talking, we will get there.

PIUS LANGA (b. 1939) was only nine years old when the policy of apartheid took root in South Africa. He rose from working in a shirt factory to practicing law in Durban, Natal, South Africa, in 1977. He represented many who were charged because they resisted the injustices of colonialism and organized members of the legal profession to bring about a free and democratic South Africa. In 1994, he was appointed one of the first Justices of the Constitutional Court of South Africa, subsequently serving as the first black Chief Justice of South Africa (2005–2009). A witness to apartheid's atrocities, he was also, and continues to be, at the forefront of the fight for equality and justice.

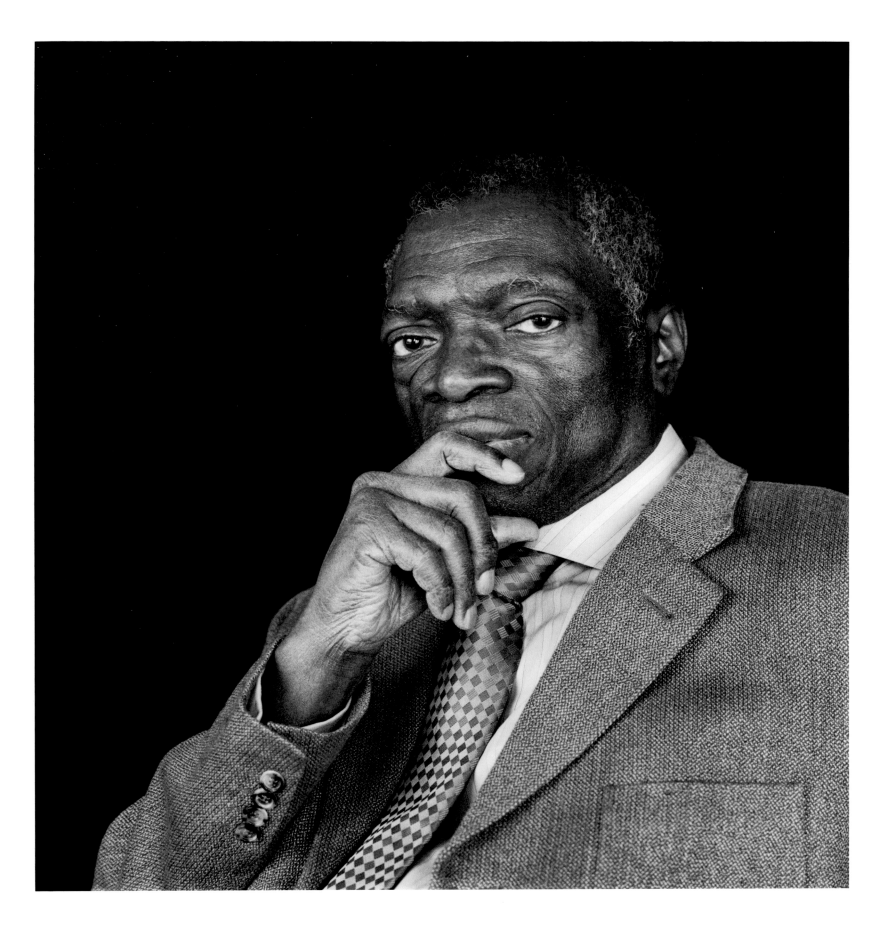

LOUISE ARBOUR

CANADA — JUDGE/ACTIVIST

THE LAW WAS A GOOD FIT FOR ME FROM THE BEGINNING. It had the right mix of intellectual rigor, ethical grounding, and practical application. I became particularly interested in criminal law, and the work I do today to some extent reflects my lifelong interests in the fine lines between deviance and nonconformism—between confrontation and accommodation, power and abuse of power, liberty and security, good and bad.

I have old French-Canadian roots; some of my ancestors are believed to have come off one of the early boats that touched the shores of the New World. This is why I always found it ironic, in my later international human rights work, to be described in some parts of the world as a neocolonial imperialist. If you overlook what we did to the earlier inhabitants of the continent, my story is that of a conquered, colonized people. I swear I don't have a colonialist predisposition, but I concede that bad attitudes are not all inherited and most can be acquired.

My career to some extent speaks of an era—not just of opening opportunities for women in the legal profession and in public life but also of greater opportunities within the law for everyone. My work in Canada, first as an academic, then as a judge, is largely a product of the feminist movement of the '60s and '70s and of the liberalization of society that followed. The impetus for the kind of change reflected in my professional life is rooted, I think, in The Canadian Charter of Rights and Freedoms, which in 1982 launched a culture of rights anchored in ideals of equality and fairness.

The opportunities that presented themselves to me on the international scene were of the same nature. The prosecution of war criminals in the former Yugoslavia and in Rwanda in the mid-1990s was an unprecedented effort to see justice as a form of peacemaking. But there is still tension, internationally, between the aspirations of peace and of justice. In the common law system, a police officer is called a "peace officer." A crime is a "breach of the peace." Yet the prosecution of war criminals by international courts is often viewed as an irritant to peace processes. Many still argue that tyrants and dictators responsible for atrocities should be given amnesties if that is the price that must be paid for their peaceful departure. While it is true that war may be too high a price to pay for justice, peace built on unredressed grievances and real injustices is unlikely to be lasting. As elsewhere, the tensions between these two legitimate aspirations—to peace and to justice—can only be accommodated in a contextual fashion, and without elevating either as an exclusive absolute. Everything—peace, justice, truth—can be either pursued with too much zeal or abandoned at too high a cost.

In my work in the courts of Canada, I dealt with controversial issues such as a prisoner's right to vote, the integration of severely disabled children into mainstream public classrooms, and a wide range of protections for criminal defendants. I conducted a yearlong inquiry into what was at that time the only federal prison for women in Canada, uncovering profound failures in the administration of justice. I believe that the hallmark of a democracy is its ability to offer adequate protection to minority rights and interests, and to account publicly for its shortcomings.

After moving from international criminal justice to the broader field of international human rights, I took a dramatic plunge into the unknown to join the International Crisis Group. The Crisis Group is a nongovernmental organization whose mission is the prevention of deadly conflicts. It has intellectual rigor, ethical grounding, and practical applications. Even though in that sense it is a comfortable and familiar environment, I am very conscious that I have now abandoned the law that had been my intellectual framework and my comfort zone. I have abandoned the formal institutional environments in which I had spent my entire life: the convent school, the courts, the United Nations. I wore a uniform until I was 20 years old and ready to go to law school. I swore I would never wear a uniform again. Then I became a judge, and wore a uniform again for the next 15 years. In retrospect, it is clear that I liked the anonymity of it all, and the sense of belonging.

I travel broadly and frequently. When I am asked to fill out a customs and immigration form, I always pause at the question, "What is your occupation?" Although I am president of the International Crisis Group, somehow I find that "president" is both pretentious and nondescript. So I always write "lawyer."

LOUISE ARBOUR (b. 1947) was Chief Prosecutor for the International Criminal Tribunals in the former Yugoslavia and Rwanda, where she indicted then-Yugoslav President Slobodan Milosevic for war crimes—the first time a serving head of state was prosecuted before an international court. She was subsequently appointed UN High Commissioner for Human Rights. She has been a Justice of the Canadian Supreme Court, and writes extensively on human rights, gender issues, international law, and conflict. She is President of the International Crisis Group.

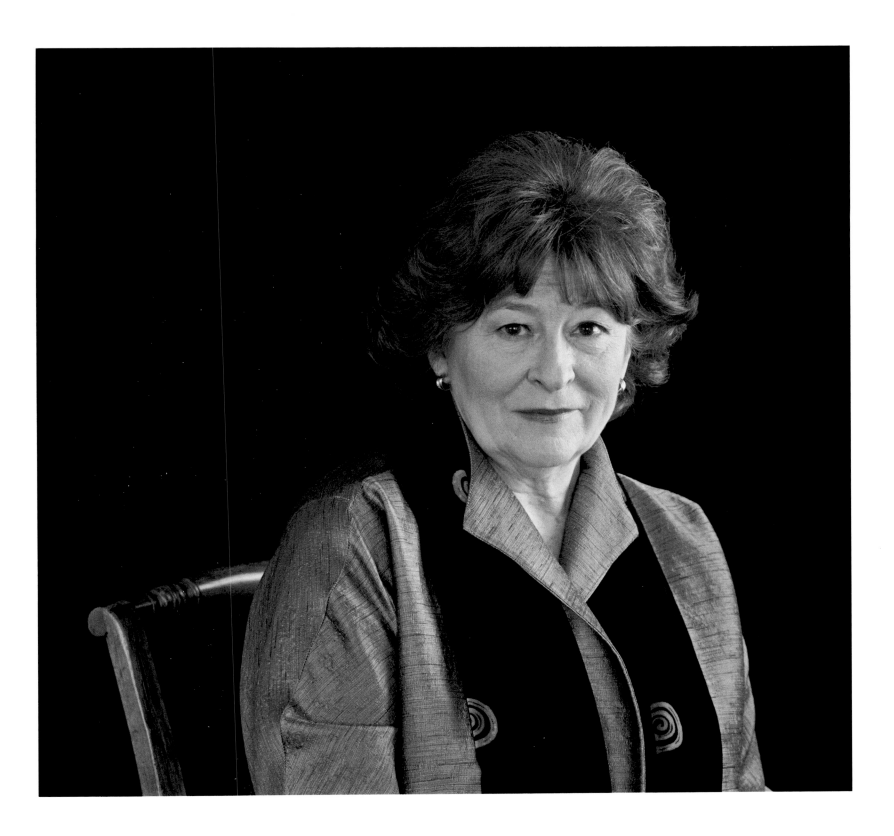

PETER NEUFELD

UNITED STATES — LAWYER/TEACHER

IN JUNE 1982, REBECCA LYNN WILLIAMS, a white 19-year-old mother of three, was raped and murdered in her Culpeper, Virginia, home by a black man. The case was a "heater." The public was scared and outraged. The press hounded the police to quickly solve the crime, but there were no clues.

Almost a year later, Earl Washington, a 22-year-old black sharecropper's son with an IQ of 69, was charged with the murder when, after a prolonged police interrogation, he cried, "I did it." Although, when pressed by the police, he did not know the race of the victim, the location of her home, or that her three kids were present during the crime, the police claimed his confession was truthful, pointing out that it contained critical facts that only the killer could supply. The confession alone was enough to get him convicted, and the failure of his lawyer to make any argument during the penalty phase earned him a bed on death row. Earl came within nine days of execution.

I was part of a team that for 20 years fought to save Earl's life, ultimately winning his exoneration and freedom through DNA testing, which also identified the real perpetrator—a serial rapist who struck repeatedly after the Culpeper attack.

Since my partner, Barry Scheck, and I founded the Innocence Project (IP) in 1992, we have participated in exonerating more than half of the 300 men and women who were languishing in prison after having exhausted their appeals. Some, like Earl Washington, came perilously close to state execution before being cleared. The Innocence Project might have exonerated hundreds more if biological evidence had not been lost, destroyed, or overlooked during investigation, or if more prisoners had access to DNA testing.

Following exoneration, the IP deconstructs the criminal investigation and trial to understand what went wrong. We have learned that DNA does not hold all the answers: it only shows us the right questions. We have discovered that, like Earl, 30 percent of those exonerated had been manipulated into giving false confessions; their interrogators had fed them nonpublic details, which then became the centerpiece of the prosecution's case. Misidentifications were a factor in 75 percent of the cases. Forensic scientists used unvalidated techniques or exaggerated the value of the evidence. Police and prosecutors engaged in misconduct, defense lawyers fell down on the job, and jailhouse informants lied in exchange for favorable treatment.

I have observed that rules are broken more frequently when the accused innocents are black or brown: we have a long way to go before banishing the pernicious impact of racial and economic disparity. Nevertheless, our work has shifted the death penalty debate from entrenched philosophical and political posturing to a growing recognition that our system is far too susceptible to error to allow the ultimate punishment, with no chance to undo should new evidence of innocence emerge.

The IP collaborates with scientists and criminologists to find new ways to get to the truth, encouraging the use of investigative and forensic tools that are as free as possible of cognitive bias. We try to win over legislators, the courts, and members of the executive branch to our common-sense reforms. We have encouraged the initiation of 50 similar projects across the country and another 10 abroad. Our goal is to transform the culture of criminal justice.

How did I get here? My parents were activists long before my brother and I were born. My dad supported the anti-fascists in the Spanish Civil War, worked for Norman Thomas's and Henry Wallace's runs for the White House, and worshipped civil rights as his only religion. My mom provided a moral center for us in the Society for Ethical Culture, a secular humanist religion with congregations in many large metropolitan areas. She set up an innovative bail fund, enlisting churches and synagogues to post their buildings as security for defendants too poor to make bail—acutely aware that no judge would dare foreclose on a house of worship. At 92, she remains a political force.

At 14, I was impeached as class president and suspended for organizing a petition against the compulsory recitation of the Pledge of Allegiance. I wasn't opposed to the pledge per se; just to folks' making me recite it every day until it lost all meaning. In college, I helped plan several national marches following the Vietnam War's expansion into Laos and Cambodia. After law school, I was hired by the Legal Aid Society's South Bronx office, where I met my wife, Adele, as well as Barry Scheck, with whom I have worked ever since. I found a legitimate outlet for my passion for politics and social justice.

PETER NEUFELD (b. 1950) is Co-Founder and Co-Director of the Innocence Project with Barry Scheck, which represents hundreds of inmates seeking post-conviction release through DNA testing. In its two decades of existence, the Innocence Project has assumed a leadership role in the emerging civil rights movement to identify and address the systemic causes of wrongful conviction. He is also a Co-Founder of the civil rights law firm Neufeld Scheck & Brustin and has successfully represented victims of police and prosecutorial misconduct, battered women who defended themselves against their abusers, and victims of police and prison torture.

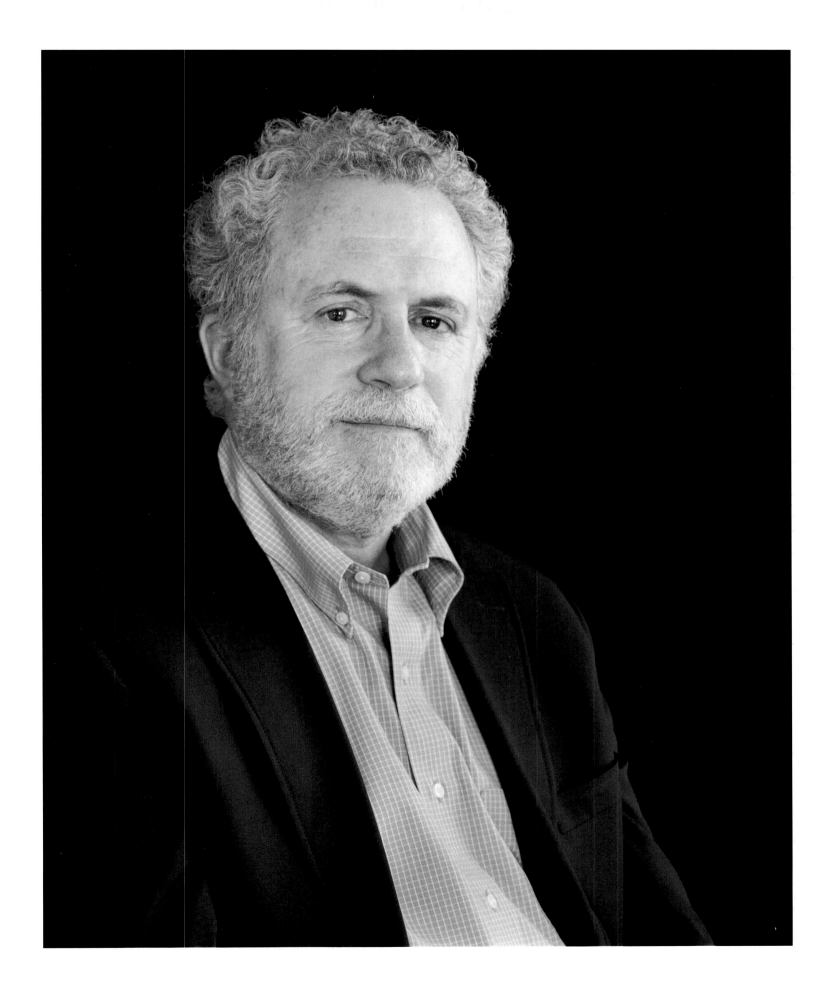

MARGARET H. MARSHALL

UNITED STATES — JUDGE

I WAS BORN AND GREW UP IN NEWCASTLE, NATAL, in what Nadine Gordimer called the "rigidly racist and inhibited colonial society" of small-town, provincial South Africa. My childhood was secure and comfortable, far different from the lives of the majority of South Africans, black South Africans, whose ghettos ("townships") were never seen by us. We—the white community, the government—existed in existential blindness, blinding ourselves to reality because seeing it would be too painful. It was a willful unknowing that left us ignorant of the suffering that surrounded us.

But not always: I am perhaps eight years old. It is a typical Sunday afternoon. After church, our family often drives to a hotel in the surrounding mountains, where my mother and father like to drink tea on the veranda. On this particular Sunday, the car ahead of us slows down as it approaches a black man on a bicycle, pedaling on the shoulder, well out of the car's path. As the car pulls up alongside, a white hand holding a long leather whip emerges from the passenger window. The passenger brutally whips the black cyclist, who falls to the ground. We drive on, in silence.

The existential blindness of apartheid was banal, quotidian, but not total. When Senator Robert Kennedy made his momentous trip to South Africa in 1966, thousands responded to his call for the "ripples of hope" that can bring change. "Each time a man stands up for an ideal," he said, "or strikes out against an injustice, he sends forth a tiny ripple of hope, and crossing each other from a million different centers of energy and daring, those ripples build a current which can sweep down the mightiest walls of oppression and resistance."

I was one of the student leaders who invited Senator Kennedy to South Africa. How did I, the sheltered white child from a small rural town, get there? I was fortunate: I learned about justice from our Anglican bishop, Bishop Ambrose Reeves, a man of great courage, of open eyes and heart. In 1962 I came to the United States as a high school exchange student. I could read books here, by Alan Paton and others, which were banned at home. I was astonished to find the great issues of the day— civil rights, Soviet missiles in Cuba—openly debated. I learned that law could mean justice, not the will of the powerful. I went home to university, ready to struggle against apartheid. I came to know black student leaders. Stephen Biko, a colleague and friend, was later beaten to death in a prison cell.

The white student leaders who had preceded me had been jailed and banned. I felt the fear of what might happen to me in the apartheid state. I returned to the United States, this time as a graduate student. It was 1968, and Dr. Martin Luther King Jr. and Robert Kennedy were murdered within weeks of my arrival. But I began to understand the vision of this country, summed up in the phrase "freedom under law."

I had never had an interest in the law. Now I did. I was admitted to Yale Law School and practiced law in Boston. I became vice-president and general counsel of Harvard University. Then, in 1996, Governor William Weld appointed me to the Supreme Judicial Court of Massachusetts. Three years later I became chief justice. My judicial experience has strengthened my belief that justice—and, with it, a stable and prosperous society—is best obtained through a written charter of government; this charter apportions public power, guarantees fundamental rights, and entrusts the ultimate protection of those rights to an impartial judiciary comprised of judges who, in the words of the 1780 Massachusetts Constitution drafted by John Adams, are "as free and impartial as the lot of humanity will admit."

My early experiences in South Africa undoubtedly influenced my outlook as a judge. But I, like other judges, always had in mind this country's great goals: freedom and equality. In 1783, my court was the first to outlaw slavery as incompatible with the command of our Bill of Rights that "all people are born free and equal and have certain natural, essential and unalienable rights." Two hundred and twenty years later, my court was the first in this country to rule that the state may not deny the protections, benefits, and obligations conferred by civil marriage to two individuals of the same sex who wish to marry. "The Massachusetts Constitution," I wrote, "affirms the dignity and equality of all individuals. It forbids the creation of second-class citizens." I have learned that the quest for freedom, for dignity and equality, is never over.

MARGARET H. MARSHALL (b. 1944) was the first woman appointed Chief Justice of the Supreme Judicial Court of Massachusetts in the court's then 300-year history, serving from 1999 until her retirement in December 2010. She previously served as an Associate Justice from 1996 to 1999. Among the many opinions she authored was the majority opinion in landmark 2003 decision *Goodridge v. Department of Public Health,* holding that the Massachusetts Constitution prohibits the state from denying same-sex couples access to civil marriage. The ruling made Massachusetts the first state in the United States to legalize gay marriage. Born and raised in South Africa, Chief Justice Marshall was active in anti-apartheid activities, serving as President of the National Union of South Africa Students, an anti-apartheid organization.

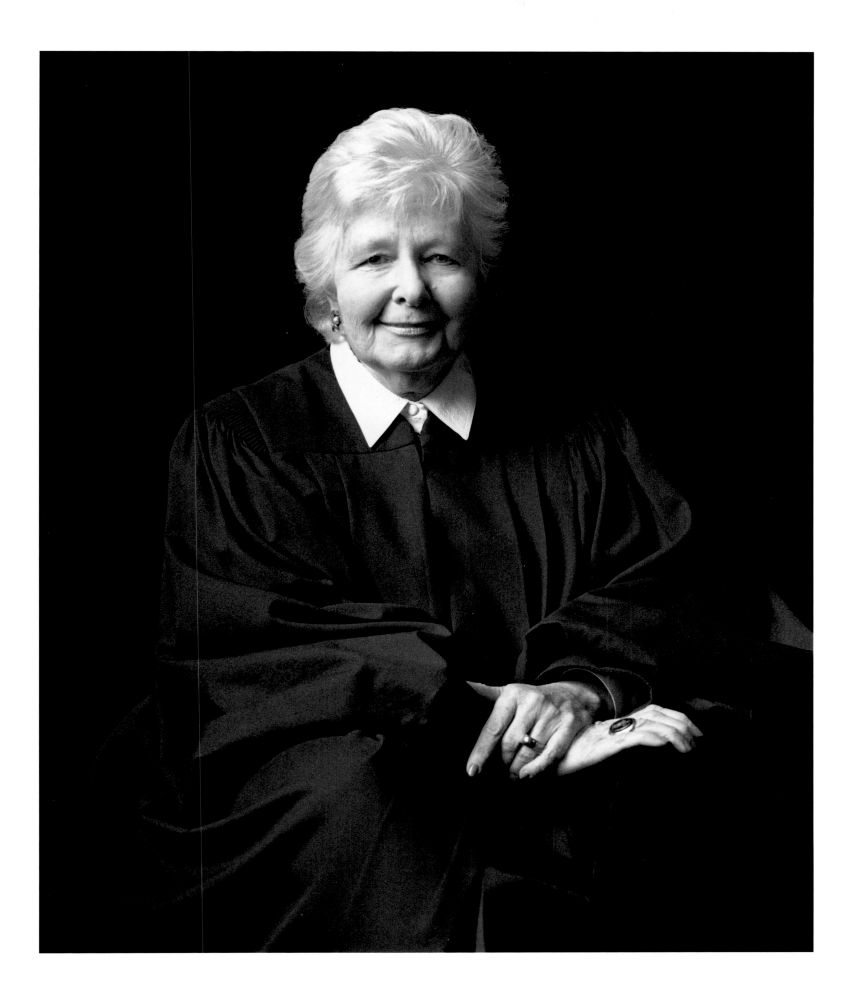

ISABELLE CHOPIN

BELGIUM — LAWYER/ACTIVIST

I HAVE A VERY CLEAR RECOLLECTION of the first time I encountered unfairness. It was during the summer of 1970, and I was participating in a sandcastle competition on a beach in Brittany. Sitting next to me on the sand was an older and taller boy, and we were both very eager to build something resembling a castle. When the competition was over, all of the children who had taken part were called over by the organizers to receive a small gift or award. However, while I was called, my neighbor was not. I remember asking why he had not received anything, as he had also built a castle. I remember very well the silent, polite, and embarrassed smiles of the adults present. I did not get an answer, and my fellow sandcastle builder still did not receive anything. He happened to have Down's syndrome.

I was five years old, but the overwhelming incomprehension and unfairness that I felt at that time still remain very vivid. It also taught me that even adults (or "those who know") can be wrong. I do not know whether this experience really left such an important mark, but throughout my life I have been obsessed with justice, what is fair and what is not. Could the same thing be fair for one person and not for someone else?

I chose to study law, and enjoyed it; it is always reassuring to be surrounded by a solid framework, a system in which one knows what can be done or not. Nevertheless, quite soon, law seemed to be missing two crucial things for me: life and flexibility. Law often remains words in a book, not always adapted to real situations and not easy to interpret or apply for those (judges, lawyers, and victims) who use it.

In early 1995, a few years after arriving in Brussels, I became involved in the Starting Line Group campaign advocating a very concrete proposal for a European directive prohibiting racial discrimination. The Starting Line Group was an informal network, joined by more than 400 organizations throughout the EU and accession countries, created at a time when Europe was faced with not only a series of racist and xenophobic incidents, but also the rise of nationalist and extremist political parties. It was appalling to see how discrimination was dealt with differently in the European member states and that discrimination based on nationality often served to conceal racial or religious discrimination. In 2000, two directives were adopted aiming at implementing the principle of equal treatment—irrespective of a person's race or ethnic origin, religion or belief, disability, age, or sexual orientation—in different fields. "Those who know" and had qualified this aim as totally unrealistic are not always right!

Since then, I have joined the Migration Policy Group, an independent Brussels-based organization working in the fields of anti-discrimination, integration, and immigration. As law is a living instrument that must be used, I have been working on monitoring the correct transposition and implementation of the directives at a national level. What I enjoy most is trying to make things possible by transferring the little knowledge I have to those who need it most; it was therefore essential for me to raise awareness of these directives and national anti-discrimination laws among civil society organizations. It is more than possible to be creative with law: many organizations in Eastern and Central Europe have proven this in the past when fighting discrimination against Roma. If it is clear that, in democracies, the citizen should respect the law, what is also crucial is that law should serve the citizen.

We must enable local organizations to work with these new concepts. Giving those who are doing the "real work" on the ground the ability to efficiently fight discrimination and make the law accessible to all: this is what I am most passionate about. I have been involved in developing training for both organizations and victims to offer them the tools they need to understand basic legal concepts and how to strategize. How do you monitor policies and laws? How do you prove discrimination? Can one use situation-testing in court? And, if so, how?

It is a blessing to see people with very different backgrounds and prejudices from a diverse range of countries (including religious groups in Cyprus, disability groups in Turkey, gay and lesbian organizations in the U.K., elderly associations in Sweden, Roma groups in Hungary or Romania, and trade unions in Germany) concluding that there is no hierarchy in discrimination and that, not only is it finally possible to act against discrimination, but that it is possible to do it together. I enjoy seeing people share experiences and expertise and, in the end, deciding what is best for them in their own national contexts.

George Bernard Shaw once said that in life there are people who see things as they are and wonder why, and people who see things as they are not and ask why not. The second category has always felt much more attractive to me.

ISABELLE CHOPIN (b. 1965) persuaded the European Union to adopt its Racial Equality Directive in 2000. She took advantage of the European Union's existing law on gender discrimination and its embarrassment over the rise of anti-Semitism and xenophobia in the '90s, especially the ascendancy of a neo-fascist movement in Austria, to accomplish this. It was an outstanding example of making lemonade out of a lemon.

PHEROZE NOWROJEE

KENYA — LAWYER

MY FATHER WAS A SPORTSMAN AND AN ATTORNEY. He carried the quality of fairness from the sports field into the courtroom, moving logically from fair play to due process. He was the fairest person I have met. Such professionals often put their skills to use in the defense of the weak. He did.

Challenges to oppression rarely promise success. They need, nonetheless, to be undertaken. They offer some shield against harm to individuals. They delegitimize tyranny. They hold up the alternative of the rule of law, and they enhance the processes of change. In these slow processes, the personal cost to both client and counsel is high. To help us survive with consistency, resilience, and effectiveness, we draw upon our professional values and traditions.

Lawyers often come across as highly individualistic, but we actually come from well-established lines of professional traditions, and we follow those who embody those traditions. Fine advocates like D.N. Pritt and Bram Fischer influence us by their effective mix of legal skills and social conscience. They inspire by shaping their profession's purposes to search for and bring freedom and greater equity to the societies they serve.

It is work, however, that does not exclude other legal arenas. Every lawyer working in human rights also does journeyman work in other fields of law: contract, personal injury, or defamation. We pay our dues to the partisan needs of clients. This is the largest part of legal work, and we should not divorce ourselves from the reality such work reflects.

Lawyers everywhere share the task that Jawaharlal Nehru of India spoke of, "To build a just society by just means." Lawyers are a nation's trained workers in what is "just." The burden of struggling for or safeguarding a just society falls squarely—albeit not exclusively—on the legal profession. The currency of our daily work is the negotiation of fairness and equity among our fellow citizens. But a just society is not only about legal justice. It encompasses social justice—an equal share in the resources of the country and the assurance of a quantum of dignity in the daily living of a nation; political justice—an equal share in the government and decision-making of the country; and equal rights and equal treatment without discrimination for any reason.

Our work is inextricably bound to the injustice that exists in society. This is because we work among the mechanisms of state structures, so we are the first to become aware of the breakdowns that bring about unintentional injustice. And we are also the first to see the pathologies that foster intentional injustice. It is therefore our obligation as lawyers to correct both types of departures.

We should, however, always be suspicious of too much certainty about the processes we are part of and of our own judgments in them. Those doubts are necessary safeguards against authoritarianism and injustice of another sort.

PHEROZE NOWROJEE (b. 1939) is an Advocate of the High Court of Kenya who has waged a tireless crusade for the observance of the rule of law and respect for fundamental rights and freedoms of Kenyan citizens. He was voted Jurist of the Year in 1995 by the International Commission of Jurists (Kenya Section) and received the Bernard Simons Human Rights Prize from the International Bar Association in 2002. He supports the abolition of the death penalty in Kenya and Tanzania and has devoted much of his time advocating for defendants in capital punishment cases.

W. W. LAW

UNITED STATES — ACTIVIST

WHEN I WAS 50 YEARS OLD, my fifth-grade teacher told me that she had been present when I was born on January 1, 1923. She said that my grandmother had knelt at my birth and prayed that I would one day be a leader of our people.

We grew up in my grandmother's house. She took in washing and laundry. She raised us in a home where there was a sense of church, a sense of racial advancement and pride. The first books I saw were books about black history, even before I went to school.

When I got older, along came Dr. Ralph Mark Gilbert. He was probably the most talented person to have located to Savannah during the 20th century. First, he became the pastor of the First African Church; then he formed a state association of all the existing NAACPs in Georgia at that time; then he began to ride throughout Georgia, county by county, organizing where the NAACP had not sought new clients before.

In 1950, I became head of the chapter in Savannah. In early 1960, I told members of local youth groups that I would support them in the sit-ins if they would submit themselves to training in nonviolence, in order to see whether or not they really had interest. I knew that the effort would not be an easy one. Finally, in March, I was satisfied. I gave an extra assignment to a shy fellow who liked to draw: he should go to each of the department stores and draw a floor plan as to where the exits were and where the counters were. We wanted to have easy access to the store and to be at the counter before they looked up and saw anything. On March 16 we told them that they were ready; the groups gathered in the basement of the First African Church and then set out for various lunch counters.

The lunch counters everywhere were immediately shut down. It was only at Levy's, where the manager of the store had been a displaced Jew who had been forced out of Germany—he had no compunction about arresting the young people who sat in, knowing the arrests would further our cause.

And the arrests triggered the entire movement.

On that Sunday, we called a mass meeting and agreed there would be a boycott. We immediately instituted picketing of Broughton Street. The city, in very short order, outlawed the picketing except two to a block. That made picketing very hazardous, because the rednecks came into town attempting to make up for the withdrawal of patronage that blacks had given. It meant that the two lone picketers on any one street were exposed to being heckled and spat upon.

The mass meetings spread the word. There were very few blacks at the meetings whom I did not know. I knew we had to draw on the heritage that they had come from, the rural churches. So the meetings began with a hymn singing, with spirituals. People would come forth with the songs that they had learned as children. The mass meetings were so well attended that we could tell the people Sunday afternoon what our strategy would be for the rest of the week, and they would carry it out faithfully.

Finally, the city passed an ordinance that prohibited us from picketing at all. But the people who once carried the signs would still walk the streets, and they became what we called the "silent picketers." They would walk by somebody and, if they would find a person who didn't get the word, say, "We are not going in the store." The person would turn around and keep on going. All of us understood that the key to the Savannah effort was to withhold our moneys from the cash registers and to bring these merchants to their knees. Nothing would break the boycott. It held about a year and a half.

Eventually, we desegregated the restrooms, the water fountains, the lunch counters. We insisted on the hiring of black clerks—and not just on upper floors but in positions of exposure on the first floor as well. All of these things were part of the demands that we made before we returned to the stores.

In my young days, I had been fascinated by Civil War history. And I realized that, even in the freedom struggle, it had to be done in the same way that an army would move: there had to be a certain amount of strength within the ranks. There would be some falling off, but there had to be others who would keep you on the field and keep you in the battle.

W. W. (WESTLEY WALLACE) LAW (1923–2002) credited his mother, grandmother, and the Reverend Ralph Mark Gilbert with nurturing his dedication to social justice. After service in the Armed Forces during World War II, Law became President of the NAACP Youth Council, organizing a boycott to protest inadequate school facilities and then organizing voter registration drives. In 1950, Law, who worked as a postman, became President of the Savannah NAACP branch. Following the 1954 *Brown* decision, Law and the branch were at the forefront of efforts to desegregate all public facilities in Savannah. Law devoted his later years to preserving the civil rights history of his community and established a civil rights museum named for his mentor.

ROSE STYRON

UNITED STATES — ACTIVIST

I FIND, STILL, GARDEN HOURS the most promising for writing poetry, for reflection, and for taking deep breaths before forays into the unblossoming world of mean streets, offices, prisons, and morgues. I backed into a career in human rights through poetry—first through the belated awareness of the persecution of poets under dictatorships.

In the '60s, after the shock of JFK's death, my husband, William Styron, and I pursued anti-war and anti-racist activism. In 1968, the assassinations of Martin Luther King and Bobby Kennedy undid us. Bill had written *The Confessions of Nat Turner*; his personal turmoil deepened when the novel was condemned by certain prominent blacks. The Soviets applauded the book as a rebel tract, and because I had published translations of poems of the Stalin and post-Stalin era—Mandelstam, Akhmatova, Tsvetaeva, Esenin, and Mayakovsky as well as contemporaries like Yevtushenko, Voznesensky, Akhmadulina, and Brodsky, who became friends—I was invited with Bill to a Soviet Afro-Asian writers' conference. We were the sole Westerners.

Arriving in Moscow during the Soviet occupation of Czechoslovakia, we writers, voicing our disapproval again, were sent to Tashkent. Under little surveillance there, we met and talked freely. I learned about the gulags—not only in Russia but in Egypt and Palestine and China. Beleaguered writers gave me their manuscripts to take back and get translated. I tried to bring the bad news to Washington, but the State Department blew me off. Luckily, I was introduced to Amnesty International's initial group in New York, and I was hooked. Forever. Russia's Sinyavsky, Daniel, and Bukovsky were still in my mind; Palestinian poets Mahmoud Darwish and Muin Bseiso in my heart.

My first Amnesty case, assigned to me by London, was Nelson Mandela. I corresponded with Winnie in between her visits to Robben Island. Amnesty also sent me as a delegate with Ramsey Clark, Joan Baez, and Andrew Blane to its Paris launch of the Campaign for the Abolition of Torture. Among the leaders I met there, Ireland's Sean MacBride became a mentor.

I was sent to Chile shortly after the junta's takeover; Santiago's Moneda was still smoking. The wives of Allende's ministers and generals met me covertly; in a swimming pool, while tossing a big red beach ball, they whispered bits of information on the dreaded prisons their husbands and others were sequestered in. I was to memorize and give these facts to Hortense Allende for her upcoming speech at the UN. Dodging our government followers daily, my 17-year-old daughter, Susanna, and I met with members of the underground Catholic clergy, who copied endless data for us to smuggle out.

Most disturbing, beyond the stories of torture and murder, was learning of Washington's complicity in Allende's overthrow. Kissinger was at the bottom of the destabilizing national truck strike. The tall ships in Valparaiso's harbor were used as prisons, guarded by America's navy. When I again went angrily to Washington, this time, Ted Kennedy and Attorney General Levi embraced my information and set up a parole program for Chilean dissidents, enabling their release. I had become ashamed of the imperial, often tragic, roles our government played abroad—not to mention our criminal justice failures at home.

I have been a witness to crises in El Salvador and Nicaragua; Czechoslovakia, where I met Vaclav Havel and his ingenious dissident cohorts; Poland, working with Adam Michnik, which included conversations with Lech Walesa and a day outside Warsaw with underground Solidarity leaders. Kurt Vonnegut was my companion there, and in East and West Berlin for PEN. What fun to travel with him, his Eastern European brand of humor putting our hosts at ease. I attempted later to interview President Havel in his office at the exact moment he happened to be somberly announcing the separation of Slovakia and the Czech Republic. I backed out. He ordered me back in and listened to my first question, "At what moment in your prisoner-of-conscience circumstance did you sense you would emerge to change your society?" Thoughtful, smoke curling from the cigarette he held like a unicorn horn atop his head, he proceeded to tell me a funny story about crawling under a prison commandant's desk. A sense of humor is a salve for our serious tasks and foibles.

From the early days of the human rights movement through the Arab Spring, on street corners and in parks and cemeteries around the world, I have met brilliant leaders, dedicated and risk-taking lawyers and clergymen, fearless students. My encounters with these extraordinary people have sealed my conviction that humanity can triumph over tyranny.

ROSE STYRON (b. 1928) is a human rights activist and a poet. A former Chair of Amnesty International's National Advisory Council, she has served on the boards of Human Rights Watch, the Reebok Human Rights Foundation, Equality Now, and the Lawyers Committee for Human Rights. She has published three volumes of poetry and has contributed articles on human rights and foreign policy to many publications, including *The New York Review of Books, The Nation,* and *The New Republic.* She created Writer's World, a series of conversations with publicly engaged novelists and poets produced by "Voice of America."

HASSAN JABAREEN

ISRAEL — LAWYER

I WAS BORN IN 1964 IN UMM EL-FAHEM, the second-largest Palestinian Arab town in Israel. My father was the first lawyer in our town. Although my grandfather was illiterate, he was rich, and he wanted to send my father and me to study. My mother was in the same class as my father in elementary school. She was a better student than he was, but she did not attend high school. There was no high school in Umm El-Fahem at that time. My father went to a Christian Arab private high school in Nazareth. The language of instruction in the school was English; even the Arabic-language class was taught in English. My father had to live in dorms, and when he traveled from our town to Nazareth, he needed a permit from the military governor.

Immediately after the establishment of Israel in 1948, the 150,000 Arabs like my family, who remained in their homeland and became citizens of Israel, were put under military rule until 1966. Their right of movement was restricted and they were not allowed to leave their villages without a special permit. Most Palestinians in 1948—about 650,000–700,000—fled or were deported and became refugees in Arab countries. They were not allowed to return to their homeland. My grandfather's parents and his two brothers lived in a small village in the West Bank next to our town, but after 1948, we were not allowed to visit them. When Israel occupied East Jerusalem, the West Bank, and Gaza in 1967, we started to visit them again. The occupation was a moment of defeat nationally but a happy one for our family. Later, Israel built a separation wall between Umm El-Fahem and this village.

To continue his studies at the Hebrew University in Jerusalem in law, my father had to switch to a new language: Hebrew. In fact, when my father completed high school, he did not know either of the country's two languages well; almost all Arab professionals in Israel have no real mother tongue. They study in Arabic until high school, and then they switch to Hebrew at university. Since there is no Arab market, Hebrew becomes the language of their profession. My father made a deal with one of his professors at Hebrew University who later became a Supreme Court justice. The professor took my father to a Yeshiva to learn Hebrew, and in turn my father taught his son English. In order not to be suspected by the police or to be harassed, he sometimes used the name "Rafi" instead of his Arabic name, Rafiq.

I studied law and philosophy at Tel Aviv University in the late 1980s. We were only two Arab students in the law school class. I studied during the first intifada and was once arrested for seven days just because I participated peacefully in a demonstration. Others in that protest lost a year of study. When I wanted to rent an apartment in Tel Aviv, the other tenants held a meeting to prevent it. The owner of the apartment suggested I try to convince the leader of the resistance in the building that I was a good Arab man. One evening I knocked on her door. "I am not against you personally," the resistance leader told me, "but each cultural group should live separately and alone." She was working on her master's degree about the history of fascism in Europe. We spoke about her thesis late into the night, and I saved my rental contract.

My grandfather wanted my father and me to be lawyers. His first experience with the state of Israel was in courtrooms in order to save his land; Israel confiscated almost half of his land during the military regime period. He saved very few dunams with the help of his lawyer. In fact, 76 percent of the private land owned by Arabs in Israel was confiscated, based on arbitrary laws. My grandfather died soon after I established Adalah with my wife, an American lawyer. Adalah is the first legal center to defend the rights of the Palestinians before the Israeli courts. In my moments of success, I remember my grandfather, and I wish he were alive so I could share my small legal victories with him.

Three years ago, a group from Umm El-Fahem came to Adalah's office. They wanted us to bring a case to retrieve their land, which had been confiscated by the state in the 1950s. I recalled that my grandfather had also been an owner in that area. He loved his piece of land, and he believed that it would be returned to him one day. Adalah challenged the confiscation before the Israeli Supreme Court. The courtroom was full of people from Umm El-Fahem. We argued that the state should return the land, since it had declared that the confiscation was for public purpose, and now, after more than 50 years, it was still not used for any purpose. The Supreme Court dismissed the case. After the decision, an old man who attended the hearing approached me and said, "Your grandfather is proud of you and he is telling you, 'Don't lose hope!'"

HASSAN JABAREEN (b. 1964) is a Palestinian citizen of Israel, a lawyer, and the Founder and General Director of Adalah, the leading legal center for promoting and defending Arab minority rights in Israel. He has litigated numerous landmark human rights cases before the Israeli Supreme Court on behalf of Palestinians living in Israel and the Occupied Palestinian Territory (OPT). Since 1998, he has also taught at Israeli law schools as an Adjunct Lecturer on the constitutional status of Palestinian citizens of Israel. He has received top public-interest lawyering awards and was a Yale World Fellow.

BOB MOSES

UNITED STATES — ACTIVIST

I GREW UP IN THE HARLEM RIVER HOUSES, housing projects near the Macombs Dam Bridge, which links Manhattan to Yankee Stadium. My family moved there in the late '30s. My father was an armorer, part of the janitorial service at the 369th Armory. I went to high school at Stuyvesant, which was like America for me—a real mixed bag. It was there that I first experienced the larger world outside the projects and began to internalize feelings about the country.

At Hamilton College in 1952, I was one of only two black students. When everyone was rushed into a fraternity, we were the rejects in the Commons. But I also had some good experiences there. My philosophy professor was writing a logic textbook—it was a new idea for me, that people I might know actually wrote books. I decided to major in philosophy and continued my studies at Harvard on the Whitney fellowship.

I earned an M.A. in '57, and then the bottom fell out. My mother died of cancer and my father had a breakdown. I dropped out, came back to the city, and got a job.

I was teaching math at the Horace Mann School in 1958 when the sit-ins broke out. For the first time, there were pictures of young black kids on the front pages of *The New York Times*. When I saw their pictures, something clicked. I went down to Newport News, Virginia, and walked the picket line. And when an office for Martin Luther King was set up in Harlem, I started going to that office on 125th Street every afternoon.

Eventually, I went to Atlanta and learned about the Student Nonviolent Coordinating Committee (SNCC). During the 1950s, all the talk was about the Iron Curtain and how people in Eastern Europe couldn't vote. It blew my mind that there was a congressional district in America where black people were the majority; they were eligible voters and nobody was voting. When my contract was up at Horace Mann, I went down to work with SNCC. I took people to register to vote in Amite County. You had to go through layers of resistance: the courthouse was protected first by the police, then by the highway patrol, then by ruffians. The second time we went down, I got beat up. I took my case to the county's prosecuting attorney. The radio picked it up and the Justice Department stepped into the case. Apparently, it was very unusual for the federal government to step into a criminal case.

The Freedom Summer of 1964 put issues on SNCC's plate that were too big for them to resolve. Vietnam heated up, and I was asked to speak at the first rally that Students for a Democratic Society (SDS) held against the war in 1965. In '66 I was drafted, and I decided to leave the country. I met my wife in Canada and we moved to Tanzania, where my three oldest children were born. We returned to the States in '76 when President Carter established amnesty for people who had avoided the draft. The Ford Foundation was offering fellowships for blacks to get their doctorate degrees, so I returned to graduate school, at Harvard.

When my daughter hit the eighth grade and was ready to do algebra, I discovered it wasn't being taught! I decided to follow the kids to school and teach them algebra. I taught their classmates too. That's when I started the Algebra Project.

I think of the project in terms of the movement. We learned how to use the voting issue as an organizing tool to get political access. Now technology organizes what people think. We've had a shift from the industrial age to information-age technology. Underneath it all is this little subject called math. It's quantitative literacy. For a little while, we have a window of opportunity to use math to achieve equality in education, which would then promote economic access.

There's an old argument that if kids can't read, they can't do algebra. The project has shown us that that's not true; we've got some kids who are still not reading up to snuff but are passing their math exams. We've figured out a way to get them into the system, and math has become the tool.

BOB MOSES (b. 1935) was teaching mathematics in a New York City high school when the sit-in movement began in 1960. Remembering the images he saw on television, he later recalled, "They looked how I felt." Moses went south, met the legendary Ella Baker in Atlanta, and joined the Student Nonviolent Coordinating Committee. He took SNCC into Mississippi and, working with rural blacks, initiated voter registration efforts that grew into a statewide movement, culminating with the Freedom Summer in 1964 and the Mississippi Freedom Democratic Party's famous challenge to the all-white Mississippi delegation at the Democratic National Convention. In 1966, after being drafted by the U.S. government at the height of the Vietnam War, Moses went to Canada and then Tanzania. He returned to the United States in 1976. In 1982, with the support of a MacArthur fellowship, Bob Moses founded the Algebra Project, which has grown into a national program dedicated to facilitating community-based efforts to demand and secure equal, quality education for all children, as an essential citizenship right.

THOMAS BUERGENTHAL

UNITED STATES — PROFESSOR/JUDGE

I AM FREQUENTLY ASKED WHY I have devoted by far the greater part of my professional life as law professor, advocate, and international judge to international law and human rights. As one of the youngest survivors of the concentration camps of Auschwitz and Sachsenhausen, I believe that it was natural for me to want to put my legal training at the service of a branch of the law that can play an important role in preventing genocides wherever they might occur. My commitment to the promotion of human rights has been my way of honoring those who perished in the Holocaust and giving meaning to my own survival.

I spent my childhood in the camps, from the age of five until eleven; unlike my parents, it was the only life I knew. I arrived in the United States in 1951 at the age of 17 to stay with my uncle. I had to be privately tutored since I'd had no schooling in the camps and managed to graduate from high school in a year and a half. I attended the only college that offered me a scholarship despite my lack of formal education: Bethany College in West Virginia. I completed my legal education with degrees from New York University Law School and the Harvard Law School, and embarked on a two-pronged career teaching international law and human rights and engaging in activities designed to promote the international protection of human rights.

When I started to teach international human rights law, I realized that there were only two other American law professors—Professors Louis B. Sohn at Harvard and Louis Henkin at Columbia—who were offering such a course and that there existed no casebooks on the subject. Recognizing that without casebooks few American law professors would be willing to teach separate international human rights courses, Professor Sohn and I decided to remedy that situation by publishing *International Protection of Human Rights* in 1973. Since then, an ever-increasing number of American law schools have been offering human rights courses and seminars. When a major American law book publisher invited me to write a student text on the subject, I jumped on the opportunity and wrote *International Human Rights in a Nutshell*, first published in 1988. This book, now in its fourth edition, has also been translated and published in various countries in Europe, Latin America, and Asia.

Over time, my books, articles, and lectures resulted in my being widely consulted on international human rights issues. That in turn led to my being invited to serve on private and public commissions and boards. My first judicial appointment came in 1978 when Costa Rica nominated me to the Inter-American Court of Human Rights that was then being established by the Organization of American States. Elected in 1979 as one of its first seven judges, I served on the court for 12 years, including terms as vice-president and president, and was thus able to help lay the foundation for a regional judicial institution for the protection of human rights in the Americas that has become increasingly more effective. It was also where I met my wife, who happened to be a conference interpreter.

This position was followed by memberships on the United Nations Truth Commission for El Salvador and the United Nations Human Rights Committee. In the 1990s, I was named chairman of the Committee on Conscience of the United States Holocaust Memorial Council. In that capacity I was able to encourage the committee to draw inspiration from the Holocaust by engaging in contemporary efforts to help prevent genocides wherever they might occur.

In 2000, I was elected to the International Court of Justice at The Hague. Service on the court, the principal judicial organ of the United Nations, is the highest honor any international lawyer can aspire to. It offered me the unique opportunity to play a role in contributing to the promotion of the rule of law throughout the world, in order to lay the foundations of a more peaceful world. I retired from the court in 2010 and returned to the George Washington University Law School, where I currently teach international law and human rights.

THOMAS BUERGENTHAL (b. 1934) is one of the youngest survivors of Auschwitz and an eminent authority on international human rights law. As a judge and President of the Inter-American Court of Human Rights (and the only U.S. citizen to ever serve on that court), he ensured Guatemala's compliance with a court order dictating the end of special tribunals that ordered executions of human rights activists, and stopped the practice of "disappearances" in Honduras. He was the first U.S. citizen elected to the UN Human Rights Committee and served on the UN Truth Commission for El Salvador. He served from 2000 to 2010 as the American judge on the International Court of Justice. Currently he teaches at the George Washington University Law School and has taught at the University of Texas and at Emory, as well as serving as Dean of the American University College of Law for five years. He was also Director of the Human Rights Program at the Carter Center. He co-authored the first textbook on international human rights law and believes that Germany today serves as a testament to the power of education and reconciliation in transforming a killer state into one of the most democratic countries in Europe. His superb memoir of his early life is called *A Lucky Child*.

RUTH BADER GINSBURG

UNITED STATES — JUDGE

Dear Mariana,
When Marty died, June 27, 2010, I found on his desk a speech he had written about that case. He was to deliver the speech at the Tenth Circuit Judicial Conference in August 2010.
Sincerely, RBG

HOW THE 10TH CIRCUIT COURT OF APPEALS GOT MY WIFE HER GOOD JOB *(excerpt)*
Martin D. Ginsburg

MY FIELD IS TAX LAW, and today I am going to recall for you the one case in which the Honorable Ruth and I served as co-counsel. It was also the one occasion either of us was privileged to argue in the 10th Circuit.

In the 1960s, I was practicing law in New York City, and Ruth was teaching at Rutgers Law School in Newark. One of the courses she taught was Constitutional Law, and she started looking into equal protection issues that might be presented by statutes that differentiate on the basis of sex. A dismal academic undertaking because, back then, the United States Supreme Court had never invalidated any legislative classification that differentiated on the basis of sex.

Then, as now, Ruth and I worked evenings in adjacent rooms. One evening in 1970 I was reading Tax Court advance sheets and came upon a *pro se* litigant, one Charles E. Moritz, who, on a stipulated record, was denied a $600 dependent care deduction under old §214 of the Internal Revenue Code, even though, the Tax Court found, the operative facts—save one—fit the statute perfectly. Mr. Moritz was an editor and traveling salesman for a book company. His 89-year-old dependent mother lived with him. In order to be gainfully employed without neglecting his mother or packing her off to an old-age home, Charles paid an unrelated individual at least $600—in fact, a good deal more than that—to take care of her when he was at work.

There was just one small problem. The statute awarded its up-to-$600 deduction to a taxpayer who was: a woman, a married couple, a widowed man, or a divorced man. But not to a single man like Mr. Moritz who had never been married.

Mr. Moritz, although not a lawyer, had written a brief. It was one page in length and said: "If I were a dutiful daughter instead of a dutiful son, I would have received the deduction. This makes no sense." From that brief, the Tax Court gleaned the taxpayer might be raising a constitutional objection. "Deductions are a matter of legislative grace," the Tax Court answered, adding that if the taxpayer were raising a constitutional objection, forget about it: everyone knows that the

Internal Revenue Code is immune from constitutional attack. To my mind, however, Mr. Moritz's one-page submission was the most persuasive brief I'd ever read.

Well, I went next door, handed the Tax Court advance sheets to my spouse, said, "Read this," and returned to my room. No more than five minutes later—it was a short opinion—Ruth stepped into my room and, with the broadest smile you can imagine, said, "Let's take it!" And we did.

Ruth and I took the *Moritz* appeal pro bono, of course, but since the taxpayer was not indigent we needed a pro bono organization. We thought of the American Civil Liberties Union. When Mel Wulf, the ACLU's then legal director, read the brief, which was in truth 90 percent Ruth's, he was greatly persuaded.

The 10th Circuit—Judge Holloway writing for the panel—found Mr. Moritz to have been denied the law's equal protection, reversed the Tax Court, and allowed Mr. Moritz his $600 deduction. Amazingly, the government petitioned for certiorari. The 10th Circuit's decision, the government asserted, cast a cloud of unconstitutionality over literally hundreds of federal statutes that differentiated solely on the basis of sex.

In those pre-personal computer days, there was no easy way for us to test the government's assertion. But Solicitor General Erwin Griswold took care of that by attaching to his cert. petition a list—generated by the Department of Defense's mainframe computer—of those hundreds of suspect federal statutes. Cert. was denied in *Moritz*, and the computer list proved a gift beyond price. Over the balance of the decade, in Congress, the Supreme Court, and many other courts, Ruth successfully urged the unconstitutionality of those statutes.

So our trip to the 10th Circuit fueled Ruth's career shift from diligent academic to enormously skilled appellate advocate—which in turn led to her next career on the higher side of the bench. And, with Dean Griswold's help, Mr. Moritz's case furnished the litigation agenda Ruth actively pursued until she joined the D.C. Circuit in 1980.

All in all, great achievements from a tax case with an amount in controversy that totaled exactly $296.70.

RUTH BADER GINSBURG (b. 1933) has served as an Associate Justice of the United States Supreme Court since 1993. She is the second woman ever appointed to the court, and the first Jewish female justice. She was General Counsel for the ACLU from 1973 until 1980, when she was appointed a Circuit Judge of the United States Court of Appeals for the District of Columbia Circuit. She has long advocated for the equal citizenship rights of men and women and was instrumental in launching the Women's Rights Project of the American Civil Liberties Union in 1971. Her work has led to the end of gender discrimination in many areas of law, and she has distinguished herself as an eloquent oral advocate and a staunch independent on the bench.

CLIVE STAFFORD SMITH

BRITAIN — LAWYER

MY FATHER, WHO IS BIPOLAR, used to do fairly extraordinary things. I remember when I was seven, he came into the living room and gave me £200 and told me to buzz off and go live by myself because I was old enough. He would do things like that quite often. It was a huge relief to me to learn that he was mentally ill and didn't really believe in all these crazy ideas. In the United States, he clearly would have been locked up. The fact that he wasn't is a tribute to Europe, which is a relatively gentle world—you never got locked up for anything. I represented lots of people in America who were bipolar and who suffered a lot from living in a society that treated them very harshly.

My personal experiences shaped my view of how we should judge other people. You shouldn't condemn them—certainly not until you have some sense of who they really are. If we treated everyone else the way we treat the people we love, the world would be a much saner place.

As a teenager, I became obsessed with the death penalty. I went to America to write a book about it because I had an absurd, juvenile notion that I would convince the world of the error of its ways. Various things inspired my fascination with it. Bizarrely, one was a picture of the English burning Joan of Arc at the stake. Up to that point, I'd been taught that whatever we did to the French was a good thing. In this picture, Joan of Arc looked remarkably like my sister, Mary, and it all struck me as rather barbaric.

Researching my book, I met many guys on death row in Georgia. I was horrified to discover that someone on death row in the richest country in the world had no right to a lawyer. They have a right to a lawyer at trial or direct appeal, but for the years of collateral appeals, they were meant to represent themselves. In *Murray v. Giarratano*, the Supreme Court said you have no legal right to a lawyer. It's *crazy*, really insane. I decided it would be far more useful to get a law degree than just sit around writing about it.

"Human rights" is a nice term. It's an effective term. It's actually very important in the American context, because we as Americans look at constitutional rights much more than we look at human rights. That means that if you are a foreigner, you are therefore not party to our Constitution in Guantánamo Bay and you have *no* rights—because we have not signed any human rights convention that's enforceable against us.

I devote myself to helping people who I think have been made the butts of societal hatred. The existence of the death penalty says that we as a society *so* hate a person that we want to ritualistically kill them. It doesn't get much worse than that—although it is arguable that what has happened at Guantánamo is worse. I spend my time trying to rectify the imbalance of power between the individual who is being persecuted or hated and the society that's doing it to him. On the other hand, people who think that there was a golden age of the rule of law don't know much about history. By and large, the world is much more attuned to human rights today than it was a hundred years ago. We would execute people left, right, and center, and nobody did anything.

The rule of law versus public opinion is a matter of interest. Of the first 500 prisoners we got out of Guantánamo, not one— zero—was released by an order of the court. They were released for various political reasons. We focused on the principle that if we opened Guantánamo up to public inspection, they'd close it down, because it would be horribly embarrassing, because what we're doing there is profoundly wrong. In that sense, the court of public opinion is exponentially more important than the court of law. We sometimes overvalue the latter at the expense of other more effective tools.

One wonders what's more important: "justice" or "equal rights." I tend to think equal rights are more important. If the people with power have an obligation to treat the people without power equally, that's probably more important than defining some amorphous notion of justice. I would choose the equal protection clause over the due process clause in the U.S. Constitution. I think all people are equally valuable and that it's our misbegotten notion of what humanity means that makes us think they're not. It is utterly beyond my own understanding why people who were born with a silver spoon in their mouth think it deserves to metamorphose into gold. People who are fortunate have an obligation to help people who are less fortunate. We're not going to win that debate immediately, but we'll keep trying.

CLIVE STAFFORD SMITH (b. 1959) is the British-American Director of the London-based charity Reprieve, which provides legal assistance to prisoners on death row and those held beyond the rule of law in Guantánamo Bay and other secret prisons. Since he left law school in 1984, he has only represented prisoners without resources who could find no other assistance. For 20 years, these were people facing the death penalty in the Deep South, but since moving back to the U.K. in 2004, he now helps prisoners around the world.

SABIN WILLETT

UNITED STATES — LAWYER

IN 2005, I began to learn what was going on in Guantánamo. I don't know military law and don't practice criminal law. But people were being held in a terrible prison without any court review, and that seemed wrong, and I did have a license to try to do something about it. So I took on the Uighur cases and began to wrestle over a question that's been fundamental for centuries: "What happens when the king puts somebody in jail—is there anything that can be done?"

The Uighurs are the Tibetans you've never heard about. The cases quickly became poignant because the men—who were never America's enemies but refugees from the People's Republic of China—had been cleared for release by our own military. They were in Guantánamo only because no one knew what to do with them. Other countries didn't want to brook China's displeasure by taking its refugees, and America wasn't about to admit a mistake. So they sat in the prison.

The Uighurs got there the way most people did: they were sold by bounty hunters to United States forces in Pakistan or Afghanistan. (The U.S. rarely caught people on battlefields. That's a myth. People were sold.)

The attitude of the last Bush administration was the attitude of the bully. It had the violence and the cowardice of the bully, and it employed the secrecy and bluff talk of bullies. I don't like bullies—that's what started it. But the quantum leap came when I met the clients. All of a sudden, it isn't just a policy; it's Adel, sitting in a prison. After a visit, you get on a plane home, thinking, "He's still there, and I've got to file this motion, and that's going to take three weeks, then three more weeks before a hearing, and then the judge is going to stay it because of some other thing that's going on in Congress, and the government will appeal." You are swept along, always thinking, "Adel is down there and hasn't talked to a loved one in five years."

The Uighurs were kept in solitary confinement for more than a year. We'd go down every three months and find clients who used to be bright and chipper receding into the fetal position, turning into shells. You could bang your drum in the courts; you could try to make noise in the press. Nobody cared, because in post-Fox News America, torture meant waterboarding. Torture didn't mean leaving a guy alone in a blank cell until the only companion he knows is the voice in his head. I used to go to Camp Six to see them. I'd wait for the client in a tiny concrete room. Even in 20 minutes, I'd think, "The guards have forgotten I'm here—do they know I'm still here?" Camp Six scared the hell out of me.

The case was up to the Court of Appeals, and for a while it was in the Supreme Court. Typically, there was a development to tell them about and to prepare for. The guys were somewhat bemused by this, because it never made much difference in their lives.

Every once in a while we had a breakthrough. Bermuda accepted four Uighurs in 2009. I left Bermuda on a charter plane at midnight, arrived at Gitmo at 3 A.M. We touched down in Bermuda by dawn, before the news broke. Bermuda is neat as a pin. These four men had been to Pakistan, Afghanistan, and Guantánamo, and they drove from that airport into a paradise of window boxes and pastel colors.

Picture this. We walk into a sleepy store in a little village to buy them clothing. A sleepy guy behind the counter. On the radio, a Bermudian Rush Limbaugh is denouncing the government for bringing throat-slitting terrorists onto the island who will destroy the economy and kill everyone in their beds. Just then, four Asians with long beards walk into his shop. What a double take that was! But a half hour of blue jeans and T-shirts later, and guys trying to communicate across a language barrier about inseams, the shopkeeper motions at the radio and says, "Never mind about that lot. Welcome to the island." The human touch—it's powerful.

Five men never made it—they were still in Guantánamo in April 2011, on the morning the Supreme Court at last bolted tight the courthouse door. "There's a heartbreak at the heart of things," as Virgil says. Here's the biggest heartbreak of all: we learned, following President Obama's inauguration, that America actually loves Guantánamo and doesn't want to let it go. Closing it means doing something with the people, and America won't budge. It's a pretty tough sell to go to Bermuda and Europe and say, "You solve our problem, because we won't." Americans were embarrassed about torture of the Fox News variety, but we are xenophobic. If we can keep brown people on a prison island far away, that's a good thing, as far as most of us are concerned.

I believe in Lincoln's First Inaugural—in "the better angels of our nature." I tried to help my countrymen find those better angels. Mainly, I haven't succeeded. At least not yet.

SABIN WILLETT (b. 1957) is an outspoken critic of U.S. detention policies and the sanctioning of torture. Since 2005, he has represented, on a pro bono basis, Uighur (Chinese Muslim) prisoners in Guantánamo prison in an attempt to restore the rule of law. A partner in the Boston office of the law firm of Bingham McCutchen LLP, he passionately defends the writ of habeas corpus.

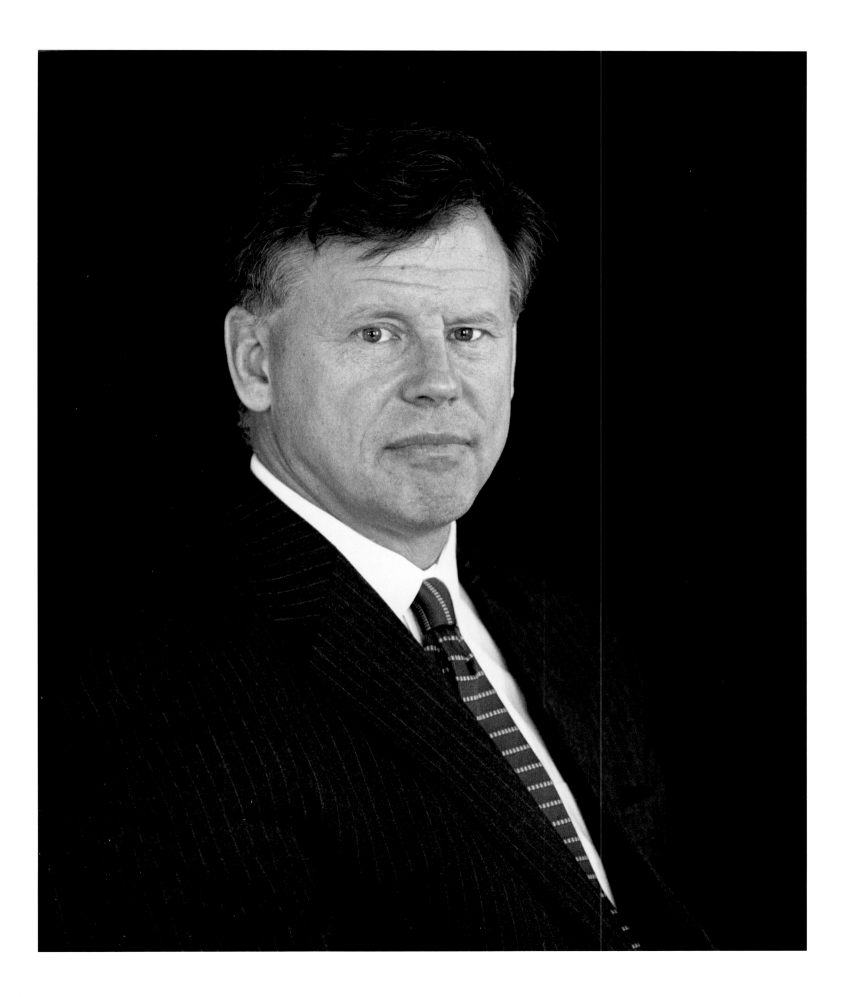

KATE O'REGAN

SOUTH AFRICA — JUDGE

I WAS BORN IN LIVERPOOL, ENGLAND, in 1957, the second of five children and the only daughter. My mother was Irish and had been brought up on a farm in Mayo in the west of Ireland. My father's parents were both Irish, but he had been born and brought up in England. When I was seven, my parents decided to immigrate to South Africa to join my mother's sisters, who had all immigrated to South Africa from Ireland in the aftermath of World War II.

During the years of my childhood and youth, the apartheid government introduced and enforced racist laws and practices with devastating consequences and ruthlessly quelled political dissent by authoritarian means, including detention without trial, censorship of the press and publications, and the outlawing of political opponents. Watching these events left one with no doubt that South Africa was a society where for many civil liberties did not exist, and where social inequality was actively pursued by the government.

Although I initially wanted to study journalism, I realized when I was a student that law was a potential, though imperfect, tool for promoting justice. After completing my law degree, I went into legal practice at a time that coincided with the reemergence of a broader resistance movement in the country that included churches, trade unions, student and community organizations. I was fortunate during those years to be able to work with many of these organizations. My years as a young lawyer working for trade unions and other organizations taught me some invaluable lessons: that law can be used to promote justice, but that it is at its most effective when coupled with socially powerful organizations; that lawyers should be modest about using law as a tool for social justice, but also uncompromising in demanding that law should always be just. During this time, the possibility of a different South Africa, one based on the values of human dignity, equality and freedom, one that would emphatically reject the evils of the authoritarian, apartheid system, emerged. It was a great privilege to be alive and in South Africa then.

What an even greater privilege it was as a relatively young woman (37) to be appointed to serve on the first Constitutional Court in 1994, where I worked with many of South Africa's leading civil rights lawyers to attempt to give life and meaning to the new constitutional text.

The judicial oath of office is to "uphold and protect the Constitution and the human rights entrenched in it, and [to] administer justice to all persons alike without fear, favor, or prejudice in accordance with the Constitution and the law." It is an awe-inspiring responsibility, undertaking "to administer justice," particularly in a society where justice has been so absent and evil so present.

How do we forge a just future in the context of such an evil past? There is a need to remember the injustice of the past, to analyze it, understand it, and accept it. But we do need to be cautious about the purpose to which we put our memory of the past. In *Untimely Meditations*, Friedrich Nietzsche wrote, "We need history, certainly, but we need it for reasons different from those for which the idler in the garden of knowledge needs it. . . . We need it . . . for the sake of life and action."

Our memory of the past must thus be employed positively for the purpose of creating a better present and paving the way for an even better future. In this lawyers and judges have a role, but by no means the most important one. Nor is it only the task of government. For a just society is, at the end of the day, created by many citizens in different walks of life repeatedly asserting the values of dignity and equality and freedom. Such a society is never fully attained. It is always a work in progress. And in South Africa, there is still much work to be done.

In the words of a great American, Martin Luther King Jr.: "Change does not roll in on the wheels of inevitability but comes through continuous struggle. And so we must straighten our backs and work for our freedom."

KATE O'REGAN (b. 1957) is a former justice of the Constitutional Court of South Africa. She was appointed to the newly formed court by Nelson Mandela in 1994 and served until 2009. Prior to her appointment on the court, O'Regan worked as an attorney and law professor, specializing in labor law, land rights, race and gender equality, and constitutional law. She was Chair of the United Nations Internal Justice Council from 2008 to 2012, is an honorary professor at the University of Cape Town, and a visiting law professor on the Faculty of Law at the University of Oxford. She also serves on the board of Corruption Watch, an organization dedicated to eradicating corruption in South Africa, and has served as an ad hoc judge of the Namibian Supreme Court since 2010.

JOHN SHATTUCK

UNITED STATES — LAWYER/ACTIVIST

MY HUMAN RIGHTS EDUCATION BEGAN when I was nine, growing up in a small town north of New York City. My father was a lawyer, a Republican, and a former U.S. Marine platoon leader who had been awarded two Purple Hearts during World War II. My mother was a community leader, proud of her Irish ancestry and deeply committed to fair play. In the summer of 1952, the town newspaper smeared a Democratic Party candidate for the school board by quoting anonymous people accusing her of vague "Communist connections." In a letter to the newspaper and at a meeting of the school board, my father challenged those making the anonymous charges to either prove or withdraw them. Soon nasty things were being said about him as well. I remember hearing them from my schoolmates. My father explained to me that he did not know the Democratic candidate personally and was opposed to many of her policy positions, but that politicians like Senator Joseph McCarthy and his supporters in our town would destroy the freedoms he had fought for if he didn't stand up to them. My father's words planted the seeds of justice in my mind, and my mother's commitment to fairness helped them grow.

I became a civil rights lawyer in the United States. The civil rights movement had a transformative effect on American society, and Martin Luther King, its central figure, defined a new kind of leadership, with the principles of justice and human rights at its core. The Bill of Rights in the U.S. Constitution provided a legal framework for these activities. As an American Civil Liberties Union lawyer, I had many human rights leaders and activists as clients, including people of sharply differing views. I learned early in my career that freedom of speech and other fundamental rights have to be equally protected for everyone, or they are protected for no one. This meant that the defense of Martin Luther King's right to march through the ethnic white neighborhoods of Cicero, Illinois, also required the defense of provocative Nazi marchers in the Jewish neighborhoods of Skokie.

Government officials in a democracy have to be held accountable under the rule of law. During the presidency of Richard Nixon, massive violations of the rights of American citizens were committed by government agencies. I helped curb these abuses by using the courts and the Constitution to hold accountable Nixon administration officials—including the President himself—for illegal wiretapping, spying, and unconstitutional invasions of privacy. Years later, after the collapse of the Soviet Union, I was asked by Russian lawyers to advise them in creating a legal framework for holding their own newly elected officials accountable.

The post-Cold War world of the 1990s produced both new opportunities and new challenges for human rights and justice. The fall of the Berlin Wall, the peaceful democratic revolutions in Central and Eastern Europe, and the defeat of apartheid in South Africa were dramatic examples of the new opportunities. But ethnic and religious conflicts in Rwanda and Yugoslavia, stimulated by cynical leaders, were equally powerful symbols of the post-Cold War period and led to massive crimes against humanity. As the U.S. assistant secretary of state for the Bureau of Democracy, Human Rights, and Labor, I was involved in an effort to create new international institutions to bring to justice the perpetrators of genocide and to stop or deter massive human rights crimes. The International Criminal Tribunals for the former Yugoslavia and Rwanda, created in 1993 and 1994, and the International Criminal Court, established in 1998, are the first such institutions. As the first international official to investigate the killing of 7,000 Bosnian Muslim men in Srebrenica in July 1995—the worst genocide in Europe since World War II—I was gratified when Ratko Mladić, the Bosnian Serb general who ordered the killings, was finally arrested in May 2011.

I am privileged to have played a small part in a far-reaching effort to enforce the principles of justice and the rule of law at national and international levels. Modern democracy and human rights have been created by centuries of struggle against oppression. These most precious assets of humankind require the commitment of each new generation.

JOHN SHATTUCK (b. 1943) is an American lawyer and diplomat serving as President of Central European University in Budapest. As an American Civil Liberties Union lawyer during the Watergate era, Shattuck successfully sued former President Richard Nixon and other officials in his administration for illegal political surveillance—acts that later contributed to Nixon's impeachment by the House of Representatives. In the Clinton administration in the 1990s, he was U.S. Assistant Secretary of State for the Bureau of Democracy, Human Rights, and Labor, playing a major role in the establishment of the International Criminal Tribunals for Rwanda and the former Yugoslavia, the Dayton Peace Agreement, and other efforts to end the war in Bosnia. In July 1995, his reports on the genocide in Srebrenica contributed to the UN-authorized NATO intervention a month later. His strong advocacy on Bosnia, Rwanda, Haiti, and China often made others in the Clinton administration nervous. He also served as U.S. Ambassador to the Czech Republic, helping to overhaul the country's legal system and design innovative civic education programs.

KENNETH ROTH

UNITED STATES — ACTIVIST

I AM OFTEN ASKED what got me started in human rights work. There's no single answer. One big influence was hearing my father's stories about growing up as a young boy in Nazi Germany. Some stories were fun—about Bobby, the mischievous horse from my grandfather's butcher shop—but others were serious: about being segregated in an all-Jewish school, fearing arrest for some minor infraction like riding his bicycle on the sidewalk, and enduring many long months of separation as his family tried to escape. I learned to appreciate the evils of which governments are capable.

I also came of age with human rights. I was in law school as President Jimmy Carter introduced the novel idea that promoting human rights should be an important part of U.S. foreign policy. I found that vision to be enormously exciting.

I was also very much a child of the 1960s. Like many others of that era, I wanted a career that allowed me to work for what I believed. I was too young to have taken part in the major U.S. civil rights battles; by the time I graduated from law school in 1980, international human rights were the new frontier. I wanted to be part of it.

My career didn't begin auspiciously. In law school, I signed up each year for the one human rights course on offer, and each year it was canceled. As a result, I graduated with no formal training in my chosen profession. To make matters worse, there were no jobs. At that time, Human Rights Watch had all of two employees. Amnesty International was only slightly larger. I settled for working by day as a lawyer—first as a civil litigator in private practice and then as a prosecutor—and volunteering nights and weekends doing human rights work. I did that for six years (mostly work relating to Poland after martial law was declared to crush the independent Solidarity trade union movement), until one day I received a phone call out of the blue from Human Rights Watch, asking whether I would be interested in a job.

My friends thought the idea was crazy. They were aspiring to be partners at major law firms, while Human Rights Watch then was small and obscure. But I knew what I wanted to do, and I accepted the offer immediately. It was the best move I ever made.

My work at Human Rights Watch has been enormously fulfilling. I gain tremendous satisfaction from seeing the difference we can make in people's lives—whether freeing a political prisoner, ending the use of torture, stopping atrocities in wartime, or bringing a brutal leader to justice.

Reflecting my litigator's training, I particularly enjoy the battle. Governments that abuse human rights frequently try to cover up, lie, or justify their abuses. I enjoy cutting through that obfuscation, knowing that the more we can shame a government for its misconduct, the more pressure we can build for change. Going head-to-head with governments can be challenging, but we have a trump card on our side—the truth.

When I first began doing human rights work, I focused initially on Haiti under military rule. I loved traveling "to the field," conducting investigations, meeting victims, working with local activists. It was exhilarating. My contribution was tangible; the people I was helping stood before me.

Human Rights Watch now has a staff of 350 working in some 90 countries, and I must leave the investigations to others. I still visit the field, but only to hold a press conference or to meet with senior officials—not activities that bring me the same close, sustained contact with the people of a country. I enjoy representing the organization, pushing governments to end abuses, or defending our reports before the press. But I miss the immediacy of my early human rights work.

That said, I have discovered a new satisfaction—one that I never anticipated at the outset. I find it deeply fulfilling to build an organization—to recruit and develop a staff, to assemble a community of supporters and volunteers, to take on the myriad challenges of building an institution whose clout comes from nothing more than its principles, its credibility, and the values it represents. I have even come to like the fundraising, since I see the direct effect that financial contributions can have on our ability to protect people from abuse.

Today, Human Rights Watch has become part of the architecture for protecting human rights around the world. It is not only the victims and activists who look to us, but also policy makers, journalists, and the general public. Living up to the trust that they put in us is an enormous responsibility. I feel extraordinarily fortunate to have had the opportunity to take that duty on.

KENNETH ROTH (b. 1955) is the Executive Director of Human Rights Watch, a leading international human rights organization, which operates in more than 90 countries. Prior to joining Human Rights Watch in 1987, Roth served as a federal prosecutor in New York and for the Iran-Contra investigation in Washington, D.C. Roth has conducted numerous human rights investigations and missions around the world and has written extensively on a wide range of human rights abuses—devoting special attention to issues of international justice, counterterrorism, the foreign policies of the major powers, and the work of the United Nations.

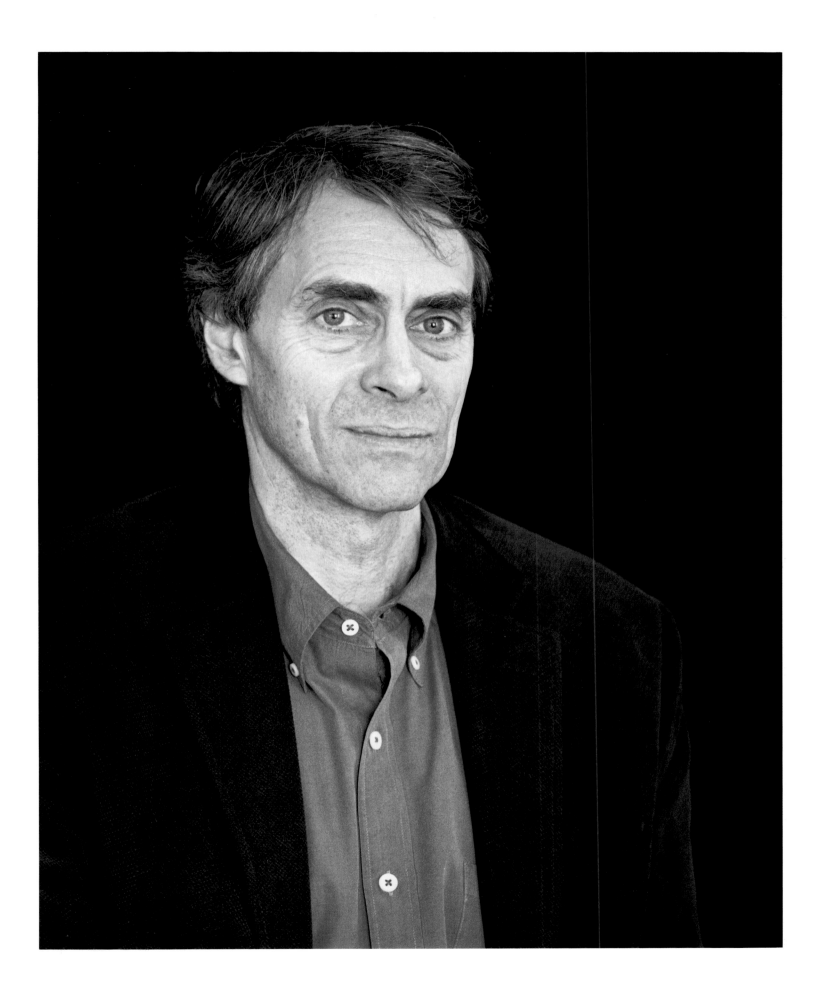

SAMANTHA POWER

UNITED STATES — LAWYER

SHORTLY AFTER COLLEGE, I headed to Berlin to teach English. The Wall had recently fallen, but the city's most noticeable feature was its refugees, who were largely Bosnian Muslim. To my knowledge, I had never seen a refugee before. The people tumbling into Berlin were fleeing for their lives. Many were reliving the horrors they had experienced: concentration camps, besieged cities, children picked off their bicycles by snipers. My response, however, was to walk away as quickly as I could. I told myself the same story that American politicians were telling themselves: that Bosnia was the product of ancient hatreds that could never be resolved.

When I returned to the United States, I went to work for an extraordinary man named Mort Abramowitz at the Carnegie Endowment for International Peace. For him, Bosnia was the singular moral and strategic challenge of the 1990s. Either we were going to stop genocide in Europe or we were going to legitimize terror and ethnic cleansing, thereby sending a signal to tyrants everywhere that the new world order would disregard crimes against humanity. I had found in Mort a shepherd for life.

I read *The New York Times* and could sketch what was going on in the Balkans, but I hadn't read the stories with any sense that they implicated me or my country. I quickly came to realize what people who lived through the Holocaust had long known: there is knowledge, and then there is the kind of deep knowledge that knocks the wind out of you. I felt powerless to help until I remembered that I had learned at least one practical skill in college: how to write. I moved to the former Yugoslavia and for two years wrote hundreds of thousands of words for a variety of publications—somehow managing to convince my mother that I was working from relatively peaceful Croatia (rather than war-torn Bosnia) until I had arrived home safely.

Back in the United States, I was struck by a powerful dissonance in American culture: the gap between the promise of "never again" and the contemporary horrors of Bosnia and other places. Steven Spielberg's *Schindler's List* had recently drawn tens of millions to theaters. The Holocaust Museum had opened on the Mall in Washington. College seminars were taught on the "lessons" of the singular crime of the 20th century. But why, I wondered, had nobody applied those lessons to the systematic murder of 200,000 Bosnian civilians between 1992 and 1995, and the extermination of some 800,000 Rwandan Tutsis in 1994? Did "Never Again," as writer David Rieff had asked,

simply mean "never again will Germans kill Jews in Europe between 1939 and 1945?"

I began researching American responses to the major genocides of the 20th century: the Armenian genocide, the Holocaust, Pol Pot's murder of two million Cambodians, Saddam Hussein's gassing of the Kurds, Bosnia, Rwanda. The United States and other countries found themselves bystanders again and again. And yet in every case of genocide in the 20th century, there were people who risked their careers and lives to speak up on behalf of distant victims. During World War II, Arthur Koestler described those frustrated few who spoke up in newspapers and public meetings against Nazi atrocities as "screamers." The screamers would succeed in reaching their fellow citizens only briefly before the listeners would shake the unwelcome knowledge off "like puppies who have got their fur wet."

By the early 21st century, though, something remarkable had occurred. Contemporary screamers had found new ways of connecting with one another, of organizing, and of leveraging their numbers to do genuine good. Young people, church-goers, Jewish groups, visitors to the Holocaust Museum, and everyday readers of the newspaper found one another, and their voices grew harder to ignore. Dedicated anti-genocide groups sprang up on college campuses as the memory of Rwanda, in particular, helped create a new kind of collective conscience. These individuals are determined to make their demands heard by policy-makers.

The movement isn't large, but it is loud. Its members call their congressmen, raise money to fund refugee camps, make viral videos to educate their neighbors. In short, there is now a community of people who are not inclined to walk away from those in desperate need but instead are disposed to walk towards them.

SAMANTHA POWER (b. 1970) is an Irish-American academic and writer who served as Special Assistant to President Barack Obama and as Senior Director of Multilateral Affairs on the staff of the National Security Council. Power began her career by covering the Balkan Wars as a journalist, and she won the Pulitzer Prize in 2003 for her book *"A Problem from Hell": America and the Age of Genocide*, which analyzes U.S. responses to genocide over the last century. She is also the author of *Sergio: One Man's Fight to Save the World,* a biography of the famed UN diplomat and trouble-shooter Sergio Vieira de Mello, who was slain by a suicide bomber in Iraq in 2003.

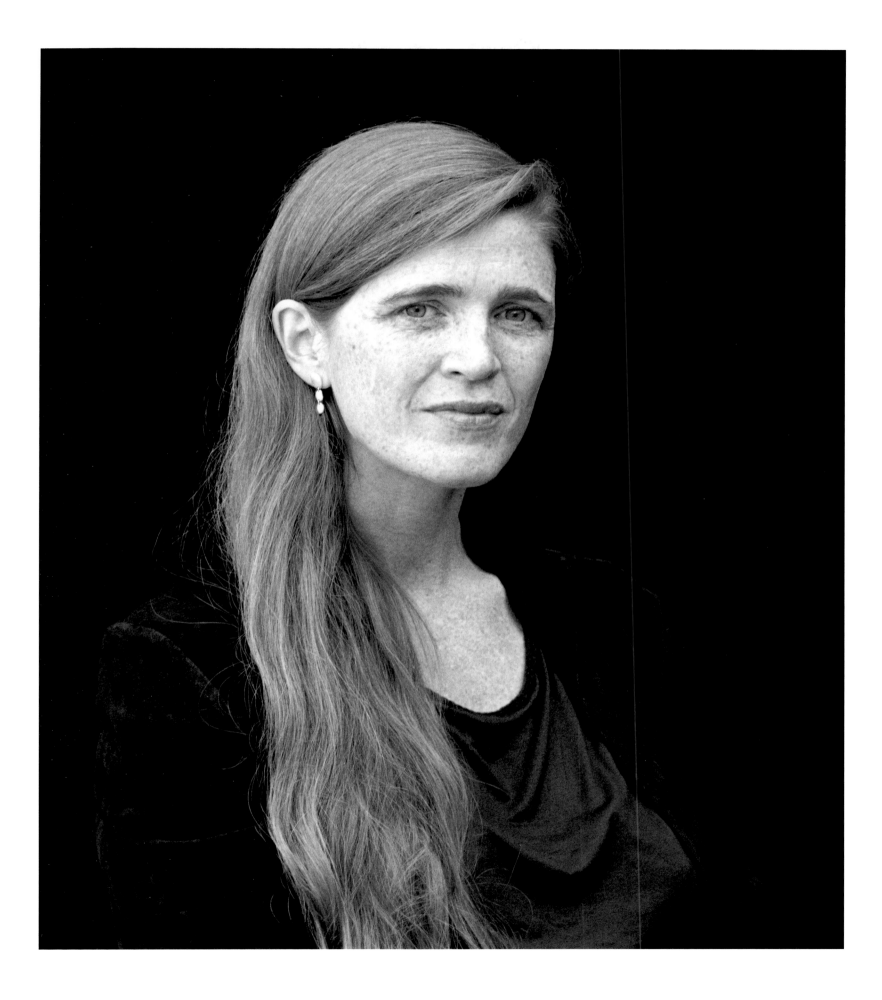

JOHN MINOR WISDOM

UNITED STATES — JUDGE

HISTORY WILL REMEMBER JUDGE WISDOM primarily for his strength and courage in leading the Fifth Circuit and the lower federal courts to end racial segregation in the South. Judge Wisdom's work in civil rights cases conferred upon millions of Americans the full stature of equal citizenship and made him a giant of the law and a hero of the nation.

Judge Wisdom was the founder of the modern Republican Party in Louisiana. In 1952 he had the imagination and foresight to use national television as a political tool in arguing (successfully) that his Louisiana Eisenhower delegation should be seated at the Republican National Convention. He was also a wizard at bridge. His exuberant spirit and irrepressible joie de vivre pervaded all he did.

The judge was the consummate teacher. He taught his clerks and also the friends of his clerks, the clerks of his friends, the spouses and children of his clerks, his students at Tulane, young lawyers who argued before him, and young lawyers who met him on the street, at plays, at concerts, at the opera, and in museums. He taught by example that one can live a life of rectitude; that one can follow high principles; that one can believe in the duties of citizenship; and that one ought to care about the quality of the lives that others lead. The judge taught us to have due regard for the humanity of all people, whether they are similar to or different from ourselves.

Perhaps the most important aspect of Judge Wisdom's teaching was his determination to write opinions in a way that would teach basic principles of democracy, equal protection of the laws, and constitutional federalism to lawyers, government officials, and the general public, so that all would better understand the reasons behind the court's decisions. Judge Wisdom was well known for the clarity and precision of his writing. His spare yet elegant style was well suited to the task of explaining firmly and clearly the court's reasoning in reaching what were often unpopular results. One example is his opinion in *United States v. Jefferson County Board of Education* in which he crafted practical instructions to guide the lower federal courts in desegregating hundreds of school districts in six states. Judge Wisdom stated the court's holding simply and in practical terms: "The only school desegregation plan that meets constitutional standards is one that works." He then explained: "*Brown* erased Dred Scott, used the Fourteenth Amendment to breathe life into the Thirteenth, and wrote the Declaration of Independence into the Constitution. Freedmen are free men. They are created as equal as are all other American citizens and with the same unalienable rights to life, liberty, and the pursuit of happiness. No longer 'beings of an inferior race'—the Dred Scott article of faith—Negroes too are part of 'the people of the United States.'"

The depth and breadth of the concept of federalism underlies Wisdom's opinions. It is important to remember that the opinion he wrote for the court in the *United States v. Jefferson County Board of Education* case appeared many months before the Supreme Court itself rejected the "freedom of choice" principle of *Briggs v. Elliott*. Judge Wisdom wrote:

> The Constitution is both color blind and color conscious. To avoid conflict with the equal protection clause, a classification that denies a benefit, causes harm, or imposes a burden must not be based on race. In that sense, the Constitution is color blind. But the Constitution is color conscious to prevent discrimination being perpetuated and to undo the effects of past discrimination. The criterion is the relevancy of color to a legitimate governmental purpose.

His style exhibits eloquence, intellect, classical learning, pith, and vigor, and not only ornaments every opinion but becomes an essential part of it. Judge Wisdom's opinions are works of art. In later years, Judge Wisdom wrote down his style tips for law clerks. With characteristic humor and modesty, he called them "Wisdom's Idiosyncrasies." They convey a good sense of the man who knew the value of fun while keeping sight of the serious purpose at hand.

This text was written by Allen D. Black, a former law clerk to Judge Wisdom and a partner of Fine, Kaplan and Black.

JOHN MINOR WISDOM (1905-1999) struck down racial barriers as a Federal Appeals Judge during the height of the civil rights struggle. His father was a New Orleans cotton broker and old-line Southern Democrat who walked in Robert E. Lee's funeral procession. Wisdom's rebellious streak emerged when he was a law student at Tulane and joined the Republican Party as a protest against the corruption of Huey Long. President Dwight D. Eisenhower appointed Wisdom to the Fifth Circuit Court of Appeals in 1957, which then included most of the Deep South. Wisdom was one of four judges on the Fifth Circuit whose rulings provided for the broad application and enforcement of the 1954 *Brown v. Board of Education* decision, impacting not only schools but voting, employment, and jury service. He wrote the opinion ordering James Meredith's admission to the University of Mississippi in 1962. In 1966, Wisdom's landmark ruling in *U.S. v. Jefferson County* took aim at Southern defiance of the spirit of *Brown*, holding that "a century of segregation requires much more than allowing a few Negro children to attend formerly white schools. It calls for the organized undoing of the effects of past segregation." This ruling was considered to be the legal foundation of affirmative action.

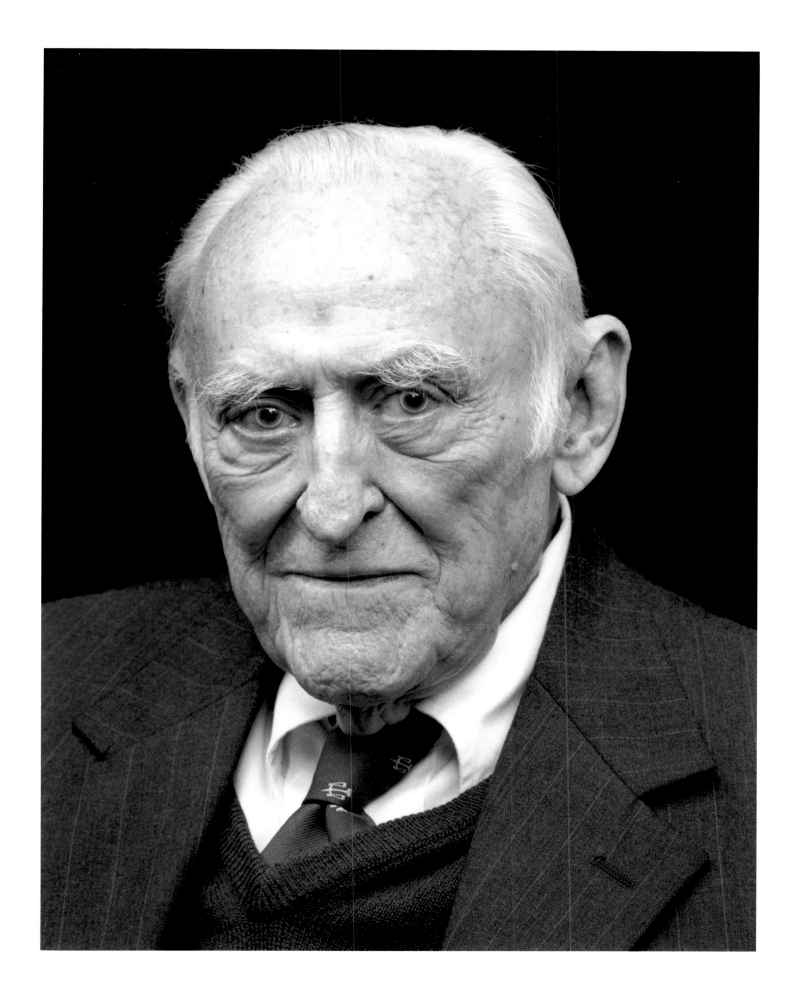

INDEX

ACKNOWLEDGMENTS

IT WAS AT DINNER WITH ANTHONY LEWIS that I first conceived of this project in a general way; he helped me give it focus and made many suggestions of people to include. His interest and confidence provided the caring attention I needed throughout—supported all the more by his beyond-wonderful wife, Margaret H. Marshall. His longtime friend Aryeh Neier provided a list of international subjects and greatly facilitated their participation, a remarkably generous personal gesture. Anthony Lester shook me up, offering names of more women and young advocates—he was both imaginative and insistent. Patricia Sullivan spent a significant amount of time assisting with various aspects of the civil rights movement entries. I am grateful not only for the time she gave, but for her belief in my efforts.

I am indebted to my agent, Jason Allen Ashlock, for his enthusiasm and sane attention to the book's publication. Ruth Mirsky has been both thorough and diligent in editing the texts, not to mention intelligent and kind in bolstering me when the work was overwhelming. Alice Truax came in with a fresh and objective eye on the texts, making them all the better with her acute and insightful editorial skill and wise counsel. Many thanks go to my assistant, Trellan Smith, for keeping the boat afloat at all times. Doug Leax is an even keel in the studio—his warm heart, keen eye and technical knowledge are godsends. Debbie Berne has given her all to the design, both in its practical aspects as well as offering the infinite patience this project has required. Enrico Battei helped me supervise the press run with his half-century of experience and gentility. I am grateful to my publishers, Silvia and Andrea Albertini, for their leap of faith in publishing this volume.

In addition to the subjects themselves, the book could not be what it is without the generosity of numerous others who helped in securing either portrait sessions or texts. I name a few: Peter and Amy Bernstein, Allen D. Black, Chesa Boudin, Andrea Coomber, Jonathan Cooper, Katy Cronin, Henry Finder, Wendy Gimbel and Doug Liebhavsky, Irena Gross, Heron Haas, Kate Hughes and Robert del Tufo, Anna Husarska, Olivia Kraus, Clifford M. Kuhn, Libby Landis, Katya Lester, Hans and Susanne von Meiss, Mabel van Oranje, Sidney Orlov, Robert S. Pirie, Tracy Pogue and Michael Hausman, J. Stapleton Roy, Sarah Stillman, Kyaw Swa, and Maureen Aung-Thwin. Finally, all my thanks and love go to my husband, Hans Kraus, for his constant patience and faith in me and my work.